CRITICAL STUDIES AND MODERN ART

INTRODUCTION

This book addresses some of the issues and debates around working with modern art in schools and galleries. In particular, it focuses on Critical Studies, an approach to the teaching of art that has developed in recent years from within educational institutions. Critical Studies grew as a response to the rather traditional and narrow discipline of art appreciation. It attempts to combine historiography, critical analysis and understanding as well as exploring the social, political and cultural meanings and contexts in which artworks are created. Debate continues here and elsewhere about whether Critical Studies means an engagement with art which leads onto practical 'art-making' activity. The National Curriculum for Art in the United Kingdom, for instance uses the term Visual Literacy in the following way. 'In order to develop Visual Literacy, pupils should be taught about the different ways in which ideas, feelings and meanings are communicated in visual form.'

Whether we are talking about Critical Studies or Visual Literacy we hope that this collection of essays will raise issues of real concern for those wishing to engage in a critical practice that is positive about visual culture at the end of the twentieth century.

This book provides a selection of both previously published work and newly commissioned articles which will support the professional development of teachers in primary and secondary schools as well as education officers in galleries and museums. We believe that it will also be of interest to many others involved in art education and that it will provide an exciting opportunity to reflect on the multiplicity of differing theories, approaches and practices.

In section one we have brought together a collection of articles that variously discuss the role of critical studies in educational institutions. Historical analyses of the development of critical studies in the UK and America are provided (see chapters 1–6). It is also proposed that there is now the opportunity to change the socio-political agenda and to challenge the 'canon' of modern art. This shift reflects the changes in art history, theory and criticism (and indeed practice) evident over the past twenty-five years. There are arguments presented here for critical studies to be seen as being at the core of the art curriculum and no longer subordinate to practical art activity (Thistlewood in chapter 1 and MacDonald in chapter 3). However what is recognized and accepted throughout the articles collected together here is that working with modern art can at times be difficult and questions are asked about the appropriateness of introducing discourses on modern art to primary and secondary school pupils (Hulks in chapter 4 and Taylor in chapter 5). Critical Studies and Visual Literacy are discussed as active experiences, we have to learn and use 'languages' which interrogate works of art. It is not only the work of art that has significance and meaning but also the viewers' culture and experience (Clive in chapter 6). Debates about the role of Critical Studies are initiated, that continue to be questioned and argued about throughout the rest of the book.

Having discussed differing definitions and practical issues surrounding Critical Studies, the next section 'Teaching and Learning in Art' goes on to broaden the debate. Section two covers a wide range of issues from the philosophical and socio-political dimensions of working with art to practical work in schools and galleries. Issues surrounding aesthetics education are debated. For example, the rationality of 'feeling' in contrast to the 'experience' of the aesthetic moment are discussed in the papers by Best and Abbs (chapters 7 and 8). Other analyses are presented that challenge the dominant discourses prevalent in modernist views of art. Another challenge to the 'canon' in the modern period from feminist

critiques and feminist practices in modern art are debated. Questions are asked about the nature of patriarchal culture, (defined as male, white and middle-class) and the authority it has held (see Pollock chapter 9). Such questioning of cultural authority is important because it opens up the possibility for recognition of the 'other', (those who have been ignored and devalued) and the relation between 'centre' and periphery. Articles in this section review ideas of the value of 'multi-culturalism' and question whether we should be concentrating on teaching style and the content of the curriculum or whether it is about creating a new internationalism in which the artist and the artwork set the rules, rather than specific cultures, European, African or American? (see Mason and Araeen, chapters 10 and 11). It could be said that the National Curriculum for Art document has set its own agenda for Critical Studies and several articles here analyse what that agenda might be (see Meecham, McAdoo and Allen chapters 12,13 and 14). There is a danger that the curriculum becomes a kind of 'heritage theme park', a bit of Impressionism here, an example of non-western art there and so on. Given the limitations of curricula time and resources, how do you teach and how do pupils learn 'to recognize differences and similarities in art, craft and design from different times and cultures' as stated in the National Curriculum? It is not an easy task. This section then moves from the philosophical and sociological problems of the National Curriculum to more practical strategies for teaching art and critical studies. The issues around collaboration with external agencies to the school such as galleries and museums as well as working with artists in residence are explored with the emphasis on the development of school policies and practices that are actively implemented in the gallery and the classroom (see chapter 15, Binch and Clive, and chapters 16 and 17, Moore and Taylor).

In section three 'Teachers, Artists, Galleries and Exhibitions', there is extensive discussion of the power of the gallery, museum and curators, who through their ideological and institutional practices, can misrepresent modern art, particularly art from non-western cultures. The impact of the imperial colonialist past of the west (and its contemporary neo-colonialist expression in countries like the United Kingdom) on the representation of global art forms is shown through analyses of exhibitions of non-western artists (chapter 18, Tawadros and Malik). The voices of contemporary native Americans come through strongly in chapters 19 and 20 by Meuli and Holt, modern artists whose culture and art is changing and growing. The arguments running through these articles challenge western views of aboriginal cultures, particularly when viewed as only existing as ancient cultures and therefore as 'dead' and so having no contemporary relevance (see Tallack and Bennett in chapters 23 and 24). Difficult and innovative modern art challenges 'normal' perception and attempts to destroy the illusion that the world we live in is easily understood. Two articles here look at the challenges that modern art can bring to teachers and pupils (Dawe-Lane and Cole in chapters 21 and 22). They emphasize the need for active involvement in 'reading' and enjoying modern works of art and in the promotion of plurality of meaning in a Post-Modern age. It is interesting to contrast Cole's view of working with primary pupils and modern art with Taylor's in chapter 5. The final chapter (chapter 25) by Becker analyses the 'Post-Modern' condition in the USA where the nihilism of the eighties has been transformed in the nineties through the work of young people training to be artists and wishing to represent such issues as homelessness and AIDS in their work and so challenging the discussion of what the author sees as the anti-intellectualism and the visual illiteracy characteristic of American society.

This book hopes to make more accessible some of the debates around Critical Studies in art education in schools and galleries. In particular, that modern art can be made accessible to all young people through a greater understanding by educators of the institutional and ideological practices that inevitably influence our ways of seeing and thinking about works of art.

LIZ DAWTREY

ACKNOWLEDGEMENTS

The editors wish to express their thanks to the many people who have been involved in working on this volume. This book has been the result of a partnership between the Open University and the Arts Council of England and we are particularly indebted to Marjorie Allthorpe-Guyton, Director of Visual Arts, Arts Council of England for her personal involvement in its creation. Our special thanks also go to Sandy Nairn and Colin Grigg of the Tate Gallery, London for their tremendous support and encouragement during the initial stages of production.

Our thanks go to Dave Allen, Bev Joicey, Laurie Ruscoe and Jane Placca, members of the Steering Group, for their comments on the manuscript, to Rod Taylor for his enthusiastic response to the project and to Tim Benton, Dean of the Arts Faculty at the Open University for his vision which sustained the critical early stages of development.

We are particularly grateful to the Tate Gallery for permission to reproduce works from their collection and for releasing Toby Jackson to work on the book and also to Liverpool John Moores University for enabling Pam Meecham to give of her time both as an author and as an editor. Finally, we would like to express our thanks to our secretaries, Karen Codling and Bernadette Emmet whose dedication and resourcefulness has ensured that this book has finally been produced.

SOURCES

A number of the chapters in this book have previously appeared elsewhere and are collected together here for the first time. The editors are grateful for permission to reproduce these texts, which should be read with their original contexts in mind.

CHAPTER 1 David Thistlewood, Curricular Development in Critical Studies, *Journal of Art and Design Education* , 1993, vol .12, no 3.

CHAPTER 2 John Swift, Critical Studies: A Trojan Horse for an Alternative Cultural Agenda?, *Journal of Art and Design Education* , 1993, vol. 12, no.3.

CHAPTER 4 David Hulks, The Critical Curriculum, *Journal of Art and Design Education* , 1992, vol .11, no.3.

CHAPTER 5 Brandon Taylor, Art History in the Classroom: A Plea for Caution, *Critical Studies in Art and Design Education*, ed. David Thistlewood, Longman, 1989.

CHAPTER 6 Sue Clive, Thoughts on Visual Literacy, *National Association for Gallery Education Quarterly Supplements*, Autumn 1994.

CHAPTER 7 David Best, The Rationality of Artistic Feeling: An Urgent Educational Issue, *Drawing Fire, The Journal of the National Association for Fine Arts Education*, Autumn/Winter 1994, vol. 1, no.1

CHAPTER 8 Peter Abbs, Making the Art Beat Faster, *Times Higher Educational Supplement*, 18 September 1992. For the full context of this passage please refer to chapter 4 of P. Abbs, *The Education Imperative: A Defence of Socratic and Aesthetic Learning*, Falmer Press, London, 1994.

CHAPTER 9 Griselda Pollock, Art, Artists and Women, *Framing Feminism: Art and the Women's Movement* (ch.2 Feminism and Modernism), Pandora, 1987.

CHAPTER 10 Rasheed Araeen, New Internationalism or the Multiculturalism of Global Bantustans, *Global Visions: Towards a New Internationalism in the Visual Arts*, ed. Jean Fisher, Kala Press in association with The Institute of International Visual Arts, London, 1994.

CHAPTER 11 Rachel Mason, Beyond Tokenism: Towards Criteria for Evaluating the Quality of Multicultural Art Curricula, *Different Perspectives*: Conference papers, University College, Bretton Hall, 1994.

CHAPTER 13 Nick Mcadoo, Making Sense of the National Curriculum Attainment Targets for Art: A Philosophical Perspective, *Journal of Art and Design Education*, 1993, vol.12, no.1.

CHAPTER 15 Norman Binch with Sue Clive, Museum And Gallery Education And Artists In Residence, in Binch, N. and Clive, S. (1994) *Close Collaborations: art in schools and the wider environment*, London,The Arts Council of England, where this chapter was followed by a series of case studies.

CHAPTER 16 Alex Moore, 'Bad at Art': Issues of Culture and Culturism, in Moore, A. (1989,1993), 'Bad at art/good at art: issues of assessment and pedagogy', research paper; a shorter version of which appeared in 1993, 'Bad at art': Issues of Culture and Culturism, *Chreods*, 5, pp.41–54, Manchester Metropolitan University.

CHAPTER 17 Rod Taylor, Artists, Children and Community, *Issues in Architecture, Art and Design*, 1993, vol.3, no.1.

CHAPTER 19 Jonathan Meuli, How Traditional is a Chainsaw? Cutting a Path through Forests of Prejudice, *Different Perspectives*: Conference papers, University College, Bretton Hall, 1994.

CHAPTER 21 Lucy Dawe Lane, Using Contemporary Art, in Prentice, R. *Teaching Art and Design*, Cassell, Institute of Education, London, 1995.

CHAPTER 24 Gordon Bennett, The Non-Sovereign Self (Diaspora Identities), in *Global Visions: Towards a New Internationalism in the Visual Arts*, ed. Jean Fisher, Kala Press in association with The Institute of International Visual Arts, London, 1994.

CHAPTER 25 Carol Becker, The Education of Young Artists and the Issue of Audience, *Cultural Studies*, January 1993, vol. 7 no 1.

CURRICULAR DEVELOPMENT IN CRITICAL STUDIES

BY DAVID THISTLEWOOD

Over the past ten to fifteen years critical studies has become established in the primary and secondary phases of art and design education. This has been due to a small cohort of educationalists to whom I shall refer simply as the 'pioneers' of critical studies in schools. Their work has been effective to the degree that critical studies is enshrined in the National Curriculum; yet the nature of its presence in the National Curriculum suggests two things: (1) that it is a 'discipline within a discipline' (it has no role outside the context of art and design), and (2) it is a servant discipline. The interests it serves are those of 'making' or practice, but I suggest in this paper that this role should be questioned. It may be appropriate now to consider whether critical studies may become an independent subject, studied equally for its illuminative capacity in relation to practice, or for the benefit of its own inherent knowledge systems. If this seems heretical, I suggest that the history of the development of critical studies is replete with heretical moments that have given rise to productive revisions of its role.

Critical studies is today an accepted component of the art and design curriculum. It is a collective term for a range of interests and activities that, by present consensus, enrich those practical components of the art and design curriculum that are regarded as its core disciplines. Yet though there is a consensus belief in its validity, there is in fact little general agreement about its model content. While critical studies comprises subject-matter, forms of engagement and criteria of development that are *tacit*, the art and design educational community acts as if they were explicit. This alone should be sufficient to warn against complacency.

The issues critical studies embraces are many and complex, but there is a virtual conspiracy to present them as few and simple. This may be explicable in terms of fears that critical studies may become a *served* rather than a *serving* discipline. It is possible that a general acceptance of its 'supporting' status has hampered its development, and may be responsible, for example, for what is a real, but at the same time vague, presence in National Curriculum documentation. Here is the paradox which any consideration of a future role for critical studies must address. It is vaguely present in the National Curriculum not because of some desire to accommodate it in a minor key, but because of a determination to ensure that it remains a powerful force. Those who have drafted the non-statutory guidance within the National Curriculum would no doubt maintain that in order to preserve its potency critical studies must remain tacit.

It is characterized by understatement because of what has become a convention – that it is most effective when discreet. Creative work is evaluated first as achievement and second as a means towards achievement. Critical studies cannot normally receive high credit unless a related, created

outcome is perceived to have 'succeeded'. There is a respected constituency of belief that in the very tacitness of critical studies is its potency. But to maintain it as simultaneously a potent and a tacit educational force only makes sense in relation to its projected future as a subservient discipline. Any serious discussion of a future for critical studies must include – what has previously been considered unthinkable – the possibilities that it may be engaged independently of practice, and that in certain educational contexts it may be regarded as a core discipline in its own right.

These proposals will be regarded in many quarters as provocative: they challenge the basis of a great deal of the pioneering efforts to establish the validity of critical studies – such validity having been measured by an *evident enhancement* of practice. But it is also a tribute to the great pioneering initiatives to regard them as now sufficiently well established to resist heretical questioning. They themselves were once heresies, the periodic positing of which seems to be the fundamental principle by which critical studies has accomplished its insinuation into the curriculum.

A discussion of the future role of critical studies is not the occasion for a detailed history of art and design education – nevertheless a brief outline seems necessary for orientation and contextualization. In Britain this history may be drastically simplified – so far as critical studies is concerned – as having consisted in two principal phases. There *was* a phase in which the history of art (a principal component of critical studies) was largely irrelevant to the proper study of art and design; and there *is* a phase in which the history of art is regarded as indispensable.

The first of these phases occupied practically all of the period between the Great Exhibition of 1851 and its commemoration a century later in the Festival of Britain. Drawing education was introduced into the Victorian curriculum largely as a reaction against the worst features of taste displayed in the manufactures exhibited in 1851. It had historical referents, but these were few and specific – typified in aspects of form, proportion and decorative treatment associated with Antique modelling and architecture, and with an iconography of representation associated with sub-Raphaelesque naturalism. Drawing education was minutely prescribed, down to the minutest details of its regime of exercises. A legacy of prescription survived the 1913 Education Act because – whatever its disadvantages in terms of stifling originality

– prescription at least focused on practising and executing assessable skills that were regarded as *essential*.

The second period of this simplified history overlaps the first in recognition of the alternative, child-centred, philosophies that began to be proposed as early as the 1913 Act, but which were not enabled until the Education Act of 1944. Because child-centred theory, legitimized in 1944, had all along maintained affinities with certain aspects of the recent history of avant-garde creativity (notably Expressionism) its acceptance carried an inherent obligation (on the part of teachers rather more than their pupils) to be familiar with certain aspects of modern European art. It was this need on the part of teachers that challenged the dominance of subject-centred discipline, as increasingly they used avant-garde imagery and creative strategies to encourage their pupils to be appropriately 'expressive'.

So the first heretical 'moment' in the history of critical studies was in fact an extended episode in which Modernism was proposed as an alternative to classicism as the ideal referent for art and design. It was from this 'moment' charged with risk because it challenged an ingrained orthodoxy of belief in the proper foundations of culture. At a time when its most extreme opponents identified it with madness, Modernism was proposed as the normal referent for the creative work of children below the age of ten. This 'irresponsibility' was compounded by extension: pupils themselves were to be conducted in the ways of Gauguin, Van Gogh, the Fauves. As late as the 1950s this was sufficiently scandalizing for some teachers – even while utterly accepting child-centred principles – to agitate for more wholesome role models for artistic emulation.

So the first heresy was the proposal that pupils, particularly the very young, should receive an induction into Modernism. However, it should be recalled that 'Modernism' in the 1940s and 1950s connoted very differently than it does today. At a time when a literature of Modernism hardly existed, when virtually no well-produced visual information was available and when twentieth-century art was poorly represented in museums and galleries, Gauguin, Van Gogh and the Fauves *typified* Modernism. They represented unprecedented 'visions' that were more or less associable with children's creativity, but even so, in an age when popular, incidental histories of Modernism were better known than aesthetic critiques, they also

represented unsavoury lifestyles involving lechery, mental instability and wild behaviours.

Other aspects of Modernism – its publication in newspapers remaining largely uncorrected in the absence of a dedicated press – conveyed comparable implications: Epstein modelled pregnant women: Picasso visited wilful disfiguration on his subjects; the Surrealists were unhealthily explicit about sexual fantasies; Abstractionists were said to have abandoned the easel and to paint upon the floor. Traditionalists believed that resistance to Modernism was a moral crusade. There is more than a suspicion that critical studies' tacitness is a defence characteristic naturally rooted in such controversy.

By the early 1960s it had become apparent that critical studies needed to be recognized in *policies* for art and design education. The Coldstream and the Summerson Committees (which made recommendations on the degree-equivalence of higher education in art and design, and on the need for students to experience a specializing interlude between school and art college) each contributed to the legitimization of critical studies. This was accomplished by a tactical alliance between two distinct interests. There were members of these Committees who insisted on the necessity for studio-based activities to be informed by courses in art history, particularly featuring contemporary issues. There were others who insisted that the previously narrow world of art and design be enlarged and enriched with knowledge of an eclectic range of appropriate disciplines – engineering, psychology, the natural sciences.

In recognition of the fact that only a very small number of people in Britain at this time were *capable* of teaching the history of twentieth-century art, those who spoke for art history proposed the notion of 'cultural history'. This would embrace a great variety of essentially non-artistic matters – for example, principles of architectural construction or of biological formation – which nonetheless could submit to artistic criteria and assimilate a growing body of art historical expertise. This alliance of interests produced the notion of *complementary studies* in order to comprise a range of disciplines to be afforded 'honorary' art historical status, and thus to make catholic provision for supporting studies throughout all recognized foundation and degree-equivalent courses. But the introduction of a category of study with such generalized content as implied by the term 'complementary studies' of course was to invite other,

persistent heresies. One of the more obvious of these was a 'taxonomic' approach to aesthetic analysis, justified by the biological analogy, the inherent systematization in which, however, was essentially stifling of creativity.

But in the absence of definitions of what was appropriately 'complementary', any form of study could be legitimized. For example, it was not unreasonable to inform studio-based activities with philosophy, politics and sociology – in the late 1960s and the 1970s there were manifold opportunities for graduates of these disciplines to provide supporting courses in art colleges, especially as these colleges entered the new polytechnics and thus joined *communities* of diverse disciplines. There were many productive ramifications of this widening contextualization of art and design, particularly associations with other disciplines that became reflex and were carried from higher education into secondary and primary education as art and design graduates entered teaching.

But there were at least two unforeseen consequences that were undesirable. One was the opportunity provided for outrageous contributions to complementary studies. Representatives of other disciplines who were either unable or unwilling to contribute to their own fields legitimately, could here find an arena in which to be taken seriously. While the great majority of beneficial contributors to complementary studies remain unsung (when something works well it is often unspectacular) folk-memories of this period are likely to be dominated by a few shamanists and apocalyptics. The history of this tendency remains unwritten precisely because it involved ideas that could be taken seriously in the seminar room but not in print.

The second unforeseen consequence arises from the confinement of complementary studies to the spoken discussion. As recently as the late 1970s there was still little tradition of scholarly writing in degree courses in art and design. The contextualization of art and design in bordering and overlapping disciplines – the noble cause of complementary studies – remained unrealised in students' writings while at the same time it was endlessly rehearsed in their images and objects. Without cold textualization there was an invasion of uncritical stimulation into studio practice. The perfectly legitimate concerns of politics and sociology, environmentalism and even religiosity, became the objects of visual sloganizing, debasing both medium and message. Again, folk-memories bear traces of traditional studio teachers cowed by the ferocity of visu-

al slogans they were unable to counter with their aesthetics.

It should be stressed that exceptions to sound practices provide the most persistent memories, and that while complementary studies as a whole lacked a critique there were many pockets of excellence and relevance. But it is noteworthy that the generation of educationists who are now regarded as the 'pioneers' of critical studies were motivated by the general absence of a relevant critique in those complementary studies practices that began to percolate into secondary education in the 1970s.

This generation made it its business to identify a 'proper' range of disciplines and activities that could both enhance practical art and design and provide strong criteria for assessment and evaluation of the effectiveness of this enhancement. Here curiously was another heresy: the selectivity implied in such objectives was said to cut against the grain of liberality by now associated with a complementary studies tradition. It is often forgotten that a prime distinction existed as between 'complementary' and 'critical' studies, the latter signifying an intention to regain the high ground for rigorous support for practice – by identifying critiques and contextualization that were intrinsically of practice rather than parasitic upon it. The prime criterion for admission to the critical studies canon, therefore, was (and substantially still is) the notion of what, from the wide realm of experience, stimulates the creativity of the representative practitioner.

Now of course this embraces much that came within the possible scope of complementary studies, but an essential difference resided in the principle that all contextualization was to be filtered through practice. Critical studies thus was seen to represent a reciprocation of rigour: rigorous practice (which art and design educationists could be confident of recognizing) and rigorous critiques (measured by their relevance to practice) could exist in profitable mutuality.

Instead of bringing a range of concepts to practice and insisting they be accommodated, therefore, critical studies (in the forms it has assumed over the last ten or fifteen years) addresses such concepts through the practices that have engaged them. Practice remains paramount and also paradigmatic in terms of a critique. The notion of integrity is important, often stated, but little defined – a prime example of the vagueness associated with critical studies which ensures its tacitness. The

principal educational method is the case study, explored through the literature of art and design, or by real interaction with artists and designers (perhaps in residencies), or by location work (for example in galleries). The most common focus of investigation is the artistic or designerly 'problematic', revealed through perceived 'intentionality' as volunteered by the artist or designer, as argued by the critic or historian, or as evident in the objective reality of the work of art or design. It is perhaps the greatest achievement of critical studies that such issues today are commonplace in secondary and even primary education, whereas twenty-five years ago they were rarely encountered even in higher education.

Why then should there be concern about the future role for this much valued component of the art and design curriculum? There are several reasons, including simple avoidance of complacency, for giving it some thought. The most obvious aspects to be questioned, from time to time, are its tacitness and its subservience – the former because the tenor of the times suggests that what remains tacit is soon discounted and lost; the latter because of the potentiality in critical studies that will be unfulfilled through lack of an obvious application.

In order to stimulate debate it may be appropriate – especially in view of the heretical nature of the development of critical studies – to propose a number of new heresies. The first of these would be to suggest that critical studies at present reinforces a conception of artistic creation and design origination that can only be relevant to a very small cohort. This is the romantic notion that the artist or designer 'lives' principally in his or her creative work, and that the rest of this individual's experience is of significance only in its capacity to inform practice. It may be true that certain 'heroic' paradigms of, for example, contemporary architecture (half a dozen individuals shaping the course of world events) and avant-garde (artists living lives that are themselves fashioned as artistic 'projects') confirm a principle of total dedication to creative practice, but this is surely inappropriate for the overwhelming majority of recipients of education.

New heresy no. 1 is therefore that critical studies *should not necessarily inform the practice of art and design,* and its corollary would be that it might well be engaged independently of 'making' disciplines. It will be protested that even though only a small cohort of pupils will be destined to be artists and designers, all pupils will be future *consumers* of art and design. In order to consume with discrimina-

tion, these citizens would require intimate knowledge of those processes that have sustained production, including that corollary of the romantic paradigm, the intense struggle that dignifies and authenticates the truly creative. However, there are at least equally compelling reasons for shielding consumers of works of art and design from graphic knowledge of their gestation in the minds and habits of their creators. This is a version of old concerns about whether appreciation of the works of such as Gauguin automatically conveys indelicate knowledge otherwise accessible only in his *Intimate Journals.*

However, there is no inherent requirement for detailed 'process' knowledge to inform the activity of consuming art and design. It is not axiomatic that relevant 'critiques' emerge only from 'process' knowledge. Conversely, deep interest in 'process' does not require this justification. Clearly there are distinct critiques of 'process' and of 'product', each of which may equally serve critical studies if critical studies is accepted as a discipline in its own right. This is more heretical than it may seem, for critical studies (in primary and secondary education) has conventionally addressed 'process' in order to generate a critique of 'practice' that would facilitate an evaluation of 'products'. What is suggested by 'new heresy no. 1', then, is that critical studies may address a culture of images and objects *directly* as things in completeness, as things in interactive relationship with other goods, habits and values, and not simply as outcomes of process histories.

'New heresy no. 2' follows from this: art and design practice may then be undertaken principally for the benefit of informing critical studies. There is a potentially illuminating correspondence here with subjects that also have tacit presence within the art and design community of interest and which are likewise unrecognized as prime disciplines – photography and media studies. Here it is acknowledged that while each significantly enhances the other, each may also stand alone. They are both *serving* and *served* in their mutual relationship. It is this that makes them difficult to assimilate entirely into the art and design community as presently conceived. The rest of this paper compounds the second heresy by speculating that critical studies may more satisfactorily fulfil *its* potential as an educational force if photography and media studies are permitted coequal status within a community of disciplines comprising art and design, photography, critical studies and media studies.

There are tangible similarities between the *actual* relationship of photography and media studies and the *potential* relationship of art and design and critical studies, which may be apparent in the following discussion. There are obvious distinctions to be made between seeking knowledge *through* taking photographs (through making art) and seeking knowledge *in* the study of photographs (in the study of artworks). However, there is a clearer conceptual separation of these two activities in the realm of photography than there is in the realm of art. If this relationship of separate but mutually-enhancing disciplines works well in respect of photography and media studies, it is worth considering whether it may be paradigmatic for art and design and critical studies.

The activity of taking photographs challenges pupils to pursue complex activities associated with art and design (1) to scrutinize their environment for perceptions they can isolate from the welter of possible perceptions, (2) to interpret their observations within the potentialities of the medium, (3) to *evaluate* their subject-matter and establish positions in relation to it, and (4) to pass on their perceptions in communicable forms. At the heart of this is the principle of arresting visual data from the mass of information that camouflages them, in order to find and express meaning. However, subject-matter does not reveal itself. It has to be sought, which means that it is affected by the searcher's goals, needs, attitudes and expectations. It is recognized for its capacity to match pupils' current interests, and this is a powerful justification for a form of teaching that stimulates the search without prescribing the resulting discovery. In this sense media studies is the counterpart of critical studies – however, in critical studies there is a powerful tendency *towards* prescription in the sense that pupils' discoveries in works of art are encouraged to approximate to what is known of the artists' intentions.

This may be undesirable, but it is easy to appreciate how it has arisen. Studying a photograph presents the observer with two fundamental 'messages'. One relates to permanence (the preservation of a moment in time); the other to discontinuity (the obvious fact that the moment has been dislocated from the stream of events of which it was once a part). These 'messages' combine to oblige the observer to construe an imagined 'past' for the photographed event, and a probable 'future' – that is, to see it in a context. This context is likely to be an extrapolation of the 'event' depicted in the photograph – an 'episodic' construct based on 'facts'

observable in subject-matter. The counterpart of this contextualization of a work of art is more likely to feature the artist's *intentionality*, simply because of the obvious fact that the artist modifies his or her perception in the act of responding to subject-matter. Any suggestion that the two sets of paired disciplines under discussion – 'art and design/critical studies'; 'photography/media studies' – are alternative modes of study is thus refuted. All four are required within a comprehensive model of creative education.

The contextual knowledge constructed around photography is likely to be much more tangible than that invoked by, say, painting, because of the indisputable fact that the event isolated in the photograph actually occurred. This gives rise to something unique in education – the possibility of attaching to a photograph an imagined, explanatory context which, because it is reinforced with photographic evidence, is convincing, realistic and perceptibly 'true'. This is the phenomenon exploited in advertising, and countered by media studies.

One of the principal objectives of media studies is therefore to enable individuals to perceive legitimate meaning in photographs, discounting the illegitimate. This establishes it in the mainstream of education where meaning is sought in texts, diagrams, maps, equations, experiments, field observations, and so forth, by acts of inclusion and exclusion. By association with media studies, critical studies is also established in the mainstream (something its conventional association with art and design has failed to accomplish).

As in other realms of education, meaning is derived by making conceptual connections between discrete observations and/or experiences. For example, the realization of meaning in a photograph of a building may be reinforced with supplementary photographs of the same artefact taken at different times, under different conditions of weather and time of day. The host of alternative appearances will not contradict, but enrich, the conceptual information available in each isolated image.

Drawing or painting the same building will enhance conceptual understanding in a slightly different way, because these activities extend over time and consequently accommodate changing appearances within single images. They also result in spatially three-dimensional and discursive perceptions, which are not the usual characteristics of photography. The isolated percept (the photograph) reinforces the cumulative percepts (in the drawing or painting), and they reciprocally enlarge

and enrich the subject's contextual meaning. Meaning that is found, constructed and developed in this way is of a very high order of authenticity. Art and design thus brings photography into the mainstream of education.

Their interaction integrates two different, but complementary, forms of knowledge. A photograph is in effect 'raw evidence' of an occurrence which comes to the observer's attention relatively 'uninterpreted'. A drawing or a painting, on the other hand, consists of evidence that has constantly been subjected to interpretation in the process of its production. There is a much clearer distinction between the photograph as 'art' and as 'visual evidence' than there is between the drawing or painting as 'art' and as 'visual evidence'. There is great potential for 'raw' and 'processed' information to be exploited for their capacities to reinforce each other. As the role of media studies is transparent in the identification of 'processed' information, its presence in the curriculum, and its manifest facilitation of appreciation and criticism, may therefore provide a link between art and design and critical studies that permits the latter much more than its conventional serving capacity.

There is an evident symbiosis, then, of art and design, photography, critical studies and media studies capable of supporting productive speculation. I will offer one or two further examples in order to suggest that the field of speculation is potentially vast.

Awareness of photography tests the limitations of syntax in the work of art. Syntax consists in the structures and networks of marks, the products of pencil, brush or knife, that 'range' over and around the depicted subject, giving it tangible presence while offering evidence that it has been engaged by human perception. Photography is virtually free of syntax in this special sense: its structures and networks of marks are minute. Familiarity with the compelling 'reality' of photography's syntax-free graphic imagery, therefore, establishes an important parameter for focused discussion on this aspect of aesthetics in the realm of art, and gives purpose to a study that would otherwise be confined to comparing alternative syntactic systems.

There is also potential for pupils to become aware of differentiated effort and significance. A drawing or a painting does not deal even-handedly with all the information present in a perception. A drawing of a person or a scene, for example, may dwell on certain features and deal sketchily with others. It will therefore embody decision-making

and choice which are acceptable as evidence of a legitimate act of visual translation.

A photograph does not 'translate' appearances in this way. It 'quotes' appearances. The isolation of the photographic quotation sets it apart from the stream of events to which it belonged. This both facilitates detailed and prolonged examination and familiarization, and creates a sense of dislocation of the image that must be 'repaired' by the observer's construction for it, as previously noted, of a 'past' and a 'future'. Thus the 'length' of the quotation in the photograph is not confined to the instant of its exposure, but is as long or as brief as the reconstructed context that the observer is able to supply. The 'length' of the quotation embodied in a representational drawing or painting matches exactly the space of time expended before the object. In this sense the quotation embodied in representational art tends towards the factual and that embodied in the photograph tends towards the fictional.

Because of the often highly fictional elaborations of some received photographic images (for example, in advertising) they must first be de-contextualized of *imposed* histories of meaning before pupils can substitute their own. This activity is genuinely educational – concerned as it is with the reinforcement of existing knowledge, the searching for complementary knowledge, and the subjective sensing of meaning in the act of interpreting the ambiguous. The observer associates in direct sensation (empathizes) with and through the appearances recorded in the photograph and this is a powerful source of stimulation for other constructive, creative acts.

Photographic images share with other manifestations of the arts the capacity to elucidate concepts that otherwise defy description – profound grief, ecstasy, decay, religiosity, patriotism, brutality – but the photograph's obvious connection with a real event lends an immediate tangibility that is not easily evoked by other means. A stronger association of art and photography would reinforce a conventionally weak aspect of art knowledge – the fact that it does not readily approximate to other forms of communication and becomes diluted when the attempt is made.

But this reinforcement may be reciprocal. Photographs may be worked on, composed, cropped, enhanced and modified after the act of perception, whereas works of art are much more likely to be modified, in comparable ways, *during* the act of perception. The latter connotes greater perceptual 'integrity', which is both paradoxical in

view of other aspects of the comparable relationship of the two disciplines, and also evidence of their necessary familiality.

CONCLUSION

I hope I have outlined enough of a potential relationship between art and design, critical studies, photography and media studies to suggest that here is a profitable field for extensive speculation. The prime purpose of this paper is to stimulate other equally compelling and equally extensive fields. Of course it will be pointed out that such speculation is substantially pointless, since the National Curriculum is unlikely to accommodate further disciplinary development at least until a period of beneficial reinforcement of existing initiatives has been accomplished. My response, however would be that this does not prohibit creative thinking about developmental possibilities. Critical studies, in its present form, was for a long time 'merely' a topic that consumed much conference time and paper argument. New argument and debate should proceed in readiness for the next great revision of education, so that when opportunities for change occur the arguments will be well rehearsed. I believe this forthcoming, fruitful phase of development will centre upon critical studies. A curriculum now heavily predicated upon 'making' will transform to accommodate more and more 'critiques'. In the special case I have outlined, enlargement of the art and design community of disciplines from two to four, and the establishment of their co-equality, will not diminish but enhance the significance of the two (unequal) disciplines that are its present incumbents. Any further, fruitful, curricular development of art and design demands an immediate willingness to accept critical studies, in more than the serving capacity that has become conventional.

ACKNOWLEDGEMENT

In my comparison of the essential characteristics and disciplines of drawing/painting and photography I have leaned heavily on John Berger's philosophical analysis. For an extended discussion of this field see: Berger, J. and Mohr, J. (1982) *Another Way of Telling*. London and New York, Readers and Writers.

CRITICAL STUDIES: A TROJAN HORSE FOR AN ALTERNATIVE CULTURAL AGENDA?

JOHN SWIFT

The introduction of the term critical studies in British art education reflects art educators' views that the practice of art alone is insufficient to gain a full experience of art, and coincides with a political will to return to 'traditional', teachable forms of content and knowledge. The first position is and has been widely shared here, in North America and elsewhere; the second position is the one that will concern this paper – the potential that critical studies possesses for the manipulation and hierarchical ordering of cultural values.

Selection of 'consensual' canons appears to be a necessary consequence of introducing art criticism, art theory, and art history as tools of art knowledge into the school curriculum. One important purpose is to engage the learner's mind in the art work of others (as opposed to the experiences of self in making), and in order to be critically, aesthetically and historically aware to learn the languages of judgement, discernment and qualification and apply them to the 'best' examples available. It is the selection of the 'best' that reveals the cultural agenda (the exemplars of 'good' art that citizens must study in order to identify with 'our' national and historical visual culture), and the identification of 'our' that reveals the socio-political agenda. Consequences follow the selection of the 'best' which reflect and define the nature of

art, how it is taught in the name of art education, and how a visually cultured citizen is defined in a socially cultured population. One cannot sensibly isolate artistic preference (and therefore the cultural agenda) from what I take to be the purpose of any good education, i.e. empowering the citizen to make conscious and articulated choices in the construction of his or her own values by questioning and evaluating orthodoxies. Thus the choices made between 'high' and 'popular' art, between art, design and craft, between the art and aesthetics of the mainstream Western European tradition and that of other cultures past and present, between the work of the currently established (and largely institutionalized élite) and of minorities or cultural sub-groups, and between art objects that have stood the test of time and those that are new, by necessity reveal cultural predispositions and a view of the purpose of education.

Before developing these ideas, I wish to locate critical studies as part of a broader pattern of educational and art educational thought which could be generalized as moving to a more theoretical, knowledge-based learning, which typifies to different degrees Discipline Based Art Education (DBAE) in North America and Critical Studies in Britain.

1. Starting in the early 1960s, there was an educationally motivated reaction against

child-centred or progressive education on the grounds that it paid too much attention to practice and making in the name of self-development than it did to the acquisition of content and knowledge of the subject, and that freedom of exploration should be replaced by more rational and achievable curriculum objectives.[1] In Britain ten years later, the authors of the Black Papers[2] took a more overtly politicized stance in reclaiming similar objectives for 'traditional' education.

2. About the same time there was an American movement to relate what was taught in the name of art to the disciplines that constituted an understanding of art – these were generally agreed to be practice, criticism, history and aesthetics, which eventually grew to be known as DBAE in the mid 1980s.[3] This approach was echoed in Britain through the work of Allison whose four-domain curriculum in essence retained the practical, critical and historical, but replaced the aesthetic with the perceptual, thereby creating a different implied balance between the acts of making and reflecting upon the made, and removing the rationale from one strictly related to disciplines.[4]

3. As American ideas concerning each discipline's comparative importance developed, so did concern over the selection of art to be studied. Good quality responses and thought were seen by some as only promised by 'good' quality objects, and the selection of exemplary material began to be contentious. Smith's book on *Excellence in Art Education* took a clearly élitist view, and this was followed by *Cultural Literacy and Arts Education* which claimed priority and superiority for one set of cultural values.[5] These will be examined later. British art educators have not taken a parallel stance – in the main they have been at pains to pay attention to under-represented or marginalized values, persons, and artefacts.[6] However, the government's right-wing Centre for Policy Studies has argued a political position for 'excellence', a nationalist curriculum and 'shared' élitist cultural values.

The development outlined above rejects the supposedly anti-intellectual and anti-knowledge base of child-centred or progressive art education,[7] and there is some truth in the assertion that many followers of child-centred art education were more concerned with what the learner felt about their learning, than with any broader socio-cultural understanding of art as a human phenomenon. This is not to deny that many would learn a considerable amount about the nature of art through the process of making visual images, but to suggest that unless this experience was contextualized within a broader framework than that of self, it would deny the learner informed access to work from other periods, contexts and cultures, which manifested different values, positions and beliefs.

It might be assumed that the absence of such ideas and/or appropriate materials occasioned an emphasis on art practice, but whilst the quality and availability of materials was uneven, there is ample evidence on both sides of the Atlantic of the introduction of picture study, art appreciation, art history, travelling collections of either original works or reproductions for schools, the growth of commercially produced visual aids, the appointment of education officers in galleries and museums, and artists-in-residency schemes starting as early as the nineteenth century, and apart from the last two, dating before 1970. Thus such study was possible even if it was not well-used or understood – the problem appeared to be that these opportunities were generally tagged onto practice in an *ad hoc* manner which undervalued their significance, and that this represented the lack of a coherent theory of what should be taught as art. This was resolved by locating art education within its parent disciplines; away from a psycho-biological emphasis towards a socio-cultural explanatory framework.

DBAE manifests its parent disciplines, i.e. practical, critical, historical and aesthetic approaches at a theoretical level in a variety of ways: it can vary from attempts to integrate the different activities in either an even manner or one that gives priority to one activity – 'it is the task of art educators to develop and implement ways to integrate learning from the four fields ...'[8] – to keeping the different activities quite discrete.[9] The strong art discipline-based identification has affected British thinking in the creation of critical studies which includes critical, theoretical and historical understanding. In the 1970s as Allison developed his domains and Hughes, Hildred, Mortimer and Taylor developed practical ways of involving knowledge of other artists' ideas and practices, their efforts were not towards isolating the activities of production, criticism, or history (aesthetics has not been emphasized by any of the important innovators in Britain), but rather towards finding ways of so integrating them that they manifest a

seamless robe. In terms of the selection of art and artists to be studied, early practice-based critical studies tended to emphasize Western European examples, with a particular fondness for late nineteenth-century and early twentieth-century painting that has some degree of representation, but the need to incorporate a more multicultural approach was also observable, and more slowly, the need to react to changing views of the discipline of art history and a broader cultural agenda.[10]

The positions taken in terms of disciplines and awareness of other cultures was evident in the first and seminal Pennsylvania State Seminar of 1965.[11] This is sufficiently important in terms of future developments in America, and here, to examine more closely. One finds a variability in the degrees of conscious awareness of monocultural or pluralistic views in that the discipline specialists were more naive than the broader contextual specialists such as the sociologists. There was little disagreement over the basic premise of the discipline-based approach; there were certainly differences over the bases for the selection of art to be studied and the relationships these might have to social and cultural values. The discipline specialists' views reflected an ignorance or 'innocence' rather than a deliberate intention to marginalize the artistic presence of the 'other'.

Taylor, the art historian, illustrated his paper with works from the Western European tradition, but accommodated 'equivalent' work from other cultures;[12] Villemain's philosophical paper also used European examples throughout, but explicitly commented on the cultural relationship between art education and a democratic society;[13] Rosenberg, the art critic stressed the need for an 'ever deepening comprehension and clarification of the tradition of the new' in order to avoid 'a structure of bureaucratic assents' which too typically represented how knowledge of art is passed down without 'critical consciousness';[14] Kaprow, the artist, argued that all artefacts (high, low, fine, popular, ethnic, folk or whatever) could be admired, as publication, the media, and foreign travel 'has eliminated in fifty years the last possibility of aesthetic parochialism, and with this, aesthetic certainty'.[15] Alone among the four discipline specialists Kaprow wished for contact with all sorts of art, and more specifically with the artist, whom he wished to act as a 'Pied Piper' in primary schools – a sort of cultural *agent-provocateur* in residence – an appealing idea that was dis-

liked by the majority of art educationalists.[16] The papers by art educators such as Eisner and Barkan developed the discipline argument in terms of curriculum, and Barkan's examples of 'great works of art' were consistently Western European, produced by male, white artists, and safely dated away from really contemporary work.[17]

There is a failure to come to grips with the full implications of selecting the 'best' art for study, which may be partly explained by the views of Tumin, sociologist and anthropologist. Tumin held optimistic views of America's social future envisaging a period of equality for women and minority groups, more autonomy for young people, and a more collaborative America as one of the major powers, but more germane here is his view of the development of culture: 'the amount of cultural diversity from nation to nation, and continent to continent, constantly diminishes and in ever-increasing detail we are becoming citizens of a world culture.'[18]

McFee's contribution was perhaps the most challenging to any concept of a common cultural set of values where she argued that 'American society may have a broad identifiable culture, but it has many sub-cultures, large and small sub-societies' and that recent research had shown that two trends were current – one that pressured for conformity (from middle-class education and the extent and intensity of mass communication), and another that pressured for diversity (from sub-cultures of race, religion, national origin, and economic level), and that the latter was 'stronger than had been assumed'.[19] The implications for art education were clear in that more attention would have to be paid to 'art in culture and social trends among minority people' and 'cultures far removed from our own' in order to gain views beyond, and an awareness of, inherent monoculturalism.[20] McFee counselled against discarding all currently held 'traditional' values, but argued for a readdressing of them in terms of what they included and excluded. Responses to McFee's paper show some hostility, and suspicion that her suggestions would 'damage the integrity of the discipline'.[21]

In discussion sessions a speaker claimed that the reason for mediocrity in US education was because 'teachers deal so much in received ideas' and were not actively involved in creating their own knowledge, and another warned against 'telling a student what he must value', but Taylor summed up the seminar's majority feeling con-

cerning the hierarchical ordering of high, applied and popular arts which identified whose culture and what content was valuable: '... what they are learning about great works of art, i.e., established works of art by artists, is also to be discovered in other things around them ... but shouldn't abuse it – e.g., studying funny papers ... and drawings of Rembrandt.'[22] '... in education – art as part of our humanistic knowledge ... has to do with our evaluations of ourselves, of our fellow-men, our sense of tradition of the past, our sense of continuity.'[23]

It would have been interesting to have known who the 'our' represented, and on what moral basis the claim was made, but this is to be wise after the event. What is evident is that the views of Tumin and especially McFee sat uncomfortably within the urge to reach consensus over the 'best' examples that could be used to engage critical, historical and aesthetic analysis. One gets a sense of 'lip service' to the 'other', but an overriding wish for or belief in some sort of universal position/truth that would be applicable to all situations at all times. There was little question that such an 'universal' was Western European thought and practice on which America's Bill of Rights and democracy were based, and coexistent with it, the visual arts and culture that in some undefined way were broadly classed as those of the American peoples.

There is little point in searching for an equivalent point of departure and magnitude within the history of British art education in the 1960s – no such event took place. Art history had been introduced as a mandatory subject into new diploma courses in art schools which led to much initial opposition and difficulty, and university board examinations offered papers in art history at O and A level as separate, rather discipline-based activities. The field of art education as a subject of advanced study was small – programmes of research were 'just beginning at Birmingham, Cardiff, Leeds and London',[24] the first Masters course in the subject in this country opened ten years after the Pennsylvania Seminar, and doctorates were virtually unheard of.[25] As Field suggested the theoretical basis of much British art education from the 1950s to the 1970s relied on the research of our American colleagues.[26] However in the mid-1960s if such a conference had been organized, it is difficult to believe that British dispositions and values in terms of discipline-bases and cultural identity would have been significantly different.

It is for this reason that so much attention has been paid to an American phenomenon whilst purporting to write about Critical Studies, because the significant factor that is now emerging from DBAE (and elsewhere) is a much more conscious attempt to claim priority for a white European-based cultural arts agenda. There do not appear to be many art educators in Britain who publicly support these views, but there are certainly influential members of the Conservative Party who do. The American views, although argued from an apparently educational and philosophical position, e.g. by Ralph Smith, reflect the old fears of the 'redneck' and the new fears of the ex-liberal. The latter was happy to support minorities, i.e. ethnic and other marginalized groups, in terms of equality of opportunity, but as some major American cities now demonstrate, if the demographic majority were actually in power, the whites and their European traditions would be the minority or sub-culture. As the minorities have grown more vocal, skilled and adept at claiming their rights, so has the position of cultural equality become more difficult for some ex-liberals to maintain. Instead we see a claim made for a broadly American culture (thus attempting to defuse the big city emphasis which offers a very different picture and where most of the élite institutions of culture are located), that retains the particular élite manifestations of what counts as culture as traditionally defined by white Europeans.

Two specific texts are selected concerning culture, art and education, the first being written by Smith, and the second edited and part-written by him. *Excellence in Art Education* explores three areas – excellence in art, excellence in art education, and élitism. In 'excellence in art' a distinction is made between modernist art that is culturally continuous (identified as the most genuine and important),[27] and that which is radical and politicized (identified as confusing the role of art with propaganda and social history and therefore less important). The former is identified by its formal aesthetic properties and the latter by its sociopolitical leanings.[28] Smith blurs 'aesthetic' art with the élite and 'social' art with the populist culture respectively. His mistaken argument is that only the traditionally oriented can be part of a continuity of culture. 'Excellence in art education' means appreciating the highest and most complex excellences decided upon by experts. 'Masterpieces, classics or exemplars' are to be studied through a curriculum which emphasizes history

and aesthetics and marginalizes art practice.[29] This of course begs the question of the definition of masterpieces, whether these terms are as permanent as Smith suggests, or any 'notion of feeling or imaginative knowing'.[30] Smith's view of élites posits two types – closed élites (closed by wealth, class, etc.) and open élites (open through professional standards). Smith claims to be of the latter who oppose the populist beliefs that élites are oppressive, art judgements are relative, only current work has meaning, and cultural paternalism is wrong.[31] The question is begged of the history of such élites and who they comprise – artists, art historians, art gallery curators, dealers, connoisseurs, collectors, critics, aestheticians, others, or a mixture? I suspect one would not find unanimity either within or across the disciplines. This well written and persuasively argued book posits a rhetorical choice – either subscribe to 'excellence' or be identified as supporting mediocrity. Smith's trick is to convince us that his idea of excellence is actually 'excellence' by definition; in reality, he is attempting to reify what is a moving and dynamic field by claiming universal means of identifying stable examples of excellence through expert opinion.[32]

Smith's other book *Cultural Literacy and Arts Education* takes a paper by Hirsch which ostensibly examines whether contextualization clarifies or obscures our understanding of art work. In so doing it devalues practical skills, elevates 'symbolic and communal associations' through the study of 'excellent' examples, and promotes a type of cultural literacy dependent on shared knowledge which is based on 'indispensable' reference points. Hirsch places special value on social cohesion, and would achieve this by dividing education into two types – 'what every American needs to know' and what cultural sub-groups might value. The inherent inequality of such a division does not delay Hirsch, or inhibit Smith's too-ready defence of his cultural imperialist position.

Three different positions on cultural identity have been critically explored, and it might help now if they are separately identified and placed against three alternative positions. The three latter positions are ones that I believe Critical Studies is and should remain aware of. All six positions may be found in current attitudes.

1. The first is the 'naive' view – the uncritical employment of a mainstream tradition that is essentially Western European in terms of history, definitions and exemplars. This position may or may not include modern, more 'difficult' work, and may or may not show an awareness of the 'great' examples of other cultures – the Taj Mahal, Benin bronzes, etc. It identifies 'good' art from the above and reflects mainstream gallery and museum policy and art publications. It allies itself with and sustains the definitions of connoisseurship, élitism, and the art institutions, and seeks to direct and elevate taste and discernment.

2. The second is the 'covert-naive' view – an educational strategy of showing interest in what learners know and appreciate in order to alter it, and enable the unlearned to subscribe to the 'naive' (or 'hardline') view. It takes a pragmatic position of entertaining the popular and 'low' arts temporarily in order to change the recipients' views to those of the cognoscenti. In this transaction there is an overt value judgement and closure to popular arts or the arts of the 'other'.

3. The third is the 'hardline' view – it is fully aware of the multiplicity of cultural values and makes a conscious choice of superiority. It argues that social cohesion depends upon shared, historically-given cultural values that represent the 'best' of human achievement, and are a necessary requirement of education for everybody. In North America this movement selects the same priorities and examples as the 'naive', but it does so consciously by 'allowing' the visual arts of the cultural sub-groups to be studied by those who may be interested, while insisting that all groups are immersed in the national culture – 'what every American needs to know'. This position is both academic and political, but has not been promoted in British art education.

4. The fourth position is the 'minority exclusive' view – the reaction of cultural sub-groups to mainstream dominance by closing references to the latter and only allowing identification with the sub-group's cultural values, e.g. its own indigenous art expression and forms. The problem with this view is its élitism and that it retains a sub-cultural identity and closure to other experience with no social or cultural advantages of hierarchy.

5. The fifth position is the 'covert-minority' view – a more obviously effective and often a later variant of the view above. It uses the sub-group's cultural values to question,

undermine, and eventually replace those of the mainstream hierarchy. For example, in hegemonic terms women (and women artists) are/were part of a cultural sub-group, and their effective means of disrupting the orthodoxies of art practice, art history, psychology, and philosophy (amongst others) have been and are some of the most exciting intellectual challenges of the last two decades.

6. The sixth position is the 'pluralist' view – this has derived from the above view, research in sociology and ethnography, deconstruction theory, and post-modern eclecticism. This view accepts the multiplicity of cultural values and artefacts, but rather than attempting to classify by superiority, examines and entertains the richness that diversity allows. It refrains from making judgements based on those from 'alien' cultures or from narrow aesthetic positions, and seeks to contextualize any experience in order to better understand and appreciate its quality. In this sense it is open to a variety of impressions, to all forms of visual making, to both 'high' and 'low' art, and its value judgements are contextualized rather than claiming universality.

Critical Studies in Britain although deriving from the same theoretical material as DBAE in America has not progressed the situation in the same way. It has not followed the discipline-based argument in such a rigorous (or rigid) manner, but has sought to enmesh the disciplines in an interactive and overall learning experience. It has attempted to avoid a simple division of the understanding that comes from making art, and the understanding that comes from the study of others' art. In so doing it has tried to avoid the problem of 'weighting' different disciplines that plagues DBAE, and has attempted to integrate, interchange and vary the order of the related areas while retaining a fuller representation of the making process. It has made the making process more intellectually and cognitively demanding, but the use of artists' residencies has allowed the physical excitement, personal obsession, hard work, and critical engagement to be manifest. It is this opportunity for real critical engagement before, during and after the making process which makes critical studies so potentially exciting. However, this should not make us complacent because it can be argued that critical studies has already developed certain orthodoxies of approach and content, and that the

title 'critical' is rather generously applied in too many circumstances. For me the answer is not a form of DBAE or a type of humanism where the making process becomes subservient or a 'feature' of cognition, but a richer culturally conscious process of making in which critical, comparative awareness and discernment is always functioning. Just as we are able to 'read' signs of critical engagement and decision-making in the images of others, so we are able to develop these abilities within our own work and that of those who are taught by us. Practice at its best gives a conscious and communicable insight (no matter how limited) into the nature of art-making where the reflecting, thinking and feeling processes are involved, and where critical, comparative theory is integral throughout the work's development. Anything less is unworthy of the appellation 'critical'.

How far do we have to go to reach such a position? There has certainly been evidence of greater cultural awareness and the significance of the interpretation of images in art educational publications and in galleries and museums policy. The improved liaison with education officers of art galleries and museums (some of whom have been active in rethinking the way that art objects may be made more available) has opened ways of contextualizing art and its objects from a variety of sources, periods, and cultures. However, we still have some way to go. The incorporation of multicultural issues into critical studies began to be informally and sporadically addressed in the late 1970s, and ten years later the need to represent the marginalized was belatedly addressed in terms of women and black artists, and specific cultural minorities. These items appear to raise problems for many teachers who lack the sort of training or INSET provision to enable them to feel confident in introducing such issues into the classroom.

We should be consciously integrating theory and practice, consciously using the richest variety of art objects and cultures and values they represent, consciously attending to previous lack of representation of minority groups, and consciously raising interrogation over who defines art and on what basis, in order to embed these ways of thinking into normal art education practice. If we are seen to pay lip-service to these issues and essentially subscribe to a mainstream view of art, we will lose the opportunity we have gained, and open ourselves to appropriation by the right wing to teach élite values more effectively, and this will probably mean a method which elevates learned

maxims at the expense of practical and critical enquiry. Critical Studies grew bottom-up from art teachers and art educators; its 'new' approach brings with it continuing concerns in terms of content. We should be alert in keeping control of its integrative and organic structure, and its potential for the democratization of art.

NOTES

1 See Barkan, M. (1966), 'Curriculum problems in art education', in: Mattil, E. (ed.) *A Seminar in Art Education for Research and Curriculum Development.* Pennsylvania State University & USA Office of Education, pp.240–55; *idem* (1967), 'The challenge and adventure of change', in: *Art Education USA* Special Edition; Mattil *op.cit.* Eisner, E. (1966) 'Concepts, issues and problems in the field of the curriculum', pp.222–35; *idem* (1967), 'The challenge to art education', *Art Education USA* 20(2); and Field, D. (1970), 'Art education in the future', in: *Change in Art Education.* London, Routledge & Kegan Paul, pp.120–4.

2 The Black Papers were a series of pamphlets steered by the right wing of the Conservative Party with the aim of unsettling comprehensive education, re-establishing selective education, and returning to 'traditional' teaching values in order to raise standards which were claimed to have fallen under progressive educational methods.

3 Efland, A. (1989), 'Curriculum antecedents of discipline-based art education', in: Smith, R. (ed.) *Discipline Based Art Education: Origins, Meaning and Development,* University of Illinois, p.61, lists Barkan, Chapman, Eisner, Madeja, Hubbard, Rouse, Hine and Broudy as educators who took different approaches to different aspects of DBAE, but in essence contributed to its current concept. Bruner's *The Process of Education* (1960) is probably the precursor where it argues that the basic ideas and structures of school learning should follow those of scholars in the respective discipline. There had been role identification before, e.g., the 'child-as-artist' or 'artist-teacher' as Smith points out, but these all tended to elevate the role of artist at the expense of critic, historian or aesthetician. Smith, R. (ed.) (1989), *op.cit.* p.4, referring to Mendelowitz's use of these terms.

4 Allison, B. (1982), 'Identifying the core in art and design', *Journal of Art and Design Education* 1(1), pp.59–66 contains a clear picture of his curriculum ideas.

5 Smith, R. (1986), *Excellence in Art Education* (National Art Education Association USA), and (1991), *Cultural Literacy and Arts Education.* University of Illinois.

6 The art document despite the attempts of the National Curriculum Council and parts of the government has managed to retain its attention to the work of women artists, black artists, and cross-cultural emphases. It is more arguable how central these are or how much they have been reduced to window-dressing.

7 I have argued elsewhere that this identification in terms of art education is based on unproven assumptions and bad examples rather than on actual good practice, and that the momentum gathered against it was politically rather than educationally driven. See SWIFT, J. (1993), 'On not learning from the past', *National Research Conference in Art and Design,* Fribble information systems on disc.

8 Clark, G., Day, M. And Greer, D. (1989), 'Discipline-based art education: becoming students of art', in: Smith, R. (ed.) *op.cit.* (1989) p.151.

9 Smith, R. *op.cit.* (1986) pp.49–50.

10 Perhaps aesthetics has retained some of its philosophical discipline although attempts to stand 'outside' its context are increasingly seen as suspect. In Britain, the effect of mainland Europe's post-modern theory has altered views of constants. A more relativist and pluralist perspective, consciously or not, has cautioned art educators against a too precipitate move to a strongly discipline-based position.

11 Mattil, E. (1966) *A Seminar in Art Education for Research and Curriculum Development.* Pennsylvania State University. The seminar may be seen as a model for DBAE in that it invited an artist, art historian, art critic, and philosopher to offer papers and take part in discussion with art educators, and used sociological and psychological inputs to further contextualize the findings.

12 'Some thought should be given to the possible inclusion of Far Eastern, African or early Middle American art, but precedence should be given to the arts of the western tradition since they are basic to so much that the student sees ... [they] might well be offered optional courses ...' *ibid.* p.45.

13 'There is ... in the doctrine of democracy or freedom a point of purchase for grappling with the value judgements undergirding curriculum development in art education for American society ...' ibid. p.18.

14 ibid. p.66.

15 ibid. p.79.

16 ibid. pp.84, 86–9.

17 ibid. pp.250–1.

18 ibid. p.107.

19 ibid. p.124.

20 ibid. pp.126–30.

21 ibid. p.137.

22 ibid. p.276.

23 ibid. pp.276–7.

24 Field, D. (1970), *Change in Art Education*. London, Routledge & Kegan Paul, pp.100–1.

25 See Allison, B. (ed.) (1986) *Index of British Studies in Art and Design Education*. London, Gower, p.10, and Swift, J. (1987), 'Research In British art and design education', *Canadian Review of Art Education* 15(1), pp.22–3.

26 Field, D. op.cit. pp.55, 111.

27 Smith, R. (1986) op.cit. p.30.

28 ibid. p.32.

29 ibid. pp.49–50.

30 Webb, N. (1987), Editorial, *Canadian Review of Art Education* 14, p.9.

31 Smith, R. (1986) op.cit. p.64.

32 Even if one accepted his position, one could question his facts. He does not know his art history, and is obviously ignorant of the ways in which past experts erected criteria to judge the 'best' artists, the results of which certainly bear no resemblance to modern-day experts' opinions. His position of traditional continuity does not allow for artefacts 'to become' art or to lose this status, and yet there are examples of both. Explanations would have to account for changing views of excellence (relativism) or different artistic contexts (socio-political), both of which Smith abhors as positions.

33 Smith, R. Ed. (1991) op.cit.

CHAPTER THREE

CRITICAL STUDIES & CULTURAL ISSUES: THE SCOTTISH CONTEXT

STUART MACDONALD

There has been an upsurge in interest recently in what is broadly termed Critical Studies, meaning the collective term for a range of interests and activities which enhance the productive aspects of Art and Design education. Paradoxically, this interest has been rekindled by the perceived assessment-led separation of the subject into two Attainment Targets in the English National Curriculum on the one hand, and the *laissez faire* approach taken towards Critical Studies in much GCSE work, on the other. Co-terminously, such concerns have focused on national policy-making and attempts to interrogate such policies using ideas such as centralism or pluralism. The position of Critical Studies is not uniform, though, in policies across the UK, and contemporary policies, like Critical Studies, can be ideologically evasive. This chapter examines the development of Critical Studies in the Scottish context since its inception some ten years ago in the national examination structure as an inseparable part of the Standard Grade curriculum for 14–16s, and as a defined part of the National Guidelines for 5–14s (SOED 1993), as well as its extrapolation into the wider cultural policy context.

CRITICAL STUDIES IN SCOTLAND

Critical Studies, which in Scotland is called respectively, *Critical Activity* and *Evaluating and Appreciating*, is both fully integrated with practical activities as well as being a mandatory requirement in national examination or assessment. This indicates the post-synthetic status of Scottish Art and Design education, which has left behind the polarities bequeathed from the first half of the century, referred to as 'two mutually exclusive traditions' or, the *essentialist/contextualist* axis (Thistlewood 1992). This chapter looks at this Scottish development, tracing its antecedents, and importantly, in terms of the current debate, examines the *contextualist* dimension of Art and Design in Scotland which differentiates it systemically from the rest of the UK. Thus, the recognition of external social and cultural pressures in Scottish curricula provides a primary focus, especially where that involves the inter-relationship of policy-making in Art and Design education with wider cultural issues, particularly the large-scale public festivals being planned as Britain moves toward the millennium. In that broadened context Critical Studies is also examined in terms of pro-

viding a bridge between theory and practice, between philosophy and methodology, and a widened range of ideas and discourses are drawn on from critical theory as well as art educational philosophy and practice. It is this proximity between design and delivery in educational and cultural policies which elevate and interweave Critical Studies that is proposed here as the Scottish contribution to the debate.

What is the Contextualist?

Historically, the *essentialist* which has been depicted as being instrumental or prescriptive in character and linked to a historical period in which functionalism reigned, is one pole of the traditional axis. Opposite to that, though in fact they overlap, is the *contextualist*, which although historically linked to child-centredness and its association with free-expression is in fact by definition, broader. The *contextualist* can mean to assume the aesthetic (Baynes 1990) or the critical (Eisner 1972), (Allison 1982). In all of these the implication for the Critical is for improvements to practice, either directly by supplying informing theory, or indirectly through the provision of a relevant background; or as a means of educating for a more informed participant. And, in all Critical Studies, however termed, it is seen as both co-efficient and cohering factor, where curricular balance is prerequisite. This constitutes a *contextualist* trend and is a permeating strand in the literature of Art and Design education, although in terms of implementation it has been demonstrated historically to be difficult to put into practice. It can also assume other connotations. Most of these have arisen from the latter part of the eighties as a result of increasing external influence on schooling and the curriculum; this has occurred co-terminously with a rise in the interest of Art and Design agencies outside the school or education system in the formal Art and Design curriculum. This has given rise to in some instances, a double transference. For example, the idea of the empowerment of people and the communities in which they live using the arts as a vehicle for change (Harding 1993), has been projected back on to the formal system, with a concomitant increase in the interest of educational policy-makers at all levels in art as an agent for effecting change in the environment and ethos of schooling. The following examples are necessarily limited, but hopefully representative of the contextualizing influence of Critical Studies in

Scotland, and which may illustrate the *contextualist* as a useful pattern-making device in the analysis of present-day policy-making in Art and Design education.

Antecedents

The roots of Critical Studies go back to Art Appreciation, which in Scotland has enjoyed an exalted position in policy documentation since the very first *Memorandum on Drawing* was published in 1907 by the recently established Scots Education Department. They were not averse to innovation, including promoting child-centred methods, in order to distance themselves from the regime they had inherited from South of the Border. It was, however, the 1947 Advisory Council report which is agreed to have set the pattern for what is today universally seen as the model of the modern secondary curriculum in Scotland. From first principles, the report set out a 'core and periphery' model, and indeed, the arts featured strongly in this 'core'. Importantly, the Report adduced three aims for art:

- to train the pupils in executive techniques;
- to provide facilities for creative work in various media;
- to develop the appreciation of artistic excellence in many forms (SED 1947)

The case for this productive/critical correlation came about through a delicate bit of juggling as this extract from the report reveals:

> They (teachers) have known the contrasting temptations to over-emphasize and to neglect the 'grammar' ... in art the elementary principles of draughtsmanship and colour harmony. Overstressed, it reduces teaching to jejune routine; but its disregard is followed by formlessness in the creative effort and by shallowness of understanding on the appreciative side. Again lack of standards of excellence has proved as fatal to the child's creative efforts as any deficiency in technical training, while even the very limited practice of art which is possible for the untalented finds its reward in more disciplined powers of appreciation
>
> (SED 1947)

As well as containing an implicit criticism of child-centred art education by alluding to lack of standards within a document that was predominantly progressive in its thrust, two other paradoxes were raised. One arose through the need to balance creativity and 'grammar' symmetrically; the other

was in terms of production *versus* appreciation. The corrective – the fulcrum in other words – was offered as *appreciation*. This analysis is crucially important, for it grounds appreciation, perceived historically as being a peculiarly Scottish promotion in art education, for the most part, not as an element of liberation, but as a corrective adjustment to undisciplined self-expression. This contrasts with the contemporary English parallel, for, as Thistlewood (1993) has indicated, the 1944 Education Act legitimized child-centred theory which in terms of art education meant avant-garde creativity (notably Expressionism), and thus children received an induction into modernism which was ultimately to flounder for lack of both an adequate rationale and instructive exemplars. Interestingly, Thistlewood has suggested that the diffidence of Critical Studies to definition is an evasion tactic rooted in the controversies surrounding art such as the inadequacies of child-centred expressionism. Nevertheless, from that time, and not unequivocally, appreciation took on a greater significance in art education in Scotland.

THE STANDARD GRADE DEVELOPMENT PROGRAMME

Several decades were to pass, however, before appreciation developed into a serving discipline to which all secondary pupils were fully entitled. This came about in the late seventies and early eighties through the Munn and Dunning reforms that gave birth to the Standard Grade Art and Design pilot programme (1983–5), and then, curriculum, which promulgated the internal logic of the three assessable elements: Design, Expressive and Critical, with the latter interrelated to both of the former. A more detailed account of this development is available (MacDonald 1985), but for the purpose of this chapter it is sufficient to say that the equal accommodation of those three elements was indebted to a range of factors: Eisner's identification of three 'aspects' of artistic learning, the 'productive, the critical and the cultural' (1972); Allison's four domains including the 'Historical/Cultural' (1982); and Hildred's work at Morayhouse in Scotland into what he termed 'Practical Appreciation' (1986). Therefore, while Rod Taylor's innovative work at Drumcroon, Wigan, in the *Critical Studies in Art Education Project* introducing practice-informing values was an influence, the introduction of Critical Activity was indebted to a number of antecedents, not least

Scottish sources. Occurring almost simultaneously with Taylor's work, the Standard Grade programme could claim to have gone further, certainly in terms of assessment and the development of appropriate tools. Critical Activity especially, given its new-found systemic status, its relationship to the productive elements and its assessment, offered considerable scope for research. One of the most novel features of the second year of piloting (1984–5) was the trial of an assessment instrument relating to Critical Activity, carried out in conjunction with the Scottish Examination Board (SEB). As a criterion-referenced test design utilizing the new Grade Related Criteria (GRC), it entailed statistical analysis of reliability between teacher-marker and the appropriacy of the graded test items, and testified to the seriousness then being attached to Critical Activity within the pilot programme. Devised as a 'visual response type' chapter, it probably remains unique in Art and Design in terms of public assessment beyond the limited context of higher degree research. The analysis arose from the recognition that Scottish art teachers would have to develop formative instruments to help pupils learn more effectively on the one hand, and build up a profile of pupil performance on the other. The chapters were marked by external examiners, who were also required to comment on the test in several respects, particularly with regard to the appropriateness of the visual-type questions, relative to the criteria.

Naturally, assessment in Art and Design, which had always been contentious, was becoming even more-so with the compulsory introduction of Critical Activity for the entire 14–16 cohort. Concern was also growing about the introduction of an element that demanded the use of verbal and writing skills to evince a meaningful response. One of the results of the Objective Pre-test was the reaction of the markers to the quality of response from low ability pupils. Although the growing teachers' militancy at that time was to prevent further development, the exercise, remarked on by all who took part as worthwhile and surprising in its results, stood for more than simply a referential experiment for those interested in assessment. It represented a significant change of emphasis, the use of research to underpin contextual change. Furthermore, it offered an empirical model for developments in appreciation and evaluation at the *Revised Higher Grade*, which eschewed the traditional essay-type in favour of

the visual-type question. As a consequence, in common with the Netherlands, Scotland is one of only two European countries to offer pupils at the senior stage of secondary education such a paper in a national examination.

It remains true that while much has been written of Critical Studies, and this has been added to by the literature on Discipline Based Art Education (DBAE) from the USA, little has been attempted on its assessment. Scotland, for the pragmatic reasons rehearsed here, may be the exception. However, it should be said that the majority of available Scottish texts are unsophisticated guides and exemplars. Primarily intended to support teacher development in relation to the requisites of national assessment and examination, these materials are extremely instrumental, and, therefore, in that sense, may not travel well. Nevertheless, that same emphasis on methodological concerns may offer generalizable models. These may be relevant to the English situation where, because of an imprecision within assessment criteria, the evidence submitted for GCSE for Critical Studies, according to Binch (1994) is most commonly based on objective drawing and visual analysis, instead of, as is the mandatory case in Scotland, study of artists, designers and their work. The experience of a decade of teaching and assessing Standard Grade Critical Activity is that students can carry out Critical Studies in context with practical work and submit appropriate evidence for assessment provided they comply with the two-handed GRC; *Handling Information* and *Making Judgements.* It should also be noted that this form of evidence is clearly distinguished from the student *Evaluation* which has a separate criterion and its own proforma and so obviates the kind of confusion with coursework indicated by Binch. Furthermore, the identification of Design and Expressive (fine art) Activities ensures that designers' and artists' work are both present. Forms of submitted student evidence are many and varied, and although the illustrated essay type is by far the most popular, at least twelve other kinds of response are discernible as acceptable to the SEB, viz.:

- short answer type – a series of statements with or without illustrations
- annotated sketches – drawings circled or mapped with short comments
- annotated photographs or reproductions
- concept maps – diagrammatic representations illustrating relationships of ideas to and in an artists'/designers' work

- letters – to real or imagined artists
- simulated newspaper or magazine articles – e.g. reports on the opening of an exhibition
- interviews – real or imagined, written or taped
- catalogue notes – for a real or imagined exhibition or display
- storyboards – cartoon type or animated visual sequences
- slide/tape or OHP presentations
- video sequences – e.g. of appraisal of local architecture
- multimedia presentations (there is growing evidence of electronic submissions using scanners and digital cameras)

Alongside these varied forms of evidence there has been a concomitant interest in differentiation, that is, the appropriation of learning materials which recognize the language level, pace and style that best suits the student. This has been motivated by the availability of dedicated graded criteria for Critical Activity for all levels of ability. Convergently, and this may also be a significant Scottish contribution, approaches have been developed which aim at facilitating flexible learning in the context of Critical Studies. Occasioned by the dual need to meet resource provision and choice in a course that balances three domains, Supported Self Study (MacDonald 1988) was introduced, where specially designed Critical Studies packs enabled students to learn autonomously at their own pace, and consequently free up valuable teacher time. The approach was also aimed at supporting the demand for more investigative work contiguous with Standard Grade (and GCSE), and which had become a methodological imperative *passim* in contemporary policies.

Some of the other significant initiatives developed at that time related to the production of supportive materials produced in partnership with galleries or artists' workshops, which hitherto had suffered from the lack of any real integrative context. These initiatives gave policy-makers, curriculum developers, gallery educators, artists and teachers a common platform. A good example of this was the development in 1984 of a pack to promote printmaking in the new curriculum supported by Peacock Printmakers Aberdeen and the LEA – *What is Print?* (MacDonald 1984). Central to this resource was a small-scale travelling exhibition of real prints (which the LEA then purchased) by contemporary printmakers and which would offer

a holistic stimulus and source of reference for all the main activities of a Standard Grade Art and Design course. Allied to this a package was produced which contained in booklet form both pupil and teacher material – design briefs; project outlines; ideas for critical study based on the prints and so on; and slides of the artists' prints for class or individual use. This form of collaborative curriculum development, with national bodies working with local agencies such as galleries and museums and their local authorities, not only aided the outward dissemination of the new curriculum by cultural assimilation but simultaneously, facilitated congruence. There were other benefits in the form of securing authentic contexts and finding in the collaborative work with these agencies a 'reality fit' for the objectives of the new curriculum, for as Eisner reminds us:

> ... we can learn the justification of art in education by examining the functions of art in human experience. We can ask, *What does art do?* To answer this question we need to turn directly to works of art themselves. (1972)

Eisner's question, could be paraphrased to relate to the wider possibilities opened up by intercourse with artists' workshops and organizations and anticipates later cultural developments. *The Art of Thinking* (MacDonald 1985), in that context, represented a more sophisticated advance from *What is Print? The Art of Thinking* constituted a collaboration between the Standard Grade Development Programme in Art and Design, the Scottish Arts Council, Higher Education in the form of the four Scottish Colleges of Art and the Artspace Gallery. Comprising a static exhibition, a small scale touring satellite exhibition, and education material, *The Art of Thinking* centred on the processes whereby artists' stimuli and ideas are developed into realized form. The exhibition, therefore, included the thoughts, recollections, resources, sources, sketches drawing and studio detritus of the six artists, who represented different approaches, and who worked in a wide range of media. This venture was unique in being targeted solely at secondary school pupils and the new Standard Grade syllabus, and it aimed for wider coverage through offering a small-scale touring exhibition in the form of a 'Book-table' exhibition, another innovative form developed by the Scottish Arts Council to get art to areas inaccessible because of geography, social circumstance or disability. The resulting publication, aimed at the 14–16 age group, took

cognizance of the limited range of art publications then written in terms that youngsters could understand, and was a further endorsement of the impact Critical Studies was making in terms of meeting differentiated needs.

The experience of teaching and assessing Critical Studies within Standard Grade, is therefore, not only transferable to the emergent needs of 5–14, but to the English National Curriculum also, and as such could help conjoin to articulate a model for Critical Studies as indicative of what educationists are actually trying to achieve as opposed to one prescribed by national fiat.

TOWARDS THE PRESENT
BROADENING THE CONTEXT

It has been widely stated that from the early 1970s there has been a growing realization, as evidenced in theoretical studies of Art and Design education, that the traditional productive orientation of art education was insufficient to develop critical, aesthetic and contextual awareness. The recent inclusion of Critical Studies in the respective systems of education in Scotland, England, Wales and Northern Ireland is testimony to that influence. Despite the amalgam of the creative and the critical – in addition to all the other benefits the past ten or so years have brought – there is, according to those promulgating a wider definition of art so as to democratize and 'ground' it inexorably in the lives of young people, still some distance to go. *Moving Culture*, (Willis 1990) aptly named, still requires it to happen, it would seem, in terms of developing an Art and Design curriculum that fully encompasses productive aspects, including design and critical activities. One which is open, individual, student-centred and client oriented, and which takes cognizance of what Cable (1994) has referred to as 'multi-identity' subsuming concepts of gender, age, and class as well as ethnicity. This multivalent intentionality is parallelled by Eisner (1994) who, talking in the context of Scottish education, has referred to the need to develop 'multiple literacies' meaning the range of representations that a culture uses to create meaning. In Eisner's thesis the function of 'multiple literacies', in other words, meaningful access to art, music, mathematics and so on, is to create equity because in that sense, meaning becomes *diversified*. What is of further interest about Eisner's proposition is that he raises the need for young people to be enabled to construct their own agendas, in

harmony, with the concept of diversity. Thus, as well as being contextually relevant, a Post-Modernist Art and Design curriculum, it appears, should also be rooted democratically in the culture and environment of young people themselves as well as promoting equitable concepts of equity and diversity. How can this flexibility be achieved without dissolving into total nebulousness? How can such contextualization be attained, and Art and Design still retain its necessary qualities?

The fundamentally democratic nature of curriculum design in Scotland, as it is construed at present, ensures that each young person receives his/her due entitlement because *Creative and Aesthetic Studies* is an obligatory *mode* within the national framework for secondary education, and *Expressive Arts* is an inseparable element of the new curriculum for 5–14 year olds. Furthermore, *all* young people aged 14–16 can opt to do Creative and Aesthetic Short Courses or two year Standard Grade Art and Design courses. Either option articulates flexibly with 16+ arrangements, whether into the national modular (vocational) system or the Higher (academic) system. Both are fully accredited by award bearing bodies and have been rendered mutually compatible in terms of university entrance. It can only be hoped at the time of writing that the proposals which emerge from the deliberations of the *Higher Still* reforms will vouchsafe that breadth and progression as far as the aesthetic area is concerned. That democratization in the arts in general, and in Art and Design in education in particular, has ensured a continuing high profile for art education in the development of large-scale Glasgow-based festivals like *City of Culture 1990* and *City of Architecture and Design 1999*. The education proposals within the successful bid for the latter were predicated on the contextualist orientation, and indicate both a set of aims and a programme:

- the creation of a coherent plan in which design is seen as a progressive development through primary, secondary and beyond, and in which institutions and individual architects and designers, play a key role
- the provision of integrated themes for design and built environment education, focusing particularly on the environment and ethos of schools, and their development plans
- innovative staff development and training through strategies which maximize the potential of artists' and designers' residencies

- encourage skill transfer through partnerships with higher education and industry
- document and communicate good practice through multi-media technology
- initiate special projects targeted on key areas of design (1994)

Indeed, the development of cultural policy has a convergent relationship with other shifts in contemporary, educational policy-making, all of which predicate a function for Art and Design as an agent of change. For example, the importance of 'multiple literacies', was raised under the auspices of the boom in policies relating to school ethos, which is a widespread concern in Britain. Indeed, the report of the conference at which Eisner presented his ideas was headlined 'Heads turn to the Arts to Boost School Ethos' (Times Education Supplement 1994), and encapsulates the issue, nicely. At the same time, educationists such as Barber and Brighouse (1992) have been adumbrating a role for artists in schools as part of a wider constituency and propose teaching 'associates' as partners to enrich the educational process. Similarly, Hargreaves (1994) has suggested students and workers mixing on-site and students being matched to opportunities in the wider community through 'curriculum brokers' as a means of making the system more creatively amenable to change. Clearly, there is a role in that sense for artists within and without schools and Critical Studies is crucial to clarifying meaning in that broadened context.

Thus a climate is being created which is conducive for Art and Design education provided it is responsive to perceiving its essential values being placed in a range of contexts. At the same time as these large-scale policy shifts are occasioning external changes, moves are also happening from within the subject. Harding (1993), who is Head of Environmental Art at Glasgow School of Art has, for example, written of the need for a 'truly public art for our time'. It is no coincidence that Harding is identified as one of the most active protagonists in contextualization, being instrumental in achieving a concurrent relationship with public art and environmental considerations in which education has prefigures. Pointing to the role of public art usefully reinserts the necessary place of language in the progress of contextualization which has been perceived as a necessary precondition of the democratization of the subject. In the domain of public art Burton has asserted that, 'there is no room in public art for private lan-

guage'. Equally, Harding has indicated the 'failure to deal adequately with the social context of public art' and the consequent need to develop social and communication skills. Therefore, if Art and Design in schools is to 'come out' and fulfil the expectations of contextualizing programmes such as *City of Architecture and Design 1999*, a policy on language is a prerequisite. This may be the juncture at which to revisit an important historical area. Clive (1994), for instance, has recently identified Critical Studies as the descendant of Visual Literacy and has allocated a role for it in terms of it being an essential ingredient in appreciating 'cultural contexts'. What Clive does, usefully, by circumnavigating the Attainment Targets of the English National Curriculum, is to reinforce the efficacy of the notion that a range of languages are at work in Art and Design, and that language in that sense is context-bound. In reaching that approximation Clive echoes Eisner's notion of 'multiple literacies'. Indeed, it is worth pointing out that the National Society for Education in Art and Design (NSEAD), in its response to the Revision of Art and Design in the National Curriculum, upbraided SCAA for its omission of the 'important concept' of 'visual literacy' (1994). Dyson (1994) has proffered a practical methodology in this regard, which includes what he terms a 'simple scaffolding of context'. Dyson's approach also includes the issue of culture as well as chronology and prestige. Visual literacy, therefore, has some potency, certainly as an ingredient of art educational policy, and according to Biancini and Parkinson (1993) the scope and ambitiousness of cultural policies is influenced by the standards and characteristics of arts education. In such a congruent relationship, Art and Design, if it is to effect its multifarious role, requires to promulgate visual literacy, especially, both as the medium for its programme and as a mechanism for its *referential* function, in other words its context. Critical Studies can provide that agency.

PRESENT-DAY INTERNATIONAL AND INTERCULTURAL ISSUES

Concerns about the universal trend for curriculum review and reconstruction and its eventuation in hasty and ill thought-out policies have also occasioned a general interest in context, especially where Art and Design has had to do battle to find accommodation with other subjects or curricular areas in an over-crowded curriculum or to find approximation with a hazily drawn ideology or epistemology which ignores the import of Critical Studies. It is possible to locate such concerns on the main *essentialist/contextualist* axis using examples from North America and Britain and to go further and suggest Art and Design as vehicle for *praxis*. Simultaneously, by questioning the foundationalist view which is predicated on outmoded philosophical constructs and by interrogating actual practice, it may be possible to move towards a redefining of Art and Design through a diverse contextualization. For example, Hughes (1995), talks about 'creating cross-curricular connections', and has gradated the 'predominantly *essentialist* approach' of HMI in the early eighties, through to the utilitarian nineties in which changing social priorities have forced school managers to link art with other subjects. In that sense, Hughes has utilized the limited concept of 'school knowledge' to underline the need to contextualize students' work, for them to seek their 'own reality' through an expanded Art and Design curriculum which encompasses Critical Studies, in particular. By relating his own experience as a teacher, Hughes grounds the notion of art as 'permeation', rather than subject, in the curriculum, in a way that supports the work of Dyson on empathy and art education. At the same time, speaking from an American viewpoint, but on a European platform, Parsons (1995) has sought a readjustment of the psychology of art based on changes in the philosophy of art itself, so arriving at certain 'consequences'. According to Parsons the present-day view offers the opportunity to integrate art with other school subjects in an important way. This can be achieved through the study of contemporary art concerned with social issues and requires to be interpreted by calling on a 'knowledge of contextual material'. Interestingly, other subjects become supports for art because they can provide the necessary contexts for interpretation. Moreover, like Hughes, Parsons sees Critical Studies, or his redefined version of DBAE, as a catalyst in the curriculum *per se* and a paradigm for the kind of critical thinking demanded by contemporary society. By setting the tasks of art education as the pursuit of multiple interpretations routed through various contexts, Parsons offers a multi-faceted rationale for art education grounded on a contemporary diversity of psychology, sociology and epistemology.

Similarly, in the UK, Buchanan (1995) has sought the views of heads of departments in

schools in order to refute *essentialist* preoccupations, or what he terms 'a golden age of skills teaching', which he sees as a debased notion centred on the artificial separation of theory and practice. Buchanan suggests a new orthodoxy; a common concern for valuing the child and for 'creating rich and varied opportunities for their learning'. In this re-appraisal of what is construed as essential, Buchanan puts a high premium on 'quality dialogue' and on time to do adequate justice to reflective practice in the classroom. In another context, the same preoccupation with language has led Buchanan (1994) to the concept of 'Critical Literacy', which, as a construct, stands between Visual Literacy and its promulgation into Critical Studies. This hybrid concept parallels Parsons's prioritization of language – the relationship of visual and verbal thinking; both are needed, according to Parsons, in interpreting artworks. All of this points towards the need for a new synthesis, a fresh integration of the productive and the critical in ways that recognize the concerns of Buchanan and Parsons. The agenda and programme for the delivery of such an approach has been rehearsed in Scotland – it has been present for ten years in the adduction of the three equally weighted assessable 'elements' or irreducible components of Standard Grade Art and Design and in its prescription for 'practical work to be done in context'. But like much of the development that preceded it, it has remained ignored with the rest of Scottish Art and Design educational history, which has been assumed to be but a cleft of larger policy initiatives elsewhere.

Where it's at – Cultural Policy

This convergence is important in terms of recent art policy-related publications which advocate a stronger congruity between art in school and art outside – for culture, in other words. This has been accompanied by a more defined sense of the comparative Scottishness of current curriculum reform. The Scottish Arts Council (SAC) has remarked that:

> The situation in Scotland differs widely from the English experience where the arts have become embattled within the new curriculum losing much of the ground painfully gained over the preceding years ... In Scotland we have the opportunity to improve radically on the English model ...(1994)

The besieged status of Art and Design, relative to other subjects in the curriculum would appear to be universal. However, as the SAC discern, Scotland is relatively free, as Art and Design, along with the other aesthetic subjects, does enjoy some degree of ring-fencing. For instance, the current issue of 'entitlement', which bodies such as the RSA (1995) perceive as vulnerable in England because of LMS and the Educational Reform Act, is relatively non-contentious in Scotland. The Scottish 1989 Guidelines for Head teachers prescribes 'Creative and Aesthetic Studies' as a mandated 'mode' in the S1 to S2 curriculum. Furthermore, the Guidelines insist that 10% minimum time be allocated to this mode, and HMI expect to see it in place in inspection programmes. In fact, the Dearing Review in England took cognizance of the Scottish Curriculum rationale in the course of its deliberations, although its final account fell far short of the Scottish prescription. And, of course, Art and Design is now mandated for 5–14s *via* the National Guidelines on Expressive Arts (SOED 1992). Scotland has, thus, achieved an entitlement for Art and Design from age 5 to age 16, which securely embodies Critical Studies.

Conclusion

This paper has mapped the erection of curriculum policy onto a cultural platform and pronounced cultural differences between contemporary English and Scottish art policies. It has also intimated a possible resolution as far as the existence of any perceived oppositional tendencies might be concerned and even touched on cultural policy-making in itself as an engine of reconciliation and synergy. But there still remains the problem of how policy-making in Art and Design can cover such wide-ranging terrain without losing sense of its distinctiveness? To ask this question is not simply to reiterate earlier arguments or to settle on concepts such as Buchanan's 'new orthodoxy' or to create a neologism such as 'Critical Literacy'. It is clear that a new synthesis is necessary that allows the actors and agents of policy to ground their ideas in everyday life; terms such as 'cultural work' and 'grounded aesthetics' (Willis 1990), which synthesize consumption and production, and are based on long term naturalistic observation of young people's actions, might offer an approach. This is where a focus on methodology becomes relevant, particularly analysis of the

operationalization of supported self study and its role in grounding Critical Studies, integratively, with practical work. The outcomes of contemporary policy, especially when factored into cultural policy, similarly demand to be actualized. Methodologically rooted description, it would appear, promises such synthesis. In that context Wojnar (1988) has proposed an expanded notion of art compounded with life, and at the same time has raised a fundamental concern within such experience, namely, creativity. It is not the function here to open up a debate about the definition of creativity, drawing on the etymological roots of the word or delving into the literature related to psychology or aesthetics. In this context creativity is significant because in its modernist conceptualization it emphasizes the new, progress and continual change. In that same context, the term 'synthetic creativity' has been coined, and it is useful to this study as it seeks to attain a holistic view through a 'softer set of skills' than those of the scientist. Furthermore, Landry and Biancini (1995) have indicated that the challenge of creativity in its modernist propensity is to recognize that opposites can be parts of the same whole.

By juxtaposing ideas from Art and Design education and from the cultural field it may be possible to arrive at an operational descriptor for creativity which will enhance the synergetic concept of educational cultural policy, with Critical Studies as a co-efficient. Speaking in the context of the evaluation of Glasgow's Year as Cultural Capital of Europe, Stuart Gulliver, the Chief Executive of the Glasgow Development Agency, has utilized Scitovsky's emphasis on individual creativity in enhancing human potential (1991). All cultural activity can be placed in this exalted category, and Gulliver advances the concept of 'art for urban regeneration's sake', which according to Gulliver can create a *milieu*, a 'climate of creativity'. And, in the same context of cultural analysis, Gulliver highlights the need to 'reconcile several disparate strands'. From an adjacent view, that is the philosophy of art, Parsons (1995) has promoted a synchronistic form of art education comprising 'productive, receptive and reflective activities', as a powerful means of cultural engagement. However, Swift (1995) has pinpointed the now axiomatic nature of individual creativity which is at the centre of Art and Design education but has also cautioned against immediate acceptance of the self-evident primacy of the individual in the framework of the Education Reform Act because it is designed to 'differentiate, privilege and condition'.

The only antidote in that sense, therefore, is to impress the efficacy of the National Curriculum as part of a wider culture. This is especially important when judged in the light of very recent research which has highlighted disparities in the relationship between leisure and culture through findings which reveal that for young people participation in the arts is a minority activity (Harland *et al* 1995). Equally, from a Critical Studies point of view, contemporary investigation has shown that young people have pre-conceived and negative perceptions of art galleries (Sellwood 1995). Both studies, therefore, reinforce that trend which is towards *Moving Culture*, which fuses consumption and production under a broadened definition. In the West of Scotland, particularly, through the synchronization of educational and cultural policy-making, disparate elements have been pulled together and posted as paradigms and strategies for implementation elsewhere. In that post-synthetic state Critical Studies is offered as an essential stratagem for sustainable creativity.

BIBLIOGRAPHY

ALLISON, B. (1982), 'Identifying the Core in Art and Design', *Journal of Art and Design Education* Vol.1 No.1.

BARBER, M. and BRIGHOUSE, T. (1992), *Partners in Change: Enhancing the Teaching Profession*, London, Institute for Public Policy Research.

BAYNES, K. (1990), in: Stanley, N. *et al*, *Art machine*, Glasgow, NSEAD/Birmingham Polytechnic.

BIANCINI, F. and PARKINSON, M. *eds.* (1993), *Cultural Policy and Urban Regeneration, the West European Experience*, Manchester, Manchester University Press.

BINCH, N. (1994), 'The Implications of the National Curriculum Orders for Art for GCSE and Beyond', *Journal of Art and Design Education* Vol.13 No.2.

BUCHANAN, M. (1994), *Children Making Art: Teachers' Attitudes and Approaches*, London, London University Institute of Education.

BUCHANAN, M. (1995), 'Making Art and Critical Literacy: A Reciprocal Approach', in: Prentice R. (ed.) *Teaching Art and Design*, London, Cassell Education.

BURTON, S. in JONES, S. *ed.* (1992), *Art in Public; what, why and how*, London, AN Publications.

CABLE, V. (1994), *The World's New Fissures*, London, Demos.

CLIVE, S. (1994), 'Thoughts on Visual Literacy', *NAGE Quarterly Supplements* Autumn 1994.

DYSON, A. (1993), *Empathy and Art Education*, Birmingham, University of Central England.

DOW, S. (1994), *Now to Create; Arts and Education Partnership*, Edinburgh, SAC.

EISNER, E. (1972), *Educating Artistic Vision*, New York, Macmillan.

EISNER, E. (1994), 'Ethos and Education', in: *Perspectives, a series of occasional chapters on values and education*, Dundee, Scottish Consultative Council on the Curriculum.

HARDING, D. (1993), 'The Context is Half the Work', *Issues in Architecture Art and Design*, Vol.3 No.1.

HARGREAVES, D. (1994), *The Mosaic of Learning: Schools and Teachers for the Next Century*, London, Demos.

HARLAND *et al* (1995), *The Arts in their View, A Study of Youth Participation in the Arts*, Berkshire, NFER.

HILDRED, M. (1986), *New Ways of Seeing, Practical Appreciation in Three Scottish Secondary Schools*, Edinburgh, Morayhouse College of Education.

HUGHES, A. (1995), 'Creating Cross-curricular Connections', in: Prentice R. ed. *Teaching Art and Design*, London, Cassell Education.

LANDRY, C. and BIANCINI, F. (1995), *The Creative City*, London, Demos.

MACDONALD, S.W. (1985), 'Developing Criteria: Changes in the Art and Design Curriculum and Examination for 14–16s in Scotland', *Journal of Art and Design Education* Vol.4 No.3.

MACDONALD, S. (1988), *A Guide to Supported Study in Art and Design*, Dundee, Consultative Committee on the Curriculum; this was one of the outcomes of the 1985 NSEAD/Berol Bursary.

MUNRO, N. (1994), 'Heads Turn to the Arts to Boost School Ethos', *Times Educational Supplement* Scotland.

NSEAD (1994) *Newsletter*, July/August.

PARSONS, M. (1995), *Visual and Verbal Learning in Art, The Consequences of Developments in Aesthetics for Art Education and the Psychology of Art*, based on notes taken at an LOKV Conference Rotterdam.

ROGERS, R. (1995), *Guaranteeing an Entitlement to the Arts in Schools*, London, Royal Society of Arts.

SCITOVSKY T. (date unknown), 'Culture is a Good Thing: a Welfare-Economic Judgement'; quoted in the context of: Gulliver S. (1991), 'Do the Cultural Industries Make a Contribution to the Urban Economy?' in: Jackson, T. and Guest, A. eds., *A Platform for Partnership*, Glasgow, Glasgow City Council.

SCOTTISH Central Committee on Art (1985), *Changes in Art Education, A Survey of Views*, Dundee, IMS/CCC.

SED (1947), *Report on Secondary Education by the Advisory Council on Education*, Edinburgh, HMSO.

SELLWOOD, S. *et al* (1995), *An Enquiry into Young People and Art Galleries*, London, Art and Society.

SOED (1992), 'Expressive Arts 5–14', *Curriculum and Assessment in Scotland's National Guidelines*, Edinburgh.

SWIFT, J. (1995), 'Controlling the Masses: the Reinvention of a 'National' Curriculum', *ibid.*

THISTLEWOOD, D. (1992), in: *Histories of Art and Design Education*, Essex, NSEAD/Longman.

THISTLEWOOD, D. (1993), 'Curricular Developments in Critical Studies', *Journal of Art and Design Education* Vol.12 No.3.

WILLIS, P. (1990), *Moving Culture – an enquiry into the cultural activities of young people*, London, Calouste Gulbenkian Foundation.

WOJNAR, I. (1988), 'Diversity of Socio-educational Functions of Art in the Modern World', in: *Dialectics and Humanism* No.1-2.

THE CRITICAL CURRICULUM

DAVID HULKS

INTRODUCTION

'Critical Studies' is a term which has been applied to a variety of new working practices, representing a fresh emphasis in art education and delivery, as well as offering new areas of study for theorists, researchers and writers eager to make their mark in this field. Critical Studies is also used to suggest a real advancement in the teaching of art in schools and colleges. By implication, therefore, it should also signify the emergence of a new type of student – the critical practitioner. If they are real, these seem significant advances indeed; and they are understood on mainly two fronts. Firstly, Critical Studies promises a superior method to the traditional study of art history. Secondly, it is seen to embody a more intelligent research-based approach to studio practice and the production of art. The following sections will evaluate the validity of such claims, and more importantly, will attempt a clearer picture of what these ideas might mean if we are serious about establishing Critical Studies within the curriculum.

The first assumption, that Critical Studies is synonymous with a 'new art history',[1] is certainly questionable. In the universities where new discourses were first introduced, the idea was to challenge the traditionalist dogmas of institutes such as the Courtauld, and to initiate new practices which would revolutionize the discipline. Whether or not a revolution has in fact taken place has become a problematic issue which is debated with-

in those same art history courses. Old study methods have been thrown into question, and the introduction of Marxist analysis, feminist perspectives, philosophical and psychoanalytical theory have brought art history closer to an advanced form of criticism. But other than emphasizing the social production of art, the new art history has failed to add anything more than a deconstructive method which is inevitably reliant upon the traditionalist practices that it criticizes. A new constructive method has not been properly defined, and the revolution has disintegrated into a complex epistemological debate, rather than reform. If old art history is out of favour, and new art history is as yet unresolved, are secondary school teachers really equipped to introduce a 'critical' art history into their lessons?

The second notion, the claim of new 'critical practice', is equally open to question. Artists and teachers have always used sketchbooks, made notes, referred to other artists, and used observational research methods. So what is new that we need Critical Studies? Before we leap onto the Critical Studies bandwagon, we should check whether or not Critical Studies does indeed supersede previous paradigms. If it fails such tests, then perhaps we have here an unhelpful and misleading idea that is endangering strong traditions. If, on the other hand, we are venturing into a new era in art learning, there should be demonstrable changes, genuine improvements and real results. We should be clear as to what we are aiming to

achieve, and not assume that by adopting the label 'Critical Studies' we will automatically have an improved syllabus.

Having noted difficulties with the very notion of Critical Studies, I would now put forward the case for its full implementation at the same time as responding to National Curriculum guidelines. Unclear as the term Critical Studies might be, it has certainly inspired a great deal of worthy study and the development of original ideas. These initiatives, however, will be bankrupt if we cannot secure a strong position for Critical Studies within the curriculum. Perhaps the impact of the National Curriculum for art and design has already been underestimated. Some have suggested that all that has been done is that the best practices have been put together into one package, and the NC art should be regarded simply as a continuation of current ways of working. However, even the best departments will have to conduct a serious review of their procedures. It would seem the ideal opportunity for instigating significant improvements and for realizing forward-thinking ideas about the ways in which art is taught in our schools. It might be possible to place Critical Studies at the heart of art curriculum modernization; and that is the idea that is explored here.

The National Curriculum clearly encourages a critical approach, without requiring a taught course of Critical Studies. It would seem, for example, that our pupils are now asked to become far more than 'student artists'. The job description has broadened to accommodate the idea of students as consumers, as well as producers of art. Whilst observational drawing is prioritized as the central research method, new research and development procedures are also encouraged, along with the requirement that students collect, analyse and organize their ideas and evaluate their own methods.

Teachers will have to review their own practices. Lesson-planning, for example, might start from the identification of aims and objectives, but in honesty lessons are normally planned with a certain outcome in mind which will dictate the ways in which lessons will be structured. This way of planning a lesson may be turned on its head. We might now concentrate our planning at the initial stages of a project, without aiming to predict what will arise. Consequently, to enable the inevitable variety of working methods that will result from an open-ended approach, we now need to teach the student how to develop and record a

progression of ideas. Here is where Critical Studies could play its starring role. Students will need to problematize the task, and to develop strategies with which to proceed. This also means engaging in extra activities, such as library research, surveys, self evaluations, and so on – all of which fit very well into the Critical Studies domain.

Critical Studies will need to mean far more than a bit of art history and a resident artist. It will need to be situated at the very core of the syllabus, embodying the sort of 'existing good practice' that the National Curriculum aims to promote. In its role as an underpinning philosophy, however, there is a danger that it will be swallowed up, forgotten and lost. It is therefore essential to establish Critical Studies as an identifiable study component as well as emphasizing its cross-attainment target function. It needs to be more than just a philosophy, it needs to be an operational method. It should be up front, printed in the syllabus, and perhaps even included in the published timetable. Certainly it should be a term that students are familiar with, understand and use.

This article sets out some of the fundamental ideas that such an approach might take. The discussion takes its examples from one initiative, an integrated component in Critical Studies instigated at Beaumont School (an 11–18 mixed comprehensive) in 1989. We are still developing this programme as we apply it. Since it is for GCSE pupils aged 14–16 it does not fall within the recently published National Curriculum for Art. Clearly, however, we will need to relate our work to the first three Key Stages, and to evaluate how this would affect students' approaches to further study.

The Content of Critical Studies
Identifying Needs and Setting Objectives

It has been assumed that the provision within the syllabus for Critical Studies deserves a full review, if not a major shake-up in the department's approach to the whole of its teaching programme. It will be important to identify existing good practice, to address National Curriculum requirements and the school's development plan. It will also be necessary to address current weaknesses, and to identify more immediate needs. The main purpose is to generate new objectives which will provide the framework for a coherent Critical Studies component.

Following a pupil-centred approach, the first task will be to assess the needs of students, rather

than those of the department. In other words, what do 14, 15 and 16-year-old children need in order that they might understand, value and use art more effectively? By putting pupils at the start of the process we can aim to avoid the assumption that we already know what pupils' needs are. Even if so, asking them first is a useful check. It is also helpful to involve children in the design of the programme, so that they become willing participants rather than alienated recipients. In all of these aims, I hope that I would satisfy Leslie Cunliffe's call for a mediational art curriculum that gives pupils 'ownership of the concept and "means of expression".'[2]

This process of negotiation is still developing at Beaumont. Important stages seem to be: (i) the introduction at the start of the course, since pupils need to be forewarned of the greater responsibility they will need to take; and (ii) the pupils' review at the end of the two year course, where they feed back their constructive criticism, suggestions, and general reflections upon the structure and content of the course as they have experienced it. Evaluation and review is an area that will receive greater emphasis as a result of the National Curriculum. The suggestion here is to extend this to encompass a continuing, open review policy of the course itself.

AGREEING A DEFINITION OF CRITICAL STUDIES

Mike Hildred, in his article 'New Ways of Seeing' (1989)[3] drew upon the ideas put forward by H. Osborne in his book, *The Art of Appreciation* (1970) in order to suggest five components, or contexts, for a Critical Studies programme: critical activity, history of art, connoisseurship, aesthetic experience, and production of art and design (this last one being his own addition to Osborne's list). This list, and Hildred's[4] further expansions on what these areas might comprise, were valuable when considering our needs at Beaumont, yet they seemed rather constricting in their apparent assumption that Critical Studies was mainly a matter of appreciation. Hildred's[5] analysis seemed to isolate too much of the act of research and comprehension from the point of view of a more critical studio practice.

There have been many similar attempts to define areas of critical discourse, but most of these tend to boil down to the same ideas in the end. We can label these the 'Three Cs and the Big H' of Critical Studies – that is: critical, contextual, cultural, and historical. The students at Beaumont use and understand these headings as components of their Critical Studies course.

HISTORY OF ART

The first issue to address was art history input. It was immediately evident that without some basic framework with which to understand when and how certain key movements have developed, pupils would not be sufficiently equipped to use examples from the history of art in the more flexible ways that we were aiming for throughout the rest of the course. The delivery of an 'introduction to art history' consequently became an early priority.[6] It also seemed to contradict the idea of a pluralist, individual needs-based approach, right from the start. So much for the 'new art history' and multiple discourses! Nevertheless, the first objective we set was:

> to give some impression of the general development of art through a historical succession of movements. Pupils will not be required to learn a detailed account of Western Art History, date by fact, but rather they should aim to acquire a concept of the progress of art and culture throughout this and the last century.

In practice this meant introducing a simple timeline chart that the pupils copied onto their coursework folders. The chart included dates, names, and, most usefully, blank boxes to be subsequently filled in to illustrate various periods in the history of art. The choice of image was not dictated, and the pupils might photocopy from books, collect from magazines, or make their own miniature paintings to fill in the blank spaces (Jackson Pollock, representing Abstract Expressionism, was a favourite here!). By doing this, the pupils began to familiarize themselves, in a visual as well as a factual way, with major movements and styles, from which they would then be able to draw in order to inform individual concerns arising in later work. Also they were able, from the start, to make their own choices as to their favourite paintings within the given movement.

If a department were to decide, as we did, that some sort of art history delivery were necessary, it would also need to consider carefully the implications of dictating such a programme. Most obvious here is the requirement that the curriculum should represent multi-cultural interests,[7] an aim which is difficult to uphold given that art history is almost inevitably a Western model, and what's

more, uncomfortably male-dominated. Again, Marxist or feminist discourses tend to offer critiques of such an approach, rather than tangible solutions. It seems that one can only make students aware of these failings, rather than redress them, as the idea of an all-encompassing global art history is probably untenable, and would certainly be unmanageable. Our introduction was further edited, both to reduce these difficulties, and to ensure that the delivery was not too off-putting. A Gombrich-style *Story of Art*[8] tracing art back to the first cave painters seemed unnecessary; although if students subsequently wanted to investigate the eighteenth-century origins of Realism, for example, that was of course encouraged.

Another failing of our nineteenth–twentieth-century time-line was that it took little account of the history of design, and as yet we have not addressed this omission. Two solutions seem possible: either rewrite the narrative to include a parallel history of design, or make the pupils aware of the fact that there are other histories, including the history of design, and that these narratives could prove equally rich in informing their studies. No solution to the art history dilemma can be perfect. However, in realizing this fact and in sharing our difficulties with the students, we do seem to be mirroring the kind of debate that is currently being pursued at university level. Is this what the new art history is all about?

CULTURAL

In the third term, pupils are invited to explore beyond their own cultures. That is, the course aims to develop a broader awareness of culture beyond individual self (first term), beyond society (second term), to look at a culture that might embody values quite different to those of the local community. Given that Beaumont is a predominantly white, middle-class English comprehensive, the problem here is that of cultural rape. Clearly it wouldn't do simply to extract certain ideas and images from another culture, and then employ these freely in one's own artwork without giving respect to their origins. For some pupils this poses quite a moral dilemma; although it is extremely refreshing to see students puzzling over such issues.

An unexpected consequence of this part of the course has been that the minority of students who have alternative cultural backgrounds could enjoy a heyday. And many of them are able to take up this opportunity with wonderful results. By accident, we have built in an element of positive discrimination which, to an extent, might be seen to offset the inevitable historical weighting towards Western art and European cultural values.

CRITICAL AND CONTEXTUAL

The headings 'critical' and 'contextual' have been commonly used in art education theory to suggest a fresh approach to art criticism and the incorporation of a social perspective to the history of art. Since their usage has been popularized, however, they have been adopted and adapted by anybody seeking to give authority to his or her particular initiative within the ever broadening field of Critical Studies approaches.

Initiatives which merely aim to extend children's experience of working with artists and designers seem to fall far short of a more ambitious, holistic approach. Rod Taylor[9] and his followers seem to assume that all that is meant by a Critical Studies approach is that children should feed off the work of professionals. Assuming that such exercises can be regularly resourced, this kind of work will, of course, probably guarantee good results from the pupils – plenty, in fact, to provide lavish illustrations for a definitive-looking book! Day-to-day use of Critical Studies will, however, require more than just the introduction of a termly visit to an architect's office or local theatre group. It will require a course programme that will cultivate powers of critical analysis, by reference to professional artists certainly, but also by learning techniques of self-analysis, group criticism, and self-presentation (this would correspond with Hildred's[10] connoisseurship and critical activity contexts).

'Cultural' would seem to imply an appreciation of worlds beyond our immediate experiences, as well as an appreciation of local cultures and personal cultural backgrounds. Contextual obviously relates to the latter, but might also imply an awareness of environments. It also alerts us to a more intelligent, anti-linear approach to art history. Seen in this light, 'critical', 'contextual' and 'cultural' become useful watchwords with which to check a potentially one-dimensional approach to the delivery of the Art National Curriculum, and its requirement that we include evaluative skills, comparative understanding, and appreciation within a broad context.[11]

We now have a general understanding of what we aim to develop in pupils with respect to a critical approach to their work. The task is a daunting one, and one that will require more than goodwill

and sound intentions. It will need careful planning and a structured programme of Critical Studies integrated into the normal practical studies course. For many teachers it will also imply the learning of new skills. Critical Studies may highlight the need for greater breadth in courses leading to art and design teaching, as well as reinforcing the argument for increased INSET provision. This particular area of the curriculum might also suggest links with other subjects. Media Studies would certainly be able to offer several useful strategies, in the same way that the new art history has been very much informed by the development of critical writing related to film studies.

There is also the considerable issue about the role of the art teacher. Working in these ways implies a heightening of the teacher's responsibility to guide and facilitate, rather than to instruct. Critical Studies, whilst emphasizing technologies to do with information retrieval, also, and more importantly, encourages good working relationships between staff and students, in an atmosphere of negotiation and co-operation (as opposed to teacher-led activities and the emphasis on instruction and passive learning). Contact with outside institutions, such as the local arts centre, the gallery and the city library also becomes more important. It begins to break down the idea that education stops at the school gates, encourages the sharing of ideas between institutions, and stretches the initiative and imagination of all students – the articulate and the less able alike.

NOTES

1 See Rees, A.L. and Borzello, F. (eds.) (1986), *The New Art History*, Camden Press.
2 Cunliffe, L. (1990), 'Tradition, mediation and growth in art education', *Journal of Art and Design Education*, 9 (3), pp.277–89.
3 Hildred, M. (1989), 'New Ways of Seeing', in: Thistlewood, D. (ed.) *Critical Studies in Art and Design Education*, London, Longman, pp.42–56.
4 ibid.
5 ibid.
6 My comments in this section were written before the National Curriculum for Art had been published.
7 Although we now realize that the National Curriculum Order favours emphasizing a Western Art History model, the second strand of AT2 does suggest that 'pupils ... need to look at ... art from different cultures and times'.
8 Gombrich, E. (1976), *The Story of Art*, Oxford, Phaidon.
9 Taylor, R. (1986), *Educating for Art: Critical Response and Development*, London, Longman.
10 op. cit. n.3.
11 These terms were taken from Art Working Group's Proposals, *Art for Ages 5 to 14* (1991).

CHAPTER FIVE

ART HISTORY IN THE CLASS-ROOM: A PLEA FOR CAUTION

BRANDON TAYLOR

The recent wholesale retreat from child-centred methods in art education is bringing about – or has been brought about by – a new interest in art as a teachable, learnable, examinable subject. Practitioners of the 'cognitive-developmental' approach are now engaged upon a considerable programme of research aimed at finding out what can be taught about art and the practice of art at different levels of the school curriculum, and, correspondingly, how much of the previous paradigm of art-as-expression can be jettisoned as worthless baggage. As readers will know the results are varied, challenging, sometimes inconsistent, but always heavy with the implication that art and art practice are there to be learnt, possibly as a core subject in general education or possibly as a major fourth addition to the still-predominant three Rs.

This is neither the time nor the place to launch an assessment of the 'cognitive-developmental' approach and all its various findings and prescriptions. Art historians, however, are bound to be intrigued by recent investigations into two proximate but actually distinguishable questions. The first is simply what types of art images are to be used in the classroom? – and here I remind you of the fact that the choice is potentially vast; that

selectivity is unavoidable. And the second question concerns how these images are to be used – for what purpose, and by what methods? It is excellent that some debate on these important questions should now be under way once more. But our discussion must inevitably have some reference to a newer type of understanding that is being developed within art history itself, an understanding which for some time now has insisted on the historical rootedness of works of art (and all other constructed images) not merely in the emotional system of the artist, but in the social, economic and ideological interchange of the society as a whole. This understanding is not fixed or immutable, thankfully. But art historians are not going to remain happy for long, I suspect, if visual images continue to be used indiscriminately in the classroom merely in the service of an unstructured notion of 'appreciation'; nor, what is worse but no less likely, given the present attack on teachers' resources by government, if artworks are paraded merely out of convenience, or for reasons stemming primarily from the taste of the teacher.

This may be a useful moment therefore to voice some fears about the dangers of unreflective art history in schools, as yet too little thought out,

and in some cases provided at too early an age for the children concerned. I argue that we need to abandon the practice of studying received 'master-pieces' alone, such as can be obtained in reproduction from museum bookstalls; and that *modern* culture in particular, far from representing the 'art of our time', constitutes a specialist minority culture that is frequently inappropriate, both technically and emotionally, for presentation to the growing child. Images of a much wider and more accessible kind must form the basis of primary and early secondary school visual education.

A good deal of research has been published in the last few years which aims to establish scientifically what was probably known all along, but had become buried under the excesses of the child-centred approach: namely, that children can and do develop through a sequence of stages in their ability to receive, articulate, appraise and form judgements about works of visual art. It would, of course, be highly surprising if this were not so. All the same, the precise description of these stages, perhaps even the measurement of them, has become a field which is ripe for experiment and rich in implications for the art educational fraternity. A major study by Parsons, Johnston and Durham in the United States, for example,[1] pointed convincingly to six distinct topics which contained developmental levels; *semblance* (whether and how a painting refers); *subject-matter* (what paintings refer to); *feelings* (the affect *in* the painting); *colour* (what colours are most pleasing); *properties of the artist* (the requirements of artistry); and *judgement* (reasons for aesthetic judgements). We know merely from everyday living that children change their responses along all of these dimensions as they grow and mature. What the study hinted at, however, but did not state, was that teachers could use this information in planning the contents of art appreciation lessons – in order to intensify, perhaps even accelerate, the pleasures and rewards of art at each developmental stage.

It actually matters little for our purposes whether the number of developmental topics in the Parsons study was six or sixty; or whether the number of developmental levels is three (as the authors state) or thirty-three. What matters is the assumptions upon which the experiment was based, the kind of teaching towards which it is implicitly aimed. A striking aspect of this type of survey for example is the *range* of images used. An assumption made by the Parsons study was to use – with perhaps one exception – canonical works of

the modern tradition, that is, avant-garde art from about 1850. Thus a *Head of a Man* by Klee; Picasso's *Weeping Woman* of 1932; and Renoir's *Girl and a Dog* for the ages roughly 5 to 11; and then Picasso's *Guernica*, one of Marc Chagall's *Circus* pictures, and Bellow's *Dempsey and Firpo* for the ages roughly 12 to 17. No reasons were given in the Parsons study either for the choice of images or for the distinction between the two age-groups; but I think we can speculate on the reasons and justifications for the choice. There are two factors here which deserve analysis: one is the assumption of the 'goodness' of 'high art'; and the other, already mentioned, is the 'goodness' of modernity.

First, the distinction between high or museum art and other types of visual imagery such as posters, television imagery, street signs and book illustrations is one that carries with it several assumptions about the 'creativity' and 'insight' of the artist, and about the special status of his or her work. Now frankly I do not know whether or not such assumptions can be upheld. Even if they can, it is surely questionable whether such assumptions should be made implicitly, without announcement to the young and thus far innocent audience. In any case, the assumption of a hard and fast dividing line between art and the remainder of the world's manufactured imagery seems to me not at all helpful at this very early stage.

Secondly, the presentation to young children of 'high art' images which are ready to hand in large numbers at an economic price is an activity which is, of necessity, both value-laden and highly selective. The inescapable fact is that only a minute fraction of the world's output of visual images is available in reproduction for mass circulation to schools, colleges and art education seminars, and yet this fact continues to go unnoticed by the majority of both producers and consumers of juvenile education in art. Indeed, this type of pedagogy may conceal more than is revealed by the pictures themselves. For instance, it seems to me to conceal the fact that 'high art' is unpopular with all but the middle or educated classes. It implicitly short-cuts the possibility that the children might value these images not at all, or even negatively. It certainly conceals the present-day use of these artworks – many of them produced without thought of a sale-price – as blue chip investments for the extremely rich; and finally it seems to me to reproduce and perpetuate a value ranking of visual images which is often one devised by the museum for the purpose of maxi-

mizing a sense of 'heritage' in the country concerned, and for heightening sales to tourists. I think one simply has to face the fact that an innocent-looking experiment in art education comes hand-in-hand, inexorably and inevitably, with a ready-made ideology of art and art production whose real nature is completely concealed.

An over-arching problem here is that any image shown without judgement to a class of children is liable, unless a disclaimer is made, to be seen by them not merely as meeting with the teacher's personal approval, but as indicative of adult taste in general. That there may be no way of presenting images value-free, without an implicit *imprimatur* from the adult world, should constitute a definite *problem* in visual education (not merely in art but in literature and history) at this early level.

A secondary problem, vastly exacerbated by the current restraints on teachers' pay and resources in the United Kingdom, is that the reduction of an artwork to the size and scale of a postcard encourages a 'reading' of the artefact which is not necessarily compatible with its intended or received purpose. Placed in a horizontal plane for easy inspection, it becomes suddenly a specimen to be copied, turned upside down, written across or sent through the post; while the artwork's luminosity, volume (in the case of sculpture), and 'thingness' all but disappear in the process. This substitution of art by an inexpensive piece of printed card conceals almost entirely the *made* quality of the object – its identity as a crafted as opposed to a mechanically reproduced thing.

But these are general difficulties. The problem of modernity – the why and the how of presenting modernity in the classroom – is I believe more specific and at the same time more difficult to discuss. I have mentioned already the fact that all six of Parsons's images were drawn from the modern period; granting for purposes of the argument that Renoir and Bellows are both modern. Now certainly it cannot be claimed, even by the wildest stretching of the facts, that modern art of the generation of Picasso, Chagall and Klee was produced for the consumption of children, even if the inspiration of children's art was a formative factor in certain of these artists, in Klee in particular and to a lesser degree in the others. I think the main problem here for teachers is to recognize the very *peculiarity* and *specificity* of modern culture.

Art teachers will be aware that modern art – the term is at once contentious and contested –

came into being in circumstances which are both extraordinary but also historically specific. Denoting nothing so simple as a stylistic 'development', modernity in painting and sculpture announced itself sometime in the course of the nineteenth century, partly as a symptom of shifting class identifications, partly as a vogue for contemporaneity, partly as a response to the changing inner life of the individual under conditions of developing capitalism. Certainly the aetiology, and to that extent the meaning, of Modernism is a complex but also a controversial topic, of high relevance, one would think, to the education of the young adult – but scarcely suitable for the young child. For the nature of this art as both ideology and history is impossible to dissociate from the visual data given. It should be impossible to separate the social and cultural formations surrounding Picasso's Blue Period pictures – which I mention here only because of their frequent use in the classroom – from the images themselves, his sense of exile in Paris after 1901 and his response to the urban poverty by which he was suddenly surrounded.

The question is simply whether the reduction of modern art to the level of the visually 'given' is desirable. My argument already will have indicated a major difficulty, perhaps even an insuperable one. But there is a further complication. It is evident from virtually every 'cognitive-developmental' study of childhood art appreciation that during the years of progressive accumulation of technical skill in representational drawing the child will baulk, apparently instinctively, at the modern expressively distorted picture. Before the age of perhaps 12 or 13 – I tread carefully here for fear of simplification – a typical response to the situation is simply that all distortions are bad. The ages between 5 and 15 elicit this verdict in varying degrees, ranging from the child who will assert without qualification that the painting is 'bad' or 'amateur' to the verdict that you 'can't tell what it is',[2] to the more discriminating response which accepts the buckled fingers in Picasso's *Weeping Woman* (1932) but baulks at the eyes which are both positioned on the same side of the face. A study published in 1983 indicated the same.[3] Children confronted with even so mild a transformation as Derain's *Pool of London* (1906 Tate Gallery) were unanimous in judging the picture to be 'poor' and the artist only an 'amateur'.

In some ways the child's difficulty with the concept of modern expressive distortion is entirely to

be expected, given acculturation. On the one hand, children inherit aesthetic attitudes from their parents' reactions to photography, snapshots especially – and we know that a belief in verisimilitude is taken for granted by the majority of the population. A photograph which is blurred in any part, for example, is *ipso facto* bad. One which catches a friend in an off-guard moment – sneezing, blinking or glancing away – is appraised automatically as an inferior representation, however much it might show the truth of the moment. Television pictures which show an actor or newscaster fluffing lines or mincing words will attract derisory laughter since the assumed norm of 'how things should be' has been – however accidentally – contravened. Funfair mirrors which distort the human figure are also hilarious because they falsify what is felt to be real and true. Thus the general hostility to modern art which is endemic in the majority of the adult population will already have been transmitted to the child of 5 or 6 upwards, if I am right, alongside other widely shared cultural norms of our society. Modern painting which appears to distort reality has an immense task to perform if it is to persuade the viewer – however young –that distortion is in some sense an aid to truth (as modern artists have often claimed) rather than its enemy.

It is reasonable to assume therefore that despite its popularity with museum curators and despite its interest to historians, modern art has had little or no purchase on the optic of restrained naturalism that still dominates the tastes of the population as a whole. To study modern art in the classroom is therefore to come up against the barriers that have been erected against it – for better or worse – in the population at large. And it would seem to follow from this that to confront these barriers actively through the planned discussion of modern art in the classroom requires a real belief on the part of the teacher that Modernism represents something other than a specialist minority programme in artistic culture with a special, and frequently perplexing (though not perhaps finally unintelligible) structure; that it represents, perhaps, a moment of supposed 'liberation' or 'progress' to which all people irrespective of age or education can gain access. Perhaps some teachers genuinely have this belief – but I doubt whether, once acknowledged, it could remain unchallenged for long.

Second, the level of toleration the child possesses for painfully fragmented images is necessarily lower than that of the adult – and long may it

remain so. As can be easily verified, the violence unleashed upon natural appearances by a 'cubified' representation or an Expressionist caricature can – I repeat can – appear deeply threatening and disturbing to a mind unequipped to cope with adult sophistications. The similarity between Picasso's high Cubist portraits and the appearances of imaginary demons or somehow violated presences should act as a caution to those who might suppose a knowledge of Cubism to be 'beneficial' to minors. Equally, of course some distortions can be highly exciting to children. The point is not to consign the whole category to off-limits, but to point to the existence of a threshold.

Thus I believe the approach taken by Tony Dyson in his article 'Art History in Schools: a comprehensive strategy'[4] is naïve in this respect. Recognizing all too clearly the perplexity induced in his young by the distortions of the Cubist portrait, Tony Dyson advises that 'the formal principle of distortion (among other important characteristics) will need to be appraised, explored and understood by pupils.'

I personally cannot imagine what childhood 'need' could be satisfied by understanding such a thing. In any case, Dyson omits to mention that that which he calls the 'formal principle of distortion' probably does not exist as a unified method of image-making, capable of being copied by several artists at once; for in fact different practices of distortion are to be found in different artists at different times. Nor does he recognize the fact that distortion in any of its particular forms is one of the most obscure and difficult topics in the whole of modern aesthetic thought, and its application to Cubist art is a particularly baffling subject upon which little has been written and probably even less understood. But he goes even further. He proposes, and here I quote in full, that

> such explorations will profitably include a consideration of examples within the scope of pupils' existing interests and experience – examples which need have no link with art beyond the fact that they happen to be illustrative of the particular principle or principles under consideration. The vital property of such examples will be their capacity to bridge pupils' existing awareness and their ultimate understanding of particular art objects.

I seriously doubt whether any such 'bridging' devices exist. Nor will it do, I fear, to attempt to round out the teaching with historical information about the aims and purposes of Cubism, obscure as

these still are even to professional historians. Collateral information about the artists' intentions is not always easy to find; and, in the case of the modern picture and particularly the Cubist one, extremely difficult if not impossible to convey to an audience lacking a considerable degree of cultural and historical awareness. In short, I remain sceptical whether the intricacies of Cubist portraiture can be sensibly addressed by the mind of a 7 or a 10 or a 13-year-old school-child at all. And in any case, what counts as 'understanding'?

The point can be made equally strongly for the case of abstract art. I have seen children of a very young age – perhaps as young as 8 or 9 – presented with postcards of the highly 'popular' pre-war Kandinskys and invited to respond to them in terms of colour-appreciation, skill, and subject-identification. The fact that these images are available in postcard form is, as mentioned already, a peculiar cultural fact all by itself – one with its own specific causation and historical meaning which would certainly repay investigation. Here, it is reasonable to assume that the children themselves, unable to travel to New York or Hamburg to see the paintings at first hand, will be led to a set of ideas about Kandinsky's picture which probably mirrors the teacher's own. These are: that the painting is basically a pattern of bright shapes and colours; that it does not matter which way up the painting stands; that it is one of the first 'abstract' pictures in modern art; that it involved relatively little skill but a high premium of intuition; that some of the shapes can probably be read as 'fishes', 'the sun', 'the sea' and so forth – identifications which the teacher regards as secondary to the meaning of the picture as a whole.

It seems to me that the enormous dangers in this process – and obviously I caricature the actual situation considerably here – is that the child will learn and retain what is, in effect, a completely false view of Kandinsky and his work as a basically trivial but pleasing artist who, like other early abstractionists, aimed principally at entertaining the viewer with the brightness of his colours and the playfulness of his forms – but little more.

I suspect that the scenario I have just caricatured may be familiar to many an art teacher today. That Kandinsky was deeply immersed in pre-First World War mysticism; that his friends in Munich's bohemian suburb, many of them health-food zealots and world-reforming priests, would be considered highly eccentric if their views were to be expressed today; that Kandinsky himself was a wealthy and highly educated Russian academic who adopted the contemporary concern for world apocalypse and spiritual reform; that at the time of the painting he may have been close to breakdown, perhaps even in the middle of an identity crisis; that he experienced synaesthesia; that the 'abstract' pictures were highly unspontaneous, even laboured; that Kandinsky could not draw; that he wanted his art to mirror the world crisis which he believed was about to come; and that his art was attractive mainly to 'modern' dealers who supplied a wealthy intellectual middle class. *These* sorts of facts, which are capable of transforming a highly coloured postcard image into a rich, even if somewhat puzzling, historical document about a unique period in a small corner of early twentieth-century cultural life – these facts, of necessity, are liable to remain remote from the teaching of young children of the primary age. Indeed I would here argue what I proposed for the Cubist portrait – that a seriously wrong understanding is worse than no understanding at all – and counsel extreme caution generally in making assumptions about the relevance of early twentieth-century avant-garde images to the life and developing interests of the younger child.

What warnings might be given for the case of the Old Masters? Here, the attractions of ready-made colour reproductions of high notoriety, such as Constable's *Haywain*, Leonardo's *Mona Lisa* or Gericault's *Raft of the Medusa*, are similar to those offered by reproductions of modern paintings; and the dangers correspond. The difficulties which stem from modern art's peculiar and unique character – its oppositional nature, its freedoms and distortions – are happily missing; but the problem of representing for the child something of the unique ideological, social and psychological meaning of particular Old Master images surely remains.

The difficulties became visible for me during an experiment in which 6-year-olds were invited to 'copy' two pictures – Raphael's *Virgin and Child Enthroned with Saints John the Baptist and Nicholas of Bari* (the Ansidei altarpiece of 1505, now in the National Gallery, London); and Millet's *Gleaners* of 1857. Here, the children reacted to the small postcard placed before them rather than to the painting itself, as before. The postcard miniaturized the picture to the point where it could be perceived whole, as a *Gestalt*, and, when placed in the same plane as the child's own work, lent itself well to the process of transcription. In some ways there-

fore it was not surprising that the painting was perceived as pattern, and only secondarily in terms of human or religious drama. The broad arch over the four figures in the Raphael, the symmetry of the group, the block-like architecture of the Virgin's throne – these features were noticed and reproduced *within* the child's already existent ability to render arrangement and visual form. The figures themselves were seldom identified correctly. John the Baptist and St Nicholas of Bari are beyond the experience of most 6-year-olds; while the Virgin and Child were instantly perceived not in terms of Biblical lore but in terms of the universal biological relationship of mother and child. (That the infant is being read a bedtime story was a favourite response to the scene).

Responses to the Millet postcard necessarily involved obliterating any reference to the economic or social status of the gleaners themselves, depicting the stooping women simply in terms of picking up corn. The events in the distance of the picture, including the supervisor on his horse and the gathering of the harvest itself, were in this case barely visible in a small reproduction –certainly not capable of being registered as a kind of counterpart to the situation of the gleaners. Once again, it is the painting *as an historical image* that becomes a casualty in the process of merely 'copying' or 'reacting to' the postcard version of a work of art.

The trouble, of course, is that in one sense the results of such experiments are remarkable. They startle and delight us in ways which other examples of children's artistry do not. We marvel at the child's struggle to come to terms successfully with Old Master paintings and we can enjoy the child's absorption – often unexpectedly long – in a task with which he or she is so obviously unfamiliar. But our pleasure in the child's achievement is surely capable of bearing examination, however tentative. Do we not find the process endearing – 'charming' is again perhaps the word – because of the very gulf between the virtuosity of the Raphael and the artlessness of the child? Are we not being entertained by the very transformation which a child has wrought in converting a deeply venerated icon into a merely colourful diagram? And is not our sense of heightened achievement, finally, to be attributed chiefly to a sense of having made a connection between the realm of adult culture and the world of the child?

That these pleasures may ultimately be illusory is the danger that we must confront. Contact with the values of early sixteenth-century Italian culture, or those of the nineteenth-century French, is precluded precisely by what we do *not* convey to the child about the task to which he or she has been put. Any grasp of the material nature of the artefact is, of course, utterly denied. The very scale, construction and physical presence of such pictures cannot be conveyed in words and is, I think, best not attempted. The rootedness of artistic production in the values of the market place – Raphael's financial interests in the picture, or Millet's in his – cannot be broached to a child who has not yet grasped the basic facts of monetary exchange. The influence of the commissioner (in Raphael's case the role of Bernadino Ansidei himself) must inevitably be left aside. The history of the picture, its cycles of veneration and neglect at the hands of subsequent generations, must also be necessarily omitted, even in outline form, before the age at which the child can give such information a place within his or her own developing understanding. In short, it may have to be faced that art history *cannot* be simplified to the level of 7 or 9-year-old comprehension in the way that arithmetic or the rudiments of reading can. If this is indeed the case, then it follows that a child's first steps in art-historical understanding may have to wait until a sufficient groundwork in other disciplines such as history and sociology – and pre-eminently the practice of art itself –has already been provided.

NOTES

1 Parsons, M., Johnston, M. And Durham, R., (1978), 'Developmental Stages in Children's Aesthetic Responses', *Journal of Aesthetic Education*, (12), 1.

2 *Ibid.* p.88.

3 Turner, P. (1983), 'Children's Responses To Art: Interpretation and Criticism', *Journal of Art and Design Education*, (2), 2.

4 Dyson, T. (1989), 'Art History in Schools: A Comprehensive Strategy', in: Thistlewood, D. (ed.), 'Critical Studies in Art and Design Education', London, Longman, NSEAD.

THOUGHTS ON VISUAL LITERACY

SUE CLIVE

The English Art National Curriculum Orders brought the term Visual Literacy up front, where it is obviously a direct descendent of Critical Studies, although Rod Taylor did not use the term in his highly influential book on the subject.[1] Robert Clement (a member of the Art Working Party) acknowledges the relationship between the two in his very well-used *The Art Teacher's Handbook*.[2] Here he equates making art with reading and writing:

> Through reading widely, they (children) come to an understanding of the possibilities of language: through familiarity with the work of other artists they can begin to grasp the possibilities of image making.

Visual Literacy for him appears to be more about the application of what he calls 'artists' systems and methods' to their practical art-making than about attributing meaning to them. The Art Working Party in both its reports[3, 4] took a broader view and brought understanding to the fore:

> Young people need to be visually literate to operate successfully in society ... (it is necessary for) each generation to understand its received images and interpret them in the light of its own experience.

The subsequent Orders[see 1] do little to take up the matter of interpretation, though. Ken Baynes,[5] writing earlier, goes further than the Working Party:

> Literacy has little to do with the acquisition of knowledge and skills in a narrow sense; rather it is about the growth of attitudes and confidence that will lead to participation.

Ken Baynes was involved with the sadly short-lived magazine for GCSE students, *Art and Design*.[6]

Michael J. Parsons[7] also believes that the ability to identify an image's reference to the seen world is only an early step towards Visual Literacy. Rather than a literal 'translation', interpretation, which depends on certain assumptions we bring to looking at works of art is essential to its development. These assumptions include:

- what is valuable about them
- what kinds of meanings they embody
- what kinds of relations they depend on
- what sorts of things we should look for in them.

In short, unlike the British literature he talks about aesthetics. The term Visual Literacy implies that there is a language to be literate in. It is often assumed that art is a language:

There is a language of marks, shapes and patterns to be acquired in order to develop the powers of expression.

The use of art-making materials is equated with the use of words:

Children have to learn how to handle paint as much as they learn how to handle words.[8]

This view begs the question whether or not it is possible to be visually literate without being able to make art.

There also seems to be a confusion about whether we are using the same 'language' when we 'read' marks, shapes and patterns in objects when we make an observational drawing, for example, as we use when we 'read' art objects. Michael J. Parsons thinks not: 'Works of art are first of all aesthetic objects and their significance is lost when they are understood as if they were just ordinary objects.' If we can be said to understand the language of art, then there must be 'something serious' – special meanings to be understood differently from other things. He uses the term aesthetic literacy rather than Visual Literacy as does Doug Boughton who also sees Visual Literacy as involving an understanding of the formal 'language' of art as well as aesthetic theory. This would include contexts of making and showing, what other people have said about the work, symbolic values, the viewer's own experiences, value judgements and so on. To be visually literate, in fact, as Wollheim says, we need to understand the artist's and the spectator's viewpoints.[11]

When visual language was defined by the Art Working Party, for example, as an objective system of marks, symbols and conventions with a syntax of its own, the more complicated notion that it is also a network of cultural assumptions, experiences and meanings was left out. Language does not merely picture the world. Like Wittgenstein's view of the function of language, for example, the function of visual language depends on how you use it.

The literate person, says Edmund B. Feldman[12] does not simply respond but has developed the power to act. Full literacy has to include an understanding of the ways language is used to govern behaviour. He speaks of a visually literate person as one whose perception of images can be seen as the interpretation and critical understanding of, for example, rhetoric and persuasive devices. And so the realm of media studies, which I believe has informed art gallery education, comes to mind. As

Carol E. Craggs[13] points out, interpretation 'is not a question of mechanically reacting to stimuli'. Rather it is a process whereby the cognitive process of visual perception is raised to consciousness. The visually literate person looks beyond what they see.

Media Studies teaching is perhaps more clear than Art teaching is about what it means by language, or languages. GCSE syllabuses[14] clearly define a language as an analytical framework for each area of media study. Understanding the language includes understanding the concepts of denotation, connotation, signs, symbols, codes, signification and structure and the ways in which meanings are conveyed and narratives constructed. It is interesting that one of the aims of one Media Language Module is 'to develop aesthetic awareness'. This word aesthetic does not appear in an equivalent Art and Design syllabus[15] which talks about informed responses, awareness and appreciation of artistic qualities and analysing, evaluating and forming and expressing judgements about art and design objects. Here language is defined as line, shape, form, colour, tone texture, rhythm, harmony, composition, balance, symmetry, space. Visual Literacy is not mentioned as such, although Art and Design is said to offer 'a unique vehicle for communication and self expression equivalent in importance to literacy and numeracy, encouraging the ability to observe, select and interpret with imagination and feeling.' In short, the emphasis is more on 'writing' than on 'reading' images. Nowhere is there any mention of the contexts within which works of art are made, shown and bought and sold comparable to the study area of ownership, control and prevailing ideologies found in Media Studies. But this aspect of the teaching of Visual Literacy was tackled in the Photographers' Gallery's teaching pack, *What do you think you're looking at?*[16]

Another recent photography publication, *Creating Vision*[17] is confident about defining Visual Literacy in its glossary as: 'a way of describing the ability to read visual texts which use conventions and structures comparable to the rules of grammar in language and writing.'

But the book, whilst acknowledging a language common to photographic images, nevertheless emphasizes the enormous range of social uses which that language serves, and its teaching strategies reflect this.

As David Thistlewood[18] points out, Critical Studies (or Visual Literacy) has a real but at the

same time vague presence in the Art National Curriculum. Art and Design educationalists, he says are not explicit about their tacit agreement on the subject. So how do we learn and teach the 'language' of art?

Probably due to the four domain Art curriculum model[19] – the practical, critical, historical and perceptual (which, in the USA would have been the aesthetic) – the development of visual perception has been seen as a means to Visual Literacy.

For a long time in this country there has been a belief among art educationalists that Visual Literacy/art appreciation is developed through drawing, painting and 3D work.[20] Visual perception, of course, appears in Attainment Target 1, Investigating and Making (AT1) in the Orders and is therefore associated there with practical art activity. One wonders whether people trained as artists still trip over things! However, if one believes that visual perception is more than a copy of the image projected on to the retina and relayed to the brain and that the eye is a social organ as well as a physical one,[21] then it will be associated as much – if not more – with Attainment Target 2, Knowledge and Understanding, as with AT1. If we believe that the meaning of what we see is bound up with language and culture, then Visual Literacy cannot be taught through practical art-making alone: 'if Critical Studies is to develop and prosper in the curriculum it will ultimately rely as much upon modes of verbal expression and discourse as upon practical art-making.'[22]

The argument whether visual perceptual abilities are innate or acquired and modified by experience, parallels that as to whether there is one language of art or whether there are languages created by the contexts within which they are 'written' and 'read'. Since Plato puzzled about the way in which many of the words we use are generalizations and yet we learn to apply them in different contexts, philosophers have discussed language in terms of truth, reference and meaning. To use words such as 'yellow', 'dog' or 'beautiful' must we have access to their form or ideal? Perhaps visual language(s) might have an 'innate' grammar that we recognize, just as we recognize, or know, that spoken Chinese is a language, rather than an incoherent noise, or that Chinese characters, although we cannot understand them, are not a series of meaningless scribbles.

Chomsky suggested that everyone possesses an innate grammar which provides them with workable rules without having to study them. They might not be the official rules, but they work.

Feldman[see 12] argues that visual communication also relies on an innate grammar of images similar to the earliest written symbols or pictograms, then ideograms, then phonic symbols. In reading we forget, or repress, all this that has gone before (words do not resemble the ideas or objects they stand for). We read by recognition and context. And so it is with reading images. We notice lines, shapes, colours, texture and tone. We recognize them as signs and form. We notice how they are arranged in space (syntactic analysis) and finally we read a total image by looking at the relationship between its symbols and forms and their spatial organization (interpretation and comprehension). In 'reading' images we develop expectations about their functions and their conventions become habitual and 'fade into transparency':

> As we become familiar with expectations and conventions they fade from consciousness and move to the periphery of awareness and there they seem more the products of nature than culture.[23]

Reading images also involves trying out several logical sequences before the viewer finds one which gives him or her some sense of formal, sensuous or cognitive satisfaction. Since more than one valid reading is possible, there is a 'poetic' richness of meaning, but there are more similarities than dissimilarities between readings. Feldman believes that there is a language of images that can be learned but that this has a foundation in what we already 'know'. All this implies that to be visually literate we need to continue to look at many images or 'read many texts.'

In teaching Visual Literacy we might want to take into account where the learner is in relation to looking at art. As a result of his observations of children talking about art, John Bowden[24] proposes six criteria of judgements that they make about it: arbitrary (I like it because I like cats); skill/technique; materials; expressive; visual language; and contextual. In referring to his fifth criteria for judgement, he does indicate that there might be more than one visual language when he talks about 'the formal qualities of the work of art or the visual language in use'. Mike Hildred[25] has adapted Osborne's[26] components of the appreciative process – critical creativity, history of art, connoisseurship and aesthetic experience – into a framework for courses in Art Appreciation which harness teaching strategies to where the children are coming from. For example, connoisseurship – a grand word – might take into account a child's

fine discrimination in matters of football or fashion. He has added a fifth component called production of art and design to Osborne's list.

Michael J. Parsons's [see 9] vast experience of listening to what people say about paintings has convinced him that their understanding of them, or their aesthetic experience, is defined by a sequence of clusters of ideas or stages of cognitive development, that they bring to them. Where individuals get to in this sequence depends on what kind of art they encounter and how far and in what ways they are encouraged to think about it. This kind of developmental theory does not imply that we all understand art in the same way and can therefore be taught in a rigid, prescribed way, but that we acquire certain abilities or insights one before another:

> People are not stages, nor are stages people. Rather, people use stages, one or more of them, to understand paintings.

We might use these stages of people's understanding of art in devising relevant teaching strategies. These might well involve creating opportunities for people to talk about their perceptions of art objects. The Museum of Modern Art (New York) Instructional Program for Teachers[27] emphasizes Visual Literacy, which is defined as involving a number of actions – observation, analysis, speculation as to meanings, discrimination. Success in these programmes, 'reveals itself in people's ability to articulate their thoughts about works of art'.

The works of art must be varied though. As Doug Boughton[see 10] points out:

> the visual and the verbal are fundamentally different in the qualitative meanings it is possible to encode within each. Within visual art we have a history of different styles, each of which reflects different kinds of qualitative syntax.

Each qualitative syntax has its own codes and logic and we are not always able to use those we already know to unlock meanings in the work, which are often ambiguous anyway. We can't make sense of it because we bring to it an inappropriate set of expectations. (I'm sure we have all seen this happening in the gallery). Repeated viewings of art of different styles, media and working methods is indicated.

Michael J. Parsons and H. Gene Blocker[see 23] point out that there do seem to be some elements of art that are universally appealing and communicate at a primal level, but the ways these elements are arranged are culturally dependent: 'art always carries overtones and nuances that are artistic, religious, and social in a particular society and not elsewhere.' The formalist view, still prevalent in art education in this country, that art can be 'understood' by the physiological action of eye (and hand) with brain and that it can be appreciated without understanding the cultural contexts (as opposed to Art History contexts) within which it was made, simply does not add up to Visual Literacy, aesthetic literacy or proficiency in Critical Studies in what I believe are gallery education terms. We believe, don't we, that to teach Visual Literacy, we have to take into account that the significance and meanings of a work of art, the 'languages' it speaks, are determined not only by the image itself but by its relationship with the viewer and the viewer's previous experience and culture?

To return to Ken Baynes:

> I do not believe that the creation of Visual Literacy ... is something that will yield to any grand curriculum strategy. It is a matter of footwork. It is a matter of detailed, local development. It is a matter of the 'small print' of teaching. It is to do with building up confidence. It is about people meeting to change one another and to create something new. At national level, it means encouraging diversity and unique local initiatives.[see 5]

NOTES

1 Taylor, R., *Educating for Art - Critical Response and Development*, Longman 1986.

2 Clement, R., *The Art Teacher's Handbook*, updated ed. Stanley Thomas 1993, first published Hutchison 1982.

3 DES and Welsh Office, *National Curriculum Interim Report*, January 1991.

4 DES and Welsh Office, *Art for Ages 5 to 14*, August 1991.

5 Baynes, K., 'Beyond Design Education', *Journal of Art & Design Education*, vol.1 no.1 1982.

6 Baynes, K., Brochocka, K., and Minshall, M., *Art and Design* (3 nos) Philip Alan 1993/4.

7 Parsons, M.J., 'Aesthetic Literacy: the Psychological Context', *Journal of Aesthetic Education*, vol.24, no.1, 1990.

8 Gentle, K., *Teaching Painting in the Primary School*, Cassell 1993.

9 Parsons, M.J., *How we Understand Art. A Cognitive Developmental Account of Aesthetic Experience*, Cambridge University Press, 1987.

10 Boughton, D., 'Visual Literacy: Implications for Cultural Understanding through Art Education', *Journal of Art & Design Education*, vol.5, nos 1 & 2, 1986.

11 Wollheim, R., *Art and its Objects*, Cambridge University Press (second edn) 1980.

12 Feldman, E.B., 'Visual Literacy', *Journal of Aesthetic Education*, vol.10, nos 3 & 4, 1976.

13 Craggs, C.E., *Media Education in the Primary School*, Routledge 1992.

14 *Media Studies Syllabus A & B*, Northern Examining Association, 1988.

15 *Art and Design Syllabuses*, Northern Examining Association, 1988.

16 NAGE/Photographers' Gallery, *What do you think you're looking at? Using Images in School and in the Gallery. A Resource Pack for Teachers*, 1993.

17 Isherwood, S., and Stanley, N. eds, *Creating Vision. Photography in the National Curriculum*, Cornerhouse Publications 1994.

18 Thistlewood, D., 'Curricular Development in Critical Studies', *Journal of Art & Design Education*, vol.12, no.3, 1993.

19 Swift, J., 'Critical Studies: a Trojan Horse for an Alternative Cultural Agenda?' *Journal of Art & Design Education*, vol.12, no.3, 1993.

20 Field, D., *Change in Art Education*, Routledge & Kegan Paul, 1970.

21 Bartley, S.H., *Perception in Everyday Life*, Harper & Row, 1972.

22 Hughes, A. 'The Copy, the Parody and the Pastiche: Observations on Practical Approaches to Critical Studies', in *Critical Studies in Art and Design Education*, ed. Thistlewood, Longman/NSEAD, 1989.

23 Parsons, M.J., and Blocker, H.G., *Aesthetics and Education. Disciplines in Art Education: Contexts of Understanding*, University of Illinois, 1993.

24 Bowden, J., 'Talking about Artworks: the Verbal Dilemma', in *Critical Studies in Art & Design Education*, ed. Thistlewood, Longman/NSEAD 1989.

25 Hildred, M., 'New Ways of Seeing', in *Critical Studies in Art & Design Education*, ed. Thistlewood, Longman/NSEAD 1989.

26 Osborne, H., *The Art of Appreciation*, Oxford University Press, 1970.

27 Housen, A., with Miller, N.L. and Yenawine, P., *Research and Evaluation Study, Report Year 1 and Report 2*, MOMA, New York, 1991.

PART TWO

TEACHING AND LEARNING
IN ART

CHAPTER SEVEN

THE RATIONALITY OF ARTISTIC FEELING: AN URGENT EDUCATIONAL ISSUE

DAVID BEST

This chapter considers what is, I am convinced, the most important topic for the arts, not only in education, but in society generally. Because space is limited only an outline will be presented of the complex issues involved.[1] Nevertheless, I intend to prove that artistic experience is as fully cognitive and rational as any subject in the curriculum, including the sciences and mathematics. That means that the arts fully involve learning, in the educational sense of developing understanding.

These days it is often assumed by teachers that such philosophical issues are far removed from classroom practice. That may sometimes be true of some philosophical issues, but it is far from true in many cases. Moreover, it should be emphasized that *no practical teaching is possible at all without some guiding, underlying philosophy*. Certainly this philosophical issue has vital practical significance. Consider: many, perhaps most, people still seem to assume that experience of art is essentially a matter of subjective feeling rather than cognition. But to say that artistic experience is non-cognitive *is* to say that it does not involve learning and understanding. And, very obviously, to deny that artistic experience involves learning and understanding is to say that the arts *have no place in education*. That is the stark truth. Yet most art-educators still

insist either explicitly or implicitly, that the arts essentially involve subjective feeling, not rational understanding. They fail to realise that in so doing they are destroying the case for art in education.

An editorial in *The Times Higher Educational Supplement* some years ago gave this as the main reason for the marginalization of the arts in education, since even art-teachers and theorists themselves proclaim that art is 'an inspirational and even anarchic activity, rather than a cognitive and disciplined process. As a result, the arts are regarded as of low academic content, and hopelessly subjective.'

As I shall show by examples, even prominent and influential theorists are frequently their own worst enemies. I cannot overemphasize this point. My arguments to prove the rational and cognitive character of the arts tend to run either into opposition, or into a bland overconfidence that this is a battle which has already been won. That is dangerously false. Certainly some people do *proclaim* the cognitive/rational character of the arts, but they lack *proof*, by reasoned *arguments*, instead of vaguely optimistic statements. It will obviously convince no one if, while remaining trapped in old-fashioned subjectivist ways of thinking, they merely stick on superficially, hopeful labels of

objectivity, rationality, cognition, and therefore educational credibility. You cannot just *claim* it: you have to *prove* it.

The great difficulty, which, again, cannot be overemphasized, is that for so many years, people have been unquestioningly convinced that experience of the arts *must* be purely subjective: they cannot even imagine another way of looking at the matter: and they cannot recognize the fatal damage such an assumption does to the arts. That is, they are so deeply entrenched in old, conventional ways of subjectivist thinking that they cannot even *consider* the possibility that a very different conception of art in education may, by contrast, make sound sense, and also offer a really sound, in-depth proof of the vital educational importance of art. It is a paradox that those involved in the arts, who are characteristically open to new ideas artistically, are usually so rigidly conservative in their, usually implicit, conception of the *philosophy* of the arts.

In a nutshell: for many years it has been an unquestioned assumption that feeling is opposed to cognition, understanding and learning – hence the assumption that one *must* be *either* a cognitive *or* an affective theorist. By contrast, I shall prove that while it is importantly true that feeling is central to the arts, it is equally importantly true that the arts are fully objective, rational and cognitive. It should also be emphasized that this issue has important implications for *how* art is taught.

SUBJECTIVE FEELING

It is of the utmost importance to my argument to grasp that the root cause of the prevailing confusions is a grossly oversimple and distorting conception of artistic feeling. This consists in the largely unquestioned assumption that the creation and appreciation of the arts are entirely the province of subjective feeling, in the sense of a supposedly 'direct' feeling, untainted by cognition, understanding or rationality. Hence the popularity, a few years ago, of theorists such as Robert Witkin, who stated explicitly that in order to achieve this 'pure' feeling for art, one needs to *erase all memories.* Such a conception was, and still is, in some quarters, popular and influential. Yet, consider what it amounts to, namely that in order to experience art one has to *eliminate* all knowledge, understanding, cognition. Imagine proposing as a justification for the arts in education that students have to forget anything they have

learned, and they must not remember anything else. *That* amounts blatantly to saying that they must not learn anything, and therefore that the arts have no place in education.

A very recent *implicit* but transparent example of the unintelligible and educationally self-defeating notion of the supposed 'pure', 'aboriginal', 'innocent', 'concept-free' artistic experience can be seen in the work of Peter Abbs,[2] who insists that analysis is 'at a profound distance from the experience of art'. In another paper[3] he states that artistic understanding requires not a critical response, but an aesthetic response – a response through feeling, the senses, and the imagination. This clearly entails that artistic response cannot involve understanding, for it is largely by means of critical analysis that we develop artistic understanding. On Abbs's view (shared by many others), *learning* would be impossible; artistic response would be merely an unthinking knee-jerk reaction.

To repeat, educationally this is a disastrously self-destructive, yet common, presupposition. It amounts merely to a transparently veiled version of the tired old misconceived cliché that the arts are a matter of feeling *not* of reason. Yet, on the contrary, perceptive analysis is an experience of art; and in extending and refining artistic understanding by means of analysis, one is extending and refining artistic feelings. The obvious presupposition of these subjectivist theorists is that knowledge and understanding will prevent or distort the possibility of 'direct' or 'pure' artistic feelings.

Yet, to anticipate my main argument, the very *opposite* is the case. The supposition of an aboriginal 'concept-free', or 'understanding-aseptic' artistic feeling is nonsense. Small wonder that the arts are not taken seriously; that they are regarded merely as entertainment; and small wonder that attempts to justify the importance of the arts in education are dismissed as mere pretentious waffle. It is because of such attempts that one philosopher characterized aesthetics as the natural home of rapturous and soporific effusion.[4] My papers, criticizing Abbs, cited in notes 2 and 4 prove unmistakably that theorists do still proclaim the kind of hopelessly untenable, and self-defeating, subjectivist/metaphysical position which I am castigating as so fatally damaging to the intellectual and educational credibility of the arts. If one assumes that understanding is not relevant to artistic experience, and that artistic meaning can be located only by introspective delving into subjective feelings, then it is perhaps almost inevitable

that, as in Abbs's case, one will spiral off into occult, supernatural, metaphysical realms to 'support' one's case. For instance, Abbs claims that artistic experience *in general* normally involves: 'being overwhelmed with powerful sensations', 'ecstatic', 'exhilarated', having 'tranced consciousness', being 'tribally grounded in some universal', 'transfixed', 'spellbound', 'mesmerized', in 'traumas', 'a form of transcendence'. He even claims that all artistic experience is religious! Remember, this is a recent article! Perhaps, given his complete immersion in subjectivist ways of thinking, such a conclusion is almost inevitable. For, if understanding and rationality ('analysis') are rejected, to what else can one appeal?

Yet on the contrary, it is *possible* to have artistic *feelings* only if one has the relevant *understanding* in a *normal*, not some weird metaphysical, sense. Paradoxically, since these are supposed supporters of the arts, in their view there could be no case at all for the arts in education. For it makes no sense to claim that an activity or experience is educational if at the same time one denies the possibility of learning, of extending, deepening understanding.

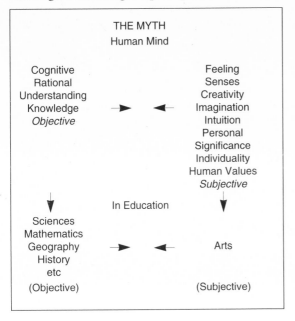

THE MYTH

This, one might imagine, is such an obviously contradictory position that it is difficult to understand how it can have dominated thinking about the arts for so long. Yet it has been an unquestioned maxim for many decades, at least. To repeat, its source is the presupposition of a necessary opposition between, on one hand, understanding and reason, and on the other hand, feeling, creativity, individuality etc. This derives from the Myth that the human mind consists in two distinct and opposing faculties – the Cognitive/Rational faculty, and the Affective/Feeling/Creative faculty. This deeply entrenched Myth about the human mind incurs disastrous consequences for education in general, i.e. not only for the arts.

Consider a schematic formulation of the Myth

An example occurs in the philosophical foundation of the influential Gulbenkian Report, *The Arts in Schools*, which defines the arts as 'the aesthetic and creative' area of the curriculum. This not only confuses and conflates the aesthetic and the artistic[5] – a very damaging yet very prevalent confusion – but it reveals that the authors are still infected by the Myth of distinct mental faculties, in that they assume creativity to be the *exclusive* province of the arts.

Yet if, for instance, the development of creative attitudes is not central to the teaching of mathematics and the sciences – and regrettably often it is not – that is an indictment of the educational policy. Creativity is not in a separate mental box, exclusive to the arts. It can and should apply to *every* area of the curriculum. The Myth connives in an attitude to education *in general* which ought to be dead and buried. Both arts and sciences require creativity and imagination.

There are numerous other examples. For instance, a few years ago, an influential discussion document of the Scottish Committee on Expressive Arts in the Primary School stated: 'The main curricular emphasis is still upon *cognitive* learning, with other areas – physical, emotional, affective – coming off second best. We maintain that a better balance should be found ...' This clearly implies that whereas the sciences and mathematics are cognitive, the emotional and affective areas, such as, primarily, the arts, are not cognitive. Again, the assumption is that because the arts involve *feeling*, they *cannot* involve cognition and reason.

The Myth often underlies arguments for the arts in terms of a *balanced* curriculum. It is assumed that the cognitive, rational faculty of the human mind is well catered for in, for instance, mathematics and the sciences, but that in order to achieve balance more time should be allocated to the supposed non-cognitive, affective, faculty, by giving greater emphasis to the arts. But again, formulating the argument in this way seriously damages the case for the arts in education.

The most that could be claimed on this subjectivist view is that artistic feelings can merely be *induced*, like sensation-feelings such as pain, and thus that learning in an *educational* sense is out of the question. This is an inevitable consequence of insisting that the arts are concerned solely with non-cognitive, non-rational, *experience*. The subjectivist construes emotions as induced effects on a passive recipient. This assumption of the essentially passive nature of emotions is still prevalent in psychology and arts-education. It is certainly manifest in the assumption that artistic creation and appreciation are matters of feeling not of cognition, and thus that the arts consist in having experiences, rather than actively developing *understanding*. There can be no possibility of the individual pupil's lively, active involvement in his/her own artistic development, or education in its full sense, on this subjectivist basis, but only something like conditioned responses.

This is not in the least to deny the importance of feeling in the arts. It is to point out that a much richer and more constructive and *personally involved* conception of artistic feeling or experience is required than is offered by the oversimple and distorting presuppositions of the subjectivist Myth.

FEELING IS UNDERSTANDING

What is required is a conception of artistic experience which reveals unmistakably its rational and cognitive character, and thus that the presupposed antithesis between feeling and reason is fundamentally misconceived. Let me repeat that I am not arguing even for the *close* relation of feeling and reason, but rather that *artistic feelings are rational*. The rationality of artistic experience is such that it *involves* the *individual* in his/her own development of emotional understanding, and therefore it is educational in the deepest sense.

In order more clearly to bring out this argument, and the dangerous weakness of the subjectivist Myth, both philosophically and educationally, let us approach the issue from another direction. According to the subjectivist, an emotion is a purely private mental event which may emerge in various ways. Wordsworth captures this notion aptly: 'All good poetry is the spontaneous overflow of powerful feelings.' On this view, an emotional feeling wells up inside and overflows into artistic expression. One might refer to this version of subjectivism as the Hydraulic Theory of the Emotions, which well up, burst out, which one dams up, or releases by opening floodgates etc.

There are at least two major mistakes involved in the Hydraulic Theory. It fails to recognize, first, that an emotional feeling is *identified* by its object: second, that the object, and therefore the feeling is inseparable from *understanding*. Let us consider both these points together. Let me emphasize that this is the foundation of my argument: it is vital to grasp it clearly. A central logical feature of emotions is that they are directed onto objects of certain kinds – one is afraid of X, angry at Y, joyful about Z. But the object has to be *understood* in a certain way. For example, my feeling is likely to *be* very different if I understand an object under my desk to be a rope from what it would be if I understand it to be a snake. My feeling is *identified* by my understanding of the object: that is, it makes no sense to suppose that I could experience *that* feeling without *that* understanding. Notice clearly, *what* the feeling IS depends upon and is inseparable from the understanding. My feeling will be fear if I believe it to be a snake, but not if I believe it to be a rope. It would make no sense to suppose that one could normally have an emotional feeling about an object which is understood in a way wholly inappropriate to that feeling. Yet, on the subjectivist Hydraulic account, which construes the feeling as an inner event, entirely independent of any *understanding*, it would make sense for normal people normally to be terrified of ordinary currant buns. But if one understands it *as* an ordinary currant bun, if one has that conception of it, then no sense can be made of being terrified of it. The feeling is *identified* by the understanding, i.e. *what* the feeling *is* depends upon the understanding. Feeling and understanding are identical.

It can be seen, then, that subjectivism presupposes a radically oversimple conception of emotional feeling. The subjectivist construes emotional feelings on the model of sensation-feelings. Since it is true that one does not need understanding to experience a sensation-feeling such as pain, the subjectivist assumes, wrongly, that the same is true of emotional feeling. Yet it is precisely the crucial role of *understanding* which *distinguishes* emotion-feeling from sensation-feeling. For instance, if someone were to poke me with what I understand to be a soft rubber stick, which is in fact a sharp nail, I shall have the feeling of pain, *whatever* my understanding. Clearly, understanding is irrelevant to the sensation-feeling. By contrast, if I understand or believe an object to be a snake which is in fact a rope, I shall be afraid. That is, in the case of emotional and artistic feeling *understanding is necessarily intrinsic to it*. This is the sig-

nificant foundation of my argument: *an emotional feeling necessarily involves, indeed is identical to, cognition or understanding* of the object of that feeling. For instance, the object has to be understood as threatening or harmful in some way for one to feel afraid of it. In the case of emotions the feeling is *determined* by and inseparable from cognition, or understanding.

Consider an example from Shakespeare:

King Lear, distraught because of the treacherous ingratitude of his daughters, is evicted, without adequate clothing, shelter or food into a violent storm on the heath. He is buffeted, cold, and drenched. His anguish and physical privation bring him to a sharp realization of an aspect of life of which he had never been aware in his days of royal comfort and luxury. He is forced to take refuge in a hovel, with a naked beggar. For the first time, it is brought home to him and he understands what it means to be one of the cold, hungry, and homeless.

> Poor naked wretches, whereso'er you are,
> That bide the pelting of this pitiless storm,
> How shall your houseless heads and unfed sides,
> Your looped and window'd raggedness, defend you
> From seasons such as these? O! I have ta'en
> Too little care of this. Take physic, Pomp,
> Expose thyself to feel what wretches feel...

King Lear III iv 28

To bring out my point clearly, let me ask a deliberately *misleading* question. Was it Lear's feeling which changed his understanding, or his new understanding which changed his feeling? The question is misleading because it presupposes that feeling and understanding are two *distinct* mental states. Yet King Lear's feeling can be identified only by his understanding the object of his feeling in the way he does. So his understanding, expressed in this speech, is not separate from his feeling; it IS his feeling. That is what his feeling *is*. It would make no sense to attribute to Lear *that* feeling without his characterizing the object of his feeling in the way he does. Thus Lear's change of feeling is his change of understanding: his understanding *is* his feeling.

Let me offer an example from the visual arts. The Crucifixion, and its symbol, the cross, is often sanitized, prettified, romanticized, in certain sentimental religious depictions. Although in fact crucifixion was deliberately intended as the most agonizing form of execution, some representations give the impression that Christ was almost enjoying it: he certainly seems indifferent to any pain. A teacher could contrast some of these sentimental portrayals with, for instance, paintings by Grünewald and Sutherland, which poignantly reveal the appalling agony of crucifixion. To understand what being crucified *really* amounts to is to feel differently from the sentimental emotional understanding of it. The understanding *is* the feeling: the feeling *is* the understanding. Other examples are Francis Bacon's paintings of the *Crucifixion*, and of *Figures at the Base of a Crucifixion*, which vividly express the barbarous attitudes involved.

This account of the understanding which is inseparable from artistic and emotional feeling is already a big step towards a sound philosophical basis for the claim that the arts are in the fullest sense educational. For, by contrast with subjectivism, it can be seen that the feelings involved in the arts are necessarily cognitive in kind.

REASON

There is another important source of subjectivism. The commonly assumed Myth of the antithesis between Feeling and Reason distorts and oversimplifies the character not only of emotional and artistic feeling, but also of reason. It is commonly assumed that there are only two kinds of reasons: deductive reasons, which are commonly used in mathematics and symbolic logic, and inductive reasons, as used in the sciences. Yet there is another, more fundamental kind which I sometimes call 'interpretative reasoning'. This kind of reasoning is important in *all* areas of knowledge, and it should be clearly recognized that it applies equally to the creation and appreciation of the arts.

Interpretative reasoning involves, for instance, attempting to reveal a situation in a different light, and this may involve not only a different interpretation or understanding, but also a different evaluation: such reasoning may not lead to unquestionable conclusions. Sound reasons may be given for different interpretations and evaluations, and those differences may be irresolvable. So my insistence on the central place of rationality in no way conflicts with that central and exciting characteristic, the creative ambiguity of art. But it does show how genuine reasoning can be used to open up new perspectives, new visions, fresh evaluations.

This kind of reasoning is equally central to scientific knowledge. Herman Bondi, the eminent

astronomer and theoretical physicist writes: 'Certain experiments that were interpreted in a particular way in their day we now interpret quite differently – but they were claimed as facts in those days.' There are numerous such examples. This exposes another confusion of the Myth. For the ability to use and understand interpretative reasons necessarily *involves* imagination, creativity. So it makes no sense to assume that reasoning and knowledge are distinct from or opposed to creativity or imagination. Einstein once said that in science imagination is more important that knowledge. It would be more accurate to say that scientific knowledge *requires* imagination; such knowledge is unattainable without imagination.

More obvious examples of interpretative reasons can be seen in the ways in which we support our conflicting opinions on social, moral and political issues. Again, such reasoning does not necessarily lead to decisive conclusions. But neither is it necessarily ineffective. Reasons given for seeing a situation in a different perspective may lead us to change our opinions.

It is obvious, on reflection, just how widely varied and numerous are the reasons given for seeing, understanding, evaluating an object or situation in a particular way. Moreover, by contrast with subjectivist assumptions, such reasoning is essentially liberating, in that it opens fresh horizons of understanding, new ways of seeing the world. It is subjectivism which is limiting, for on that view one is necessarily imprisoned in feelings and thoughts which are not open to reason.

So far from limiting or eradicating the possibility of differences of opinion, in the arts and in other areas of human life, the very *existence* of interpretative reasoning *depends* upon, and is an expression of, the variety of different conceptions, interpretations, opinions.

Feeling and Reason

There is a third step in my argument. We have seen that emotional and artistic feelings are not separate from understanding, but, on the contrary, are identified by understanding their objects. We have also seen that objective reasons can offer new interpretations, understanding, and evaluations. The third step is obvious: it consists in showing that reasons for a change of understanding and evaluation may be inseparable from a change of feeling. For example, at the beginning of Shakespeare's play, Othello takes Desdemona to be

a purely virtuous woman whom he idolizes and loves. It is that understanding, that way of seeing her, which identifies his feeling of idolatrous love. Iago gives him reasons for a different understanding of her, as unfaithful and dishonest. Othello's changed understanding of her involves a change of feeling to intense jealousy and anger, as a result of which he kills her. Too late, Iago's wife, Emilia, gives Othello further reasons for recognizing that it was Iago who was treacherous, and that Desdemona was innocent. These reasons change his understanding again, and with it his feeling to one of intense remorse. In each case Othello's feeling cannot be separated from his understanding of the object of his feeling – Desdemona. His feeling can be *identified* only in terms of his understanding. And, in at least two cases, it was reasoning which changed his understanding, and with it his feeling.

Rod Taylor provides excellent examples in the visual arts of the way in which critical analysis, by means of interpretative reasoning, is inseparable from the development of more discriminating feelings. See, for instance, the obviously intense development of sensitive, discriminating emotional involvement in Amanda's critical reasoning as she analyses Millais's painting of *Ophelia*:[6] There are many such examples, from life generally, where reasoning for a change of understanding and evaluating a situation is inseparable from a change of feeling about it.

Education of Feelings

An immensely important consequence of my argument is that there is a vast range of feelings which are possible *only* for creatures capable of the relevant kinds of rationality and understanding. I wish I had the space to explain this fully, for it reveals the immense potential human significance of artistic education and experience, in terms, for instance, of personality development. This potential remains largely unrecognized, because of the continuing dominance of crude, oversimple subjectivist conceptions of artistic feeling. For example, artistic feelings are necessarily dependent upon an understanding of the relevant art forms. Although an animal may respond to art – my neighbour's dog howls at Beethoven – it would make no sense to say that it could have an *artistic* response precisely because it is incapable of *understanding*. Thus, contrary to subjectivism, it is only because we are capable of objective understanding

and *rationality* that we can *have* artistic *feelings*. An animal cannot develop a greater range and sensitivity of feeling by means of perceptive rational analysis.

In order both to illustrate my argument, and to offer another example of very common, but unrecognized, subjectivism, let me cite the work of probably the best known art-educator in the world, Elliott Eisner. His fundamental philosophical rationale for art in education is evident throughout his work, but the clearest brief statement of it follows.[7] (I offer this example not to be negatively critical, but to bring out my own positive thesis by contrast, and to give an example of an influential figure who is unaware that his commonly accepted theory of mind and art is hopelessly, self-defeatingly, confused by subjectivism. The italics are mine.)

> Humans not only have the capacity to form different kinds of concepts, they also, *because of their social nature,* have the need to *externalize* and *share* what has been conceptualized. To achieve such an end, human beings have invented ... *forms of representation* [which] are the means by which *privately held conceptions* are transferred into *public images* so that the meaning they embody can be shared.

This is a clear example of the subjectivist conception, in that the feeling is *explicitly* said to exist *prior to* and *independently of,* understanding. On this view, the feeling is there *first,* as in the Hydraulic Theory.

Eisner illustrates his theory by reference to language, and says that human beings *invented* language in order to externalize and share private ideas, or thoughts, just as they invented the arts in order to express purely private, subjective feelings and ideas.

Again, let me explicate this schematically: in the figure below, A represents one human being, and B represents another.

According to the subjectivist account (clearly exemplified by Eisner), the mental experiences of A, her thoughts and feelings, are completely private. But she wants to communicate them to B. So, as a start, she is supposed to invent a word to communicate one of her thoughts. B hears the word and is supposed to understand it. But how can he understand it? How can he possibly know what it means, since, in terms of the subjectivist theory, the thought which A expressed by the word is entirely private and unknowable? Indeed, it makes no sense to attribute to A or to B *any*

mental experiences *at all* – hence my question marks, since we have no idea what, if anything, is in this purely private world. The *criteria* for the relevant thoughts and feelings of human beings *are linguistic* (artistic etc). On the subjectivist hypothesis, where there is no language, there is *ipso facto no sense* in the notion of the thoughts and feelings which are distinctive of human beings.

More obviously, it makes no sense to suggest that, in order to communicate her thought, A utters a *word.* For a *word* is *already* part of a *public, shared language.* Yet, according to the subjectivist account there is no such language, but only a lot of bizarre creatures each of which is locked inaccessibly in its own private realm. Thus, it makes no sense to call it a *word:* it could only be a *meaningless noise.*

Even on brief reflection, it can easily be seen that the very idea that human beings could have invented or created language is obviously absurd. It may take a little more reflection to recognize that it makes no sense to suppose that these creatures without language or any other form of communication, *could even count as human beings*! For the attributes which *distinguish* human beings from animals would be absent in the absence of language.

It makes no sense to suggest that the ideas and feelings could exist prior to and independently of language and the art forms. On the contrary, in a wide and varied range of cases, it is the understanding of language and the art forms which uniquely *gives* the possibility of those feelings and ideas.

Although it requires more explanation than I have space to offer here, perhaps I can put the point succinctly, but in a way which, to many, sounds startling, because of their entrenched subjectivism, in this way: *Normally,* the use of language is not, as is generally assumed, a symbolic

expression of thinking going on in the hidden recesses of the mind; on the contrary, normally the use of language IS the thinking.

Of course, that is not to deny that one can think and feel without *expressing* one's thoughts and feelings. But that ability is a secondary acquisition, as becomes clear when we recognize that in such cases the thoughts and feelings are *formulated* in, and *identified* by, the media of language and the arts. Moreover, think of how children learn to speak: they just react, respond, express themselves *immediately*, verbally. On Eisner's thesis, and the subjectivist conception generally, even if it were to make sense (which, as we have seen, it does not), the feelings, ideas, concepts are already *there* 'in the mind' (*since birth? before birth?*) and language and the arts provide merely the *means* to *express* them.

The thesis which I am proposing not only makes sense, unlike this subjectivist conception, but provides a far stronger educational case: for I have shown that art is not a mere *message carrier* of subjective ideas and feelings, understanding; art provides not merely the *means* of *expressing* the feelings, but far more importantly, artistic understanding uniquely gives the *feelings themselves*. So that educating artistic understanding IS educating artistic feeling.

For example, personal emotional involvement in the paintings of Turner, Egon Schiele, Fra Angelico, and in the sculptures of Michaelangelo, such as his profoundly moving Rome *Pietà*, is exclusively a matter of coming to understand the objective values *in the works themselves*. We do not need, even if it were to make sense (which it does not) to posit a supposed separate subjective mental event of feeling. That is, there are not, as supposed by the Myth, two distinct things, on one hand objective/rational understanding, and on the other hand, feeling. On the contrary, what we have is the *rationality of artistic feeling*: artistic feeling IS rational and cognitive. Artistic feeling is inseparable from understanding the work. This applies equally, of course, to the spectator and the creator of art. Lucian Freud puts the point in this way: 'I want my portraits to be about people, not like people. Not having the look of the sitter, *being* them. Whether this can be achieved depends how intensely the painter understands and feels for the person or object of his choice.'

The implications for *how* one teaches art are clear and significant: they are brought out in many perceptive classroom examples by Rod Taylor.[8] In encouraging children to give and understand reasons for understanding, with respect to both their own art and art-appreciation, the teacher is developing the possibility of progressive extension of feeling. While these reasons will be mainly verbal, they are by no means exclusively verbal. Reasons may consist, for example, in non-verbal demonstration. In educating understanding, one is educating feeling.

To put the point with oversimple brevity: Eisner states that human beings created language and the arts in order to express previously existing feelings and concepts. What I am saying, by contrast, is that *language and the arts create human beings*. That is, the thoughts and feelings characteristic of human beings are *created*, at least to a very large extent, by language and the arts.

SUMMARY

This account is too brief, but to summarize, the four main stages of my argument are:

1. Artistic feelings are cognitive in character. An artistic feeling is *identified* by an *understanding* of its object. Artistic feeling IS understanding.
2. Interpretative reasoning is of central importance for giving or changing understanding.
3. Thus artistic feeling is answerable to reasons, in that it can change as a result of reflection, or reasons for change of understanding.
4. Thus, educating artistic understanding IS educating artistic feelings.

CONCLUSION

Artistic feeling is as fully, objectively, rational as any other discipline. Largely because of subjectivist preconceptions, paradoxically shared by arts supporters almost universally, the arts have been misunderstood and undervalued for years; and thus they have not been taken seriously in education. If we reject those prevalent subjectivist preconceptions, and realize the constructive power of the thesis which I am proposing, then, because of the vital possibilities of learning in the arts, there is a strong case for arguing that the arts should be fully recognized as of *central* significance, in society, and therefore in education.

NOTES

1 For a more complete account, please see my book: *The Rationality of Feeling*, Falmer Press, 1993.

2 Abbs, P., 'Making the Art Beat Faster', *Times Higher Educational Supplement*, 18 September 1992. See also my reply: 'Minds at work in an empire of the senses', *Times Higher Educational Supplement*, 19 February 1993.

3 Abbs, P., 'The Generic Community of the Arts: its Historical Development and Educational Value', *Journal of Art and Design Education*, vol.11, no.3, 1992. See also my refutation of the once-popular but now rightly discredited notion of Generic Arts, in 'Generic Arts: An Expedient Myth', *Journal of Art and Design Education*, 1992. I expose the confusions of Abbs's paper, in 'Death of Generic Arts',

4 A more thorough explanation of the philosophical unintelligibility, and the educational dangers, of this still common resort to supernatural metaphysics as a supposed 'justification' of artistic experience, is contained in my paper 'Educating Artistic Response: Understanding is Feeling', *Curriculum*, vol.16, no.1, Spring 1995.

5 See my book, *op. cit.*, ch. 12 for an account of the important but almost completely ignored distinction between the aesthetic and the artistic. The failure to recognize this distinction continues to damage the arts, and is conducive to or part of the still-prevalent disastrous subjectivist/metaphysical conception which I am exposing as philosophically senseless, and educationally self-defeating. To his great credit Rod Taylor[9] is one of the first art-educators to recognize the educational danger of failing to see the difference between the aesthetic and the artistic, and of supposing some mystical, supernatural overarching 'aesthetic' (or worse, 'Aesthetic'!). He gives examples from Primary education of the disastrous practical effects of the assumption that aesthetic experience is the same as artistic.

6 Taylor, R., *The Visual Arts in Education*, Falmer Press, 1992, pp.106–12.

7 Eisner, E., 'The role of the arts in cognition and curriculum', *Report of INSEA World Congress, Rotterdam*, Amsterdam, De Trommel, 1981, pp.17–23.

8 Taylor, R., and Andrews, G., *The Arts in the Primary School*, Falmer Press, 1993.

9. op.cit. (note 8).

CHAPTER EIGHT

MAKING THE ART BEAT FASTER

PETER ABBS

Over the past decade we have had too much analysis written about art at a profound distance from the experience of art. As a deep corrective reaction to this anti-aesthetic orthodoxy we need to consider more closely the actual aesthetic moment of experience across the arts. We need to see what aesthetic moments of response are like; we need to discern their inner structure; to locate their import, their rhythm, their specific effects on those who participate in them. We need a major sustained study of aesthetic experience without ideological presupposition and without the baggage of sociological and critical theory.

I recently asked a group of arts teachers to describe briefly any memorable aesthetic moment in relationship to any one work of art. I have now collated and examined these moments and begin to see a quite clear pattern emerging. In this analysis I am not concerned with any one specific account but with the underlying structure for there is a remarkable consistency in structure across the accounts; and it is this structure which gives a strong clue to their abiding educational value. But even as it does so, it poses some real educational dilemmas for what we are touching upon is very deep, somehow primordial, full of energy, transformational, dangerous (at times) and at the very core of what it means to be human.

I simply asked the arts teachers to write about any aesthetic experience they had had in relationship with a work of art. Nothing more than that.

The demand was that their account should describe the experience chosen as directly and simply as possible.

The first close analysis of their ten responses led me to the following formulation: aesthetic experience is (1) overwhelming, it (2) engages powerful sensations, it (3) involves feeling, it (4) brings a heightened sense of significance but (5), it cannot be communicated adequately in words and it leaves one with (6), a desire for others to share it. I would now like briefly to examine the students' aesthetic experience under these six key headings.

AESTHETIC EXPERIENCE IS OVERWHELMING

Nearly all of the accounts described an experience that was intense and utterly absorbing. Seven of the nine are entirely explicit on the point and use what could be termed the language of excited and tranced consciousness. Here are some typical sentences and phrases: 'I stood mesmerized, enthralled. I was oblivious to the gentle jostlings of the other visitors (in the Tate Gallery). I was transfixed to the spot'; 'I was stunned by the clarity of intention, transfixed and inspired'; 'The beauty of it all overwhelmed me with emotion'.

Louise wrote: 'From being a passive disinterested observer, I had become so involved that my breathing had changed rhythm, my mind had expanded and my imagination was on full alert.' Some of the accounts gave details of the effects of this trance-like state; Jayne mentioned how the

voices in the Tate Gallery became 'faint, distant'. Liz in the theatre noticed 'the woman next to me whose huge body laps over my seat with her stentorious breathing is somehow not present.' The participants in strong aesthetic experience would seem to enter the timeless moment.

AESTHETIC EXPERIENCE ENGAGES
POWERFUL SENSATIONS

Jayne, gazing at Constable's *Haywain*, confessed she wanted to touch the painting: 'I tentatively raised a hand towards the painting. I dare not touch it. Would alarm bells sound?' Jean confronting a sculptured body similarly wrote: 'I just had to touch it. The smooth curves took my hands away from me and all I could think of was beauty.' Three of the accounts testified to a desire to cry. Watching the Indian dance Pamela wrote: 'I had to swallow hard to stop the tears coming'. Similarly Jon listening to Strauss's *The Four Last Songs* claimed to experience a 'physical tightening of the chest. Tears but not of pathos.'

AESTHETIC EXPERIENCE INVOLVES FEELING

The encounters also involved deep feeling in as much as feeling can be differentiated from sensation and the general experience of being overwhelmed. 'Various emotions bombarded me', wrote Jayne, 'I felt humbled, honoured, fortunate, ecstatic, exhilarated.' Likewise, Jean described her feelings as those of elation and ecstasy. In contrast, Candace's relationship to the *Lady of Shallot* was marked by a pervasive feeling of sadness. 'Yet over all', she wrote, 'this feeling of acute sadness prevailed. She touched qualities and emotions that leapt the centuries.' While Phil moved by some kind of metaphysical insight before a mandala image insisted: 'But it really wasn't a cold experience. It wasn't just ideas in my head, it involved feelings too.'

AESTHETIC EXPERIENCE BRINGS A
HEIGHTENED SENSE OF SIGNIFICANCE

Novalis in one of his aphorisms asserted 'All absolute sensation is religious'. Initially, this might strike one as a rather perverse and dogmatic notion. Yet reading the ten accounts of aesthetic experience by the MA students, I was constantly reminded of it. For the sensation described seemed to be saturated with meaning and the meaning outlined seemed to include the person as a spell-bound participant in something, immeasurably larger. Mary, responding to Monet's garden, wrote 'The eternity of vision lives on, and I am in it'.

The sense of the significance of the elation is brought out well in David's account of his experience of a particular production of *Coriolanus*: 'It was, I believe, because the space between the stage and myself had vanished: the play, the production and the audience had achieved a scintillating and extraordinary harmony – this ephemeral theatrical moment had become a unique part of my permanent experience by placing me both standing on the stage looking out and sitting with the audience looking in; because we were all of us in those moments, a living part of this thrilling whole.'

Here the feeling of being tribally grounded in some universal is almost inescapable. It clearly involves a kind of shedding of normal mundane consciousness and the willing participation in something infinitely larger in which one feels truly and absolutely alive. A form of transcendence. 'Such beauty', exclaimed Jean, 'Such universality of work. Such authority. And I was part of it. I was *there*, what else can I say?'

The last observation brings us to a further characteristic of aesthetic experience, at least as testified by the ten writers. It cannot be adequately conceptualized. It seems to defy translation yet, at the same time, one who has had such an experience often longs to share it, to embark on the task of finding a language to convey the power of the sensation.

AESTHETIC EXPERIENCE CANNOT BE
COMMUNICATED ADEQUATELY IN WORDS

Four of the accounts were quite explicit on this manner. Jon, responding to Richard Strauss's *The Four Last Songs* wrote 'the nub of this state is impossible and elusive to point, language here only operates in peripheral terms'. Phil makes the same kind of point with regard to the mandala image: 'It was direct intuition. All this is very mysterious. Words can't be used. Even more thoughts don't seem to be able to contain the meaning which this sign had for me.' Pamela, for her part, watching the Indian dance, asserted her conviction that, 'Such moments are in a sense beyond words, difficult to analyse: a connection, a feeling, elation' and went on to refer to Nietzsche's 'will to power' and 'the enhancement of life'. Jayne, before the *Haywain*, reiterated the point 'words are inadequate – that I had seen this canvas – in the flesh'.

AESTHETIC EXPERIENCE CAN INCLUDE A DESIRE FOR OTHERS TO SHARE IT

'There is a sense of well-being,' wrote Liz recalling her feelings at the end of the production of *As You Like It*, 'and a strong desire to smile and speak to other members of the audience – to celebrate our remarkable good fortune in having been present here'.

Candace looking at the painting *The Lady of Shallot* 'felt sure that others looking at her would experience the same emotion, indeed, I hoped they would do so'.

Having made the analysis I recalled that there had been one short study of such primary aesthetic experience in a paper called 'Dr Brunel and Mr Denning: Reflections on Aesthetic Knowing'. In that paper its author David Hargreaves wrote: 'My informants report their aesthetic traumas and in some cases they are so reminiscent of a religious conversion that a parallel or analogy between the two is in order.' He went on to divide what he named 'the conversive traumas' of aesthetic experience into four stages: the powerful concentration of attention, a sense of revelation, inarticulateness, the arousal of appetite.

Now there is a quite considerable degree of agreement between the two accounts. It could mean that here we discern a common delineation of a dramatic state of consciousness which holds its own educational justification. We are on the trail leading to a defence of aesthetic response as primary and primordial engagement, as acts of revelation, as the tranced states of virtually inexplicable understanding of modes of cognition 'free from concepts' to use Kant's formulation. It is here that we now need to turn our attention if we are to really understand the educational significance of the arts. It is a neglected area calling out for more research and reflection.

ART, ARTISTS AND WOMEN

GRISELDA POLLOCK

A feminist intervention in art initially confronts the dominant discourses about art, that is the accepted notions of art and artist. These involve those typical ideals which popularly circulate and the historical inflections of the terms at any particular time and place. In the late 1960s the paradigm of the artist was unquestionably masculine and the history of art both past and present offered little space for women. The injection of a feminist consciousness raised basic questions for the women involved in art who became part of the emerging Women's Movement. What relationship do women have to art? Could there be a feminist aesthetic? How does art made by women relate to current forms of art? Is there a difference between art made by women and art made by men? Is artistic practice an area women should reclaim, or abandon, and why?

Several books published in the mid-1970s by American artists or critics documented the massive reorientation for women in the arts which the arrival of a new phase of feminism initiated. In *From the Center* (1976) the critic Lucy Lippard provided a biographical introduction to a set of essays written exclusively about art made by women. Lippard explained how the Women's Movement changed her whole approach to criticism and undermined all her inherited certainties about both art and women. In 1977 the artist Judy Chicago published *Through the Flower*, an autobiographical account of her move from being 'one of the boys' making macho, abstract metal sculptures in the late 1960s, through research into the

history of women into an involvement with feminist art education and the development of a feminist imagery. Both Lippard and Chicago posed the question of a feminine aesthetic and wondered if there were stylistic features of art made by women in the past, for instance central-core imagery, which could now be consciously employed to express women's pride in themselves, their bodies and their sexuality. Feminism had a considerable impact on both women new to the practice and on established professional artists in the USA. Feminist education programmes and such enterprises as the Women's Building in Los Angeles have offered important points of identification for women through which to orient their feminism to an artistic practice.

The situation has been different in Britain. There is little or none of what Martha Rosler has termed 'art world feminism' (identification with women's struggles by established artists, using the 'woman' question to gain space for their work). On the other hand the Women's Movement in Britain has been suspicious of a culturalist as opposed to political analysis of feminist concerns and therefore only slowly did women active in the arts accommodate their interest in artistic practice with priorities of political movement for the transformation of women's economic and social condition. Several artists working in Britain in the early 1970s attested to the problems they first encountered when they became actively involved in the Women's Movement. Susan Hiller told us in an interview in March 1982 that when she joined a

consciousness raising group in 1973 anything to do with art was deemed to be secondary to the discussion of women's issues:

> Art seemed to have nothing to do with the way we lived. Women in the group wanted me to give up art and return to anthropology. The movement did not need artists and the only conceivably useful thing I could do was to make posters. I did that. It was difficult for me to assert my right to make art. it was very undermining.
>
> ('Interview', March 1982)

There could be many explanations for this initial suspicion of art's validity or relevance but two main ones can be suggested. In the early 1970s women knew precious little about women's history. As part of the rediscovery of women's history, investigations into art history began to reveal a tradition of women who had participated in cultural production of all kinds. The reclaiming of women's creativity became a part of the positive valorization of women for which the Women's Movement aimed. Furthermore the generally accepted notions of art – based upon what was being produced and sold then, for example minimalist sculptures and abstract paintings – seemed to be irrelevant to women struggling against economic, sexual and racial exploitation. Elona Bennet recalled how difficult it was to find a way through these related problems:

> I didn't know anything about women artists at all; maybe Barbara Hepworth and Elizabeth Frink. When I left art school I was in one or two exhibitions and there was talk about a women's history group. There was a conference in Oxford (March 1970). It was the first time women got together on a mass basis. I felt I must find out about women's history and the History Group started from there. Everything took off and flowered. I met Mary Kelly. We'd both been at St Martin's School of Art together but we'd not known each other. Both of us felt we wanted somehow to be involved in feminism and link up our art with it. We both became involved in the Artists' Union and the film *The Nightcleaners*. Both these activities enabled us to work more polemically, in a more direct way. I couldn't immediately see a way through at that time. My art was then very abstract, big steel structures. I had an exhibition at the Birmingham Arts Lab at the same time as the Miss World Protest (November 1970). I was making abstract conceptual works about Time. There was a huge gap between my art work and my involvement with the women's movement.
>
> ('Interview', July 1982).

The closing of this gap was obviously more than a matter of overcoming initial doubt about the usefulness of art to the movement. Feminism forced artists to question many of their assumptions about the character of contemporary art and about the social definition of art and artist in general.

Our commonsensical definitions of the artist today are still a combination of the Romantic notion of the artist as 'Genius' and expressive theories of art. To the artist is attributed a heightened sensibility and even a visionary capacity to see beyond surface reality and to probe human experiences which are expressed through so great a creative ability that it is assumed that it must be innate. It cannot be learnt. Art is the externalization of the internal feelings and mental contents of this distinctive type of personality – the artist. Thus the primary object of art becomes in fact the artist whose being is expressed in it.

This idea of the artist developed historically in relation to massive changes in the organization and evaluation of human labour and social production. In the grand-scale transition to mechanized factory production of goods for exchange and wage labour fundamental changes in the practical division of labour and the definition and purposes of skill were wrought. Certain categories of skill were defensively attributed to a redefined realm of the arts. A new notion of art gained meaning in historical opposition to industry, and in such polarities as fine art against useful arts, art against technology. The representative figure for these differentiated skills and procedures, the artist, was categorically distinguished from the scientist, the artisan and the operative – the latter being the labourer produced by the dominant social relations of capitalism which collaterally redefined the meaning of the activity work. Once work referred to any activity or skill; in modern societies it means being hired, waged. (It is only in this sense that a woman working at home with children is deemed 'not to work'.) Art is idealized as the opposite of work, i.e. of wage labour. It retains the idea of work as a self-realizing skilful activity which yields a total product, something affirmative of its maker. The artist is mythically idealized as the free agent of this creativity. Yet all

production is subject to the laws of capitalism and the freedom the artist mythically celebrates is conditioned in practice by the market economy. Thus as Raymond Williams summarizes the results:

> Art and artist acquire general and vague associations while art works are practically treated as marginal commodities and artists function as a category of skilled independent workers producing a marginal commodity in an uncertain market.[1]

The democratic impulse of the Women's Movement undermines the fantasy of the artist as genius, decrying its élitist pretensions and revealing its mystification of the real conditions which facilitate the success of a select few from select class, racial and gender groups. In her essay 'Why have there been No Great Women Artists?' (1971) the American art historian Linda Nochlin exploded the myth of the genius by showing how recurring conventions in artists' biographies shore up the notion that true greatness will always find its recognition. And since genius will always win in the end, those who do not make it are proven to be inevitably second rate, not geniuses; not true artists. Linda Nochlin showed the power of social and economic conventions in determining who is able to produce art and gain renown.[2] The myth of the artistic genius serves to desocialize the production of art, to disguise the facts of privilege and convention which regulate access to training and advancement. A product of a classed and gender-divided society, this idea of the artist is a veil for the inequalities which sustain its élites.

There is, however, a material underside of the myth – the economics of art, how artists live in a market economy. While the Women's Movement has gradually accepted the idea of a specialist – the professional artist who lives by her practice – there have been as yet no sufficient analyses of the economics of art production. Women artists are left to drift upon the open market, eking out a precarious living. This problem relates to another. Feminist critiques of current notions of art have also addressed the relationship between art and its audiences. Modern artistic production is typically private production. Artists generate work as independent producers, rarely commissioned, living more often by teaching than by sales. The work that is produced is not made for an audience, but for a market. The market exchange to unknown private consumers is mediated by the operations of cultural managers, museum curators, critics, exhibition organizers and Arts Council officers who attempt to shape a public image of the living culture. Art lacks an audience in the sense of a special group who interacts with the meanings and values being circulated in this form of social exchange mediated by objects. Feminists have tried to explore new constituencies of audience and to articulate the experiences and interests of hitherto culturally dispossessed groups, women, or working people, or cultural minorities, for instance. Yet the financial basis of survival as an artist remains tied to the current market conditions where there is little audience, just consumers and managers. Without alternative systems of financial support those who want to work as artists have to negotiate a relationship with the existing discourses and institutions of art and artist. In an interview Susan Hiller explained the critical attitude in the movement to this practical necessity:

> The idea was that women were creative and their creativity came out in unrecognized ways. And that this was the way of the future. This should be encouraged and one should withdraw from male notions of exhibitions, careers, vast projects and goal-oriented work. Any of these sorts of things were seen as wrong. In the United States the women who had made it are still seen as having sold out.
>
> Of all the political movements feminism above all other demands that we live our ideal feminism in a society that is not feminist in a way that socialists are not required to live their socialism in a non-socialist society, to the same extent. Yet on the other hand we agree that our actions now must presage future social relations. Now we face the situation of having to live with the struggles and make some peace with them.

(March 1982)

Feminist art historians have extended this debate by the historical analysis of the gendering of the mythic artist figure. Art history writes about art and artist when in fact it exclusively refers to work by men. Art made by women is designated by the prefix 'woman' before art or artist. This signifies more than art by female persons; it means that art is different and therefore less good. In our book *Old Mistresses, Women, Art and Ideology* (1981)[3] a history of the meanings of the word Artist was traced and compared with the history of the designation 'Woman'. It was suggested that these sets of definitions altered in increasingly antagonistic ways as massive historical changes impinged upon social

and gender relations. What changed was not the fact of women's practice. Women have always made art. From the medieval period onwards not only did the conditions of women's and men's labour alter but so did the way in which sexual difference was defined and represented. It was argued that a division was established by the late eighteenth century between representations of the Artist as a Man of Reason and of Woman as a beautiful object. With the development and consolidation of bourgeois social forms and gender relations the process of opposition between Artist and Woman became subject to an increasingly rigid divide between public and private spheres, between professional activity and self-sacrificing domesticity and procreativity. Across these sets of oppositions a divisive map was drawn of those social spaces and behaviours which were designated as masculine and feminine; 'Artist' and 'Woman' were placed in separate and gendered territories.

In addition, the complex relations between the bourgeoisie and its cultural agents impinged upon the spaces occupied by the artists. The Romantic myth and its urban derivative the Bohemian placed the artist decisively in the sphere of the masculine – in touch with Nature or steeped in the underworld of modern urban life – but this was in an oblique relation to bourgeois norms of masculinity which were lived and regulated in the office, factory or the home. The myth of the freedom of the artist has further gender implications, therefore. In opposition to the Respectable norm of masculinity whereby manliness was achieved by hard work, duty and both economic and sexual thrift, the artist is projected in difference as the figure of freedom from such social regulation. As such, the artist articulated the contradictions of bourgeois ideologies of masculinity. Bourgeois culture generates the fantasy of freedom through which the artist has direct access to Nature and to Truth. The artist is imagined as a free agent outside of society exercising a liberated sexuality which realises some imaginary, primordial, masculine self-determination and power. One conclusion of this was the Surrealist ambition for total liberation from bourgeois gender norms. Jean Cocteau provided the conceit of the artist as the unity of masculine and feminine wherein art was a kind of parthenogenesis uniting reason and fertility, offering a dream to men of wholeness and confirmation of their universality.[4] In the tradition of Cocteau and the Surrealists the complementary

combination of masculine and feminine is possible in a man, unnatural in woman.

June Wayne has analysed the feminization of culture from another perspective in an article 'The Male Artist as Stereotypical Female'. She points out how the artist is viewed as inept in money matters, impractical, absent-minded and in need of mangers and housekeepers, manipulated by dealers and collectors. However, if a woman is single-minded and rational she is condemned as aggressive and unwomanly and if passive, impractical or inept this would be taken as proof not of genius but of innate, 'feminine' temperamental weakness.[5] However, with such figures as Jackson Pollock, late twentieth-century myths of the artist reinforce the machismo masculinity of the artist, and in recent developments in contemporary art the 1950s image of the suffering and self-expressing painter-artist is clearly once again in circulation.

Since the nineteenth century, therefore, the notion of the artist has acquired a complex of significations. A complementary type, the woman artist, came into discursive existence side by side with this ideological construction, but it is fractured across the system of gender relations which attempts to establish an absolute and hierarchical difference between masculine and feminine. The woman artist is also marginalized by the appropriation of the terms 'artist' and the concept art within discourses on masculinity. Today, as we have already seen, over fifty per cent of students at British art schools are women. But the term woman artist is already captured and disfigured as a perverse hybrid struggling to conform to incompatible stereotypes. To define oneself as an artist without the qualifier 'woman' is to repress the important and desirable fact of being a woman. To be labelled a woman artist is to be placed in a separate sphere where only gender matters, where gender is assumed biologically to determine the kind of art that is made. There remains an unsolved contradiction for women who nonetheless justifiably claim that women should be recognized as producers of culture, as artists.

Feminism has only partly been concerned with supporting more women to become artists. It has become increasingly clear that the very structures of the practice, its terminologies and guiding ideologies are sexist. They reproduce in a variety of ways the dominance of men and the subordination of women. It has become a vital necessity to develop, therefore, a political analysis of culture and a political strategy for women's involvement in its sphere.

NOTES

1 Williams, R., *Keywords*, Glasgow 1976, pp.34–5; see also *Culture and Society 1750–1950*, London 1958, Introduction.

2 Nochlin, L., 'Why Have There Been No Great Women Artists?', in *Art and Sexual Politics*, ed. E. Baker and T. Hess, New York and London, 1973. Compare V. Woolf in *A Room of One's Own*, London, 1928, p.105.

3 Parker R., and Pollock, G., *Old Mistresses: Women, Art and Ideology*, London 1981. See also Pollock, G., 'Vision, Voice and Power; Feminism, Marxism and Art History', *Block*, 1982, no.6.

4 Pollock, G., 'History and Position of the Contemporary Woman Artist', *Aspects*, 1984, no.28.

5 Wayne, J., 'The Male Artist as Stereotypical Female', *Art Journal*, Spring 1973, pp.414–16.

CHAPTER TEN

NEW INTERNATIONALISM OR THE MULTICULTURALISM OF GLOBAL BANTUSTANS

RASHEED ARAEEN

Introduction

What does 'Recoding the International' [the title of the seminar at which this paper was given] really mean? If 'recoding' only means changing the codes but not transforming the 'object' itself, would it not make nonsense of the whole idea of a *new* internationalism? Would it not imply the construction of a new facade or outer wall, in the manner of postmodern spectacle or decoration? I'm not playing with words: the meaning of what one intends is coded in the language. My fear is that this may in fact turn out to be the reality.

There is an urgent need to shift the concept of internationalism; but is a radical shift possible without questioning the prevailing internationalism and the ideas, attitudes and values which form and code its structure? Are we seeking to dismantle this structure? Is this possible within the prevailing Eurocentric framework?

Indeed, there has recently been a substantial critique of Eurocentricity, but it is often part of a search for alternative centricities. Given the continuing historical dominance of western civilization, and without a profound shift in political and economic power from the West to other cultures, wouldn't an escape from Eurocentricity be an illu-

sion? It is not so much the centrality of European civilization and its ideas of progress which should necessarily be a problem, but how this centrality is ideologically constructed. What concerns me here are those components which construct the world in which the white race is seen to be the only civilizing agency. These components, as I will show later, play a central role in the construction of western nation-states and their alliances on which the prevailing notion of internationalism is based.

Before I look at the key issues that underlie the proposed 'new internationalism', I would like to say something about what has led to its initiative. I don't want to give the impression that Britain is central to this debate about internationalism; I recognize that the struggle against the dominant forces has been waged globally. But it is also important to recognize that a struggle for true internationalism has been waged within British culture by Afro-Asian peoples for the last forty or so years, and that this struggle has been constantly undermined by the very same forces which now claim to have initiated this debate. Does this represent a genuine change on the part of our art institutions or a smoke screen?

It is in this context that I hope to examine not so much the various aims and objectives of the

proposed 'new internationalism', but, more importantly, the problems and difficulties which may obstruct its realization. It would be naive to think that there would be no attempt to obstruct or sabotage the development of a new internationalism if it is realized that this might challenge the existing system and its privileges. The obstruction may, as has often happened in the past, be in the form of an institutional intervention which appears to be in support of cultural egalitarianism but in reality only reflects an ongoing paternalism. A case in point is the prevailing idea of cultural diversity or multiculturalism, but I shall come to this later.

My main argument is that without critically examining the situation within Britain we cannot conceptualize our relationship with the world at large. If there really is a process taking place in Britain which reflects our desire for a new internationalism, what is the evidence for this process? Is it part of a debate within the mainstream art community: does it reflect changes that are taking place within art institutions? The answers to these questions, I regret to say, are not positive.

If the objective is to eliminate the differentiation of different peoples, or, to put it more bluntly, making distinctions between white people and peoples of other races or cultures why is this objective still wrapped up in the institutional rhetoric of cultural diversity and pluralism? If 'new internationalism' means a global projection of the idea of cultural pluralism, or multiculturalism, as it has been formed in the West, then I'm afraid we are on shaky ground. If the underlying concern here is only about accepting artists of other cultures, particularly those who are not part of our own society, who we think have been excluded from the discourses of art of our time, we do not need a change in the system. The exhibition 'Magiciens de la terre' is a recent example of a new development in terms of showing together works of art from both the western and non-western worlds. Not only were there all sorts of objects gathered from all over the world and put together without any regard for a common artistic criterion or framework, but also these objects were legitimized differently as art in terms of preconceived distinctions between the West and non-West. This exhibition is now seen by many, particularly in the West, as the model for a new internationalism. But if we examine its underlying paradigm it becomes clear that the function of such a model is no more than the West's search for redemption in return for the favours it lavishes on others in its desire to maintain its hegemony of the world.

THE PREVAILING INTERNATIONALISM AND ITS DOMINANT MODEL

We know that independence from colonialism did not end the hegemony of the West. If anything, the West's hegemonic position and its institutions were reinforced through its increased economic, political and cultural domination of the post colonial world. The post-war internationalism of art was, and is, a reflection of this shift, particularly with the move of the West's artistic centre from Europe to the US with its Cold War manipulation of the world. However, this shift did not diminish Europe's importance as it entered into a new alliance with the US. Although, as I will discuss later, there was a desire in Britain to identify itself with its former colonies on the basis of some human equality, this desire faded as Britain became increasingly entangled with the US's post-war imperial ambitions. This had tremendous repercussions on the art that British institutions showed and legitimated.

It is important to remember that the West's post-war pronouncements on internationalism, particularly in art, were part of its cultural propaganda to lure the newly independent countries into its sphere of influence. The geopolitical reality of this internationalism is the alliance between European and North American nation states, based on shared economic, political and military interests; ideologically this alliance extends into the production and promotion of art. What is most remarkable is the way art scholarship became complicit with art institutions, relinquishing its claims of objective empiricism to repress facts which would otherwise expose the fiction of the historical supremacy of Euro-American artists. This fiction became particularly useful in the face of the post-war migration to and settlement of Afro-Asian peoples in the northern metropolises.

The exclusion of non-white peoples as historical subjects from the grand narratives of modernism is understandable within the context of colonialism, but how do we justify this exclusion in the context of post-colonial freedom and the presence of others as historical subjects within the modern metropolis? Why has the history of art of the twentieth century remained a white monopoly? The reasons, I would argue, are to do with the way national cultures within the West are per-

ceived. The notion of the mainstream as representative of indigenous values, continually reconstructed by indigenous artists, has not changed; and this indigenousness remains trapped within the notion of western culture as racially homogeneous. It does not, of course, deny the presence of others amongst its ranks. Nor are others denied their demand for equality, but this equality is offered in such a way that it does not impinge upon or question the dominant paradigm and its genealogy: different roles are provided for different artists based on racial or cultural differences.

INTERNATIONALISM OF
AFRO-ASIAN ARTISTS IN BRITAIN

The notion of western national cultures as constituted only by their white citizens, which formed the basis of international cultural alliances, was challenged by the post-war arrival in Europe of artists from its former colonies. This gave rise to a new social and intellectual space within which Afro-Asian artists were able to function; a few were even somewhat welcomed and celebrated by the British intelligentsia in the 50s and early 60s. It was in this context that artists like Francis Souza and Avinash Chandra, both originally from India, achieved a tremendous success. Moreover they were not the only non-white artists who were accepted and recognized and who contributed to the British art scene. In some respects, the distinction between white and non-white artists at the time seemed to disappear. Despite this, there was something disturbing in the way Afro-Asian artists were located and framed. They were seen as representatives only of their own cultures, creating otherness from which the artists were trying to escape. This problem of otherness could have been resolved had British society been allowed to develop into a truly multiracial society and its art institutions correspondingly transformed. But this was not to happen due to contradictions both inherent in British culture and in its relationships with other nations.

However, the presence of Afro-Asian people in Britain gave rise to a historical process that transformed its capital, London, into an international cultural centre. Although this change was seen by some as a 'breath of fresh air', to quote Denis Bowen who ran the New Vision Centre and whose policy was to show artists from all over the world, the position and status of Afro-Asian artists remained vulnerable to the conflicting forces within British society. While there was a genuine

desire for a new society, this also posed a threat to the values and institutional structures of Britain as a nation-state traditionally seen as a monolithic and homogeneous entity.

During this time something else happened which sharpened this conflict, exacerbating the contradictions surrounding the presence of Afro-Asian artists within a white society, and ultimately led to their exclusion from its patronage. This was the increasing dominance of US culture in Europe, particularly in Britain. In the mid-1960s the cultural exchanges between London and New York intensified and were promoted by a new generation of dealers, curators, critics and art historians for whom, however, the internationalism of the British Commonwealth was an anathema. This new development was also a victory for conservative forces, who saw the presence in Britain of Afro-Asian people as a threat to their established values. It seemed, therefore, that the London-New York link was unable to tolerate any alien presence within its ranks and was, I think, responsible for the 'ethnic cleansing' of the postwar history of British art.

The mid-1960s was a crucial period in terms of geopolitical changes and a historical watershed in art which questioned the facile formalism of high modernism, offering a radical shift in the investigation and perception of sculptural form. In Britain, the Signals Gallery, which showed international avant-garde art, particularly that being produced outside the Euro-American network, played a crucial role in challenging Euro-American hegemony. It was in this intellectual milieu that some non-white artists in Britain achieved what Hal Foster calls 'historical ruptures and epistemological breaks'.[1]

The story of Minimalism, Conceptualism, Arte Povera, etc. is known as one in which all the heroes are white Europeans and North Americans. But is this story acceptable? It can be accepted, for instance, only if we can prove that the conditions, both historical and epistemological, which produced Minimalism were exclusive to New York and that similar developments did not take place elsewhere. I'm not questioning the post-war centrality of the New York art world or the self-interest of New York artists; but to believe that new ideas can develop only in one centre, New York in this case, particularly at the time when the discourse of modernism had been globalized, is a kind of chauvinistic assumption which is historically and intellectually unacceptable.

When American Minimalism arrived in Britain in the early 70s and was promoted by British institutions, the facts about British Minimalism were known. But facts in themselves have no value: they must enter a legitimizing process before they have any significance or status. As Charles Harrison, an eminent British art historian, puts it: 'I'm aware of the "actual facts" as you recount them. We may differ in the status to be accorded to them – but that tends to be the way with "facts".'[2]

Let us look at the facts. In the mid-1960s there emerged an opposition, in historical terms, to the dominant mode of sculpture, represented in Britain by Anthony Caro *et al*, in the form of what later became known as Minimalism, Conceptualism, Arte Povera, etc. This should not have surprised anyone, given the material conditions of the time, both in terms of the multifaceted nature of British culture and of the need to break with what had become the stifling dominance of 'New Generation' sculpture. We know well enough which white artists were part of this historical opposition, but the real surprise is that this task was also performed by those from whom it was least expected.

It can be argued that the avant-garde achievement I have alluded to has remained unrecognized because it failed to assert its presence in the market-place. But this raises an important ethical question: should we leave the recognition and legitimation of 'historical ruptures and epistemological breaks' only to the whims and interests of market forces?

The problem is not so much that the American story was accepted here, but that the institutions, knowing the facts, continued to promote Minimalism as an exclusively American phenomenon. Thus, a historically important British contribution was erased from official history, not so much by misrepresentation as by a falsification of history, not just in terms of the suppression of an Afro-Asian achievement but of the very core of internationalism which had developed within Britain.

THE BLACK STRUGGLE IN ART

I now want to say something about the struggle which Afro-Asian artists waged in trying to recover their history in Britain and its repercussions in general, as well as institutional responses to it. It is important to stress that this struggle has been for an internationalism in which no artist is differentiated and discriminated on the basis of the country of origin. It is not so much a question of eliminating differences as recognizing their historical roles in the critical deconstruction of the dominant discourse.

From the beginning we knew that we couldn't expect much from the establishment. So we set up and organized our own programmes and agendas in the form of research projects, archives, conferences and publications, which would help Britain recognize its true post-war history. One of the main outcomes of this research was *The Other Story* exhibition at the Hayward Gallery in 1989–90, which showed that at stake was not so-called Ethnic Minority Art or Black Art or an expression of cultural difference or identity, but the gaps in the official history of art. Although this exhibition was well received by the general public, with 25,000 visitors, it has so far made little difference to the institutional view of things, as was demonstrated recently by the *Gravity & Grace* (1993) and *The Sixties Art Scene in London* (1993) exhibitions. Both shows conformed to the genealogy of official history from which non-white artists continue to be excluded.

It was in the 70s that we realized that there was something fundamentally wrong with the British art world, and that we had to do something about it. It was also the time when the establishment realized that it couldn't carry on ignoring the cultural aspirations of Afro-Asian peoples, whom it began to call 'ethnic minorities'. But, instead of changing its old views and developing new policies that would unite and integrate the different peoples of British society, the creation of a separate 'ethnic minority arts' category created further divisions and separations, very much in the pattern of cultural bantustans. This cultural apartheid, which received official blessing with the publication of Naseem Khan's report in the mid-1970s,[3] continues today. Its harmful effects are disguised by institutional separate funding for multicultural or cultural diversity programmes.

There is nothing wrong with multiculturalism *per se*, so long as the concept applies to all. But in the West, it has been used as a cultural tool to ethnicize its non-white population in order to administer and control its aspirations for equality. It also serves as a smoke screen to hide the contradictions of a white society unable or unwilling to relinquish its imperial legacies. It is in this context that we should understand the fascination and celebration of cultural difference.

The multiculturalism of the visual arts is also rationalized by Post-Modernism's 'anything goes', often in complicity with what is called 'post colonial discourse'. The problem here cannot be located only within Post-Modernism; it extends back in time to colonialism, and how native artists responded to what was imposed upon them as a modern civilizing discourse. Did they succumb to its domination, producing pastiches of western art, or was it a starting point for a painful journey which eventually took them to the modern metropolis? What exactly did they do in the metropolis? Did they only produce second or third rate derivative works, as we are told by art institutions and their spokespersons who call themselves art critics and historians? The problem here is not only of recognizing the claims of 'other' artists to modern achievements, but how and where to locate these claims historically. As for the dominant discourse, it is so obsessed with cultural difference and identity, to the extent of suffering from an intellectual blockage, that it is unable to maintain its focus on the works of art themselves. Here is an example:

> It is probably salutatory for someone like me, who is British, white and the inheritor of a whole apparatus which is undeniably privileged, and which descends on me from the imperial structure, to say that however well I can intellectually understand the problems that Rasheed here confronts, coming over to this country, and trying to reconcile his inheritance with the established inheritance which he sees here – however much I can sympathize with his problems and feel that I ought to counteract it at the same time I think we who are western and white ought to be honest about this and admit that we do find it difficult to engage with the kind of cultures that we say should have their right to exist.[4]

This statement by Richard Cork, an English art historian, is self-revealing and it is not necessary for me to comment upon its full implication. What is worth noticing is the way the dominant gaze shifts the problem from itself to other cultures, which are thereby seen to be in need of sympathy, or perhaps help.

The obsession with cultural difference is now being institutionally legitimized through the construction of the 'post-colonial other', who is allowed to express itself only so long as it speaks of its own otherness. This has produced a problem for the critical assessment of works of art, as was recently noted by *October* magazine in its round-table discussion on the last Whitney Biennial.[5] I sympathize with Rosalind Krauss's concern about the shift of frame from the signifier to the signified. But I think we ought, at the same time, to pay serious critical attention to the nature and limitations of the prevailing dominant signifier. However, the *October* discussion rightly pointed out the dangers of providing institutionally predetermined spaces for other artists; these may provide an opportunity for them to assert their presence, but they would also frame them on the basis of their difference.

The prevailing western notion of multiculturalism is the main hurdle we now face in our attempt to change the system and create an international paradigm in which what takes precedence is art work with its own set of rules for production and legitimation in terms of aesthetics, historical formation, location and significance, rules not necessarily derived from any one originating culture.

Before concluding, I must acknowledge the institutional support we have received in our struggle.[6] Without the support of the Arts Council we would have no *Third Text* and no 'The Other Story'. But at the same time, it is necessary to point out that the prevailing dominant perception of things and its relationship with the rest of the world is fundamentally flawed. It is based on old imperial structures, and is in conflict with the aspirations of the post colonial world giving rise to a crisis which cannot be resolved without an open and informed debate. It is not enough to set up a separate organization such as the Institute of International Visual Arts to deal with the question of internationalism or discuss the issues in an international symposium comprising an exclusive audience. There should also be a debate within the mainstream as part of its overall development. But such a debate cannot take place unless there is a recognition by the art world as a whole that the issues we are talking about here concern us all. These issues are not necessarily only about the predicament of 'other' artists within a globalized western culture, or non-white artists in western societies, but they are much to do with the nature of the dominant discourse and its institutional structures. These recognize and privilege certain artists and ignore others on the basis of a perception which is predetermined by the legacies of the colonial past, and although benevolent, they are unable to examine their own premises and limita-

tions. The complacency of the privileged is understandable but let us not deceive ourselves that we can change the world without questioning this complacency. We should, of course, think beyond our own problems in this country. We need an international alliance, a network of artistic exchange, which goes beyond the Euro-American alliance and hegemony. I would like to quote here something I wrote about twenty years ago:

> The development of a true international platform/movement, from/to which all cultures could make their unique contributions, is not only possible but desirable in the long run. But if this is to serve the true interests of all peoples rather than become another instrument of selfish western interests, it must be based on the clear rejection of western culture as the mainstream.[7]

Perhaps the time has now come for its realization. But can we develop a new internationalism, a network of interrelations and exchanges across the globe in terms of artistic without first putting our own house in order?

NOTES

1 Foster, H., 'Introduction', *Recodings: Art, Spectacle, Cultural Politics*, Bay Press, Seattle, Washington, 1985.

2 Letter to the author, 16 June 1986.

3 Khan, N., *The Arts Britain Ignores: The Arts of Ethnic Minorities in Britain*, Arts Council of Great Britain, Calouste Gulbenkian Foundation and Community Relations Commission, London, 1976.

4 'The Multinational Style, The State of British Art: A Debate', *Studio International*, vol.194 no.989, December 1978.

5 'The Politics of the Signifier: A Conversation on the Whitney Biennial', *October 66*, MIT Press, Cambridge, Massachusetts, Fall 1993.

6 This institutional support was received after a long struggle. It was in 1978 that we put forward a proposal to the Arts Council of Great Britain (which was turned down) to research into the history of Afro-Asian contribution to art in Britain: followed by the setting up of Project MRB in 1982 to carry out this work with the idea of establishing an archive and publishing the research material. However, having carried out some preliminary work with funding solely from the GLC and GLAA, a proposal for Black Umbrella (with its publishing section Kala Press) was launched in 1984. The idea was to set up a centre/organization with a comprehensive programme for research, seminars, publications exhibition projects, education and training in the visual arts, primarily in relation to the work of Afro-Asian artists in Britain but also extending this work internationally.

In 1987, now with financial support from the Arts Council, Kala Press began to publish *Third Text*, which has now established itself as a major international art journal with a unique theoretical perspective, providing a critical forum for the discussion and appraisal of the work of artists hitherto marginalized through racial, sexual and cultural differences.

7 Araeen, R., 'Preliminary Notes for a Black Manifesto', *Black Phoenix*, Winter 1978.

BEYOND TOKENISM:

TOWARDS CRITERIA FOR EVALUATING THE QUALITY

OF MULTICULTURAL ART CURRICULA

RACHEL MASON

MULTICULTURAL EDUCATION AND ART

A multicultural education reform movement that attempts to respond to a crisis emanating from the issues of inadequate accommodation of social equity with cultural diversity (Lynch and Mogdil, 1992, p.1) has been a feature of most western nation states in the past thirty years. I am assuming, therefore, that most people are able to conceptualize art curriculum practices that could be labelled multicultural though you may not be able to agree on a definition of what multicultural art education actually is.

Next, I want to point out that most of what has actually gone on in the name of multicultural education policy and practice has tended to be nation specific – in the sense that it has been shaped by historical-contextual factors such as religious and linguistic differences, specific geographical movements of peoples over time and a particular nation's historical and political structure and economic concerns. My interest is in a global or internationalist perspective on so-called multicultural reform. What I mean by this is that, for me, the core issues go beyond national boundaries. They embrace the interrelated responsibilities of North, South and East and West world regions for greater economic and social equity on a global scale.

CRITERIA FOR GOOD MULTICULTURAL ART EDUCATION PRACTICE

Over the past ten years I have engaged in extended analysis of both national and international multicultural art education theory and practice and have come to the conclusion that multicultural art education reform (anywhere, of any kind) has to operate from the following premises. Namely that:

- The arts are culturally determined and diverse.
- Present curricula, (at least in the Western Europe, North America and Australia) are 'Eurocentric' and biased towards Fine Art.

And, following a typology devised by James Banks (1989),[1] that the criteria for good practice are whether or not an art lesson/programme or project:

- Challenges the above two conventions and/or,
- Addresses the injustice and oppression of so called ethnic minority or third world persons, peoples of colour and/or Blacks.[2]

I will now go on to describe typical content approaches to multicultural art education reform in this country and examine the extent to which they are/are not effective.

CONTENT APPROACHES TO CURRICULUM REFORM IN ART
LEVEL 1: CONTRIBUTIONS

One very common form of content addition to the art curriculum is 'celebration' of a British ethnic minority cultural festival or non-Western artwork using criteria similar to those applied in selection of mainstream artworks or cultural events. Afro-Caribbean Carnival or the Hindu New Year festival of Diwali are popular choices of festivals. Popular examples of 'great works' of non-Western Art frequently selected for celebratory purposes are the Taj Mahal mausoleum in Agra, Northern India or the woodblock print by the Japanese artist Hokusai the *Hollow of the Deep Blue Sea*. The problem with the contributions approach is that it easily results in marginalization or trivialization of non-Western peoples and arts. Because the focus is on unique aspects of those cultures, students are not helped to see them as complete or dynamic wholes. Instead they view the artists and/or cultural forms, from within the context of the mainstream Western art canon.[3]

LEVEL 2: CULTURAL

In this kind of reform, art teachers add non-western concepts techniques and themes without altering the basic structure of their curricula – which takes substantial time, effort, training and rethinking. I have argued elsewhere (Mason, 1988) that the most popular cultural additions seem to be single courses or units involving students in practical art activity stimulated by Third World or ethnic folk arts/crafts or ethnic minority (Black) artist residencies. Source materials for teaching non-Western cultural units are in short supply. Typically, however, the content is (or was) derived from in-service education materials developed by committed individuals or small groups of curriculum reformers operating outside mainstream art education. Non-European artist residencies may be funded by the Arts Council working through its regional arts boards in association with minority arts associations. I believe cultural additions can operate successfully as a first phase in restructuring an art curriculum with genuinely multicultural content perspectives and paradigms. Characteristically, however, they result in students continuing to view the non-Western art input from the culturally biased perspectives of mainstream Western artists and art historians (who continue, for example, to classify sophisticated examples of sixteenth-century court art from Benin as 'primitive'.)

LEVEL 3: TRANSFORMATION

When the transformation approach is taken on board I believe the addition of content *can* address our criteria for effective multicultural art education practice in that they have the potential to effect changes in the canon or basic assumptions underlying the mainstream art curriculum: and enable students to view concepts, ideas, issues, themes, and problems from culturally diverse perspectives. The goals for art education at this level become those of extending students' understanding of the nature, development and complexity of the subject of art with a view to assisting them to participate in the foundation of new art paradigms. Securing access to multiple voices about art and its relationship to life (including the voices of oppressed Black peoples) becomes a major preoccupation of the mainstream art educator.

Examples of this kind of content addition in action in schools are difficult to locate. But the Arts Council funded publication called *Third Text* offers a rich curriculum resource, as do an increasing number of exhibitions on contemporary Black British art organized by national and regional galleries and museums. The 1991 Hayward Gallery exhibition called *The Other Story* is one such example.

This exhibition offered significant food for thought in the way in which it challenged the concept of ethnic minority arts being promoted at that time by mainstream art educators.[4] The curator, Rasheed Araeen (1989, p.9), described it as a 'story of men and women who defied their otherness and entered into a forbidden space, modern space – namely avant-garde art of the West'. He selected work by four kinds of artists of Asian, African and Caribbean origin originating in the United Kingdom over the last five decades: (1) artists whose beliefs are located in the modernist aesthetic that postulated the idea of self-expression as its ultimate goal and do not question the idea of art; (2) anarchists and ritualistic artists in the radical European tradition; (3) artists who were born

in Britain whose works express intense anger and frustration; and (4) artists who consciously attempt to create a synthesis between the West's constant search for cultural difference and their own desire for cultural identity. Mainstream art critics were dismissive and the gallery educator writing on the catalogue noted that making an exhibition on the basis of racial origin is 'not something that comes easily to the British Fine art world' – all of which is a splendid source material for discussion in art classes in schools.

LEVEL 4: DECISION MAKING AND SOCIAL ACTION

The fourth level of content addition includes all the elements of the other three approaches together with an extra component that requires students to take action related to controversial social issues or problems (i.e. race relations) that are simultaneously studied in class. Since the goal is to teach students thinking and decision making skills that empower them for action in later life and help them acquire a sense of personal, social and political efficacy, it is my view that this necessitates art teachers working within cross curricula or inter-disciplinary frameworks.

Once again, examples of this kind of content additions in art are difficult to find in schools (The most pertinent examples I have located have been in social studies, history and personal and social education). The teachers' instructional pack Walters, S. *Anti-Racism and Art in Britain and South Africa* (published prior to liberation in 1988) provides one such example of how this might occur.

The content focuses on the Black struggle for justice and equality (before liberation). Unit I is called 'Art for a Free South Africa'. Work covered by students includes analysis of photographic imagery depicting life under apartheid, reading personal stories about people living under apartheid, learning about the African National Congress's Freedom Charter and studying the art of the Liberation struggles. A number of art activities are built into the study programme and it includes a final directive to students to convey or interpret the message of the freedom charter in an alternative socio-cultural context – for example, Britain.

I do not want to give the impression that it is realistic to expect art teachers to move from a highly Eurocentric curriculum content approach (enshrined in the orthodoxy of National Curriculum Design Technology and Art) to a transformationist or decision making approach. Such a move is likely to be gradual and cumulative. The following is an example of how a content addition in art at the cultural level can function as a catalyst for moving to a transformation level.

A multicultural advisory officer I work with organizes in-service education workshops on Indian wood-block printing for teachers using the resources of a local museum. Sudha Daniel utilizes Indian artefacts from the museum loans collection for schools (e.g. a sari, shishi/mirror-embroidered skirt, decorated toran/door-hanging and block-printed pachedi/sacred cloth) as the stimulus for practical art activity combined with environmental, social and cultural learning in art. He affords credit first and foremost to knowledge and understanding of textile crafts within their local cultural context. Rural crafts in India are explained as living traditions that serve functional, economic and aesthetic purposes; and in doing so he makes extensive use of documentary videos and films. Teachers attending his workshops print fabric designs using small wooden painting blocks manufactured in India. Accurate representation of border patterns on the source material is demanded to make the point that perpetuation of tradition is regarded as desirable in rural Indian craft production.

I believe that this kind of cultural addition does have potential for bridging the gap between the two approaches because the new art content is not underpinned by Western models of representation and imagery. Assessment of practical work challenges Western concepts of creativity and originality.

IS THE CONTENT APPROACH AN ADEQUATE RESPONSE?

So far I have concentrated on what Banks calls the content approach to multicultural art education reform not because I believe it is *the right* answer but because I suspect 'changing the content of what I teach' is the most common, or typical response by art teachers to the problem at hand.

Before we finish with the visual examples I want to remind you that there are other kinds of multicultural art education responses going on which have nothing to do with changing art content.[5]

Amrik Varkalis, for example, dismisses the concept of multicultural art education in the way I

have been presenting it completely. (She sees it as a kind of 'fiction' about pluralism invented by middle class, white people such as myself which is irrelevant to the needs of ethnic minority pupils). Instead she concentrates on pedagogy rather then content. She uses bicultural and bilingual teaching methods to instruct Asian pupils in Bradford in the mainstream art (GCSE) curriculum and in doing so applies what is known in the USA as a 'teaching the culturally different' multicultural approach.

HUMAN RIGHTS EDUCATION

The point I want to stress now is, if it really is greater social and economic equity we want (either within a given nation state or with reference to the interrelated responsibilities of North, South, East and West world regions), then art educators cannot go it alone. This kind of reform clearly demands what James Lynch, among others, calls 'a whole school approach'. By this I mean that every aspect of schooling in an institutional sense has to be subjected to intensive scrutiny and targeted for multicultural-antiracist reform (e.g. school policy, parent-teacher relations, staffing, hidden curriculum, teaching materials etc.). The following diagram illustrates this point.

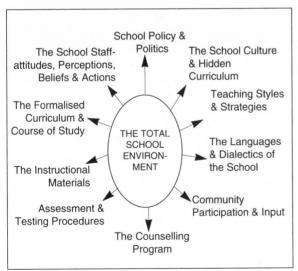

I want to end on a general education note by referring you to proposals emanating from Human Rights Education policy (e.g. Starkey, 1991) and from Canadian legislation which has adopted this as a conceptual framework for multicultural education reform.

This is what human rights education activists have to say about *inadequate* pedagogical styles when the issue is dealing with culturally diverse student populations in schools

- Classroom reality is determined by the teacher's beliefs about the nature of their subject and knowledge of available material,
- Teacher decides on the combination of these three factors alone.
- The dominant instructional tool is the text book.
- There is little interdisciplinary work.
- Large group, teacher controlled lectures and recitation are the instructional norm.
- Memorization of information is frequent.
- Respect for others' views is 'expected' without question.
- Motivation is extrinsic.
- Content and instruction is uninteresting.
- Affective objectives are rarely seen either as important or legitimate.

(Evans, in Lynch 1989 p.8)

And here are some examples of adequate, as opposed to inadequate, techniques of evaluation and monitoring:

- The content, rubrics and procedures for assessments are scrutinized for race, ethnic and credal bias.
- The picture of other countries portrayed in examination situations is balanced, up-to-date and fair.
- Special arrangements are made for those with special cultural or religious needs, including handicapped students.
- Students have opportunities for group projects and for involvement in their own assessment.
- There are a wide variety of opportunities for students to demonstrate performance in both discreet and integrated tasks through different modes of media.

(Evans, in Lynch 1989 pp.63–4)

These kinds of assertions have significant implications not just for individual art teachers, but for British art education institutions and processes as a whole (i.e. examination systems, national art association policy, entry regulations for HE art courses etc.) which have become entrenched and atrophied over time.

NOTES

1. Banks presented his four levels of integration of additional content which he described as 'varying in aims, methods and outcomes and intellectual challenge and potential for success', in a keynote paper at a conference on Education and Cultural Diversity held at the University of Southampton in 1991. They are the (1) Contributions, (2) Cultural, (3) Transformationist and (4) Decision making and Social Action approaches.

2. In using the term 'Black' with a capital B, my intention is to emphasize its political significance.

3. A canon, according to Banks, is a norm or standard that operates as a basis for educational criticism and evaluation. Professors and teachers and students internalize this norm. Because it is rarely explicitly defined, it is accepted as true and valid. The multicultural critique of the art education canon in the UK is discussed in Chapter 3 of my book Art Education and Multicultural Education (Croom Helm, 1988).

4. They argue that ethnic arts policy with its tendency to emphasize traditional crafts forms denies Third World artists access to a place in the contemporary art scene.

5. Alternatives to the content approach to multicultural curriculum reform referred to by Banks are (1) Achievement (2) Intergroup and (3) Prejudice Reduction approaches. Amrik Varkalis's work with Asian students in Bradford seeks to help them achieve success in the British system by drawing on their different cultural strengths and life styles and by using teaching styles and strategies that are consistent with their cultural characteristics. In Bank's terms, this is a 'cultural difference' version, or strand, of the achievement approach.

BIBLIOGRAPHY

ARAEEN, R. (1989) *The Other Story: Afro-Asian Artists in Post-war Britain*, London, South Bank Centre.

BANKS, J. (1989) *'Education for Cultural Diversity'*, unpublished conference paper, University of Southampton.

DANIEL, S. & MASON, R. (1993) *'The visual arts'*, in King,A. and reiss, m. (eds.) *The Multicultural Dimensions of the National Curriculum*, London: Falmer.

LYNCH, J., & MOGDIL, C. & S. (1992) *Cultural Diversity And The Schools Volume 1 Education for Cultural Diversity: Convergence and Divergence*, London: Falmer.

LYNCH, J. (1989) *Multicultural Education in a Global Society*, London, Falmer Press.

MASON, R. (1992) *'Art Education for cultural diversity: Developments in the United Kingdom'*, in *Discipline Based Art Education and Cultural Diversity*, Los Angeles: Getty Center for Education in the Arts.

MASON, R. (1988) *Art Education and Multiculturalism*, Beckenham: Croom Helm

STARKEY, H. (Ed) (1991) *The Challenge of Human Rights Education* London: Cassell Educational.

VARKALIS, A. (1992) 'Bilingual and bicultural approaches to art and design', *Journal of Art and Design Education*, 11 (2) 167-185.

WALTERS, S. (1988) *Anti-racism in Art in Britain and South Africa*, Oxford: OXFAM Education.

WHAT'S IN A NATIONAL CURRICULUM?

PAM MEECHAM

If a Post-Modern condition can be characterized at all, and numerous attempts have been made to identify the current state of cultural disarray, it must at least be acknowledged as a crisis of cultural authority. The focus has been, or seems to be, specifically located within the institutions for centuries the embodiment of consistent values and eurocentric perspectives inviolably rooted in Greek ideals and Renaissance values. That all the old certainties seem to be swept away (although some institutions seem curiously immune to siege), is at least tacitly acknowledged by most commentators. The coming of pluralism, one of the most significant manifestations of Post-Modernism, however has not been a harmless, enthusiastic détente, an easy embrace of the 'other'. The bewildering variety of cultural practices and, crucially, the lack of a language with which to deal with them, particularly in the visual arts, has led to some disparate and desperate solutions. The need to evaluate, categorize and hierarchically sort out a rubric by which to systematically utilize, display and evaluate art works from other cultures and value systems has caused angst in even the most patrician educators. An alternative has been to abandon any notion of evaluation and opt for a cheerful diversification that sees every object and crucially every interpretation of an object as worthwhile.

There is a growing tendency to deny art works any autonomy, encouraging a system of 'looking' that is profoundly ahistoric.

The fact that the National Curriculum for Art finds itself attempting to accommodate a variety of positions, and that it is failing to achieve coherence, only serves to highlight the difficulties of working in a period 'when we acknowledge the end of a sort of cultural monopoly, be it illusory or real, we are threatened with the destruction of our own discovery. Suddenly it becomes possible that there are just others, that we ourselves are an "other" among others. All meaning and every goal having disappeared it becomes possible to wander through civilizations as if through vestiges and ruins'.[1] Utilizing the past is not a simple process unless the theme park approach is going to hold sway. It is all too simple to present the past as unproblematic. With 'knowledge and understanding' it is just possible that art teachers and educators can use the past to understand the present better, but an uncritical romp through the 'past and the present', although fun, will not equip young people for a culturally diverse world where cultural heritage is now acknowledged to be more than an interesting collection of memorabilia relating to a colonial past. History, even art history, does not benefit from a high moral tone, but to

see it as a simple reflection of the way things were is to induce a form of aspect blindness. This affects looking at the past through pictures no less than any other account of history.

The National Curriculum for Art acknowledges in its programmes of study the need to embrace a variety of art practices, from painting to graphic design to local and contemporary work from a variety of periods and cultures, western and non-western. Key Stage 1 Programmes of Study 3 concludes with the statement: 'The selection should be made in order to develop pupils' artistic experience and knowledge and an appreciation of the richness of our diverse cultural heritage.' Excusing for now the assumptions behind diverse cultural heritage and western and non-western, the apparent all-embracing compass of the National Curriculum exudes a ghastly liberal angst as it tries to accommodate all art and visual culture practices (with the notable exception of popular culture) and art motivations that can encompass an expression of ideas and feelings. It is at the site of diversity that the real problems lie. I want to argue that the National Curriculum for Art, in spite of some recognition of the problem, fails to put the creative act into any social context – throwing heritage at it won't do – and that its insistence that pupils 'recognize differences and similarities in art, craft and design from different times and places' is not a simple undertaking. It is of course a laudable aim but on what basis is the recognition being done? Who is playing 'other' that we might better know ourselves? The principle of 'difference without antagonism'[2] can only be attained through a process of 'assimilation' through the mainstream, in itself a major problem. 'Works selected from non-western cultures should exemplify a range of traditions from different times and places' may of course include a remit to use contemporary art practice but the placing of non-western next to 'a range of traditions' does suggest otherwise.

Underpinning the document are several assumptions about art making and the history that subsequently supports art practice in the west. In spite of the plea for a widening of the terms of reference, the emphasis in the document is still on 'feelings'. Pupils are continually asked to explain what they 'feel' about a work of art, craft or design. What supports this emphasis is a western, largely Modernist assumption that art works both in their construction and their reception deal with catharsis and the expiation of the self, rooted

in notions of expression. It may be, of course, that this model for art practice has its place, but it is a construction of an art practice that is deeply embedded in ideas that attempt to separate art from wider cultural issues. Still apparent is the artist as Romantic hero.

The document does ask that pupils should relate art, craft and design to their social, historical and cultural context, for example, that they should be able to identify codes and conventions used in different times and cultures; it continues in reckless mode 'identify how and why styles and traditions change over time and from place to place recognizing the contribution of artists, crafts people and designers'. This is a task to daunt any social historian, never mind the beleaguered art teacher with practical consequences in mind. What is at issue here is the complexity of the task for teachers with no training in art history. The construction of arts histories is an area of debate with very few certainties. This may of course be to complicate the task, that all that is required is a token gesture. However, take the case of 'artists' contributions' and the recognition of that contribution as an example. The artefacts that we value and those that we discard are subjected to a whole constellation of conditions. Artists' intentions may be one way of reading the art works they produce, for instance, but will only offer a partial understanding, in some cases leading to misunderstanding. It will require understanding of a wider kind to even begin to root some of the works we study into the social, historical and cultural, and still see them as art works.

Intention as a means of understanding an artist's work had of course been the standard approach to dealing with recalcitrant works refusing to yield their wares. This approach has been called into question. It is often the case that artists' intentions are not recoverable or are simply expedient historical calculations that support ideological constructions of artists and the function of their art. It is not a natural process, somehow a given, it needs to be seen as part of a wider set of cultural practices. Some cultures do not have artists as we understand the term and the construction of the artist as male and an alienated individual, culturally and historically located as it is, is still the major image that underpins the skimpy text. He, usually he, was well represented in earlier versions of the document. The fact that the last document has chosen to remove all artists names does not remove the problem. The initial

working party version of the curriculum at least acknowledged that teachers' own art education has ill equipped them for a Post-Modern period that has gender, race and class on the agenda. It did provide the teacher with references, and the fact that their removal was in part due to teachers' sense of confusion when faced with artists and designers who were unfamiliar to them, is an indication of the need for support, not a justification for the removal of the objects from the field of vision in one ostrich-like move.

There are then several fundamental flaws in the National Curriculum for Art, one of them sited in the emphasis on formal language, i.e. pattern, texture, colour, line, shape, form and space. What is inadvertently emphasized is the idea of the creative act somehow being an amalgam of these elements. How? Work has been made that looks like recourse to formal elements as the sole act of creation – but looks aren't everything. It has become accepted as natural that art teaching should be centred around the process of the formal elements. No doubt the teaching of morals and rhetoric once seemed natural too, and 'how many angels can dance on the head of a pin' was a pressing concern. Of course pupils need access to skill-based work but twenty-first-century youth also needs a visual vocabulary that enables them to decode visual images, not just the means of reproducing what they see, but with 'feeling'. That the future will be visually complicated is understood. That young people will need more to equip them for the end of the millennium than nineteenth-century illusionist mimetic techniques is accepted by most. The National Curriculum does acknowledge some of these problems but it fails to accept the complications that will ensue if teachers are asked to deliver what they see as a revised curriculum that the National Curriculum Council advisors perceive to be improved through the 'removal of unnecessary text'.[3] The emphasis on the formal elements, making little sense with much modern art that eschews their use, plays into a concept of art making that is at odds with the reality of pluralism and contemporary art practice. Artists never work in isolation, they are never the sole originators of a work of art, they are never 'free' from social, political and economic constraints, anymore than a child is a free agent in the classroom. A day spent visiting six different classrooms will quickly eliminate notions of child-centred creativity as the basis for art making; departmental skills, enthusiasms and teacher commitment, as well as resourcing, are what is visible. But the mythologizing around creativity and artist, Modernism and aesthetic value still abounds in even the most pragmatic department. What the National Curriculum for Art attempts to sustain, albeit unwittingly, is still the conception of art as above social, political and ideological implications. This other-worldly attitude is of course imbedded visually in the artist as teacher – the only teacher who can dress that badly with barely a look of reproach from the head teacher. Eccentricity and absence from the 'real world of management' have of course been widely utilized by the ever-resourceful Head of Art, but it is a small indication of art's status as somehow 'other', not concerned with the exegesis of the every day, existing on a more spiritual plane. Design students of course are often disenfranchised from art departments who utlize Fine Art mythologies. Add to this equation the notion that the child shouldn't be anything but an unpolluted source of authentic feeling, creatively unfolded/ unlocked by the pleasure of working on the inner self, and the difficulties abound. Children must, it has been argued, be separate from the social and political. Attempts to divorce art from its social origins have a long history, gaining ground with Greenbergian Modernism. The call for painting to be situated in its social and economic setting is hardly new, however. There was a nineteenth-century German tradition of this kind of art study long before being taken up by John Berger in the 60s and crucially T.J. Clark in the 70s, so why has it taken so long to enter the last bastion of formalism, the nation's art rooms? Some still 60s-lead fine art departments have resisted changes to art practice since Pollock's death: the images may change but the rhetoric doesn't. Why has the National Curriculum for Art half acknowledged this issue by putting in 'ideas', but failed really to take on board the possibility of a radically different agenda, by not acknowledging the complexity of the tasks they have set.

Implicit in the National Curriculum for Art is acquiescence to a status quo imbedded in an artistic practice based on a largely Modernist tradition (not without its strength of course); but the purity of high Modernism, coupled with the so-called purity of the child's vision (such a major motivation in the quest for an authentic voice in the work of Karel Appel, Dubuffet et al.) has hindered a move to a more dynamic and importantly relevant art education.

The National Curriculum for Art is part of an institutional structure committed to some notion of an art that is necessarily of itself good. If art educators are a little dismayed at its length, they have taken heart that its lack of incisiveness confers an 'anything goes' philosophy. Visual culture can then become an unproblematized area of the curriculum, not one that has suffered the soul searching of the English and History National Curriculum documents: which writers do we work from? Whose history do we teach?

If, as the National Curriculum for Art (and even the title is problematic, visual culture is less specific and encompasses a broader range of practices) states, it is necessary to acknowledge that other cultures do exist and are cultures worth working with, it is also necessary to accept that other cultures do not operate on the same value systems. The notion of self expression itself is culturally specific and not universalized and so presents a major problem when evaluating say a Javanese print. Applied arts and painting in western culture do not carry the same connotations, their respective places in the museum or art gallery are indications of the status that they are awarded. Handicrafts are still perceived as popular and utilitarian or at best decorative. Fine Arts are usually perceived as elitist and idealist, with a slide into the decorative being seen as a grim fall from grace. In Fine Art, utility is ousted by contemplation. That craft is a sullied concept within Modernism and indeed British education as a whole is implied in what Paul Greenhalgh has identified as 'a dichotomy of falsehood',[4] and is evident in craft's peripatetic search for a home in the school and art college curriculum. The inclusion therefore of crafts from other cultures, worthy though that is, does not acknowledge the status accorded to craft in western culture, and thus all too easily can reduce the creative output of whole civilizations to ethnic craft making. Women have also been marginalized by the established placing of traditional areas of women's skills as outside fine art practice – no matter that Oldenberg's wife stitched up the soft sculpture. Women's craft practices are placed in an ambiguous position that is not helped by a curriculum that does nothing to tackle assessment, notions of quality and evaluation.

If pluralism is to mean anything and the National Curriculum at least accepts that much, a future art history/art practice that really does embrace knowledge and understanding will have to broaden its agenda and crucially re-evaluate its hidden assumptions and desires. A curriculum needs to include television, video, photography and film. Pupils will at least see the relevance of the curriculum and probably tolerate some of the art teachers' more Luddite tendencies. Art teachers will no doubt feel the possibility of kitsch and the ghost of Clement Greenberg knocking at the door, but no matter.

Feminism has already challenged the central orthodoxy of Modernism – the construction of the artist as genius – this construction being gendered in the masculine. This understanding of gender as socially constructed rather than biologically determined has had its effect on art production and the way in which art history is written about. The National Curriculum for Art would like to see more women artists used in the classroom but this only amounts to tokenism; it does nothing to undo the structures that hold in place received opinion which argues that women's art is derivative and not innovative enough to gain a place in a canon defined in a masculine culture. The dead Frenchman model is a hard paradigm to shift. Feminism's most significant impact has not been merely to broaden the agenda to include misrepresented women, but to make systematic inroads into the structures that support existing models of art practice and its supportive history. The sometimes subversive skirmishes of, for example, The Guerrilla Girls collective[5] have identified the institutions as the repository of ideological constructions of gender and power. The National Curriculum for Art by implication or default falls into a model of helpless complacency by not taking these issues on board. The assumption that the delivery of these issues is unproblematic does little to help teachers.

With this broadening of the media and range of art works and an understanding of the structures that make up art history's chosen objects, it is necessary to have a lessening of a Euro-centric emphasis. Currently the survey approach dominates, for example, 'A variety of cultures, western and non-western'. It is necessary to go beyond this in order to 'absorb', reflect, and understand another culture, and here the National Curriculum for Art finds itself 'looking through the glass darkly'.[6] There is little at present to cope with other cultures beyond using western standards and notions of quality and western systems of analysis. The National Curriculum for Art ignores this problem. To apply notions of classical or modernist appreciation to other cultures is inappropriate, as the

power relations are not equal, and the works do not fit the model. The notion of quality is problematic enough in western culture without cross-cultural transference.

So where does that leave us – with a National Curriculum that promotes an almost multi-cultural approach, with an eye to the National Heritage? Is the National Curriculum for Art just another form of cultural plundering? Rasheed Araeen points to the difficulty of change in this area when writing about the establishment of a 'new internationalism'. 'It would be naive', he suggests, 'to think that there would be no attempt to obstruct or sabotage the development of a new internationalism if it is realized that this might challenge the existing system and its privileges. The obstruction may, as has often happened in the past, be in the form of an institutional intervention which appears to be in support of cultural egalitarianism but in reality only reflects an ongoing paternalism.'[7] To be sanguine about it at this juncture seems inappropriate. That an opportunity has been lost between the initial documentation and the final minimal orders is obvious. The paring down to essentials might make for faster reading, but it does not adhere to the 'If I'd had more time I'd have written you a shorter letter'[8] approach. More time in this case has left teachers with no visible means of support. A kind of Minimalism without the coherence of a sound theory.

The introduction of 'knowledge and understanding' is essential to a healthy modern curriculum of relevance to young people. Much modern art acknowledges the need to comment on the past, for example the work of Barbara Kruger and Anslem Keifer – a cue that the National Curriculum for Art could heed. If the curriculum is to do more than reinforce stereotypes or add a few more names to the pantheon of greats it needs to acknowledge that its own past was specifically located within practices that were not value-free, no matter how comforting a flight into formal values and aesthetics might be. It needs to recognize that adding a multicultural and feminist agenda requires at the very least a glance at how these things stand in relation to the values already in place.

NOTES

1 Ricoeur, P., 'Civilisation and National Cultures', *History and Truth*, trans. C. A. Kelbley (Evanston North-western University Press), 1965 quoted in Owens, C., 'The Discourse of Others: Feminism and Post modernity', in *Post Modern Culture*, ed. H. Foster, Pluto Classic, 1983.

2 'Difference without antagonism' was the phrase used during Roosevelt's New Deal in Depression hit America of the 30s. It was used to describe the programme that promoted Black Arts, part of an attempt to democratize the visual arts then seen as suffering from the malaise of an elitist European Modernism.

3 National Curriculum document (1995). School Curriculum and Assessment Authority, London, HMSO.

4 Greenhalgh, P., 'Art and Craft: A Dichotomy of Falsehood', *Ceramic Review* 116, 1989.

5 The Guerrilla Girls are an American Feminist collective that targets art galleries that do not show artists of colour or women's work. They use witty posters to identify areas of discrimination in the art world.

6 I Corinthians 13:11, The Bible.

7 Araeen, R., 'New Internationalism or Multiculturalism of Global Bantustans', *Global Visions*, Kala Press, 1994, pp.3–11, reprinted here ch.10.

8 Pascal, B., 'I have made this longer than usual, only because I have not had time to make it shorter', *Lettres Provinciales*, 1657, no.16.

MAKING SENSE OF THE NATIONAL CURRICULUM ATTAINMENT TARGETS FOR ART

A PHILOSOPHICAL PERSPECTIVE

NICK MCADOO

Since I first wrote this paper, the original trilogy of attainment targets (ATs) dominating the first draft of the National Curriculum for Art.[1] 'Understanding', 'Making' and 'Investigating', has been reduced, in the 1992 version[2] to two. Amazingly, however, we seem to have ended up with more than we started with - namely, (1) 'Investigating and Making', and (2) 'Knowledge and Understanding' - perhaps in deference to the time-honoured principle that in art, at any rate, 'less means more'!

In essence, the two new ATs, like the original three, may be seen as an attempt to remedy the following educational problems: (a) the widely prevailing imbalance between the development of creativity and appreciation; and (b) the often very haphazard way in which art educators relate aesthetic form to thematic and expressive content (or to put this in plainer English, art to life). This latter problem seems to be the main focus of the first target, although the complex relationship between 'investigating' the world and transmuting the results of this investigation into an aesthetic form is never very clearly addressed. In fact, the choice of 'investigating' as a sub-title here is doubly

unfortunate, not only because of its normal associations with scientific method which the document does little to dispel, but also because, strictly speaking, 'investigating' is only ever a means to the end of gaining understanding and therefore not something that can be targeted on its own. I shall return to this problem in due course.

The current widespread neglect of appreciation, doubtless a reaction to earlier, more rigid styles of art teaching, has long been in need of attention. Not only has this state of affairs deprived the art curriculum of a rich and varied content both European and non-European, but it has also had the effect of limiting rather than liberating children's creative powers for, as the National Curriculum pointed out:

> without adequate sources ... many pupils tend to use stereotypical symbols which communicate only at a superficial level. [3]

Furthermore, while not every child will grow up to be an artist, all grow up, for better or worse, to be appreciators of art and their environment with important consequences for their future happiness.

The second problem arises in so far as much current art teaching would appear to be dominated by a narrow aesthetic formalism, especially at GCSE and 'A' Level where the 'still-life' so often calls the tune. This too, may possibly be seen as an over-reaction to the kind of Philistine approach that overemphasized the idea that paintings should 'tell a story', thereby tending to produce works of conspicuous aesthetic banality. Nonetheless, today's currently fashionable 'formalism' seems equally one-sided in so far as the subject matter of painting is seen only too often as a mere peg on which to hang the garment of aesthetic form.[4] As such, it fails to recognize that other function of art which, as an earlier draft of the National Curriculum pointed out, is to reflect and comment upon the 'complexities' of life.

APPRECIATING AND CREATING

Let us turn first to the document's attempt to harmonize the appreciation and production of art. Uppermost in the minds of the authors here is the classroom where:

> A narrow range of [art] activities has been dominant, centred almost entirely on 'making' and accompanied by an uncritical reliance on pupils' possessing instinctive powers of self-expression.[5]

How has this come about? Often as a result of the widespread belief that artistic creativity and appreciation are so subjective that each child's individual potential, as David Best has ironically pointed out, 'can be fully realized only by avoiding all formative influences'.[6]

This view may have originated, in part, as a reaction to the kind of art teaching which simply handed down artistic knowledge from on high, with students simply there to be 'educated' and their responses not to be 'listened to' in any way. The problem with the 'subjectivist' view is that in treating all aesthetic response as irreducibly personal, which automatically rules out any possibility of querying the appropriateness of the response to the work itself, it completely cuts the educational ground from under its own feet, for what is there left to teach? We are already, each of us, the leading authority on our own personal tastes, and who is the teacher to tell us otherwise? In fact many 'subjectivist' teachers not only admit this, but actually proclaim it - as in David Best's celebrated example of the dance teacher who is reported to have said that 'Dance is such a subjective matter that there is nothing that can or should be said about it!'[7] The fact that many such teachers nonetheless 'carry on teaching' merely illustrates how easy it is to live with a contradiction upon which one has never reflected.

Of course the 'subjectivist' position does contain a half-truth: at the heart of artistic creativity and appreciation lies an irreducibly personal and spontaneous element which can never, even in principle, be subject to any set of rules. This is because, if it could be regulated, then creating and enjoying art would become quite mechanical activities which we could nowadays leave to our computers to carry out for us. However, although artistic creativity can never be rule-governed in the same way as, for example, mathematics, it must clearly be governed by 'rules' of a sort in the sense that, however open-ended our conceptions of art, not just anything can be a 'painting' or a 'drawing' or such terms would be meaningless.

In all cultures, art is subject to conventions, traditions, styles and techniques which may be followed, questioned or rebelled against but which cannot be ignored on pain of unintelligibility. To think therefore as the 'subjectivist' teacher does, that the student is most liberated when most shielded from such a background is to display the same kind of innocence as that of the dove in the celebrated parable of the eighteenth century German philosopher, Kant:

> The light winged dove, cleaving the air in her free flight, and feeling its resistance, might imagine her flight would be still easier in empty space.[8]

The message that this carries for art education is that the child artist, full of his or her own originality and spontaneity, inevitably comes up against a whole range of constraints that paradoxically both set limits on, and yet at the same time make possible, the creative act. For a start, of course, the child's activity must reflect his or her own concept of art, which will inevitably reflect the culture that shaped it, while at the same time being modified by new ideas that the teacher may introduce. This is why the National Curriculum's first attainment target rightly emphasised the need for all students to develop their appreciation of the richness of our diverse cultural heritage.[9]

For example it is often a major new discovery for children to find out that art does not have to be representational, as in the case of modern abstract art, or that it can take real liberties with the every-

day world, as in the case of Cubism or the fantasies of Chagall. The history of art is full of such moments, such as the Impressionists' discovery of Japanese landscape prints, or Picasso and Braque's discovery of African masks which exerted such a profound effect on the genesis of Cubism.

What else does the student artist come up against? Obviously, the limits of the physical medium in which he or she is working such as paint on paper, chisel on wood, or clay spinning on a wheel, which have all generated a whole range of skills to be mastered. This, of course, is the main focus of AT1, which is probably why it has been sub-titled 'making' rather than 'creating' to emphasize that in many, if not all cases, it is really 'ten per cent inspiration and ninety per cent sweat!'

The next kind of constraint is of a very different kind, namely the demand that the work be in some way faithful to its subject matter. It is not, of course, a necessary condition of art that it always has to depict the world as it is, for this would be to rule out both purely abstract art and the art of fantasy. Nonetheless, much art does deal with the real world whether it be a primary child painting his or her best friend or Picasso painting a weeping woman. Where this is the intention then considerations of being in some way 'true to life',[10] not to mention the moral dimension that this brings with it, must have a significant impact not only on the shaping of the work but also on our appreciation of it. In particular, children need to learn that 'close observation; is only one of many ways in which artists have sought to explore the world and, as the National Curriculum pointed out, it is quite a 'limited' one at that,[11] although highly influential in European art between the Renaissance and the end of the nineteenth century. I shall return to this point in the next section when I come to consider the nature of 'significance' in art.

The student then, like any artist, comes up against all these constraints, and out of the ensuing struggle, which is often hard and sometimes seemingly effortless, comes the work of art. But now we come to the final constraint. One of the most fundamental of all features about any work of art is that it is nothing without an audience to appreciate it. This would be true even where the artist is the only person to see his or her own work because even in the most private acts of creation artists must from time to time step back and pass judgement on the work in progress. In fact artistic creativity would be inconceivable without such judgmental checks. Furthermore, this can never be a totally private act because in becoming appreciators of their own work, they must inevitably enter the more public world of their potential audience, either through discussion with others or internalizing such discussion within themselves. This is because, as the French philosopher Jean-Paul Sartre points out for literature, and it is just as true for the visual arts:

> It is the joint effort of author and reader that brings upon the scene that concrete and imaginary object which is the work of the mind. There is no art except for and by others.[12]

To lose sight of this, as happens from time to time with avant-garde art, brings not greater freedom but an impossible isolation for the artist.

However, although art appreciation should properly be understood as central to any artistic activity in so far as it aims to provide the most fertile climate in which the artist can flourish, in many people's eyes it has come to be seen as somehow rather inferior to the creative act. This may be in part due to its unfortunate associations with the narrow élitism of the art 'connoisseur' or the stereotype of the 'heartless, analytical critic'. It may also be due to the fact that it is perceived, quite wrongly as a rather passive, supine activity by comparison with the dynamism of the creative act. Once again, such attitudes may be attributable to the sterile way in which art appreciation has often been taught in the past. Properly understood, however, appreciation is itself a very dynamic act, making high demands on what the National Curriculum in 1992 called the students' 'ability to engage with an artefact'.[13] This requires powers of concentration, intelligence, imagination and a capacity to feel, not to mention an adequate background knowledge of the traditions from which the work has sprung.[14]

The work of art then, needs an audience to breathe life into it, but not just any audience. What is really needed is an educated audience which, as the National Curriculum rightly recognizes, requires not just a background knowledge of art in all its extraordinary variety, but the development of powers of judgement. Here once again, however, we come up against the popular belief that the subjective nature of appreciation makes it ineducable, as embodied in the trite slogan that 'beauty is in the eye of the beholder'. What is most unsatisfactory about this belief is its tendency to

confuse two quite separate senses of 'subjective' - namely (i) the self-evident sense in which all perception and emotion can only take place in a perceiving and feeling subject, and (ii) the quite different and far more dubious sense in which all taste is seen to be totally relative to the individual. Of course it cannot be denied that there is a personal dimension to appreciation and that furthermore, works of art, unlike scientific facts, are often able to sustain a variety of legitimate, even if contrasting responses

Nonetheless, this is by no means to accept the subjectivist's view that 'anything goes' which arises, as we have just seen, from illegitimatley running together the tow differing senses of 'subjective' mentioned above. Thus for example, one might see Munch's famous painting The Dance Of Life either as tragic or, perhaps, as bathed in wistful nostalgia. There is no way however, that one could see it as a jolly country dance in the manner of Breughel!

The problem that really needs addressing here is a central paradox, familiar to aestheticians since its discovery by Kant in the eighteenth century.[15] Which is this: on the one hand, aesthetic judgement depends for its authenticity upon a personal response, yet on the other hand, unless we can in some way justify that response, however tentatively, by reference to features in the work itself, then aesthetic judgement (and along with it, aesthetic education) would be quite pointless. As David Best says:

> While an artistic judgement expresses a personal attitude to a personal experience, there are reasons for it ... [16]

as when, to take a fairly straightforward example, I justify the 'cheerfulness' that I find in a Matisse by reference to its bright colours and dancing lines. Such 'reasoning' may lack the hard edge of objectivity that one finds in science, but it is all that we have got to stand between us and the kind of anarchy which would make art education of any kind impossible.

Interestingly, such 'reasoning' often displays itself most persuasively not in highly articulated critical theory, but in the kind of intuitive judgements that underlie the ebb and flow of our most animated talk about art. As Sibley puts it:

> What we have to investigate is ... the reasons and justifications ... we ... give in non theorising moments to support favourable or adverse judgements or particular works of art.[17]

It is unfortunate that the National Curriculum, while rightly emphasizing the crucial role of discussion, has not gone further into how the teacher is to reconcile the subjective and objective demands of art.[18]

AESTHETIC FORM AND SIGNIFICANCE

I referred at the beginning of this paper to the often very random way in which art teachers relate art to life. I shall illustrate this with two very contrasting examples of what can go wrong. First, there is the teacher who, full of enthusiasm for some new-found approach such as spatter-painting or computerised design, plunges the students into its aesthetic possibilities but is quite indifferent as to the choice and significance of the subject matter. Then, at the other extreme, there is the teacher who, full of some exciting idea such as the exploration of a powerful emotion is so caught up in the development of the theme that the aesthetic form in which it might be explored (for example, bold, abstract expressionism for the emotion) is either quite overlooked or regarded as of only minor importance compared to the meaning that the children should be exploring.

The first teacher rightly focuses on the aesthetic delights to be found in the play of colour, line, texture, balance, and so on, but in downgrading the signifying side of art is in danger of making it a fundamentally unserious activity having little bearing on the rest of life. The second teacher, by contrast, while making the life issues central, completely fails to show the children what is so distinctive about art. As such it invariably invites the sceptical question: 'What is so special about making a picture of x when you can go out and experience the real thing?'

Now although the 'investigating' aspect of AT1 serves to alert us to the important relationship between art and life, it also at the same time obscures this by never adequately identifying what artistic 'investigation' is supposed to bring about. To say, as the authors do, that

> through investigating, pupils will learn to be visually perceptive and to visualize ideas[19]

is unhelpfully circular, leaving quite unanswered the key question: 'What is all this activity aiming at?' Perhaps the closest we get to it is the statement that

> through observing and recording their experiences of the world around them, [pupils] may come to know its complexities[20]

but as it stands, this does not seem much different from scientific method. Now artistic understanding may at times come close to scientific understanding, as in the case of Leonardo's anatomical drawings, but it can never be identical to it, or there would be no point in calling it 'art'. In fact, as with Leonardo's drawings, what really makes the 'close observation' work of children so aesthetically attractive is never primarily its accuracy but rather the expressive element that still manages to break through despite the quasi-scientific goal. As the French philosopher Dufrenne says:

> The aesthetic object is distinguished from ordinary objects which present themselves through impoverished sensations, dull and transient, and promptly hide themselves behind a concept ... It is necessary that the object exert a kind of magic so that perception can relegate to the background that which ordinary perception places in the foreground. [21]

We may see this, for example, in the strange magic of Van Gogh's chair, Hokusai's wave or Monet's poplars.

What the 'investigating' aspect of AT1 fails to address adequately is the fact that all art which draws its inspiration from the world around us (from the most representational to the most abstract) aims to transmute its subject matter in the process into an aesthetic configuration. However, we need not really worry here because this is already more than adequately covered by the second AT! Thus, as part of 'understanding' art, pupils are required to look not just at its history and techniques but also at the richly varied ways in which artists themselves have aimed at understanding the world.

I cannot for the life of me see why we need to weigh down AT1 with the burden of 'investigating' which, as I hope I have shown, is both redundant and confusing.

The Importance of Aesthetics

Most of the problems that I have been discussing may be seen to arise from the failure of art educators to take sufficient account of aesthetics. Sadly, the same is largely true of the authors of the National Curriculum who conspicuously fail to consider what the study of aesthetics itself might contribute both to the underlying rationale of art education and to the actual content of an arts curriculum. True, for one brief moment, the Interim Report of the Art Working Group did suggest that some aesthetic issues might be introduced to older pupils, but this was quietly dropped in the final proposals without explanation. I should therefore like briefly to fly the flag for this neglected field of study and also to offer a few reasons for this neglect which I hope will themselves shed some light on some of the current problems that face art education.

Contrary to popular belief, aesthetics has its roots not in Olympian and abstract theory but rather in a natural wonder and curiosity at the very existence of art. As the philosopher, Frank Sibley puts it:

> People are puzzled by the strange power ... which works of art may exercise over them. We find ourselves, and to our surprise, filled with delight by pictures or sculpture and it is unclear why they should so affect us. We find ourselves ... moved, fascinated or disturbed, and by what we know full well to be mere fictions ... Often we are affected by them almost more than by realities. [22]

Out of such puzzlement the philosophical questions begin to form. For example, starting with the enigma of why we should be so captivated by Van Gogh's painting of what is, after all, only a very ordinary chair, we may be led on to ask fundamental questions about the differences between artistic and everyday perception. Similarly, our surprising ability to enjoy a painting with such a disturbing theme as Picasso's *Guernica* may lead us on to question the very nature of aesthetic pleasure or the strange power of art to both engage and distance us from the real world. Probably the most familiar philosophical question of all is simply 'Is it art?' Interestingly, this question underlies the one and only example of real aesthetic enquiry to find its way into the 1992 version of the National Curriculum when the authors made the enterprising suggestion that children might

> make a list of all the things they have at home which they consider to be examples of art ... [and] discuss their findings with their teacher and peers.[23]

Such self-evidently important and fascinating questions as these form the life-blood of aesthetics. Why then, have they been so ignored? The most obvious reason is the plain institutional fact that aesthetics is rarely taught outside departments of philosophy, although this may be as much a symptom as a cause. Undoubtedly many people

working within art education are quite happy with this arrangement, for if this were not the case, why has aesthetics not enjoyed the same popularity in art colleges as, for example, the history of art and art criticism?

Looking beyond the institutional facts therefore, I would suggest that one of the main reasons for the relative neglect of aesthetics is simply that it has always suffered by comparison with the brilliance of its subject matter. The individual work of art is vivid, concrete, sensuous and expressive. Aesthetic theory, by contrast, is of necessity abstract and often prosaic in its delivery. This view is also linked to the even more widely held one that any talk about art must pale beside our direct experience of the work's perceptual and emotional riches. The critic George Steiner, for example, gave voice to such a view in his book *Real Presence*,[24] wherein he argues that rather than stuffing ourselves full of critical theory, we would do far better to fall silent before the awesome presence of the work of art itself. But Steiner himself pours out a torrent of words in order to make out a case for silence before the work! What he should have done was to follow the advice of the philosopher Ludwig Wittgenstein that 'whereof we cannot speak we must remain silent'.[25] The fact is that despite the seeming contrast between talking about art and experiencing it at a perceptual and emotional level, language and experience depend upon each other at every point, as the National Curriculum, to give it its due, is at pains to emphasize. Without language we would not so much live in a world of direct experience as a totally unintelligible one. Kant illustrates this by comparing language to an irremovable pair of spectacles that make it possible for us to 'see' the world. The temptation is always to think that if only we could remove the spectacles, we would somehow see the world more clearly, but in reality, without them, we would see nothing at all - not even a confused jumble because 'confusion' is itself a concept, and quite a sophisticated one at that.

STRUCTURE AND SPONTANEITY

I should like to close with what is probably worrying art teachers most about delivering the National Curriculum: how is the demand for a tighter structure to be reconciled with the need to preserve an important place for personal spontaneity? This appears less of a problem, however, if we remember that artists themselves, as I hope I have shown, have always been pulled two ways here. Thus, while there must always be an involuntary element in aesthetic response that can never be produced to order, at the same time works of art are always structured, and that is as much part of their appeal as their spontaneity. As Paul Crowther says of the work of Jackson Pollock:

> the tension between spontaneity and finish in a Jackson Pollock drip-painting may make us aware of a similar tension between the yearning for spontaneity and the yearning for order in our own lives.[26]

This finds an echo in the implicit message of the National Curriculum that effective art teaching should seek to satisfy both these needs rather than going overboard on one or the other, as has happened so often in the past.

NOTES

1 DES, *The National Curriculum: Art for Ages 5 to 14.* London, HMSO, (1991).

2 DES, *Art in the National Curriculum* (England). London, HMSO, (1992).

3 DES, op.cit., note 1, para. 3.15.

4 See McAdoo, N., 'Can art ever be just about itself?', *The Journal of Aesthetics and Art Criticism,* (1992), vol.50 (2).

5 Ibid. para. 3.4.

6 Best, D., *Feeling and Reason in the Arts.* London, Allen and Unwin, 1985, p.45.

7 Ibid. p.14.

8 Kant, I., *Critique of Pure Reason* (trans. N. Kemp Smith), London, Macmillan, 1964, p.47.

9 DES, *The National Curriculum: Art ages 5 to 14*, SCAA, 1994, p.2.

10 See Elliott, R.K., 'Poetry and Truth', *Analysis,* 1966, vol. xxvii.

11 DES, op.cit., note 1, para. 3.22.

12 Sartre, J.P. (1950) *What is Literature?* (trans. B. Erechtman). London, Methuen, pp.29-30.

13 DES, op.cit., note 1, para. 4.6.

14 See McAdoo, N. (1987) Realisation in aesthetic education, *Journal of the Philosophy of Education,* 21(2).

15 Kant, I. (1966) *Critique of Judgment* (trans. J. Bernard). New York, Haffner, para. 56.

16 Best, op.cit., note 6, p.45.

17 Sibley, F., *Philosophy and the Arts,* lecture, University of Lancaster, 1966, p.11.

18 See Sibley, F., 'Aesthetic concepts', in J. Margolis, ed., *Philosophy Looks at the Arts,* New York, Scribner, 1962. See also N. McAdoo, 'Aesthetic education and the antimony of taste', *British Journal of Aesthetics,* 1987, 27(4).

19 DES, op.cit., note 1, para. 4.14.

20 Ibid. para. 3.7.

21 Dufrenne, M., *The Phenomenology of Aesthetic Experience,* (trans. E. Casey), Evanston, Northwestern University Press, 1973, p.266.

22 Sibley, op.cit., note 17, p.10.

23 DES, op.cit., note 2, p.29.

24 Steiner, G., *Real Presences*, London, Faber and Faber, 1989.

25 Wittgenstein, L., *Tractatus Logico-Philosophicus*, London, Routledge and Kegan Paul, 1960, para. 7.

26 Crowther, P., 'Alienation and disalienation in abstract art', in A. Harrison ed., *Philosophy and the Visual Arts*, Dordrecht, D. Reidel, 1987, p.130.

CHAPTER FOURTEEN

'AS WELL AS PAINTING'

DAVE ALLEN

Although it may be somewhat unfashionable, during the course of this chapter I intend to propose that the revised Order for Art in the National Curriculum, published at the end of 1994, goes a long way towards creating the context and opportunity for a significant and overdue development in the teaching of the 'visual arts' in English schools. The term visual arts is used here to describe any pedagogical practices in which making or understanding visual artefacts is a primary purpose and the focus will be on Art and Design and Media education. However, it is important to recognize that visual information has an important place in the teaching of most subjects and that this is likely to increase given the proliferation of new and often cheaper technologies.

This situation partly reflects the 'information explosion' with which the world is coping as we approach the millennium, and the extent to which information is presented visually makes it vital that we educate children to be visually literate as well as numerate and literate in more traditional ways. However, I have argued elsewhere (Allen 1994) that our concept of 'visual literacy' needs to be more sophisticated than it has been, in order to meet the contemporary challenge. Briefly the argument is that literacy refers to two related processes: 'reading' and 'writing', the latter concerned with oral and written practices, and that a comprehensive understanding of literacy should be derived from the cultural activities of all the members of a society not merely those who pro-

duce or engage with specific kinds of texts. For example, it is difficult to refute the argument that children should be enabled to become critical readers of broadcast television and, while television is not exclusively visual, it is significantly a medium which we watch. Hence 'visual literacy' should encompass an understanding of television images. However it also needs to enable children to inhabit the world of the artist, as makers as well as spectators and this dichotomy between what might be called fine art and popular or mass-imagery is a key issue for contemporary visual education and one that will be addressed in this chapter.

I will begin by describing what I believe to be the dominant practice in Art and Design education in schools, suggesting that this is a culturally and pedagogically limited practice, which no longer provides an adequate education for visual literacy in the 1990s. The development of the Order for Art in the National Curriculum will be described as reflecting the complexities of meeting this need with a suggestion that the most recent version is also the most appropriate. Finally, I will propose the concept and practice of 'collage' as an effective route to an education for visual literacy.

In May 1990, I was joint author of a research report commissioned by the Arts Council (O'Connor & Allen, 1990) and concerned with work in Art and Design and Media Education –described as 'the broader visual arts curriculum'. One aspect of the research used random surveys, interviews and 'opportunist spot-checks' to discov-

er which educational publications were most widely used by the teachers of these subjects. No attempt was made in that research to examine any more subtle links between educational literature and current pedagogical practice but an assumption was made that where specific publications were being purchased in large numbers by teachers either:

 i. the publication might be part of innovative curriculum development or

 ii. the publication would record or promote current 'good' practice.

The research was carried out during the late 1980s, as the Education Reform Act was leading to the shaping of the National Curriculum. In terms of publications we found almost no cross-over between Art and Design teachers and media teachers and most publications concerned principally with lens-based media were purchased and/or read by media teachers or photography specialists.

In the Art and Design survey, carried out randomly with secondary school teachers in Birmingham, Hampshire and Devon we received 69 replies (from 150 approaches) about publication-purchasing by school departments and individual teachers. In that small-scale survey, Clement's *The Art Teacher's Handbook* (1986) was significantly most popular, purchased by 87% of respondents. The following six titles were identified by more than 10% of respondents:

 87% – Clement (1986)
 57% – 'HMI' (DES 1983)
 52% – Adams & Ward (1982)
 48% – Taylor (1986)
 46% – Palmer (1988)
 36% – Thistlewood (ed. 1989)

Given the nature of the research some of the interpretation of these figures was and is speculative, although wherever possible over the following six years (conferences, school visits, INSET sessions etc.) I have taken the opportunity to check the evidence and found other responses broadly consistent with those figures. At the time, HMI and Adams & Ward were near the end of their significant sales period but the others have continued to sell and I have some statistically confidential evidence to suggest that up to 1993 Clement and Taylor have probably sold as well as almost any books on art education in the subject's history. I would suggest that in terms of the distinctions (above) Taylor contributed significantly to a major development in the teaching of art and design dur-

ing the past ten years (Critical Studies) while Clement exemplifies typical 'good practice' evident in so many art departments in the 1980s. Because such publications are conveniently accessible, it is also possible to claim that for future generations they will be seen as key texts for research into the teaching of the subject during a key period in its history.

A recent review of the second edition of Clement's handbook appears to reinforce this view. In the *Journal of Art and Design Education* James Hall (1994) described *The Art Teacher's Handbook* as 'widely acknowledged as a comprehensive guide to good practice in all aspects of art and design teaching from upper primary to secondary level.' (p.316)

He also described how the second edition (1993) 'takes account of' the introduction of the National Curriculum and other 'significant developments' in the subject since its initial publication in 1986. These significant developments were listed as:

- The introduction of GCSE
- An increasing emphasis on critical and contextual studies
- Extending the use of IT in classrooms
- The introduction and development of technology
- Developing relationships between art and design and other curriculum areas

Another important point made by Hall is the extent to which the author produced it by drawing upon his experience as the longest serving Advisor for Art and Design and his extensive involvement at Schools Council and the National Curriculum Council where he was a member of the original Working Group for art and Hall suggests that the book is 'grounded' in the 'richness and diversity' of teachers' practice. For all these reasons, the publication might be interrogated as representing typical approaches to the teaching of Art and Design over the past decade. If so, what is this 'typical' practice?

We can find in Clement that certain 'realist' and 'expressive' approaches and specific materials appear again and again in the examples of children's work. For example a content count of the illustrations he uses to support and inform the text reveals that, of 117 identified illustrations

- 92% (107) are observational works of objects, animals environments, people etc. and
- 64% (75) are pencil drawings or paintings, whereas only

- 10% (12) use mixed-media (paint, glue, ink, drawing etc) and only
- 10% (11) are 3D (clay, metal, wire, mixed-media)

In addition there are four examples of photographs found by or given to pupils as a stimulus for art work but there are no examples of work *by* pupils in photography, video, computer design, installation, 'live' art, environmental art etc. Remember that this is possible the best selling art book among contemporary art teachers, described by Hall as 'widely acknowledged as a comprehensive guide to good practice in *all aspects*' of the subject (my emphasis). You may wish to suggest that I am complaining about an absence of practice which cannot be found, but, if so, I would recommend Isherwood & Stanley (1994), Newbury (1994) or Hornsby (1987, 1989, 1990) on photography and teaching, Layzell (1993) on 'live art' in schools, and the publications of the Arts in Schools Project (1990) and the National Foundation for Arts Education as useful starting points. They all record work outside mainstream media and forms, which have been successful in schools or with pupils.

In terms of the approach to critical studies, Clement (p.185) reproduces a list from one school, of over fifty reproductions of oil paintings from which pupils were asked to 'produced a new piece of work ... working directly from the reproduction.' All are from the tradition of post-Renaissance/modern western painting. This is not untypical of approaches to critical studies where pupils are asked to produce work *from* another image (usually a reproduction) selected from a very limited range (anything as long as it's French 1870–1914, see Allen 1990). Out there in the 'real' world, pop into any newsagent and buy an edition of 'The Great *Artists*' (my emphasis). Why not call it 'The Great Painters'?

Clement pays little attention to broader educational issues such as those of equal opportunities with respect to race and gender. His specific aims (p.12) make no clear reference to the issues and even his identification of the 'personal and social' as a 'basic aim' focuses on the 'quality of children's learning' rather than specific educational or social issues (pp.11–12). In addition, in the context of this chapter, it is interesting to note that his third 'specific aim' is 'visual literacy' which he describes as 'confidence and competence in *reading and evaluating* visual images' (p.12 my emphasis). Note that this is a limited use of literacy, only concerned with 'reading' images and it may not be a coincidence that, with Clement as a member of the Art Working Group, the first published Order for art also limited the use of the term visual literacy to the second attainment target ('understanding') while 'making' was linked to 'visual perception'. The latest Order does not quite shake free of that connection but creates the opportunity for imaginative teaching by stating in the programmes of study for all three key stages that 'in order to develop visual literacy, pupils should be taught about the different ways in which ideas, feelings and meanings are communicated in visual form.' (pp.2, 4 or 6). Although 'visual perception' is still tied to 'practical work there seems no reason why the kind of visual literacy defined above should not be taught through practical or 'critical' studies.

Like Clement, the *development* of the National Curriculum for Art (rather than just the Order) also provides valuable information about the teaching of the subject in the 1980s and beyond. For example, the consultation process resulted in a number of publications each of which identified, defined, argued for, proposed and promoted specific ideas of art education. For the purposes of this paper I wish to draw attention to the following from the Working Group Report (1991):

- The opening statement describing the 'pleasure' and 'practical use' to be derived from 'drawing, painting, designing and other activities.'
- The comment that the 'wider purposes of education in art and design' have to do with children learning 'as much through visual images as they do through words' – translated into the aims of the first Order: visual perception and visual literacy. The observation (2.2) that the 'wide range' of practices in art education reflect the 'diversity' of professional artists and designers. The Working Group offered a list which included graphic and product design; fashion; jewellery; photography; film & video; theatre design; the use of computers and 'other new technologies'.
- Despite this, the remark that in 'approximately' two thirds of secondary schools 'drawing from direct observation predominates' (2.9). They also referred to HMI evidence that 'in most schools the activities and aspects of art and design covered consist largely of drawing and painting, with some ceramics, printmaking and work in textiles. Apart from ceramics, there is very little three dimensional work.'

Both Carline (1968) and MacDonald (1970) record how the origins of art education and its emphasis on drawing lay predominantly in the concern that drawing was 'absolutely necessary in many employments, trades and manufactures' (Carline p.51). Drawing may continue to dominate but this rationale can no longer be sustained.

In addition, the Working Group observed that most secondary schools 'give inadequate attention to the appreciation and critical judgement of work by artists and designers ... Very few include a study of the work of designers, despite the importance of design in the world of work.' This specific emphasis on drawing, painting and sculpture was reinforced in the identification of artists in the non-statutory examples. Until the publication of the 'post-Dearing' revised proposal and new Order (November 1994), each publication included non-statutory examples and at each stage these appeared to contribute to the development of a canon derived from the major figures of Western art. Drawing almost exclusively on that Western tradition only the first two identified significant designers, and the artists in the examples may be categorized as follows:

tion, T-shirt motifs, body ornament, kites, aboriginal dream maps, wall-hangings.

The problem with these two sets of examples was that they posited two alternative approaches to the teaching of the subject: a canonical recognition of the importance of specific media and key figures and a mass or popular culture project identified by artefacts and with the odd nod in the direction of 'multiculturalism'. However there was no obvious acknowledgement of the inherent contradictions between these two approaches and no clear indication of how they might build on the typical practice of the day as exemplified, say, in Clement's publication. We need not be entirely surprised about this, since the same contradictions have bedevilled the worlds of art and art education for decades but whether the removal of the examples really solves the problem is questionable, since teachers will have worked with the original Order for some time before it is superseded in September 1995. The confusion in the Order reflects, as much as it creates, a growing concern in the teaching of the visual arts that schools must extend their concept of the visual if they are to offer pupils an adequate education for the future.

Publication	Total	Pre-1800	19th C	20th C (living)	Designers	Women
W Group	26	1	8	15 (5)	2	7
Proposals	25	5	5	6 (1)	9	5
Consultation	37	12	13	12 (1)	–	2
First Order	38	13	12	13 (2)	–	2

In terms of the non-statutory examples then, the suggestion is that the first Order presented a highly culturally-specific 'model' of Art and Design which, in both attainment targets, drew principally on the post-Renaissance 'high' art tradition of painting and drawing. In addition, each refinement of the eventual Order drew more substantially on historical examples at the expense of designers, women artists and contemporary practitioners. To an extent however, this tendency was contradicted in the other non-statutory examples addressing a broad range of 'visually communicated information' such as:

family photographs, cards, teacups, illustrations, buildings, African tribal art, computer images, comics, tv commercials, photographic montage, postage stamps, computer anima-

The question of the appropriate practices for art and design education will not disappear in a world where cultural, visual and technological diversity is a daily experience.

I want to argue that these contradictions are the consequence of the continuing influence of models of art derived from Western post-Renaissance painting and a specifically 'romantic' view of the artist as maker, within a culture where other kinds of mass-produced images increasingly dominate. The 'fine art' practices and their artefacts still proliferate and clearly continue to offer authentic experiences to many people but so do many of the products and practices of the mass-media and of mechanical/electronic image-making. Further, many cultural commentators are pointing out that we are entering a period in

which images may well be taking over from print as the dominant mode of communication while, as Robins (1993) suggests 'we seem to live in a world where images proliferate independently from meaning and from referents in the real world. Modern life appears to be increasingly a matter of interaction and negotiation with images and simulations which no longer serve to mediate reality.' (p.104)

What should visual art education be like within such a culture? Since I am clearly going to suggest changes, let me stress that one of the major challenges seems to be to hold on to what is valued from the long history of art teaching, while also enabling today's pupils to understand and create images which enable them to make sense of their world. In many cases the images may well have been produced by people from other times and/or places.

In part this argument rests on a belief that there is, and should be, a relationship between the practices and histories of mature artists and art education. There is little space here to do much more than suggest that this relationship has always existed while acknowledging that it has shifted from time-to-time in relation to other educational ideas. I wish to support this suggestion by drawing briefly on the accounts and arguments of some of the major influences and historians of art education in the United Kingdom. The following quotes, without comment, offer a brief chronological support for the argument that art and art education are linked in important ways:

Stuart MacDonald (1970), p.273 (of Charles Heath Wilson, appointed Director and Headmaster of the Normal School of Design 1843)

> His policy of imitating Classical and Renaissance art was the prevalent concept of art education held by the dilettanti, the upper class and the senior Royal Academicians of his day. (p.126)

(of Alphonse Legros appointed Professor of fine art at the Slade 1876)

> The Professor ... recommended students for travelling scholarships, the purpose of which was to study and copy the techniques of the masterpieces in European art galleries. (p.273)

Marion Richardson (1948)

> During my first summer holiday something happened which influenced me profoundly ... we passed the Grafton Galleries where the first Post-Impressionist Exhibition was being held (1910 or 1912). The day was hot and through the open door I could see into the vestibule. It was hung with pictures which in some strange way were familiar and yet new to me.
>
> Impertinent and fantastic though the idea may seem, I can only say that to me a common denominator was evident between the children's infinitely humble intimations of artistic experience and the mighty statements of those great modern masters ... with my limited knowledge of art I had not, up till then, been fully conscious of having seen it elsewhere. (p.14)
>
> I told them about still-life paintings, particularly those in our public galleries, and they interpreted from my descriptions ...(p.26)

(of Roger Fry)

> Everything he said was so serious, so unsentimental and so sane. Without praising, still less flattering us, he made me feel that we were included in the wide range of his interests, and even part of the modern movement in art of which he was so great a leader. (p.32)
>
> ... most thrilling of all was permission to see the Russian Ballet at rehearsals from behind the scenes, in the heyday of Diaghilev ... I saw Picasso himself rehearsing *Parade* and *The Three-Cornered Hat* ... Such a tale I had to tell after each visit ... but if we spent much of our lesson-time in talking, we made up for it out of school hours ... We started an Art Club and met after four o'clock. (p.33)

Stuart MacDonald (1970)

> The frequent use of such terms as 'visual grammar' and 'visual elements' give us the key to the origin of the modern concept of visual education: both grammar and elements demand precise analyses of visual phenomena as advocated by Itten, Klee and Kandinsky at the Bauhaus.(p.375)

Dick Field (1970)

> Wrote about 'the life-giving relationship between the vitality and innovation of the world of the professional artists and the world of the classroom, the artroom, the workshop.' (p.6) He was keen that pupils should know more about art but that they should also 'know

something about ... a history of developing ideas of and about art' (p.109)

HMI (DES 1983)

There is no doubt however that there is evidence of a change in thinking about the balance of the art curriculum. Many of the schools described here ... lay stress on the need to educate their pupils to know about the work of other artists and designers ... (p.65)

Bob Clement (1986)

Evidence of the work of artists, craftsmen and designers, whether in original form or in reproduction, can provide children with very real support to their own studio work. (p.162)

Rod Taylor (1989)

The National *Critical Studies in Art Education Project (CSAE)*, which ran from 1981 to 1984 undoubtedly raised levels of consciousness about the place and role of *Critical Studies* in art and design education. It arose out of a growing concern that the predominant emphasis on practical activity meant that the majority of pupils were leaving school with little or no knowledge of the visual arts other than that acquired solely through their own practice. (p.27)

These references cover the significant period of art education in the United Kingdom but, while there may be in Field's terms a 'life giving relationship' between art and art education, it has also been highly selective culturally and pedagogically, based on the dominant artistic practices of the past five hundred years and specific educational traditions, increasingly rooted in liberal and 'progressive' pedagogies. In particular this has led to the identification in recent years of a type of art, particularly produced by teenagers, called 'school art' and a concern that what occurs in artrooms is limited in comparison with the practices of the world of art, craft and design and the common visual experiences of young people.

For example, Rod Taylor (1986) reports that 'again and again' interviews with pupils recorded that 'home art ... frequently ... has great significance for those involved'. Whereas many examples in the book refer to work in the more traditional media, the section on 'home art' features case studies of two teenagers: one who draws illustrations for comics, while the other makes animated films. The latter told Taylor:

Now that was done at home. I couldn't really relate it to things I was doing at school because there wasn't really anything open to me like that in Art ... (where) I was experimenting with drawing skills, improving my drawing and painting ... we didn't have much experimentation with other forms. It always had to be very naturalistic. (p.78)

More recently, Binch and Robertson (1994) observed that

A crucial concern of the Arts Council and Crafts Council ... was the enormous gap between school art and contemporary practice, the majority of which bears no relationship to 'standard' practice in schools. (p.112)

In the late 1990s, we must reconceive image-making culturally and pedagogically and acknowledge that drawing and painting in particular now constitute only one aspect of the visual arts and that, however desirable or impressive they may be, neither drawing nor painting are in any sense essential or necessary to the production and understanding of visual imagery, they are merely one aspect of it.

I have argued (Allen 1994) that a developing pedagogy of visual literacy needs to gather evidence in the form of many detailed case-studies to record and eventually theorize about how people produce and use visual artefacts, including the question of what kinds of artefacts those might be. If this were to happen (and it should be historical, contemporary and encompass all people) it would reveal a far broader range of visual forms and activities than those typically addressed in art rooms and might lead us to reconsider dominant histories of visual art and dominant practices in art education.

This paper has suggested that the dominant influence in art teaching is Post-Renaissance and Modernist painting filtered through a 'romantic' view of self-expression. In schools this may be defined more specifically through reference to the evidence such as that noted in the documents developing the National Curriculum or in relevant publications. Given that what occurs is clearly very selective the question is why and does it have to be as it is? Pursuing the question of which images are frequently used with pupils in the classroom we can consider the role and influence of modernism through a paper by Brandon Taylor (1989) who raised some pertinent questions about the complexity of using modern 'masterpieces'. He

refers to examples of paintings by Klee, Picasso, Renoir, Chagall and Kandinsky and argues instead for 'images of a much wider and more accessible kind' to 'form the basis of primary and early secondary school education.'

Taylor is, I believe, pedagogically naive in his assumptions about what can and should be achieved in a short period of time and he fails to take sufficient account of progression. Nonetheless he does urge us to consider whether we cannot broaden the range of imagery used in the classroom. In a sense however this may only return us to the confusion of the examples in the (current) Order, realist or abstract; 'high' art or popular culture; painting or design and so on – each of them unhealthy and irresolvable dichotomies.

In the remainder of this chapter I wish to argue that we might aim to rework these contradictions dialectically, not be attempting the impossible task of trying to do 'everything' but by attempting to extend our limited view of modernism, drawing from its history a range of alternatives to the themes and concerns of that specific kind of modern painting supported by the various critical approaches of such as Greenberg, Fried or *Modern Painters*, who, despite their differences are all supporters of modern *painting* and *sculpture*. My 'alternative' does not necessarily exclude painting or sculpture but it extends the concept of art in the modern period and embraces, in terms of visual literacy, what a far wider range of people did and do with visual imagery. What is also intended, is to offer a practice which, by rejecting the opposition of fine art and the mass media, enables teachers to build on the best of current art education, to incorporate work from observation, issues and aesthetics and personal expression.

In order to pursue this argument I too intend, initially at least, to be somewhat selective and identify an 'alternative' tradition within Modernism. I believe that in a *pedagogical* context this tradition offers a means of opening-up classroom practices in the visual arts and resolving the contradictions in current practice as exemplified in the original non-statutory examples. In order to do this I wish to go back to cubism and posit a history of twentieth-century art which is far less centred on culturally specific painting and sculpture than that proposed by such as Greenberg or Fried since this 'alternative' might enable a productive relationship between art and other image-making where the tradition of painting has a valuable but no longer central role. The overall 'project' might contain some of the following:

Picasso, Braque, Cubism, Marinetti, Balla, Futurism, Hoch, Hausmann, Heartfield, Grosz, Dada, Duchamp, Rodchenko, Tatlin, Constructivism, Eisenstein, Vertov, Schwitters, Surrealism, Man Ray, Ernst, Lye, Cornell, Deren, Cage, Tapies, Paolozzi, Klein, Rauschenberg, Johns, Pop, Blake, Warhol, Fluxus, Beuys, Paik, Conceptualism, Mary Kelly, Smithson, Goldsworthy, Long, Holzer, Sherman, Kruger, Kennard, Haacke, Keith Piper, Sulter, Chadwick, Viola, Hill, Buren, Koons, Brody, Woodrow, Mach, Cragg, Whiteread, Digital imagery

The list is derived from personal interests and, stated as such, presents two problems: it appears something of a 'ragbag' of disparate but possibly 'difficult' work and it is still highly specific to the practices of the art world with the attendant dangers of reification. It is not being proposed as a 'canon' of artists and movements to be studies and emulated by pupils but rather as a 'model' of an alternative practice to dominant modernist painting and sculpture. I believe that such work offers a number of ways of informing what teachers might do with pupils:

- much of it draws upon and addresses the nature of 'popular' imagery and its relationship with 'high' art
- the work is often highly personal in a way which matches many aspects of contemporary art pedagogy
- in terms of the previous point the work is often figurative, drawing upon, utilizing and challenging 'realist' representations of the world
- the work utilizes a variety of media and forms, employing an interdisciplinarity which breaks away from the dominance of painting and sculpture without rejecting the legitimacy of those practices
- some of the work acknowledges the growing importance of mechanical and electronic image-making
- the work moves beyond a predominantly formal or aesthetic approach to address issues such as representation, context and equal opportunities.

These points may help to recommend the work to teachers. However if such work is to provide a pedagogical influence for the future it needs to be conceived as more coherent than simply 'alternative' or (polemically) oppositional. Post-Modernism offers theoretical approaches which may address these difficulties but is not unproblematic. Briefly I would argue that the marginalization of this practice fits Habermas's argument that the term Post-Modernism may be premature, because the project

of modernity is incomplete. I wish to suggest that it is possible to conceptualize this alternative practice of visual Modernism while opening it up beyond the normal limits of the fine art academy, through identifying its roots specifically in those aspects of cubism which addressed the possibilities of other materials, emphasized analysis and conceptual understanding, and fragmented the dominant unity of picture surface in post-Renaissance art.

Despite its 'realist' concerns, cubism may be seen as a crucial forerunner of abstraction and hence of the dominant tradition of Modernism but it is also the ancestor of much of that practice described above as 'alternative' but which I now wish to suggest is more appropriately conceptual in approach and rooted in the *process* of *collage*. Recent scholarship around the importance of collage in twentieth century art seems to have opened up the possibility of reconceiving the modernist project, allowing an expansive view of contemporary visual practice, tied to an increasingly pluralist approach to critical engagement with visual art work. Examples from this scholarship which seem important to follow, begin with early works by Picasso, *Still Life With Chair Caning* (Spring 1912) which for Poggi (1992) is 'the first deliberately executed collage'. She goes on to argue that it instituted

> an alternative to the modernist tradition in twentieth-century art. This alternative tradition emphasizes heterogeneity rather than material or stylistic unity and a willingness to subvert (rather than affirm) the distinctions between pictorial, sculptural, verbal and other forms of expression. (p.xiii)

Meanwhile, Waldman (1992) argues that collage, assemblage and the 'found' object

> together ... initiated a process that revolutionized our ideas about the nature of art and influenced virtually every major movement of our time. Many would acknowledge that collage, assemblage and the found object have expanded the language of art, allowing for greater formal diversity and an increased expressive range. Collage has also captured some of the most momentous shifts in culture, politics and economics and can thus be said to present a compelling historical record of our time. (p.8)

Within a few years, of course, workers in lens-based media had responded to the development of collage, in film through montage described by Lavin et al (1992) as

> an aesthetic practice of combination, repetition and overlap which links the worlds of art, design & film. (p.7)

and in photography through photomontage, of which practitioner Raoul Hausmann (in Ades 1976) said

> The term translates our aversion at playing the artist, and, thinking of ourselves as engineers .. we meant to construct, to assemble (*montieren*) our works. (p.12)

Through the concept of collage and its various practices, a range of issues is addressed. For a start, the visual arts are able to acknowledge the machine and electronic technologies which are a central part of our world, largely denied in the great genres of oil painting. As Poggi points out the appearance of 'many machine-made materials and artefacts' in Cubist work help to 'establish a parallel between ... previously distinct cultural codes' and hence 'redefine originality' which now becomes the 'manipulation of pre-existing conventions and schemas' (p.xiii). Further, she argues that this bringing together of disparate elements from various sources, challenges the claim of painting's 'authenticity' based on its '*difference* from popular cultural artefacts' (p.254).

The various practices of collage are now ubiquitous in the manifestations of digital multi-media which appear in our newspapers, magazines and television. However this is not an argument that visual arts education should be dominated by mass media which seems to me one of the limitations of much generally important media education. Rather, it is a proposal that this alternative tradition of collage has maintained a critical distance from mass media and popular culture without being afraid to comment upon it. This kind of socially-aware critical creativity seems to me precisely what visual arts education should aim for. In a contemporary context the new technologies continue to offer creative possibilities for today's artists. For example in a recent work, Helen Chadwick threw paint on a wave and allowed this to stain a canvas.

> This florid, accidental stain, photographed then sampled by a computer, has been mixed with images of both Chadwick's own body cells and panoramic views of rocky coastlines. These *Viral Landscapes* are complex metaphors

for a body invaded and inundated by nature, threatened by viruses, contaminated by language. (Searle, 1994)

This last reference to the most recent work, extends our sense of collage beyond the merely aesthetic and reminds us that we inhabit a world in which science and technology have enabled or caused mass reproduction, unlimited representation, the barrage of signifiers, mass unemployment, parliamentary democracy, the diaspora, mass-machine-murder, genetic engineering, mass communication. We live in a confusing, fragmented, frightening world and no amount of seeking refuge in the coherent and calming images of a minority practice such as oil painting any longer constitutes an adequate creative response to such a world for most people.

Collage is increasingly ubiquitous in the popular and mass imagery of the late twentieth century and it has a more and more significant role in the other arts and cultural forms. With its attendant practices of photomontage, assemblage, film montage, concrete poetry, installation, graphic design, computer manipulated imagery, intertextuality etc. it is the concept and practice which enable us to theorize these otherwise disparate practices in an historical context and the root is with Picasso and Braque in 1912.

BIBLIOGRAPHY

ADAMS E. and WARD C. (1982) *Art and the Built Environment*, Longman

ADES D. (1976) *Photomontage*, Thames & Hudson

ALLEN D. (1990) 'Every Great Artist a Dead Frenchman?" in *Art Education 7* (NFAE December) pp.13-14.

ALLEN D. (1994) 'Teaching visual literacy – Some Reflections on the Term' in *Journal of Art & Design Education*, 13/2 August pp.133-144.

ARTS IN SCHOOLS PROJECT (1990) *The Arts 5–16 Practice and Innovation*, Oliver & Boyd.

BINCH N & ROBERTSON L. (1994) *Resourcing and Assessing Art, Craft & Design*, NSEAD.

CARLINE R. (1968) *Draw They Must*, Edward Arnold

CLEMENT R. (1986) *The Art Teacher's Handbook*, Hutchinson.

DES (1983) *Art in Secondary Education 11-16*, HMSO.

DES (1991) *National Curriculum Art Working Group* interim report.

FIELD D. (1970) *Change in Art Education*, RKP.

HABERMAS J. (1985) 'Modernity an Incomplete Project' in Foster H. (editor) *Postmodern Culture*, Pluto pp.3–15.

HALL J. (1994) review of *The Art Teacher's Handbook* in *Journal of Art and Design Education*, 13/3 October pp.316–18.

HORNSBY J. (1988) *Photography: towards a Multicultural Approach*, South East Arts & East Sussex CC.

HORNSBY J. (1990) *Photography in Art and English*, Surrey CC.

HORNSBY J. (1987) *Photography, Art & Media Education*, SEA & ESCC.

ISHERWOOD S. & STANLEY N. (editors 1994) *Creating Vision: Photography & the National Curriculum*, Arts Council.

LAVIN M. et al. (1992) *Montage and Modern Life 1919–1942*, MIT.

LAYZELL R. (1993) *Live Art in Schools*, Arts Council.

MACDONALD S. (1970) *The History and Philosophy of Art Education*, University of London.

NEWBURY D. (1994) *Photography, Art & Media*, UCE/Arts Council.

O'CONNOR M. and ALLEN D. (1990) unpublished research report to the Arts Council.

PALMER F. (1988) *Themes and Projects in Art and Design*, Longman.

POGGI C. (1992) *In Defiance of Painting*, Yale.

RICHARDSON M. (1948) *Art and the Child*, University of London.

ROBINS K. (1993) 'The Virtual Unconscious in Post-photography', in *Science as Culture*.

SEARLE A. (1994) 'Effluvia' exh. guide (Helen Chadwick, Serpentine Gallery).

TAYLOR B. (1989) 'Art History in the Classroom: a Plea for Caution' in Thistlewood (ed. 1989) pp.100–12.

TAYLOR R. (1986) *Educating for Art*, Longman

TAYLOR R. (1989) in Thistlewood (ed) *Critical Studies in Art and Design Education*, Longman NSEAD.

THISTLEWOOD D. (ed., 1989) *Critical Studies in Art and Design Education*, Longman NSEAD.

WALDMAN D. (1992) *Collage and Assemblage and the Found Object*, Phaidon.

MUSEUM & GALLERY EDUCATION ARTISTS IN RESIDENCE

NORMAN BINCH WITH SUE CLIVE

The National Curriculum for Art in England, Wales and Northern Ireland requires schools to provide a balance between practical and theoretical studies, to ensure that practical work is informed by knowledge and understanding of the work of artists and by some of the social, cultural and historical contexts of art. The most significant changes in emphasis from the general range of existing practices at its inception, were the requirements contained in Attainment Target 2, Knowledge and Understanding (AT1 'Understanding' in Wales and a requirement to integrate knowledge and understanding of art and artists in the two ATs for Northern Ireland). The basis for the inclusion of visual literacy and the knowledge and understanding of art, craft and design in the National Curriculum lies in the gradual and increasing development over many years of what are known as critical studies or critical and contextual studies.

In this context, visual literacy can be compared to the notion of literacy in English – the ability to read and understand the written word. In art, images need to be read and understood if they are to communicate their meaning. This means that children need to be taught how to do this through both theoretical and practical studies. They need to learn how to analyse content and form and to understand the purposes of art, crafts and design

in different contexts. An important concern is to provide pupils with an appropriate vocabulary which will enable them to talk and think about art objects and to develop confidence in expressing their own judgements.

The work of Rod Taylor and the simultaneous development of gallery education, in particular, had a significant influence on the development of critical studies but, perhaps even more significantly, the majority of GCSE syllabuses require an element of critical studies to be taught and assessed. As is usually the case, the tail wagged the dog and critical studies appeared more frequently in the lower years of secondary education. In primary schools there was simultaneously, an increasing use of artists-in-residence and visits to exhibitions and galleries.

CLARIFICATION OF CRITICAL STUDIES

It should be noted that there are considerable difficulties in achieving a clear definition of what critical studies actually are. There are differences in interpretation and substantial differences in practice, ranging from an emphasis on art history to one in which contexts are the main focus of study. The emphasis in the National Curriculum for Art is on visual literacy and an intention to make children aware of their artistic heritage, but many art educators are concerned by the additional empha-

sis on knowledge at the expense of understanding. There are also concerns about the reduction of such an important aspect of art education to mere parody and pastiche and the development of an orthodoxy in which the range of references used are restricted to only a few artists (for example, Van Gogh and Monet) whose work is easily accessible and familiar. Such an approach also largely excludes the challenge presented by exposure to contemporary practice in art, crafts and design.

The crucial point is that to respond properly to the requirements of Attainment Target 2 it is essential to engage children with real art objects and with contemporary practitioners.

EXTERNAL AGENCIES INTEGRAL TO THE SCHOOL CURRICULUM

There are, however, very real problems in developing such content to a level where it becomes integral to the art curriculum.

It is probably true to say that, for most children, direct contact with artists and visits to various outside agencies are comparatively rare and, at best, infrequent. In particular, there seems to be little provision of this kind at Key Stage 3. The reasons are well-known – the problems of teaching large classes, limited curriculum and timetabled time, lack of money, the difficulties of organizing school visits, and lack of staff resources. However, teachers with commitment can do astonishing things with very limited resources and one of the aims is to encourage more teachers to make such commitments.

The most important commitment, however, should be by the school, and the whole-school policy documents should include appropriate references to provision of enrichment and support for the art curriculum through the use of external agencies.

MUSEUM AND GALLERY EDUCATION

In spite of the pressures experienced by museum and gallery education staff (financial constraints and increased workload) during the past few years, there has developed a substantial range of innovative practice. The methodologies employed in engaging children with art objects are increasingly imaginative and motivating. For example, the detective method in which children are encouraged to follow clues, to hypothesize and reach their own conclusions before being present-

ed with information which influences their response.

The Arts Council/Crafts Council Project; *Resourcing and Assessing Art, Craft and Design at key Stage 4*, which ran from 1990 to 1993, included action research related to gallery education and its development. The resulting publication (March 1994) by the National Society for Education in Art and Design (NSEAD), contains descriptions of other methods employed by galleries. For example, in Cambridge, the Fitzwilliam and Kettle's Yard museums collaborated with a range of schools on the theme of *Image and Text*. Descriptions and analysis of the organization required for such a complex scheme provides valuable references for other gallery education staff and the teaching/learning methods employed are varied and effective. A key feature of this project, as with many others, was the involvement of artists in residence (including writers and poets), creating a productive partnership between galleries/museums, schools and practising artists. The Tate Gallery, Liverpool, was involved in exploring the nature of galleries and exhibitions as a first step towards engaging pupils with the work they contain. Such an approach provided pupils with the opportunity to question the existence of galleries and museums, to ask who created them and why, and to consider the effect that the context in which work is displayed has on its meaning.

The National Association for Gallery Education (NAGE) is an organization consisting mainly of gallery and museum education officers which is dedicated to promoting the profession and the development of gallery education. Useful advice can be obtained and there are publications which provide information and advice on what museums and galleries have to offer to schools.

LEARNING RESOURCES

A general principle of good practice is to ensure that there are sufficient reference materials and visual resources to support learning in all programmes of study. For example, a visit to a gallery or an exhibition will need to be backed up by a suitable range of relevant resources in school. These should include books, photographs, reproductions and specific information as well as a range of art objects which relate to the topic. Artists in residence would need visual resources to reinforce the learning that takes place as a result of their intervention. Often, a visit to an exhibition

requires preliminary work from reproductions, photographs and similar reference materials.

But, as valuable as they are in developing an understanding and knowledge of art, second-hand resources can never be a substitute for exposure to real works of art and to live artists. For example, they provide no sense of scale, of the sensations of confronting a painted surface or the visual and spatial complexities of an installation or video work, of the reality of a work of art and the processes through which it was made. Recent research suggests that the principle means of engaging with an art object should be through the pupil's own initial personal response followed by discussion and presentation of relevant information. It is not considered necessary, or even particularly beneficial, to prepare children for a visit to an exhibition, gallery or a museum through a presentation of a history of the exhibits. Such information appears to be more effective when used in support of the pupils' primary reactions.

TEACHING AND LEARNING METHODS

Exposure to real works of art and to live artists also provides teachers and pupils with new ideas and ways of working. All teachers will recognize the state in which they feel the need for stimulus, for contact with fresh ideas and something different from the range of work and methods to which they have become accustomed. Many schools are realizing that the intervention of an artist, craftsperson or designer in residence, or other kinds of contact with contemporary practitioners, provides invaluable in-service education for teachers. They are, quite legitimately, obtaining money for residencies from INSET funds.

One of the major criticisms of school art is the tendency to create an orthodoxy, in which the possible methods of working are reduced to a single predominant system, often producing very competent but stereotyped results. For example, the introduction of the GCSE provided secondary teachers with considerable freedom to develop a wide range of working practices within a framework which encouraged pupils to take increasing control of the direction of their own work. One important criterion was for pupils to achieve an appropriate level of independence from the teacher. Coupled with the gains in self-confidence brought about by encouraging them to argue their own case through negotiated assessment, an excitingly wide and varied range of work might have been expected. Whilst this is true in a signifi-

cant number of schools, in general, as the examination has become established, there is a discernible orthodoxy. This seems to stem from a predominant method of working which begins with investigation, extends through a systematic development of ideas, and ends with a pre-determined art product. The importance placed on assessing the process as well as the product, unfortunately, seems to have resulted in an established, single, linear methodology which can be demonstrated through presentation of coursework and preparatory studies (which are often done after the work itself is finished).

The spontaneous response tends to be discouraged, and imaginative differences in approach are often constrained by the requirement to provide evidence of the process of arriving at a finished piece of work. The constraints are not necessarily related to the requirement to provide evidence of process itself, but to the apparent insistence upon the presentation of a succession of studies which tends to re-enforce the linear method of working. In many areas of work the process of creating is not linear in this sense, it takes place by constant modification of the image itself. Presentation of the process of making in a series of successive studies is, however, relatively easy to assess and becomes a safe bet in obtaining good grades. The excitement of creative risk-taking can be largely eliminated by this method of assessment. The problem is particularly acute for many children from cultural backgrounds other than Western European, who are often completely unfamiliar with such processes and for whom objective drawing as a basis for visual investigation is completely outside their experience.

'DO WE HAVE TO DRAW IT FIRST, MISS?'

A further problem arises from the apparent insistence upon drawing as a pre-requisite for making something. The linear methodology described above usually involves drawing as a first stage in any process and this disadvantages those children who may be particularly adept at working out their ideas and discovering things for themselves through a direct interaction with materials. Whilst drawing has a very important part to play in any art-making process it should be used when it is most appropriate and the children can understand the reasons for needing to draw.

There are also significant differences between the content of school art and the concerns which many contemporary artists pursue. For example,

there has been a substantial movement amongst contemporary artists away from the formalistic and abstract concerns of post-1945 Western European art towards a concern for content – using art to explore significant contemporary issues, particularly by women artists. Post-Modernism includes references to existing works and to art history, re-assesses them and uses them to create new images in many different forms which challenge established conventions.

In many schools, there is little reference to Modernism, let alone Post-Modernism and contemporary practice. Pupils often work only in formalistic ways, with emphasis on Western European concepts of perspective and associated working methods and techniques. Such emphasis restricts the potential for developing an awareness of current artistic concerns and issues, thus reinforcing the orthodoxy of school art.

One way to avoid orthodoxy and stereotypical responses is to vary the methodologies and the starting points for schemes of work. The introduction of pupils (and teachers) to contemporary practice, particularly through the intervention of a practising artist or visits to exhibitions of twentieth century art, makes an important contribution to the development of varied methods.

THE NEED FOR A SENSE OF OWNERSHIP

There are other constraints which are not fully recognized. For example, because the National Curriculum is assessment-led, there is pressure on teachers to teach what has to be tested rather than to assess what has been taught and learnt, and in most subjects there is substantial prescribed content. There is evidence that these pressures are already creating restrictions on the range of teaching and learning methods which teachers use.

The tendency seems to be towards more didactic, class-based methods with fewer opportunities for children to take some responsibility for, and ownership of, their work. Ownership means allowing a pupil to make their work their own, to respond to their own feelings and to develop the confidence to use art for their own purposes.

There is cause for concern over the extent to which schools, particularly primary schools, may be using the Examples as a basis for art work rather than referring to the Programmes of Study. Importantly, the structure provides the freedom to engage children in experiences which are important to them personally; to provide opportunities for them to make decisions of their own and to learn by their mistakes.

If art is a language through which children can express their ideas, feelings and personal views, then teachers have a responsibility to see that children are given proper access to it. This means that, as well as acquiring control of materials and a range of appropriate skills, they also need to be initiated into what it's like to be an artist. They need to be shown that art has important functions in society and that its roles vary according to the different contexts in which it occurs.

Children need to be visually literate in an age which relies increasingly on visual information systems, especially those used in computer programmes, television and the media; they need to understand that images are created and manipulated for particular purposes both through critical appraisal and practical initiation. Whilst much of this could be achieved without the use of external agencies the potential for providing stimulating and truly educational experiences in art would be substantially diminished without them.

PARTNERSHIP BETWEEN TEACHERS AND ARTISTS

In the case of residencies, the relationship between teacher and artist is of prime importance and a true partnership in which the roles are clearly defined and neither is subservient to the other should be the aim. It is evident in some accounts of residencies that the teacher's role is that of the passive observer and it is important to remember that the professional skills of the teacher, whilst different from those of the artist, are at least of equal importance. It should also be remembered that many teachers are practising artists, yet those who organize residencies for their school will benefit from the different practices brought by other artists. Similarly, there is some evidence from other research, that the artist's role can be reduced to that of a technician. It should be recognized that the most important aspect of an artist's intervention is normally the introduction of fresh ideas and new ways of working. There is also ample evidence of the variety of working methods which can be developed through the use of external agencies and direct contact with contemporary practitioners. The freshness and vitality of the ideas generated are the key to exciting work.

CO-OPERATION AND COLLABORATION

It is, of course, unreasonable to expect schools individually to develop the art curriculum and take account of contemporary practices in art, the

history and theory of art. The Arts Council, through its Regional Arts Boards and administrative structure aims to assist in the provision of networks of support for arts education. Amongst the most prominent and important national agencies which have similar aims are the National Society for Education in Art and Design (NSEAD), the National Association for Gallery Education (NAGE), and the Group for Education in Museums (GEM). Many museums, galleries, and places of historic and cultural interest have education officers who are committed to collaborative initiatives both nationally and regionally. A list of such establishments can be found in Section 21 of the *Education Year Book*, published by Longman, although not all contemporary galleries are included. Schools may have their own copies but, if not, they should be available in all main public libraries. Other organizations, such as The Design Council and the Crafts Council, also provide lists of agencies and services.

These agencies can provide information and often help schools to make useful contacts. However, the most substantial support can often be found in the school community and local authority. It is good practice to establish some kind of formal structure, such as a Governors' sub-committee, to be responsible for the promotion and planning of arts activities, some as extra-curricular provision and some integral to the school curriculum.

An important initiative which schools might emulate is the Wigan project in which schools are encouraged to create their own 'art gallery'. These provide a permanent space for a variety of exhibitions, some of which can be borrowed from regional and national agencies, others can be exhibitions of the work of local artists or of work from the school. They provide a focus for the work of visiting or resident artists and an educational resource for the whole school community. Development of such facilities depends upon collaboration with a range of agencies and the co-operation of local people.

PLANNING
THE EARLY STAGES

Planning for the introduction of external agencies needs to begin well in advance. In primary schools, particularly, initial plans are often made when the year's work is planned and teachers decide what kind of experiences they would like to provide. Information on major exhibition programmes is usually available at least a year in advance and local galleries will also have a similar lead time. If there is an established relationship between gallery and museum education officers this information will be readily available. There are a range of agencies that will help with the selection of visiting or resident artists, in some cases the galleries themselves will be able to help. The list of agencies in the *Education Year Book* will be a useful source of information.

Decisions need to be taken at an early stage about the nature of external intervention. For example, is it to be restricted to the art curriculum or can it be used for cross-curricular projects?

The most important thing is to try to prepare clear aims. These are not easy to construct in the early stages, and it is better to allow them to emerge through discussion as the planning develops. It is particularly important to engage the artist, or other external agencies, in their preparation. Many schemes fail because they do not allow the artists to contribute their own ideas. It is also important to be flexible and to recognize that the best planned schemes often take unexpected and rewarding changes of direction.

PREPARATION

When the plans are reasonably advanced, decisions need to be taken on how to introduce the project. In most instances there will be a need to prepare pupils for the experience of working with an artist, or using a gallery, by various kinds of preliminary work in school. When using a gallery, museum or exhibition it is highly desirable for teachers to make a visit in advance of the pupils' session, and the education officer should always be contacted in advance.

Another important consideration is when to make a visit or to introduce an artist in residence. There is fairly common pattern in which the visit or residency provides the initial stimulus for a project but there are times when it is far better to use the intervention to reinforce learning at a later stage. Similarly, when an artist is involved, when is the best time to show pupils their work? There is evidence that if it is shown at the beginning of a residency the children's work can be unduly influenced by it.

ROLES AND RESPONSIBILITIES

Everyone involved needs to have a clear understanding of their roles and responsibilities. For example, there are inherent difficulties in the overlap between the roles of the artist and the teacher. The role of the artist is sometimes reduced to that

of a technician, merely helping children to cope with technical demands, rather than using their expertise to stimulate a wide range of ideas, discussion and learning. Similarly, during gallery visits the roles of the teacher and education officer need to be clearly understood.

Artists should also understand what is expected from them. In many cases they are expected to do their own work as well as becoming involved with pupils. This has to be taken into account when time and resources are considered. Is there sufficient space for the artist to do their own work? How will pupils be allowed access to it? Who provides the materials? How does the artist's work relate to the work of the children? Is there an expectation that the artist will make something to be left in the school? These are all important issues and the artist should be fully engaged in the decision-making.

TIME MANAGEMENT

This is one of the most difficult aspects of the planning and delivery of projects. Even experienced teachers sometimes get it wrong and artists who have little experience of working in a school can have completely unrealistic aspirations. It is therefore sensible to have fall-back positions, so that if a project is running out of time, less demanding aims can be substituted. It is also useful to think of a longer project in terms of smaller units and to plan to reach the final outcomes through a series of mini-outcomes. In any case a long project will need specific times set aside for discussion about its progress and to clarify for pupils what the aims are – they can easily be forgotten in the long process of development.

Account must also be taken of the changes of direction which inevitably occur as a project develops. Sometimes it is even necessary to abandon the original plans and build on whatever it was that stimulated new ideas and unexpected developments.

RESOURCES

These should include the range of materials and sources of reference which the pupils will need, materials required by the artist, and any equipment and materials needed for visits. It is especially important to provide visual reference materials which support and reinforce the artist's work or work seen on visits. Pupils need ready access to additional information as their work progresses and its use is a significant aspect of the require-

ment to do investigation and research. Ideally, the classroom or studio should become a total visual resource for the duration of the project.

FUNDING

This is, perhaps, the single most difficult issue, particularly since the capacity of local education authorities to support such initiatives has been substantially diminished. There are national and regional agencies, like those described in the section on co-operation and collaboration, and charitable foundations which make a major contribution to this form of curriculum development. However, a lot can be done with comparatively small amounts of money, and local sources should be approached for support. Importantly, the use of INSET money seems to be an acceptable source of funding which is entirely under the control of the school.

ASSESSMENT AND EVALUATION

It is inappropriate to consider assessment in detail here, but it is important to assess pupils' work and evaluate the project as it progresses. Formative assessment, which feeds back into the learning process, should be part of the planning of a project. All those involved should engage in this process. The artist can make a significant contribution if properly inducted into the school's assessment system. Engaging pupils in the assessment and evaluation of their own work helps them to develop a critical vocabulary, increasing self-confidence and self-motivation. It is also invaluable in improving the ability of teachers to establish clear aims and objectives for future projects. Knowing what you want to achieve is enormously helpful in the complexities of planning.

'STANDARDS BANKS'

As part of their assessment system for art, schools should accumulate evidence and examples of work which are characteristic of the range of standards expected from pupils.

Some schools are able to collate pupils' work in individual folders and, whilst this is desirable, for many schools it is logistically impossible. Creating 'standards banks' for each year of the school will enable teachers to develop an understanding of the levels of work which can be expected from different age groups, serve as a means of establishing consensus on standards among staff, and be of use during Ofsted inspections.

CHAPTER SIXTEEN

'BAD AT ART': ISSUES OF CULTURE AND CULTURISM

ALEX MOORE

INTRODUCTION: PUBLIC INTENTIONS AND PRIVATE PRACTICE

During the course of a research project on educational provision for newly-arrived bilingual children in English secondary schools, I recently found myself observing Art classes at a culturally and linguistically mixed inner-city school with one of the best promulgated and most carefully worked out whole-school policies for the Arts that I have ever seen. This policy, a result of two years' work by a small, cross-curricular working-party in constant consultation with the rest of the school, contained the following statements in relation to cultural and artistic pluralism:

Each culture perpetuates certain art forms which have been developed to a particular degree as a result of the customs, the social, economic, geographic and historical background, the religion, and the way of life of its people. Arts are, thus, the expression of individual creativity within the context of a particular place, time, culture and technology.

Historically, Britain has based its critical values and aesthetic standards around Western European art forms. Too often, our perceptions and understanding of arts from non-European cultures have been channelled through the perceptions and value judgements of colonial administrators.

It is our responsibility as educators to provide an arts education that gives positive recognition to the differences of culture and heritage, and that respects and affirms the identity of each individual child. Such recognition and respect will ... require a great deal of re-evaluation, study, and in-service training on the part of staff, whose own education has been largely Eurocentric.

The study of the arts in a multicultural curriculum ... necessitates a conscious break with our ethnocentric tendency to interpret and value art forms from the base line of our own cultural forms. It implies a need to be open-minded and willing to confront our own inbuilt, often unconscious attitudes and prejudices, and to acknowledge that arts are not given constraints, but that they change and adapt to circumstances.

An interesting feature of this policy was that although it received the unequivocal *public* support of every member of the school's Art Department (provided, for example, during the course of taped interviews), its pluralistic intentions were by no means embedded in every Art teacher's 'private' practice. Some pupils, indeed, found their works of art not viewed initially against the background of their own out-of-school cultural experiences and preferences, but from that very Eurocentric perspective against which the school's Arts policy so persuasively argued. It was as if the teachers of such pupils had not been

able to see exactly what 'positive recognition', 're-evaluation' or even 'multicultural curriculum' might entail on their part. Far from achieving a sense of detached objectivity through which they could view their own favoured representational forms as 'merely one kind of art (which) is confined to a few countries in one corner of the world' (Read 1964), these teachers appeared to find it impossible to 'confront inbuilt attitudes and prejudices' in their response to the work of some pupils, simply because they had never been able to stand back sufficiently to make such attitudes and prejudices visible *to themselves*.

In order to illustrate the sort of problems that such inflexibility can create for children whose out-of-school backgrounds, experiences and cultural preferences do not form a close match with the cultural preferences espoused by schools and by the examination boards which to a very considerable extent both reflect and determine school syllabuses, I want to examine the early experiences of a bilingual pupil at the school whose Arts policy I have just quoted. I have selected these experiences not for their unusualness, but because they offer a particularly clear-cut example of the sort of teaching-learning experiences I was to witness in some profusion not only at this school but at others where bilingual pupils were set tasks that might be broadly described as expressive in nature. (See, for example, Moore 1990).

INTENTIONS AND RESOURCES

Nozrul, the pupil on whom I want to focus, was eleven years old and had just come to England from the Sylhet region of Bangladesh. At school in Bangladesh, which he had attended for four years from the age of seven, he had studied Mathematics, Science, Bengali, Islam, Physical Education and a little English, but no Art or Craft subjects and none of what his new school referred to as History and Geography. On his arrival in England, he had been somewhat fortunate in being offered an immediate place at his local secondary school, Company Road Comprehensive, a popular school which did not normally have many surplus places. Company Road was proud of its anti-racist and multicultural ethos and of its positive attitude towards bilingualism. A large proportion of its intake were Sylhetis like Nozrul: above 30% in some classes. The school had a large and highly skilled ESL Department, greeted visitors with a series of welcoming and direction-giving signs printed in a variety of languages of which

Standard Bengali was one, and offered expert Bengali language tuition to Bangladeshi pupils in all years.

Mrs Green was to be Nozrul's Art teacher. She was highly qualified, very experienced, and a practising artist herself. During an early interview, she expressed complete support for the school's Arts policy, on which she herself had worked, and talked urgently of what she saw as her 'responsibility to make sure that all the children do their best, regardless of their ethnic background or class.' She was, however highly sceptical about levels of resourcing for bilingual pupils, both locally and nationally, and clearly felt that such under-resourcing made the implementation of multi-cultural policies difficult on a personal level:

> The school isn't offering enough to these (Bangladeshi) kids. We do our best, but what can you do when they don't understand a word of what you are saying? That's where the racism is (...) It's in the System, and the lack of resources. Until that's sorted out, we aren't going to get anywhere. All we'll get is the blame.

These views were clearly not without some validity, and it was hard not to sympathize with a teacher confronted (as Mrs Green saw it) by a class of pupils not simply of 'varying artistic abilities' but containing a substantial number of children who could 'not even understand properly' what she was trying to get them to do.

It would be unproductive, however, to pursue such sympathies to the point of denial of personal responsibility for, or individual teacher influence on, what happens to pupils in the school classroom. As Hargreaves (1984, p.65) has quite properly said:

> Teachers are the immediate processors of the curriculum for the child. They are the evaluators of pupils' academic work ... the assessors of their overall ability ... the immediate adjudicators of children's moral worth and the direct arbiters of the 'appropriateness' of their everyday behaviour.

It is important, consequently, for teachers themselves to be at least as aware and critical of the nature and effects of individual teacher-pupil relationships (including their own) as of the financial constraints within which they are expected to work.

'BAD AT ART': NOT DOING WHAT YOU ARE TOLD

With Christmas only a month away, Mrs Green had decided that her Year 7 class should begin

making Christmas cards for their families and friends. On a display-table in the middle of her teaching room she had placed three large, brightly-painted wooden nutcrackers: one representing a clown, two representing kings. The pupils, sitting in a wide circle round the display, had been told to select one of the figures to draw and colour in on the front of a piece of folded white card. It was understood but never stated:

i that the children were not to move away from their desks while drawing unless given specific permission by the teacher to do so (in order to change a rubber, sharpen a pencil and so on);

ii (in keeping with i) that the children's drawings were to be *naturalistic/representational reproductions* of models that were already symbolic in nature (that is to say, they were faithfully to copy stylized figures, repeating the stylization inherent in those figures but not introducing any new stylizations of their own) *from a fixed viewpoint.*

These constraints had not been stated, because Mrs Green had seen no need to state them. 'I would have thought', she told me later, 'that, whatever your culture, it is appropriate behaviour to remain at your own table unless given specific permission to leave'; and in the same interview: 'When you are asked to copy something, that is what you do. Perhaps this child misunderstood the task, but I don't think so. He could see what everybody else was doing.'

The pupils, who had each been given a pencil and a rubber in addition to their pieces of card and been told not to begin colouring in until their basic line-drawing had received Mrs Green's approval, settled quickly to their task. Nozrul was clearly pleased with what he thought he had been asked to do, and smiled cheerfully as he went about his work. However, it quickly became apparent that he had missed both the understandings referred to above: he neither knew that his drawing had to be a 'good likeness', nor understood that he must remain in his chair whilst making it. Repeatedly, Nozrul left his table, as he had seen other pupils doing (though for different reasons), to walk around the room and examine his chosen figure – the clown – from different angles. Each time he did this, he was chastized by Mrs Green, who interpreted the activity as naughtiness and instructed him peremptorily to stay in his chair:

Mrs G.: Nozrul, stop wandering about the room ...Don't get up. (Waving a finger) You must stay in your chair. (Slowly) Stay sitting in your chair.

P: Miss, he no understand.

Mrs G.: Tell him in Bengali. Tell him he must stay in his chair.

(P. explains in Bengali to Nozrul, who looks puzzled. P. shrugs)

For the most part, Nozrul obeyed Mrs Green's instructions even though he plainly could not understand why other children were allowed to leave their seats when he was not, whether he must stay permanently in his own, or how he was to draw his chosen figure without getting up to examine the parts he could not see from where he was sitting. He continued to leave his seat, and continued to be chastized for it, until finally he had completed the drawing to his own satisfaction.

The finished drawing was quite unlike that of any other child in the class, and gave an immediate clue as to why he had felt obliged so often to leave his seat (an activity dismissed by Mrs Green as 'naughtiness' and the behaviour of a child destined to 'need watching'). His figure's arms emerged from its jaws, there was a gap between head and hat, its legs had no discernible feet, and the decoration on the figure's back, not visible from where Nozrul had been sitting, appeared on its front. it was a drawing immediately reminiscent of the drawings of much younger children described by L.S. Vygotsky (1978, p.112):

Often children's drawings not only disregard but also directly contradict the actual perception of the object. We find what Buhler calls 'X-ray drawings'. A child will draw a clothed figure, but at the same time will include his legs, stomach, wallet in his pocket, and even the money in the wallet – that is, things he knows about which cannot be seen in the case in question. In drawing a figure in profile, a child will add a second eye or will include a second leg on a horseman in profile. Finally, very important parts of the object will be omitted; for instance, a child will draw legs that grow out of the head, omitting the neck and torso, or will combine individual parts of a figure.

When Nozrul took his picture to Mrs Green for approval, she sent him back to his seat and shared with me her conclusions about his performance:

You know what this shows, don't you? This child has a very severe learning problem. Look at his ... (pointing to the arms in the drawing) ... and this (pointing to the hat) ... and here ... (pointing to the decoration) ... He can't even attack a simple task like this. He's not even see-

ing properly ... And that's the problem with so many of these children: some of them are okay; they get the language and they survive ... But kids like this need special help as well as language work ... I just can't give it ... I don't have the skills, or the time ...

'BAD AT ART': DIAGNOSIS AND PEDAGOGY

Mrs Green's observation of Nozrul's artistic product is not what I want to call into question here. His drawing was, undeniably, of the kind normally associated in Western European cultures with the efforts of a much younger child: say a five or six year old. What I *would* want to question is her somewhat hasty interpretation of what she had seen, her implied interpretation ('that's the problem with so many of these children' – the term 'these children' referring to Bangladeshi children) of all such work, and the way in which her instant diagnosis of events was subsequently transformed into an unhelpful pedagogy.

Vygotsky, it will be remembered, claimed that children do not always draw what they see ('Often children's drawings not only disregard but also directly contradict the *actual perception* of the object'), suggesting that children have their own 'preferred' way of going about things and that this may be different from preferred adult ways. His description of early drawing continues thus:

> Children do not strive for representation; they are much more symbolists than naturalists and are in no way concerned with complete or exact similarity, desiring only the most superficial indications. We cannot assume that children know people no better than they depict them; rather they try to name and designate than to represent.
>
> (Vygotsky 1978, p.112)

In broad terms, this model chimes with the experiential model of drawing development described, for example, by Denis Atkinson (1991, p.58), which 'does not assume a predictable hierarchical progression, involving related assumptions of an evolution from inferior or primitive to superior levels of ability', but which recognizes that children

> use drawing to represent a range of experiential orientations ... Their drawings necessarily involve the inventive and eclectic use of mark configurations to represent such experiences. The use of mark configurations may not

always be consistent with those configurative schemes used to represent objects from a fixed viewpoint, and which are often used to assess development in drawing.

While it is not impossible to imagine Mrs Green's views on drawing development finding some areas of agreement with those of Vygotsky or Atkinson, it has to be said that they were overlain by a common-sense view of child development which demanded a biological-psychological rather than a cultural-experiential explanation of her pupils' work. Describing herself in interview as 'essentially a Piagetian' while regretting that she had 'not been able, through the pressures of work to keep up with Art-teaching theory', Mrs Green's own account of the development of children's drawing was reminiscent of Lowenfeld's (1970) series of identifiable stages. Like Lowenfeld, Mrs Green appeared to correlate 'drawing ability' with 'intellectual level' (Lowenfeld 1970, pp.25–6, 36), as a result of which doing well at Art meant (to use her words) 'replicating certain artistic genres: portraiture, still life, pattern, landscape, abstracts and so on, in a variety of approved media.' According to her, this replication was 'something that can only be taught to a certain degree. Most children's art work can be improved, but some will always be more naturally talented than others, and some will never even reach first base.'

In Mrs Green's eyes, the development in children's drawings from the symbolic to the representational was, thus, a 'natural' one that, in the normal course of events with a 'normal' child, would take place almost in spite of instructional intervention: something to do with heightened observational, manual, motor skills and with some notion of intrinsic 'intelligence'. It is for this reason, perhaps, that she saw Nozrul's symbolic representation as the result of a perceptual deficiency: if a child of Nozrul's *age* did not seek to achieve a good likeness in his drawing, then the obvious explanation was that he was 'not seeing it properly'. That there might be other, equally obvious interpretations of what Nozrul had produced – interpretations that might also explain his *behaviour* (that is to say, his constant walking about the room) – had evidently not occurred to her. One of the more obvious of these interpretations is that Nozrul, *like* younger children, had simply not yet gained familiarity with a particular set of discourses and conventions that were taken for granted by the adult natives of his (adopted) country (e.g. that drawing an object meant, unless instructed otherwise,

drawing it from a fixed viewpoint *as it appears to the observer*). This particular difficulty might well have been compounded in his case by the nature of the task he had been instructed to complete. As Leary (1984) writes, very pertinently in the context of Nozrul's experience: 'Much of Islamic art has ... been described as "aniconic" and Muslim attitudes to figurative art may involve rejection of human imagery.' Is it not possible, Mrs Green might have asked herself, that the task she had set Nozrul, a Muslim, was one that he had never been set by a teacher before, either in terms of the required style *or* in terms of the chosen content? If so, might it not also be possible that Nozrul was (Bartle-Jenkins, 1980) 'very unlikely to identify with a norm regarding figurative representation'?

My second visit to Mrs Green's Art class indicated no change in her approach towards Nozrul from that which had prevailed at the end of the previous session. Her view of what represented 'best provision' for this pupil was that he needed 'special help', that it was unfair and unreasonable for him to have been put into her class in the first place, and that she must concentrate her efforts on 'pupils who have a genuine chance of improvement'. The 'perceptual' problem she had diagnosed during the previous lesson was still at the forefront of her mind, but this had been joined by an equally strong despair at the technical aspects of Nozrul's drawing that located her diagnosis even more firmly within a developmental model of learning: 'the more I look at it ... He can't even draw a straight line. You almost wonder if he's ever held a pencil before. How do you begin to teach basic techniques like that to a child of this age, that would normally have been built up from infancy?'

During the course of their first lesson, before seeing Nozrul's first drawing, Mrs Green had managed to find time to sit down beside Nozrul and show him by example how to set about drawing a 'good likeness' of a face using geometrical principles. (The outline of the face had been sketched in first, then the features located by the intersection of various meridians.) This individual attention had taken up a good five minutes of Mrs Green's teaching time and at this stage she had clearly considered it time well spent. By the second lesson, however, her instruction towards Nozrul had ceased to be technical and become exclusively procedural, her communications to him comprising, exclusively, variations on:

Sit down.

Stop talking.

Use those pencils over there.

Get a sharpener.

The 'stop talkings' and 'sit downs' (in response to Nozrul's continued determination to find out for himself what he was supposed to be doing) effectively closed off his principal learning strategy at this stage, which was imitation of his peers. Mrs Green's tone with him was increasingly angry, her annoyance with some distant, untouchable, impositional authority having apparently found its target in the immediate human embodiment of the problem in her room. The discourse between them (teacher issues procedural instruction; pupil obeys) was fixed by the dominant adult: it was, from her viewpoint, that of inadequate, disaffected pupil looked after by long-suffering, put-upon childminder. As far as Nozrul was concerned, there was little reason to suppose that, bombarded by this dominant adult's conviction of his inability, he would not quickly come to believe in that inability himself: that he would say to himself not 'I have yet to learn the Art of this culture' but simply 'I am no good at Art'.

It is not surprising, perhaps, that in subsequent lessons Nozrul became less and less inclined to carry out any of the assignments set, and presented himself more and more as a 'behaviour problem' in this class, regularly seeking out opportunities for naughtiness that involved hiding other pupils' work and equipment, making marks on other pupils' work, passing items about the classroom, and trying to make other pupils laugh with amusing gestures.

WHAT TEACHERS CAN DO: THE IMPORTANCE OF CHALLENGING ASSUMPTIONS

At the beginning of this essay I referred to the fact that although all the Art teachers at Company Road publicly supported its Policy for the Arts not all of them put that policy into practice in their own classrooms. Mrs Green's teaching of Nozrul was, I suggest, one example of that mismatch in practice. The reasons for the mismatch are clearly very complex, and to understand them fully would require a detailed analysis of the various interfaces between Mrs Green's own in- and out-school life experiences, the resources available to her in her work, the range of ideas on Art teaching to which she had been exposed over a period of years, and her personal circumstances. (These might include,

for example, her current states of health and general well-being). For the purposes of this essay, it is not my intention to explore such interfaces, but rather to draw out from Mrs Green's conduct causes that can be addressed on a broader front and that may consequently be of use to teachers interested in developing anti-culturist strategies for their own classrooms.

Lewis (1987) has drawn an interesting parallel between definitions of Art and De Saussure's definition of Language that distinguished between individual speech acts ('paroles') and the underlying forms and constructs ('langue') from which those speech acts are constructed. Applying that distinction to the way in which teachers received and respond to their pupils' art, Lewis argues that 'if we are insufficiently familiar with the "language", we are unlikely to understand its "speech".'

A little later in the same essay, part of which could well serve as a description of Mrs Green's own situation, Lewis continues:

> If we are unaware of the construction of our personal reality, it is virtually inevitable that we will view the construction of the reality of others as an appendage of our own. Although we may enter the worlds of others with sensitivity and enjoy qualities we find there, we may perhaps see only decoration and surface (...) The messages that do get through can remain peripheral to our own deep truths. In such an event, our own world view remains untouched.
>
> (Lewis 1987, p.31)

What Lewis is arguing here, I believe, is that 'reality' is not a constant: it varies from culture to culture, both in its perception *and* in its representation through sign-systems. Teachers need to make themselves ever newly aware of this variability, and in particular to 'distance' themselves from their own cultural preferences as a prerequisite for understanding and appreciating the cultural preferences of others. If they can achieve this distancing, and so avoid making easy assumptions from the baseline of their own 'invisible' preferences (perceived by them not as preferred at all but as ideals or as norms), they should be in a position to be able to appreciate and understand what their pupils can do and are doing rather than what they are not doing and apparently 'cannot do. They ought also to be in a position from which they can, where necessary, help pupils to extend their expressive repertoires (cf Bakhtin 1986) in order

that, through adding new skills and genres to existing ones, they may have the opportunity to be perceived as successes not only in their own and one another's eyes but in the terms of the adults who evaluate and assess them. Such distancing suggests a 'removal' of artistic and indeed all cognitive-affective development from the psychological workings of the individual human mind, and its relocation in the social, cultural world of discourses and practices to which each child is, over a period of years, initiated (see, for example, Walkerdine 1982).

To say that Mrs Green had not understood Nozrul's 'langue' is not to argue, of course, that it is the responsibility of teachers to familiarize themselves intimately with the cultural preferences of all their pupils: such an undertaking could not reasonably be demanded, even if current provision for in-service training in our schools were not so woefully inadequate. What Mrs Green *could* very easily have done, however, was to avoid making the assumption that Nozrul's own cultural preferences and experiences were those of her own, or that his manifest failure to replicate her cultural norms was consequently indicative of his 'backwardness'. On a practical level, all she needed for her starting point was to follow the advice of one of her colleagues in the Art Department at Company Road, and to say to herself, in respect not just of Nozrul but of all her pupils: 'I don't know what this child had done before, and I don't know if they're used to doing things differently: but let me proceed on the basis that this is, at the very least, a distinct possibility.' This way, even if her snap diagnosis of Nozrul's drawing had proved correct in the long term, at least she would have arrived at her diagnosis by a fairer, more convincing route and, in so doing, would have learned a lot more about her pupil that she could claim to have learned from his first piece of supervised drawing in a very new and strange environment.

In taking such a course, Mrs Green could have found plenty of support both inside and outside her institution. Outside, she might have looked at the work and writing of a plethora of Art educators who have achieved enough of that distancing encouraged by Lewis to be able to begin to understand the 'langues' of their pupils without having had to take a crash-course in World cultures. Anne Taber (1981), for example, has written very appositely in respect of her own bilingual pupils:

> One needs to think more carefully about what is taken to be a 'realistic' representation of a three-

dimensional world. Our standard method of draw-
ing objects from a fixed point of observation (more
or less the procedure of photography) produces a
picture that totally distorts certain aspects of reali-
ty ... I began to realize that I was judging (my stu-
dents') work by the standards of a procedure that
they had not attempted to use. Their drawings had
an element of truth and power that projective rep-
resentation cannot achieve as it involved techni-
cal problems that mar visual clarity. For centuries
it has been taken for granted in the 'Western'
world that only the projective method enables the
artist to represent 'reality' (...) In Eastern cultures
(...) artists have experimented with different pro-
jective representations to produce more expressive
compositions or to emphasize symbolic meanings.
Modern artists, such as Picasso, have allowed us
to see that there are many ways of depicting reali-
ty. The projective method is only a 'realistic' style
when defined by current 'Western' ideas.

In order to show how practising teachers can
incorporate this kind of perspective into their
teaching in ways that will challenge their peda-
gogy through encouraging them to ask the right
sorts of question, Taber cites the example of colour:

> The question frequently asked by them (pupils
> from 'other' cultural traditions), 'What colour
> shall I use?', caused me great perplexity. My
> rather lame replies, such as 'you will have to
> decide for yourself', simply covered up my
> inability to understand exactly why they were
> asking such a question (...) It occurred to me
> that in the art with which they were familiar
> there might be a scheme of colours and they
> might feel that this was the case with all art
> work (...) The colours in religious art are not
> selected for reasons of visual aesthetics but are
> dictated by the choice of subject matter, and so
> are symbolic like a logogram or hieroglyph. An
> awareness of the iconic meaning of colour may
> help the art teacher to understand some stu-
> dents' attitudes towards the use of paint. (...)
> When seen in this light, the question 'What
> colour shall I use?' no longer implied to me a
> naive lack of understanding that selection of
> colour was an important part of the student's
> work (...) but had to be regarded as a serious
> intellectual enquiry. I felt that a satisfactory
> answer to the question would have to give the
> student some insight into the 'Western' philos-
> ophy of art compared with his own. Without
> this help in bridging a gap, he might be left to

flounder between two cultural concepts with-
out any real understanding of either.

Approaches like Taber's, which begin with a delib-
erate attempt to shake off one's own cultural
assumptions in order to be able to understand the
'langues' and thereby the 'paroles' of one's pupils,
were also to be found inside Company Road itself.
Here, for example, Mrs Green might have looked
at the work of colleagues in her own department,
who habitually provided books for their pupils
containing exemplars from a wide range of cul-
tures and countries. Those same colleagues, hav-
ing discovered through conversations with their
more experienced bilingual pupils that naturalistic
figure-drawing or indeed still-life or landscape
work would be unfamiliar to many newly-arrived
pupils, had developed strategies for encouraging
such pupils to do the things they were familiar
with and good at *before or simultaneous to* asking
them to do the things which were new to them: for
example, work with patterns or with paper and
string. These teachers not only allowed cultural
variation into their classrooms but actively cele-
brate it, so that when Bangladeshi children were
working with patterns the rest of the class was
working with patterns too, and was enjoying com-
paring different kinds of patterns from different
parts of the World.

For these teachers, no less than for the pupils
in their classes, the rewards of such efforts shone
through clearly in interview, replacing Mrs
Green's disgruntled pessimism with a genuinely
appreciative optimism on the part of teachers and
a hopeful confidence on the part of pupils. The
most significant gains, perhaps, were for the bilin-
gual pupils themselves, many of whom, to quote
one Art teacher at the school, went on 'to become
real stars'. The way in which these pupils per-
ceived themselves from a very early stage in their
English school careers was not as deficient bur-
dens holding back their 'more able' English-born
peers (the sub-text of Mrs Green's diagnosis), but
as experienced artists who had a lot to learn and
who simply wanted to get on and learn it. Had
Nozrul had the good fortune to find himself in one
such teacher's classroom rather than in that to
which, somewhat haphazardly, he had been
directed on his arrival, we can only speculate as to
how he might have come to perceive himself as an
artist and as a student, or as to how that, in turn,
might have affected the school's – or indeed soci-
ety's ultimate perceptions of him.

BIBLIOGRAPHY

ATKINSON, D. (1991) 'How Children Use Drawing', in *Journal of Art and Design in Education* (vol.10 No.1).

BAKHTIN, M. (1986) 'The Problem of Speech Genres', in Morson, G.S. (Ed) *Bakhtin: Essays and Dialogues On His Work*, University of Chicago Press.

BARTLE-JENKINS, P. (1980) 'West Indian Pupils And Art Education', in Loeb, H., Snipes, D., Slight, P., and Stanley, N. (Eds) *Projects and Prospects: Art in a Multicultural Society*, Birmingham Polytechnic Papers.

HARGREAVES, A. (1984) 'The significance of classroom coping strategies', in Hargreaves, A. and Woods, P. (Eds) *Classrooms and Staffrooms*, Open University Press, Milton Keynes.

LEARY, A. (1984) *Assessment in a Multicultural Society: Art and Design at 16+* Schools Council Programme 5 *Improving the Examinations System*, Longman for the Schools Council.

LEWIS, M. (1987) 'Culture, Communication and Personal Identity', in Loeb, H. (ed.) *Changing Traditions II Ethnographic Resources for Art Education* Department of Art, Birmingham Polytechnic.

LOWENFELD, V. and BRITTAIN, W.L. (1970) *Creative and Mental Growth*, Macmillan, London.

MOORE, A. (1990) 'Khasru's English Lesson: Ethnocentricity and Response to Student Writing', in *The Quarterly of the National Writing Project and the Center for the Study of Writing*, Vol.12 no.1 University of California, Berkeley, California.

READ, H. (1964) *Education through Art*, Faber and Faber, London.

TABER, A. (1981) 'Art and Craft in a Multicultural School', in Lynch, J. (Ed) *Teaching in the Multicultural School*, Ward Lock Educational

VYGOTSKY, L.S. (1978) *Mind in Society*, Harvard University Press, Cambridge, Mass.

WALKERDINE, V. (1982) 'From Context to Text: A Psychosemiotic Approach to Abstract Thought', in Beveridge M. (ed) *Children Thinking Through Language*, Arnold, London.

ARTISTS, CHILDREN AND COMMUNITY

ROD TAYLOR

If they are from the same communities as the pupils, then one of the great advantages is that the artists recognize themselves in those kids. In other words, they can see how they used to be through the kids and I think that relationship actually enables artists to give more to those pupils, to understand that lack of confidence in them and to develop it through practical use and development of their talents. Ultimately it's a two-way thing ... What the kids themselves then bring first-hand to those experiences actually helps the artist.

K. Hampson,
Wigan Director of Education.[1]

Darren, a previously unmotivated art pupil, produced a body of extraordinarily powerful ceramic works during Norma Tait's residency at his school. He subsequently testified that he had been 'rebelling against art' before Norma came. But why? 'Because it wasn't to do with life!' he rejoined, with great seriousness. By comparison, working with the artist was most definitely to do with life, so much so that he began to design all his pots at home so as to ensure the maximum amount of time for working with clay in the ceramics studio. The three founder members of the Artists in Wigan Schools Scheme had all been educated in Wigan schools themselves and, as the

Director of Education highlights, were therefore able to give back to their community in significant ways through their natural identification with, and sympathy for, Wigan children, in whom they recognized themselves as they used to be, while the children too, envisaged what they might become through the artists.

The Scheme began in September 1984, by which time Wigan's Visual Arts service had already acquired a considerable reputation through the work of the Drumcroon Education Art Centre and the focus of the 1981–4 national *Critical Studies in Art Education* Project (C.S.A.E.), to which Drumcroon was host centre throughout. The belief that children found art galleries boring, allied to theories about their creativity being impaired through contact with adult art, was still widespread, finding particular manifestation through 'free expression' and in 'Child Art', both prevalent concepts then: central to these was the belief that all children are 'naturally' creative and would give expression to this if only they could be protected from such harmful external influences as adult art. The art room, to some minds, therefore, constituted a kind of protective bubble, with the teacher dispensing materials and offering encouragement, but otherwise effectively sidelined through a self-imposed commitment to non-intervention. Child art was practised most fervently in

the 1960s, and subsequent developments in the 1970s perpetuated some of these attitudes, some even advocating 'Visual Studies' as the title for the subject in order to remove any last vestiges of association between what children did and Constable's *The Haywain* – or whatever – thus further emphasizing the artificial divorce between 'school art' and all other genres, past and present! As a consequence, most school art took place within the rigid confines of the art room walls, with neither essential stimulus being brought in, nor the pupils taken out. Critical studies sought to break down the barriers of the art room walls, reconnecting art with life in the process.

Some of the earlier residency schemes had foundered because of the consequent lack of appropriate strategies to relate the skills and values of the artist to the school's art curriculum. Nevertheless, residency programmes continued, as did those in galleries. Since its opening in 1980, Drumcroon had made full use of resident artists in relation to its exhibition and workshop programmes. A substantial collection of original art works was also on offer to schools, many of whom made excellent use of it. Rather than the children's own creativity being impaired, the overwhelming evidence was the opposite: the richness of stimulus led to often quite unexpected developments in their work in terms of ambition, scale, imagery and content. It was not uncommon for teachers to comment that children who had never previously performed significantly, did so during or following their Drumcroon visit. Likewise, notions of art galleries being 'boring' were frequently replaced by a new sense of excitement and wonder, leading me to define the motivating impact of many a gallery visit as 'illuminating experiences':

> I was really taken aback and amazed at the weavings done by Tadek Beutlich. Never having any other experience of seeing weavings I really found myself wanting to know how these weird shapes and patterns could be made from materials. The colours and names fitted the weavings perfectly ... Another thing that attracted my attention was the simplicity of his prints. These were just a few colours and a few abstract shapes blended together to make a beautiful, striking effect that was really inspiring ... and you want to do something like that in school.[2]

This fifteen-year-old pupil illustrates how contact with the adult artist's work can open up an increased awareness of artistic possibilities, with the pupil then inevitably wanting to develop his or her own work accordingly sometimes clearly articulating what educationists had dithered over for too long:

> Everybody is influenced by somebody else and if you could just start to formulate your own ideas, just follow the guidelines of somebody else's work and not exactly copy, just understand how they have done it, what they were thinking of and how they put it all together, instead of just doing one simple print of just a figure or something like that – and really going to town on things like that. Just to have the chance to tax your brain![3]

The C.S.A.E. Project led to the inescapable conclusion that children should be educated to know about art as well as how to make it, and that unexpected developments of a dynamic, interactive nature frequently come about through the relationships between the two.

However, it was the establishment of the school-based residency scheme in Wigan which did so much to fully integrate Drumcroon practice and philosophy with that of schools from all sectors and phases of education. The artists took Drumcroon principles outwards into every type of school in positive ways leading to the creation of a vital service, with profound community implications. They provided the crucial link in an authority-wide visual arts infrastructure. A network between teachers in one school and colleagues in others rapidly developed. The loneliness, about which so many art teachers traditionally complain, evaporated, and the concept of an art education no longer restricted by the art room walls became a reality. A whole web of links was created, with teachers visiting each others' schools, not in a spirit of competition, as is all too often the case through examination and assessment and moderation visits, but from a sense of sharing, born of genuine interest in what was happening through the stimulus generated by a particular residency.

This network not only affected teachers. In turn, it drew in other people in all sorts of fascinating ways, as one caretaker's response to the return of his school's *Ceramic Fantasy Village* following its showing in a number of exhibitions illustrates. Every child in the school had helped in its making, and it was normally displayed in the school's main entrance, for which it had been specifically designed:

When I learned the village was coming back to school I was delighted because when it was taken down the porch seemed dull. Now it's back it's brought tremendous colour and brightness to the place. I feel when I come in in a morning at 7 o'clock it's lovely to just stand and look at it for a few moments. It's so refreshing to see children are capable of this sort of work without thinking about models to do with television programmes. They've thought about this themselves, their enthusiasm when building it was really tremendous. It was fabulous to watch it grow. I'm overjoyed it's back and I hope it stays for a long time.[4]

Pupils too, began to give expression to clearly expressed views and concepts about artists' works, born of having something to say. This was refined and developed through the systematic application of the Wigan-conceived Content, Form, Process, Mood model, designed to allow children themselves to pose pertinent questions with regard to what a work might be about, how arranged, how executed and how, in engaging with it, the pupil, too, is affected. This empowering model has allowed countless young people of all ages to give expression to and communicate with others about their unusual insights into the work of established artists. In the process, they have been able to make connections between their inherent qualities and those within, or which they seek to develop, in their own practice. I have now run numerous workshops of this nature involving teachers, too. Many of them surprise themselves at the literary skills they reveal, nothing in their own art training having caused them to engage with a single art work in such depth and for such a length of time; that they can have something of significance to say is often the springboard to accepting that their children can likewise engage with art works to sometimes extraordinarily deep levels, providing a creative alternative to arid forms of art history teaching.

It became quite commonplace for schools to organize open evenings for parents to see the fruits of a residency, with them willingly visiting schools through positive and constructive, as opposed to threatening, contexts, 'It's so lovely to see the children so absorbed in their work – they obviously enjoyed this experience.' Not only were there benefits for the immediate Wigan community, but interested individuals and groups began visiting from all over the country and, indeed, from various parts of the world, establishing a wider community of like-thinking people, 'I look back with great fondness to the time I spent in Wigan and the real privilege it was to share in what you are doing there ... I was struck by the vital impact that many of the resident artists have made in their respective schools,' wrote a teacher from one of Archbishop Tutu's non-racial schools in South Africa. He has subsequently successfully established a residency programme in his own school, while two of the Wigan artists have undertaken residencies in a Services school situated in Northern Germany.

Fundamental to the Wigan Scheme is the principle of partnership, founded upon the belief that teacher and artist sharing their skills by working closely together can offer children far more than can either one, however brilliant he or she might be, when working alone. Partnership can, of course, prove complex as a concept. It can founder when one partner feels vulnerable or inadequate in relation to the abilities of the other. It requires recognition on the part of each, that teacher and artist contribute quite distinct but nevertheless complementary skills and attitudes. Many of the residencies have come close to the ideal, however, two people frequently managing to achieve what one cannot when working alone:

> And another thing, we both had projects that we were keeping for the time when we had the energy and the opportunity to do them, and we found that we could get these projects implemented between us. On your own you think, 'I wonder if I could manage this!' We'd talk about it and then we'd say, 'Yes, of course – great. We'll do it! We will do it'. Working together we had the confidence and the energy to do it.[5]

By establishing a team of artists within one authority, it was also possible to address entitlement principles and needs. Instead of a residency being simply a perk for an industrious department or an attempt to bring stimulus to one which is underachieving, the aim of all children being directly affected became a real possibility. Three artists became six the next year through the matching support of the Calouste Gulbenkian Foundation, with still further growth following. The Elephant Trust provided invaluable support at a key formative stage, their funding facilitating the provision of essential materials to make it possible for the children to work in related ways to resident artists.

Central to the Scheme from the outset was a 50/50 principle which required that artists devote

around half their time to their own work, with a brief to work with teachers and communicate with pupils for the other half. This, allied to partnership, meant that children became involved in related activities which also had their roots in the school curriculum, the teacher, too, acquiring invaluable new skills and insights in the process. Each artist had to establish a studio area which was both attractively enticing and informative through the captioning of their work. This was further contextualized by each artists selecting original works to which they were particularly responsive from the Loan Collection, and through the use of reproductions of works which had been influential upon them in some way. One head of art testifies to the impact of the resulting studio environment established by Angela Cusani in his department:

> Angela transformed a rather dull corner of the Art room into a riot of colour almost overnight, and this area was to grow in its richness and quality during the year. Colour suddenly became three-dimensional, the rich and seductive quality of which was so delightful and attractive that it was impossible to pass Angela's area without being enticed to take a closer look![6]

Long-term residencies, usually of half a year's duration, enabled artists to address whole-school populations, rather than simply working with small 'target-groups'. The impact of the artists' studios frequently radiated out into the school environment, the presence of the artist sometimes being unmistakably evident from the moment one entered the school. The combination of Drumcroon's quality of presentation and display allied to the impact of the artists on their schools, transformed the physical appearance of many schools, the skills of presentation proving to be transferable ones. Equally important, a constant supply of Wigan-generated work began to inform the exhibitions of both Drumcroon and the Leigh Turnpike Gallery, with which it had been 'twinned' since 1985. Many exhibitions combined the work of the artists with what they had stimulated in pupils to stunning effect, so that the exhibition programme became unusually alive and vital – the young people of Wigan becoming positive agents in the shaping of the culture of their locality.

The presence of the artists led to the addressing of real-life issues in significant ways. Kevin Johnson, a member of the Black Artists Alliance, dealt with anti-racist issues head-on through his powerful ceramic sculptures, in which his direct working of the clay was inseparable from the content of the works. Anne-Marie Quinn's suite of pregnant nude pastels provoked the strongest reactions from adults and young people alike, leading to the exploration of the most subtle aspects of the human body in relation to the national science and health education 'My Body' project. Norma Tait elected to work in the special educational needs sector, where she has enabled countless pupils to achieve to remarkable levels, raising their self-esteem in the process.

In addressing entitlement principles, other related strategies were devised. Geoff Brunell's *Joie de Vivre* exhibition proved seminal in this respect. He was Head of Fine Print at Manchester Polytechnic at the time, and spent two weeks in residence at Drumcroon during his exhibition, but with his students simultaneously working in schools throughout the Borough. Further groups of students have spent similar periods of time in Wigan schools every year since. Another important model was the establishment of the parallel Enterprise Artists Scheme, young unsalaried artists being provided with studio spaces in schools with a view to establishing themselves in business. The founder artist, Anne-Marie Cadman, conducted her business from a primary school studio for over two years, her presence also having a profound impact on the work of the school in practical terms even though the 50/50 principle was waived in the case of these artists.

The impact of the Scheme has been exceptional, but this did not help it escape unscathed the consequences of Wigan being poll tax 'capped' in 1990. The artists' salary bill had to be halved, and there has been a further loss of artists as others have obtained posts elsewhere and not been replaced. The government's grant structure ensures that there will be severe cuts every year, unless it is changed, thus threatening a unique service which has benefited countless pupils to date. Wigan is an area of high unemployment with considerable socio-economic problems – 44% of pupils are on free school meals, for example. 'Many children born into this drab landscape are underprivileged from the start. Few experience cultural influences at home,' suggests the Director of Education. Wigan was nevertheless twelfth in the national G.C.S.E. examination league table, 'that reads like a travel guide to a green and pleasant England' with the 'old Lancashire mill town of

Wigan the exception', observed the Daily Telegraph. The Director recognized the important correlation between Wigan's high arts profile and this success:

> ... because there is nothing else about Wigan that is different. ... through the arts in the widest sense, pupils have been given great opportunities to recognize that they do have talents and that those talents have always been there. It's not purely for the highly intelligent, for many people have got multi-talents which they have never been allowed to develop. They have seen those talents develop now and that has given them a confidence which washes over everything else that they attempt. (This), has a direct effect on how they actually perform in standard, external examinations – but it's far more important in terms of how they develop as human beings! ... The arts give pupils power by enabling them to communicate![8]

A service like the Artists in Wigan Schools Scheme has had a profound influence on current thinking about art and design education. Many of the critical studies strategies which are now widely practised were pioneered in Wigan, and the Artists in Wigan Schools Scheme proved the vital element which bound them all together into one cohesive whole. Maria Vaizey, *The Sunday Times* art critic, emphasizes that the scheme and its substructure are worthy of wider emulation while also acknowledging the extent of its impact:

> While the Drumcroon-Wigan model has yet to be copied nationally, every time there is a workshop at an art gallery, or an artist in a school now, something of what has happened at Drumcroon this past decade is reflected. If the message were carried on, eventually many of us, or our children, could at last be visually alert, so attuned that the ghastly mess we make of our environment would be altered![9]

NOTES

1 Taylor, R., *Artists in Wigan Schools: A Right for All Children*, Calouste Gulbenkian Foundation, 1991, p.90. This book provides the most comprehensive survey and record of the scheme to be published to date.

2 Taylor, R., *Educating for Art: critical response and development*, Longman, 1986, p.44.

3 ibid., p.45.

4 *The Arts in the Primary School: some of the Arts all of the time*, Wigan Education Department, 1990, p.9

5 Taylor, op. cit. 1991, p.47.

6 Ibid., p.23.

7 'Cash Cuts threaten a classroom revolution', *Daily Telegraph*, 8 Feb. 1992.

8 Taylor, 1991 op.cit. p.86.

9 Ibid. p.100.

PART THREE

ARTISTS, SCHOOLS, GALLERIES AND EXHIBITIONS

CHAPTER EIGHTEEN

(MIS)REPRESENTATIONS: THE CURATOR, THE GALLERY & THE ARTWORK

ROHINI MALIK AND GILANE TAWADROS

PAST TENSE, PRESENT PRINCIPLE

This chapter explores the ways in which work by artists from a plurality of cultures and cultural backgrounds has been represented both inside and outside the gallery space. Focussing on a number of recent exhibitions, the power structures employed in defining, displaying and contextualizing are revealed, and alternative paradigms for presenting and evaluating work are suggested.

When visiting an exhibition we should be aware that what we are seeing is a constructed entity. We are being told a story, a very particular story, based on the decisions and assertions of a curator or group of curators. Exhibiting, by its very nature, is a contested terrain. The works on display arrive in the gallery as the result of a process of selection, and once selected they do not remain unchanged; they become recontextualized. It would perhaps be easier if curators of exhibitions could somehow inform their audiences that what they are seeing is not material that 'speaks for itself', but material filtered through the tastes, interests, politics, and state of knowledge of particular individuals at a particular moment in time. Behind the selection of works lies a hidden agenda.

These issues are particularly pertinent to exhibitions displaying objects and artworks from other cultures. As viewers, we need to ask questions about the ways in which the perspective and authority of curators mediate the representations of other cultures. It is difficult to separate the representation of non-European cultures – through displays of their cultural artefacts – from the political and economic framework which makes these representations possible. Most exhibitions of non-Western art are curated by people from the west. The legacy of colonialism with its connotations of ownership and control prevails as we ask: who collects and curates whom? As the Cuban art critic and curator Gerardo Mosquera writes, 'the world is practically divided between curating cultures and curated cultures at their convenience curating cultures select, legitimate, promote and purchase'.[1]

Power belongs to those who name, define and bestow identity, the storytellers. While the artworks and cultural artefacts have their own stories to tell, these original voices are to a certain extent silenced by the curatorial narrative imposed upon them. According to Hou Hanru, a Chinese curator based in Paris, 'the function of a contemporary art museum is usually to separate

artworks from the progress of time in order to define, evaluate and legitimate them'.[2] The works become, in a sense, 'frozen', fixed in time and space, by labels and glass cases, so that we may encounter 'Otherness' and 'difference' within the safety of our own terms. This discussion will become clearer as we look at two exhibitions held in major British galleries in the last couple of years: *The Art of Ancient Mexico* at the Hayward Gallery, London, in 1992, and *Africa Explores* at the Tate Gallery, Liverpool in 1994. Both exhibitions did more than just present works of art, they sought to package and communicate entire cultures for the consumption of the viewer.

The Art of Ancient Mexico presented artefacts created during the two and a half thousand years before the conquest of the Aztec-Mexican capital by the Spanish forces of Cortes in 1521. This is an enormous time span to recreate with a single exhibition. It is hard to imagine an exhibition of British art covering a period of similar length i.e. from about 1500 BC (the completion of Stonehenge) to AD1500 (the reign of Henry VII). The exhibits in *The Art of Ancient Mexico* are arranged geographically rather than chronologically, so that a sense of stylistic and technical innovation through time was lost. It is as if the exhibition organizers wished to distil the very essence of ancient Mexico and deny any historical developments that took place during those 2,500 years. The fact that the exhibits in *The Art of Ancient Mexico* were presented as works of art should also be questioned. In the foreword to the exhibition catalogue, Sonia Lombardo de Ruiz suggests the 'the idea of presenting an exhibition of Pre-Columbian art clearly presupposes a modern concept of art'. While exceptionally well made pieces were valued for their beauty, the items in the exhibition were not created by the pre-Hispanic inhabitants of Mesoamerica as works of art in the sense we are used to, to be framed and displayed in galleries, but as objects and ornaments used for a variety of ritualistic purposes. How did the works suddenly transform from artefact to art, and why did these processes of redefinition and re-contextualization occur?

Much has been made of the fact that many modern European artists, including Brancusi, Modigliani and Henry Moore, were greatly influenced by pre-Hispanic works. It has been suggested that it was only at the beginning of the twentieth century, when western artists recognized the 'value' of these works that they came to be redefined as 'art'. But redefined on whose terms?

The pieces are further re-contextualized when placed in a contemporary art gallery. How different would the exhibits have seemed if the exhibition had been staged at the Museum of Mankind in London? The agenda there would have been quite a different one. Through the aesthetics of installation and display the objects at the Hayward are manipulated, and we are presented with *The Art of Ancient Mexico*. Meanings and definitions are not absolute, but contingent. The exhibited artefacts are cultural objects that have numerous meanings and can be interpreted in a variety of ways; one of these interpretations is that of 'art'.

Susan Vogel the curator of *Africa Explores*, asserts that she uses the category 'art' only as a conceptual tool. This exhibition surveys a broad selection of African art created throughout the twentieth century, and aims to challenge Western perceptions of African art as either 'primitive' or blindly derivative of European art. However, while Vogel assures us that the exhibition 'seeks to focus on Africa, its concerns and its art and artists in their own contexts and in their own voices',[3] it is disappointing to discover that in the end it is Vogel's voice which can be heard loudest.

The entire continent is dealt with as if it were a single entity, while Vogel divides the works into categories of her own; 'traditional', 'new functional', 'urban', 'international' and 'art from the past in the present', each displayed in a different coloured room. By imposing her own divisions, Vogel is asserting an authority, and it is implied that we would be unable to understand these works without such labels to point us in the right direction.

Although unstated, implicit in these categories is a hierarchy. While 'international' artists are those 'who are academically trained or who have worked under the guidance of a European teacher/patron ... live in cities ... are widely travelled', 'urban' artists, making signs and other commercial images, are described as 'rather like craftspeople, making art to earn a living. Most have only a primary school education and rarely travel'. In other words they are not seen as equal. The room displaying the 'international' artists is painted white – the conventional appearance of a contemporary art gallery – while the other rooms are painted in various colours. Perhaps Vogel is implying that only the work in this room is to be taken seriously as 'real art'.

Refusing to recognize continuities between current and past African art forms, Vogel insists

on telling a story on her own terms, asserting that contact with the West has been the determining experience for African artists in the twentieth century. Critical of those who dismiss contemporary African art as merely imitative of and contaminated by the West, she stresses creativity, but creativity only in response to Western influences, not in combination with indigenous traditions.

Africa Explores was designed to challenge audiences' preconceptions and prejudices, and while the value of the exhibition, in showing us a wide selection of work we would not otherwise have been able to see, must not be dismissed, it is clear that the story we are told has also been constructed in a very particular way, and unequal relations of power are in operation in defining and categorizing the works. Perhaps we should ask: How might the exhibition have been different if selected by an African artist or curator? Although of course, no one curator will have the authoritative voice.

These two exhibitions should be seen in the context of a whole history of collecting and appropriating non-Western works of 'art' and 'culture' by people and institutions in the West, an extension of the colonial enterprise.

'BETWEEN TWO WORLDS' AND 'THE OTHER STORY'

During the early to mid-eighties in Britain, there was a growing awareness of the work of artists from a plurality of cultures and cultural backgrounds. This increasing awareness was due to a great extent to the efforts of the artists themselves who adopted the role of curator and/or writer to draw attention to the work of established artists whose presence had largely been ignored by the art establishment for over a decade and an emerging generation of young artists whose work was rarely exhibited or reviewed.[4]

These initiatives coincided with critical debates around definitions of race, nation and representation and the activities and interventions of black cultural practitioners and critics across a range of art forms:

The early eighties ... saw the gathering of a critical mass through collectivist activities whose emergent agendas began to impact upon public institutions during the mid-eighties around the key theme of black representation [...] Such developments in film or cultural studies were of a piece, then, with paradigm

shifts undertaken in relation to photography, visual art and across the black cultural sector as a whole. While tactics varied, in terms of individual and collective efforts operating autonomously or from inside institutions, the common result was to call into question the very identity of the components of the national culture.[5]

In 1986 the Whitechapel Art Gallery organized the exhibition *From Two Worlds*. The exhibition was selected by the artists Sonia Boyce, Gavin Jantjes and Veronica Ryan with Jenni Lomax, Rachel Kirby and Nicholas Serota from the Whitechapel and included the work of sixteen artists; Rasheed Araeen, Saleem Arif, Franklyn Beckford, Zadok Ben-David, Zarina Bhimji, The Black Audio Film Collective, Sonia Boyce, Sokari Douglas Camp, Denzil Forrester, Lubaina Himid, Gavin Jantjes, Tam Joseph, Houria Niati, Keith Piper, Veronica Ryan, Shafique Uddin. In their introduction to the exhibition catalogue, Serota and Jantjes sought to contextualize the exhibition within a longer history of cultural plurality and artistic practice in Britain which extended back to the early years of the twentieth century and the contributions of Jewish artists like David Bomberg and Jacob Epstein to the history of British art:

Put simply, it is far too easy to draw a tight boundary round the vision of an artist by describing a painting or sculpture as 'Indian' as if the label itself is sufficient explanation for the complex synthesis of ideas and cultures which are present in the work. Of course this is not the first generation of artists whose work has been critically circumscribed in this way. Although on this occasion the selectors have chosen to show artists of a younger generation the history of cultural synthesis would span at least sixty years in the West and Europe. The Cuban painters Wilfredo Lam and Sebastian Antonio Matta and the Japanese-American sculptor Isamu Nogushi are examples of an early avant-garde.[6]

The selectors considered the work of nearly fifty artists before making their final selection. Their principal criterion for selection was 'the works' achievement as an innovative synthesis of a "lived" cultural plurality. [...] The exhibition aims ... to pose questions about the viewpoint from which we regard the world and the way in which an artist with a plural cultural experience can give expression to his or her vision.'[7]

The works shown in the exhibition inevitably represented a variety of approaches and means to the theme of cultural synthesis on the part of individual artists which reflected the artist Keith Piper's observation that 'for a black artist living and working in this country, the issues which arise around the realities of existing at the interface between diverse cultural and creative traditions are complex and multi-faceted'.[8]

By way of example, Sonia Boyce's colour pastel drawing entitled *She Ain't Holdin Them Up, She's Holding On (some English Rose)* (1986; Plate 1) explores the ambivalence of personal identity and family relationships. This image was particularly inspired by the work of the Belgian surrealist René Magritte whose play on the fragile distinction between image and reality is employed by Boyce to articulate the tensions between imagined and real identities and between public and private experience. The pattern of black roses which covers the artist's dress in this self-portrait refers formally to the designs of William Morris, chief architect of the Arts and Crafts movement, but also signals the ambivalence of definitions of 'Britishness' and 'blackness'. Boyce's work rejects simplistic categories for defining either cultural and national identity or visual art practice:

> ... different cultures, historically, are interrelated, ...although we can talk about a European tradition, this tradition feeds off other art traditions such as those of Africa, Asia, North and South America etc., just as those traditions are influenced by what is going on in the West. There are very different modes of looking at and theorizing about art in different cultures, but artists' concerns cross cultural boundaries so it becomes difficult to separate out influences.[9]

Veronica Ryan's abstract sculptures, composed of bronze, reinforced plaster and colour pigment, suggest a number of readings which are inflected by the viewer's own experiences and memories. She creates a world of pods, fruits, seeds and shells, inspired by the fruits and plants she has seen in the West Indies and Africa but which suggest a delicate balance between containment and freedom, solidity and fragility, rigidity and softness. Above all, Ryan's work attests to the richness of diverse traditions and ways of seeing:

> I think what upsets me is the way it seems that there's an attempt to reduce African art to one blob, with everybody the same. You go to Ife

and there's work coming from a specific philosophical, cultural and religious background; you go to Benin and OK there are similarities, but the work there too is coming from a distinctive background ... each culture has its own way of manifesting itself visually.

Of her own work, the artist says:

> A lot of black art is overtly political and I feel my work could never be like that. The difference is in how people translate what they're receiving ... I'm trying to re-enact a sort of history in my work. I wouldn't go to all the bother of making sculpture which is very, very difficult if it was just a desire to create for the sake of creating.[10]

From Two Worlds had focused deliberately on the work of younger artists, those who had either been born in Britain or had moved to this country at a young age. Three years later, a major survey exhibition presented the history of African, Asian and Caribbean artists in post-war Britain from 1945 onwards. *The Other Story* exhibition eventually came to fruition at the Hayward Gallery in 1989 after a prolonged struggle lasting almost ten years during which the artist Rasheed Araeen attempted to have his proposal accepted by the Arts Council to give an alternative account of post-war British art. As Araeen wrote in his introduction:

> This is a unique story. It is a story that has never been told. Not because there was nobody to tell the story but because it only existed in fragments, each fragment asserting its own autonomous existence removed from the context of collective history. It is therefore the story of those men and women who defied their otherness and entered the modern space that was forbidden to them, not only to declare their historic claim on it but also to challenge the framework which defined and protected its boundaries.[11]

The exhibition aimed to expose the work of artists who had made and were/are making significant contributions to British art practice, yet whose work had been consistently ignored, classified as 'ethnic art', and excluded from the 'master narrative' of Western art history.

The story begins with those artists who came to Britain in the post-war years, artists such as Ron Moody (b.1900, Jamaica), Ivan Peries (b.1921, Sri Lanka), Francis Newton Souza

(b.1924, India), Avinash Chandra (b.1931, India), Aubrey Williams (b.1926, Guyana), Ahmed Parvaz (b.1926, Pakistan), Frank Bowling (b.1936, Guyana), Balraj Khanna (b.1940, India), Li Yuan Chia (b. 1932), David Medalla (b.1942, Philippines), Avtarjeet Dhanjal (b.1939, Punjab) and Araeen himself (b.1935, Karachi, Pakistan):

> Throughout history artists have travelled from one country to another in search of patronage, quite often ending up in the dominant centre. The arrival of Picasso, Brancusi, Mondrian, for example, in Paris, in the early years of this century, was very much part of this tradition. So when artists from the ex-colonies began to arrive in the metropolis after the War it was not an unusual phenomenon. The independence of their countries removed the constraints, both physical and psychological from travelling to those places where they could find institutions to support their work.[12]

Many of these artists attracted considerable critical acclaim in the 1950s and 1960s in Britain and abroad and were seen (as indeed they saw themselves) as part of the rich fabric of post-war European modernism even as they drew on cultural and artistic influences outside Europe. According to the artist Aubrey Williams, his work addressed itself principally to the question of the 'human predicament, especially with regard to the Guyanese situation.' This synthesis of the local and the universal, the European and non-European, was at the heart of Williams's artistic practice. Talking about the impact of American Abstract Expressionism on British artists in the 1950s, he says:

> Pollock was everything. Pollock was our god! All those artists – Kline, Newman, Rothko, de Kooning! They were all great! But for me the most important was Gorky. He fitted in some way with my own perception which was basically informed by the pre-Colombian Indian iconography of Guyana.[13]

By the end of the 1950s Williams had become quite famous, but while many reviewers expressed great admiration for his work, they also differentiated him on the basis of his race. His work was often defined in terms of 'primitivism', as this review, written in 1959, illustrates: 'his art reflects the instinctive sense of rhythm of the Negro fused with the mytho-poetic imagination of the Indian-Voodoo and the image of gods and man.'[14]

The work of Avinash Chandra and Francis Newton Souza, both of whom arrived in Britain during the post-war period, was also highly revered, but again defined in terms of the artists' racial origins. Araeen suggests that the success of both Souza and Chandra had to do with their being Indian. They were not artists, but 'Indian artists', and the significance of their work for the British audience lay in the way they played around with the notion of their 'Indianness' with imagination and power. Their work was often defined as being highly erotic and sensuous, and this in turn was perceived as an essentially 'Indian' quality, reminiscent of the erotic sculptural decoration of ancient Hindu temples. While traditional forms in India may have influenced their work this was only one among many influences, including European art practice. Chandra himself admitted that his style was influenced by his fascination with artists such as Van Gogh and Soutine, yet in Britain his work was seen as representative only of his 'Indianness'.

The critical acclaim received by Aubrey Williams, Avinash Chandra, Francis Newton Souza and many of the other artists named above in the 1950s and 1960s died down as the initial post-war euphoria for the Commonwealth also diminished. By including these artists in this exhibition, Araeen attempted to re-write the history of post-war British art practice. Works by a younger generation of British artists from various cultural backgrounds were also included in *The Other Story*.

Images by some of the younger artists, such as Eddie Chambers and Keith Piper, dealt directly with racism and inequality as experienced in Britain. Other artists, such as Gavin Jantjes (b. South Africa) and Mona Hatoum (b. Lebanon) expressed in their works the feelings of struggle, alienation and displacement they experienced in their countries of birth, while at the same time articulating more general questions about human freedom.

The exhibition included twenty-four artists in all who represented at least two generations. The press received the exhibition with almost universal disdain and, at times, alarmingly violent criticism. In his review of the exhibition for *The Evening Standard*, Brian Sewell observed 'for the moment, the work of Afro-Asian artists in the West is no more than a curiosity, not yet worth a footnote in any history of twentieth-century Western art'.[15] In response to the charge that the exhibition placed artists in a 'ghetto', Araeen responded by

pointing out that '[black artists] already have been ghettoized, this is an attempt to get out of the ghetto'. Commentators tended to overlook the fact that the exhibition had taken nearly ten years to be realized and ignored Araeen's explicit desire that there would be 'no need' for such an exhibition in the future. Writing in *The New Statesman*, Homi Bhabha and Sutapa Biswas sought to articulate the sea-change in the cultural politics of race and nation which other responses to the exhibition studiously avoided:

> Most reviewers have panned the polemic and the controversy arguing that the best post-colonial British artists – always the same two solitary figures, Anish Kapoor and Dhruva Mistry – have kept out of the 'ghetto' show [...] No critic has attempted to ask whether the self-image of metropolitan (post)modernism has to be re-thought in relation to this particular, post-colonial hybridity, its cultural migration and its translation of artistic traditions.[16]

It is no longer useful to think of 'tradition' or 'history' or 'modernism' as linear or exclusive entities, but rather as expressions of various overlaps, borrowings and juxtapositions across cultures and through time. The works in *The Other Story* in fact tell many stories – and they attest to the hybridity of the post-colonial experience.

INTERNATIONAL INTERVENTIONS

The notion of cultural hybridity proves to be very useful when discussing alternative paradigms for presenting and evaluating the work of artists from a plurality of cultures and cultural backgrounds. In the post-colonial age it has become increasingly difficult to think of nations as singular entities with their borders intact. Historically, there have always been interactions and migrations between different cultures, not only of people, but of ideas, practices and traditions, and now more than ever this situation of hybridity and cultural mixing needs to be recognized and addressed.

The widespread use of the terms 'multiculturalism' and 'ethnic arts' in Britain and the United States over the last decade may at first appear to be an attempt to recognize the current situation of plurality. However, Rasheed Araeen[17] and others suggest that there is little difference between these terms and the older, more overtly racist concept of 'primitivism'. The problem lies with the way in which 'multicultural' artists and their works are defined and valued. White artists are not included within the debate on multiculturalism, and retain their position of superiority as evaluators, definers and owners of 'ethnic' artworks. Interactions and exchanges between different cultures tend to be ignored or denigrated unless it is the West's appropriation of the 'Other' which is being exposed and celebrated. 'Multiculturalism' remains stained above all by the West's failure to engage in a dialogue of equality with its neighbours and to relinquish its control of meaning production.[18]

In the 1980s two major exhibitions were held which aimed to address and rectify the exclusion of non-Western artists from major international shows. Both included works by artists from numerous cultures, however the following discussion will illustrate the ways in which the hegemonies of Western thought operated to produce biased and unequal representations.

Primitivism in Twentieth Century Art: Affinity of the Tribal and the Modern, was staged at the Museum of Modern Art, New York in 1984, and juxtaposed works by European modernists including Picasso, Brancusi and Giacometti, with various 'tribal' artefacts whose creators remained anonymous and timeless. A very particular story was told here: that of the influence of these non-Western objects on Western artists. In a sense, the exhibition could be seen as an original story of Modernism recounted on modernist terms.[19]

The differences between the Western and non-Western works were not explored, and the exhibition focused only on the similarities, purely visual, between them. Through curatorial strategies, a single angle of vision was maintained expressing a universal message of affinity, and other possible stories were excluded The question of non-Western modernisms was not addressed. In fact the title of the exhibition, *Affinities of the Tribal and the Modern* made it very clear whose work was considered the most valued, and the message of affinity made no allusion to the context of appropriation in terms of colonial power and a fascination for the 'exotic'.

Five years after the *Primitivism* exhibition the Pompidou Centre, Paris staged *Magiciens de la Terre*. Presenting works by one hundred artists from all over the world, it marked a departure from the New York show by including works by living, named non-Western artists as opposed to anonymous artefacts. However, the significance of this departure was not all that far reaching; the non-Western pieces in the exhibition were by artists working largely in 'traditional' modes and

they were displayed in such a way as to highlight their similarities with the works by contemporary Western artists. The common denominator here was the presumed 'magic' of all works.

While the director of the Centre Pompidou claimed that one of the main objectives of the show was to create a dialogue between Western and non-Western cultures on an equal terrain, no attempt was made to include non-Western artists working in modernist styles. With the works that were on display an illusion of equality was simulated by focusing only on visual similarities. But how could an equal exchange really take place within a framework which looked only at aesthetic values and did not seek to challenge the unequal power relations between the 'centre' and the 'periphery'?

'Equality' was achieved by ignoring the differences between works. By way of example, in one room on the floor, in front of a large wall work by the British artist Richard Long was a recreation of a ceremonial ground painting by the Yuendumu Aboriginal community. The works were placed in such a way that their similarities eradicated their differences, and no reference was made to the neo-colonial appropriation of non-Western art styles by Western artists. There was a failure on the part of the selectors to take into consideration the historical and material conditions of the other cultures they were representing, and the positive values of difference were ignored. Works by the 'Other' were only included in this exhibition if they bore some visual similarity to the Western works on display, they were not there on their own terms.

Is it possible for 'difference' to function critically in a curatorial space where the criticality of 'difference' is in fact negated by the illusion of visual similarities?[20]

Considering the failure of these two exhibitions, how may alternative paradigms for a new 'internationalism' be conceived? It has been suggested, with concern, that variations of 'primitivism' may continue to provide the definitional core, not only from the point of view of Western curators, but also for 'third world' artists.[21] Some may in fact adopt the 'primitivist' persona in order to enter the internationalist arena, not only striving for inclusion in 'multicultural' exhibitions, but also for commercial reasons – to attract the attention of Western buyers. Real reciprocity cannot be achieved unless the powers of selection, critical

appraisal, contextualization and ownership are at least shared between the so-called centre and periphery.

Fundamental to any move towards reciprocity is a recognition and evaluation of difference and hybridity. At present, the term 'multiculturalism' tends to include only Other artists, those who have migrated, those whose origins are somehow elsewhere. A better understanding of 'multiculturalism' may be achieved if we begin to recognize that all identities are constructed through difference and attempt to follow Stuart Hall in redefining 'the general feeling which more and more people seem to have about themselves – that they are all, in some way, recently *migrated*'.[22]

In the late twentieth century, in the context of the enormous social, political and technological changes of the past hundred years, the work of artists from different cultures can rarely be seen in isolation from each other, either within the narrow confines of a single national culture or as part of a vast landscape undifferentiated by time and space. Rather, we need to view works of art as part of a dynamic and ongoing exchange of images and ideas. Artists throughout history have moved from society to society, from culture to culture, and there exist longstanding traditions of internationalist exchange and mutual influence.

'Art, like language, lives by appropriation and assimilation and interactions take place in all directions'.[23] The problem is that when Others appropriate from the 'West' they are often labelled as imitators and their work is deemed derivative, contaminated and impure. This attitude stems from the West's desire to contain and control the Other in terms of a fixed identity. Fluidity rather than fixity provides an alternative framework, and artists from all cultures may be seen as working within and through 'the contingencies of ambivalent identities, discontinuous but intertwined histories and the diasporan experience'.[24]

Recognizing the dynamism of intercultural exchange and the importance of multiple voices provides the starting point for a new internationalism where artistic practice may be seen as an open process, an 'endless grafting, uprooting, borrowing, adding'.[25] The artist Lubaina Himid reclaims the process of artistic appropriation as part of her history. 'The artistic practice of gathering and re-using is said to have been invented in Paris in the twenties by Picasso ... the "discovery" of Africa ... (but) gathering and re-using has always been a part of Black creativity.'[26]

Himid's installation *Freedom and Change* (1984)[27] was a reworking of Pablo Picasso's *Two Women Running on a Beach* (1922). Picasso's small neo-classical image of two white women racing across a deserted coastline was appropriated by Himid and transformed ... In her piece two black women, their bodies clothed in a patchwork of coloured fabrics run across a plain of purple cloth, ahead of them are four black dogs, behind them the heads of two white men. While Picasso's painting is an example of the universalizing tendencies of Modernism, where the past is abstract and not fixed by historical time or place, Himid's piece assigns central importance to a particular history and the position of difference. The two black women are breaking free from a past, artistic and political, presided over by a white male presence.[28]

In the strategies and messages employed by Himid in this work and by a number of the artists already discussed, working across boundaries and in-between spaces a model may be found for curatorial practice. Weaving together diverse histories and identities with varying categories of creative expression suggest a paradigm for curators working on dialogical projects and founding, along with artists and writers, the stepping stones towards a new internationalist framework.

As a way forward it should be possible to curate on the basis of themes that are not 'universal truths' or cultural essentials, but which tap into certain intellectual and aesthetic preoccupations of artists from a plurality of cultures and cultural backgrounds. By way of example, *Time Machine* at the British Museum (December 1994–February 1995) showed works by twelve artists from a variety of cultural backgrounds exploring themes with ancient Egyptian art. Installed among the antiquities in the Egyptian sculpture gallery, the works achieved a rare juxtaposition of ancient and contemporary art. Contesting the idea that ancient Egyptian artefacts are stagnant remnants of the past, disconnected from the present, the exhibition attested to the continuity of ideas and expressions across cultures and histories.

NOTES

1 Mosquera, G., *Some Problems in Transcultural Curating*, Global Visions, Kala Press, London, 1994, p.135.

2 Hanru, H., *Entropy; Chinese Artists, Western Art Institutions: A New Internationalism*, Global Visions, Kala Press, London, 1994, p.88.

3 Vogel, S., *Africa Explores*, exh. cat., Centre for African Art, New York, 1991, p.9.

4 See, for example, Lubaina Himid's exhibition *The Thin Black Line* (ICA, 1985); Eddie Chambers's *Black Art; Plotting the Course* (Oldham Art Gallery, Wolverhampton Art Gallery and Bluecoat Gallery, 1988); D-Max (The Photographers' Gallery, 1987); Rasheed Araeen's *The Essential Black Art* (Chisenhale Gallery, London, 1988).

5 Mercer, K., *Welcome to the Jungle*, Routledge, London, 1994, pp.14–22.

6 Jantjes G. and Serota, N., *Introduction*, from *Between Two Worlds*, Whitechapel Art Gallery exh. cat., London, 1986, p.6.

7 Ibid. above, p.8.

8 Piper, K., quoted in Solake, A., *Juggling Worlds* from *Between Two Worlds*, Whitechapel Art Gallery exh. cat., London, 1986, p.10.

9 Sonia Boyce in conversation with John Roberts, *Third Text 1*, Autumn 1987, p.64.

10 Veronica Ryan quoted in Solanke, op.cit., pp.11–12.

11 Araeen, R., *Introduction: when chickens come home to roost*, The Other Story, Hayward Gallery exh. cat., London, 1989.

12 Araeen, ibid. above, p.12.

13 Araeen, *In the citadel of modernism*, op.cit., p.30.

14 Quoted in Araeen ibid., p.32.

15 Sewell, B., 'Black pride and prejudice', *Evening Standard*, 4 January 1990, p.25.

16 Bhabha, H.K. and Biswas, S., 'The Wrong Story', *The New Statesman*, 15 December 1989, pp.40–2.

17 Araeen, R., 'From Primitivism to Ethnic Arts', *Third Text 1*, Autumn 1987.

18 Fisher, J., Editor's note, *Global Visions*, Kala Press, London, 1994.

19 See James Clifford's discussion of this exhibition, *Histories of the Tribal and the Modern*, The Predicament of Culture, Harvard University Press, 1988, pp.189–215.

20 Araeen, R., 'Our Bauhaus Other's Mudhouse', *Third Text*, 6, Spring 1989, p.8.

21 See Kapur, G., 'A New Inter Nationalism: The Missing Hyphen', *Global Visions*, Kala Press, London, 1994, pp.39–50.

22 Hall, S., 'Minimal Selves', *Identity: The Real Me*, ICA

Documents 6, Institute of Contemporary Arts, London, 1987, p.44.

23 Nicodemus, E., 'The Centre of Otherness', *Global Visions*, p.99.

24 Tawadros, G., 'The Case of the Missing Body', *Global Visions*, p.109.

25 Maharaj, S., 'The Congo is Flooding the Acropolis', *Third Text*, 15, p.90.

26 Lubaina Himid, quoted in Tawadros, 'Beyond the Boundary', *Third Text*, 8/9, p.121.

27 Exhibited in *The Thin Black Line*, ICA, London, 1985.

28 See Tawadros, G., 'Beyond the Boundary', op.cit., for a more detailed discussion of this work.

BIBLIOGRAPHY

ARAEEN, R., 'From Primitivism to Ethnic Arts', *Third Text* 1 Autumn 1987, pp.6–25.

ARAEEN, R., 'Our Bauhaus Others' Mudhouse', *Third Text*, 6, Spring 1989, pp.3–17.

THE ART OF ANCIENT MEXICO, Hayward Gallery exhibition catalogue, 1992.

BHABHA, H.K. and BISWAS, S., 'The Wrong Story', *The New Statesman*, 15 December 1989, pp.40–42.

CLIFFORD, J. (1988) *The Predicament of Culture*, Harvard University Press.

CUBITT, S., 'Going Native: Columbus, Liverpool, Identity and Memory', *Third Text*, 21, Winter 1992–3, pp.107–20.

DANTO, A.C., 'Artefact and Art', in S. Vogel (ed.), *Art/Artefact: African Art in Anthropology Collections*, Center for African Art, New York, 1988, pp.18–32.

FISHER, J. ed. (1994) *Global Visions: Towards a New Internationalism in the visual arts*, Kala Press, London.

GILROY, P., 'Art of Darkness: Black Art and the Problems of Belonging to England', *Third Text* 10, Spring 1990, pp.45–52.

GREEN, R., 'Collectors, creators and shoppers', *Frieze*, 18, pp.6–7.

HALL, S. (1987) 'Minimal Selves', *Identity: The Real Me*,

ICA Documents 6, Institute of Contemporary Arts, London.

JANTJES, G. and SEROTA, N., introduction, Solanke, A., essay (1986), *From Two Worlds*, Whitechapel Art Gallery exh.cat., London.

KARP, I., and LEVINE, S.D. eds (1991) *Exhibiting Cultures: The Poetics and Politics of Museum Display*, Smithsonian Institute Press.

Maharaj, S., 'The Congo is Flooding the Acropolis', *Third Text*, 15, summer 1991, pp.77–90.

MERCER, K., 'Black Art and the Burden of Representation', *Third Text* 10, Spring 1990, pp.61–78.

MERCER, K. (1994) 'Introduction: Black Britain and the Cultural Politics of Diaspora', *Welcome to the Jungle*, Routeledge, London, pp.1–31.

MOSQUERA, G., 'The Marco Polo Syndrome: some problems around art and eurocentrism', *Third Text*, 21, Winter 1992–3, pp.35–42.

NAIRNE, S. (1987) 'Identity, Culture and Power', *State of the Art, Ideas & Images in the 1980s*, Chatto & Windus, London.

THE OTHER STORY: Afro-Asian artists in postwar Britain, Hayward Gallery exh. cat., South Bank Centre, London, 1989.

OWSU, K. ed.(1988) *Storms of the Heart – an anthology of Black Arts and Culture*, Camden Press, London.

ROBERTS, J., 'Interview with Sonia Boyce', *Third Text* 1 Autumn 1987, pp.55–64.

SAID, E., *Orientalism*, Penguin, London, 1978 (reprinted 1991).

TAWADROS, G., 'Other Britains, Other Britons', *British Photography: Towards A Bigger Picture*, Aperture, New York, London 1988.

TAWADROS, G., 'Beyond the Boundary: The Work of Three Black Women Artists in Britain', *Third Text*, 8/9, Winter 1989, pp.121–50.

TAWADROS, G., 'Is the Past a Foreign Country?', *Museums Journal*, September 1990, pp.30–1.

TURNING THE TABLES, summary of seminar reviewing 'critical curation', Camerawork.

VOGEL, S. ed. (1991) *Africa Explores*, exh.cat., Tate Gallery, Center for African Art, New York.

WILLIS, A.-M. and FRY, T., 'Art as Ethnocide: The Case of Australia', *Third Text*, 5, Winter 1988–9, pp.3–20.

HOW TRADITIONAL IS A CHAINSAW?

CUTTING A PATH THROUGH FORESTS OF PREJUDICE

JONATHAN MEULI

In the catalogue of the opening exhibition of the new National Museum of the American Indian in New York, the editor, Tom Hill, himself a Native American (Seneca), describes an episode from his family past. He writes about a family elder, Ezekiel Hill, who was a member of the Iroquois 'False Face Society' and the guardian of some of the masks used by that society in its ceremonies.

Ezekiel told me about the masks, but only when I asked. 'Why is the nose crooked?' I would ask. Or, 'what do you feed them?' And Ezekiel would explain. He told me how the masks were carved from living trees that consented to sacrificing a part of themselves. He reaffirmed my confidence in what I had seen and experienced: that, in the ceremonies, the masks had the power to focus the attention of all who saw them on natural forces that we experience but cannot understand. Through the masks, I learned about good and evil, the Creation, healing and respect. They gave me a sense of history, too, a feeling of being part of a long chain of life.

I realized later that Ezekiel was not the only one who had masks: museums found them irresistible public favorites, amusing displays. But these exhibitions never captured the masks'

spirit. Whenever I see a mask in a museum, I think how different it is from those that hung by Ezekiel's stove. Behind glass, they become objects. I feel insulted and denigrated by the way they are treated, and I can understand how they have become emotional symbols of cultural control and loss. Some Iroquois enjoy seeing a connection between the fire that ravaged New York State Museum many years ago and the power of the masks imprisoned there.[1]

The National Museum of the American Indian is an important development in the way in which Native American culture is presented to the general public. The museum is part of the Smithsonian Institution; it was approved by the US Congress in 1989 to take over the George Gustav Heye collection of American Indian objects, one of the largest and finest in the world. It is 'the first national museum dedicated to Native Americans and ... a forum for Native Americans to tell their own stories ... in their own words', according to W. Richard West, Jr, the director, and himself a Native American (Southern Cheyenne).[2] This level of direct involvement by the Native community in the curation and display of its own culture is unprecedented, although it has been prefigured

for a few years now in a number of important exhibitions of historic and contemporary works which have involved Native American people to an ever greater extent as curators and advisors.[3] One of the preoccupations of the designers of the National Museum of the American Indian displays has been 'the propriety of exhibiting and publishing objects of great cultural and spiritual sensitivity'.[4] This is a sensitivity shared by museums worldwide, and affects their display of objects from many non-Western countries. In the Canadian Museum of Civilization in Hull, Quebec, masks which would originally have been stored out of sight when not being performed, are displayed behind slats, so that they are only partly visible. Certain types of aboriginal artefact, such as Australian *churingas* (sacred boards) are rarely now displayed because their original context was hidden / sacred. Other 'popular' items are being removed from display; at the Museum of Archaeology and Anthropology in Cambridge, Jivaro shrunken heads are no longer displayed because they had become 'too much of a focal point, iconic and emblematic, to the distraction of other items in the museum', and Maori tattooed heads have also been removed from public view, because 'the Maoris consider the heads sacred'.[5] The Pitt Rivers Museum, Oxford, has made the same decision about Maori heads, although some of the other 'dark and ghoulish manifestations of humanity, such as shrunken heads and skull racks, remain on display to challenge us'.[6]

This sort of debate about what is ghoulish or what is challenging may seem a rather unedifying one to the outsider: but there is little doubt that to most museum curators, the ethical dilemmas that their profession places them in are extremely real, and they struggle to make the best choice they can between the interests of their public, scholarly integrity, and the interests and concerns of representatives of other cultures'.[7]

It is interesting to consider the extent to which we may continue, quite unintentionally, to perpetuate the colonialist and oppressive premises that curators realize underlie their collections, in the way in which we currently teach children about the art of other cultures. Any casual visitor to, say, the Museum of Mankind in London, will be aware that children form one of the largest audiences for the museum's displays, and that much effort is put into the production of informative, sensitive and un-biased educational material about the cultures presented. The same is true of the National Museum of the American Indian in New York, where the Native curators view the education of children, Native and non-Native, as one of their priorities. As I have pointed out, museums can make choices about which items they show. Certain artefacts are no longer likely to be publicly displayed, including, for example, Iroquois False Face masks. Curators can also make sure that all the material that they do display is fully and accurately described and that the opinions and views of its creators are as fully represented as may be. In this respect at least, museums are trying to ensure that the children who visit these museums are not encouraged to hold cultures in low esteem or to view them as a source of ghoulish thrills. Another extremely important task of the museum curator is to ensure that a living culture is portrayed as living, not as embedded in an idealized anthropological past. 'Eskimos' (Inuit) do not live in igloos (any more), as a recent exhibition at the Museum of Mankind reminded us. They live in houses and watch *Roseanne*, or *CNN*. A Native American carver friend on the Northwest Coast told me a story of how a non-Native watched him shape out a block of alder for his next carving, using a chainsaw. 'That's not traditional', she said. 'No,' he answered, 'and when I go to Vancouver I don't go by canoe. ' Levels of ignorance about the contemporary and changing circumstances of non-Western cultures remain high in all of us, and the continued emphasis on the teaching of a certain set of ideas about 'traditional' cultures without continued reference to contemporary life-styles only makes it more likely that we will continue to pass on ill-conceived (and fundamentally racist) ideas about 'primitive' arts and cultures to the next generation.

Ultimately, however, there are limits to what museums can do in the educational field. One thing they cannot do, or are very unlikely to want to do, is to abolish themselves completely. Given that they are there, receive public money, and must mount exhibitions to justify it, they must show something. It is worth simply noting that many of the political, aesthetic, and ethical dilemmas about the display of non-Western objects arise from the fact that many of them are owned by Western cultures, and were often obtained in doubtful and even criminal ways. The history of this aspect of collecting non-Western art for museums and for the art market has been given extensive airing,[8] and specific cases have been analysed. The Kwakwaka'wakw [Kwakiutl] 'Potlatch Collec-

tion', for instance, is well covered in the literature on the Northwest Coast. Following the repeated ignoring by the Kwakwaka'wakw of a ban on their traditional potlatch, a large collection of masks and ceremonial paraphernalia was confiscated and sent to museums in Ottawa, Toronto and New York. Some were illegally disposed of on the open market. Eventually the bulk of the collection was returned on condition that it was housed in two specially built museums on Kwakwaka' wakw land at Alert Bay and Cape Mudge, British Columbia. The affair has been described in great detail[9] and its consequences have been described by the Kwakwaka'wakw anthropologist Gloria Cranmer Webster both on film and in print.[10] The general artistic, political and ethical issues that the story raises have also been touched on.[11] The confiscation of the Potlatch collection has rightly been portrayed by the now relatively powerful Kwakwaka'wakw lobby as an outrageous abuse of colonial authority. It is sadly true that in the scale of colonial abuse in pursuit of museum collections, it ranks low: many far worse abuses were committed. Collection of non-Western objects occurred elsewhere and on a large scale – the French collected in West Africa, the Belgians in Central Africa, and their excesses are well documented.[12] In some cases complete collections of material from particular cultures were acquired; the Benin treasures taken by the British punitive expedition of 1897 being a well-known example.[13]

Given that the history of ethnographic collections is a dubious one, it is certainly reasonable to ask whether we have any inherent right to continue to own and display objects that were acquired by doubtful means. Certainly, numbers of artists and writers are now beginning to question that right[14] and their concerns are familiar to the museum establishment, which in a number of countries has begun to repatriate culturally sensitive objects to representatives of the cultures from which they were taken. Even so, only a relatively small proportion of objects will ever be repatriated, and it remains true that however good the educational materials available and however sensitive the display techniques, the strongest message given to a child on a museum outing is that s/he has a *right* to see what is on display. We cannot help but actively encourage children to share in the proprietorial attitudes of our imperialistic past by continuing to take them to view it.

If educating children about other cultures by taking them on museum visits can legitimately be questioned, then so too can the way in which we educate them about non-Western art in the classroom. I am aware that for many teachers in schools the practical problems of art-making in the classroom seem much more pressing than the apparently more esoteric concerns of art history. However, I make no apology for drawing the examples that follow from art history rather than from classroom practice, partly because that is the area which I know about, and partly because it would be quite wrong to suppose that what is taught about art or self-expression, even at the most junior level, in a classroom, is unconnected from the wider debates about how art is made, marketed and valued in our society as a whole. My references to art history are not new in and of themselves: they are simply examples of what we value in artistic practice and artistic methodology, examples that happen to be well known to a large number of people, and examples that have a correspondingly pervasive influence on the artistic practice of even those who would not consider themselves to be interested in art history.

When I studied Fine Art in the early 1980s, I was struck by how culturally rapacious the art student was encouraged to be. Metaphors of conquest, domination and forcible acquisition were prevalent in teaching about the craft of making a painting[15] The art student was encouraged to be ruthless and self-interested in choosing from *any* source, visual materials to stimulate his or her creative inspiration. Art history was seen by students simply as a fund of images to be plundered at will. I wonder whether art school teaching has changed at all in the intervening twelve years. I suspect, however, that a majority of art teachers in schools, have, like me, been inspired by the myth of the Self-Expressive Hero-Artist, full of dynamism, putting creativity and imagination above almost all other artistic values. It is very important to remember that, of course, this particular way of making art is culturally specific to the West. Different cultures have at different times produced what we might term art objects in many different ways. Consider the following examples, taken at random, of ways in which 'art objects' which our culture recognizes as being of high quality were made in ways which did not stress individual creativity or innovation:

 i. Chinese pots were, by the eighteenth century, being made in a mass-production method during which they passed through as many as seventy pairs of hands: a technique which

astonished the Europeans who witnessed it.[16]

ii. Medieval artists in Europe collaborated on the production of painted and sculpted works and specialized in the depiction of particular attributes: one artist might specialize in hair, another in drapery, another in faces and hands.[17]

iii. Carvers of the traditional forms associated with the *Malangan* ceremonies in late nineteenth-century New Ireland were restricted in their choice of style and subject by what amounted to a form of copyright: certain styles were 'owned' and passed from generation to generation as valued property. Notwithstanding these restrictions, the carvers of Malangan produced some of the most brilliant and flamboyant of sculptures.[18]

The reader with even the slightest acquaintance with art history can extend this list indefinitely. The point of my examples, however, is not to make them into a sort of parlour game for marvelling at human ingenuity and cultural diversity, but rather to use them as a contrasting backdrop against which we can view a little more clearly some of the preconceptions and prejudices which characterize the highly individualistic and 'rapacious' artistic methods which we have come to value in the West in the late twentieth century.

The idea that I want to consider in most detail is that of the hypothetical right of the artist, or the supposed advantage to the artist, of being able to borrow or appropriate material from sources outside his or her immediate visual tradition. This borrowing is characteristic of the twentieth century and there are few better examples of this particular artistic behaviour than Pablo Picasso. He has been credited with the invention of collage (using 'alien material' *i.e.* material not until then considered appropriate to the craft of painting),[19] with the early use of *objets trouvés*[20] and with using the 'primitive' arts of African and Oceanic peoples that were then appearing on the Paris market as a source of inspiration. There is a sense in which all this 'alien material' was considered on the same level. Picasso said that he never read anything about African art and showed little or no interest in the significance of the objects in their original context, or the aesthetic differences between African and European traditions.[21] Picasso's self-belief and historical happenstance encouraged him to take not merely mass-produced oil-cloth for a collage, but also the artistic productions of other cultures as though they had no more symbolic significance or content than mass-produced oil-cloth.

This attitude of the artist towards the appropriation of material from outside the 'proper' sphere of artistic activity has characterized many of the artists whom we have incorporated into the history of twentieth century art. The use of 'primitive' art, in particular, by the twentieth century *avant-garde* was well documented in the exhibition *'Primitivism' in Twentieth Century Art* organized by William Rubin at the Museum of Modern Art in New York (Rubin, 1984). In that exhibition the borrowings of a large number of artists were scrutinized: Brancusi, the German Expressionists, Modigliani, Epstein, Léger, Klee, Giacometti, the Dadaists, the Surrealists, Moore, the Abstract Expressionists, and contemporary land and performance artists like Long, Goldsworthy, Morris, Holt, Turrell and others. It is broadly true that all these artists have considered the art of other cultures to be a legitimate source of inspiration.

There would be few who did not regard highly at least some of the artists documented in the *Primitivism* show. But although we may admire their artistic ingenuity, and the work that they have produced, it is also perfectly legitimate to question the social attitudes which led them to consider such appropriations to be reasonable and ethically unproblematic.

There was a wide-spread perception, that the *Primitivism* show's juxtaposition of named and dated Western works with frequently anonymous and undated non-Western 'sources' did less than justice to the non-Western component, and the exhibition aroused intense feeling among those who felt that it was patronizing to continue to show non-Western art simply as an adjunct to or source of inspiration for Western art.[22] It also gave fresh material to the feminist critique of the 'heroic' avant-garde that had begun in the late 60s and early 70s; a critique that concentrated on some of the most revered items in the modern canon. I will again take the example of Picasso, not to make any positive or negative comment about his work, which is outside the scope of this essay, but as an example familiar to most of us, and subject to much art-historical debate. As I have mentioned, Picasso was an extensive and unapologetic borrower from non-Western traditions. An interpretation of Picasso's iconography now increasingly common among art historians gives less weight to Picasso's individual genius and the inspired nature of his artistic borrowings than to the profoundly disquieting association that his work reveals between ideas of 'woman' and 'primitive'

and the culturally and sexually imperialistic nature of the society in which these associations were *accepted* as revelatory and inspirational.[23]

Moving on from specific examples from early twentieth-century art, I think it is legitimate to ask to what extent all art professionals involved with making and the teaching of making are today still affected by the idea that free borrowing is acceptable and to be encouraged. And to suggest further, that such encouragement, particularly with regard to the arts of formerly colonized peoples, may *implicitly* foster attitudes that we would *explicitly* discourage. While I lectured at Bretton Hall, there were behind me two fine works of art produced by children based on the arts of African and of North American cultures. One took a Northwest Coast mask and made it the focus for a complex and ambitious meditation on a theme of environmental destruction. Another took an African design and made a decorative work from it, labelled *'Chic Afrique'*. I admired in both works the formal abilities of the artists, and worried in both cases that no *obvious* attention seemed to have been given to matters of meaning, context and respect for other cultures.[24]

If it is fair to question the educational premises which underlie the apparently innocent notion of a museum visit, then it is equally fair to question the apparently benign ideal of an artistic education which stresses individual creativity and the ethical validity of making artistic 'borrowings'. If the study of non-Western art practice teaches one anything, it is that the act of creating art objects is *not* necessarily dependent *either* on a notion of the ideal of individual expressiveness *nor* on the desirability of looking outside one's own artistic tradition for inspiration. These are Western ideals.

I would like to consider briefly a section of the 'Notes for Teachers' Art and Design pack on North American Indians that formed part of the materials handed out to delegates at the *Different Perspectives* conference at Bretton Hall.[25] In this pack, an Iroquois False Face mask is illustrated and its use in its Iroquois context described. Suggestions are given for making a 'False Face' mask and other types of North American Indian mask, in papier mâché. In the section headed 'Evaluation ...' the following points are listed:

- Were the problems set in this activity realistic?
- How imaginative were the children?
- Was there any evidence of problem-solving?
- How might you do this activity differently?

- Were the children made more aware of possible decorations for facial features?
- Did the children experiment with the given range of media?
- Did the children provide images which show a personal response?

On first viewing, the suggested projects seem educationally worthwhile and the benefits of the exercise hardly seem worth questioning. However, I think it possible, in the light of the issues discussed above, to raise a number of queries and suggestions about this type of classroom project. First, although the notes for teachers do explain the use and context of the Iroquois mask, an appreciation of these points by the children is *not* part of the 'evaluation', which suggests that a knowledge of context is considered as being in some way 'separate' from the artistic stimulus the children are to receive, a separation which I would suggest is both contentious and ethno-centric. Second, the teachers are not given any indication of the sensitivity of the material with which they are dealing, or any indication that the contemporary users of such materials might view them as sacred in any sense. Third, the educational aims of the project could be summed up as imagination, personal response, experimentation, problem solving, and awareness of potential sources; a *list* which distils many of the century's preoccupations among Western artists, but one which by no means exhausts the range of possible artistic mind-sets. In this particular context, the list for evaluation makes no mention of respect, tradition, sacredness, or ethnic identity, all of which I suspect, would be themes much stressed by Native American elders. Compare Alastair Laing's suggested evaluation with the points that the young Tom Hill was encouraged to consider by his family elder: *'good and evil, the Creation, healing and respect ... a sense of history, ... a feeling of being part of a long chain of life.'*

On the more general point of the stress on individual creativity, I hope that this essay has made clear that there is no *intrinsic* reason why art should be seen as the subject in which individualism is fostered, any more than it is absolutely necessary to see sport as the necessary arena for the inculcation of ideals and methods of co-operation and team-work. Just as teachers have realized that the collectivism emphasized in team sports can have negative effects on underachievers, so it is time to realize that the individualism encouraged in art lessons can be equally damaging for those

whose self-expressive self-confidence is small. I believe we should think long and hard about the political, moral and racial implications of what we have chosen to believe are worthwhile objectives in the art room. No single school or individual can change these attitudes single-handedly, but the effort to treat other cultures with genuine respect should be a first priority, and as a close second, I would suggest the consideration of projects which stress and evaluate collaborative endeavour (and perhaps, even, manual dexterity or simple visual skills) at least as highly as self-expression, and the detailed and competent use of the resources *within* a visual tradition at least as highly as the act of seeking to refresh that tradition by taking material from outside.[26]

These ideas were raised by my experiences of teaching undergraduates rather than school-children, and the wish to convey to them certain of

the ethical dilemmas that face anyone who wishes to study non-Western arts. It might seem to the reader that the problems that I have raised offer no easy solution; if so, I think I would agree. It is worth mentioning one final point, however; I do not claim to speak for Native American people about how their culture should be interpreted. That is a decision for those individuals and nations to make for themselves in their own way. However, one characteristic of many – perhaps all – North American indigenous cultures that I believe they themselves would agree on, is their great affection for and tolerance of children, an affection which far surpasses that of Anglo-Saxon culture, and which, however wayward children's artistic efforts might be, would be principally concerned that those children grew up to respect their own heritage and that of others. On this fundamental aim, at least, we would be in accord.

NOTES

1 Hill and Hill, 1994, p.18. The exhibition of a similar mask at the Glenbow Museum's *The Spirit Sings* in Calgary, Alberta in 1988 was considered objectionable by Native groups opposing the exploitation of land and culture by non-Natives: the issue went to court and became the catalyst of major protests throughout Canada.

2 W. Richard West, Jr., in the leaflet *Introducing the National Museum of the American Indians* published 1994 to encourage charter membership of the Museum.

3 For a number of years the museum community has been trying to involve Native people more in the choice and presentation of exhibitions. A *Time of Gathering: Native Heritage in Washington State* (Wright, 1991) at the Burke Museum in Seattle in 1991 was heavily reliant on Native Indian input. In 1992 in Canada, *Land Spirit Power* (Nemiroff, 1992) exhibited contemporary Native artists at the National Gallery in Ottawa for the first time, while *Indigena: Contemporary Native Perspectives in Canadian art* (McMaster and Martin, 1992) at the Canadian Museum of Civilization in Hull, just across the river from Ottawa also showed a new interest in contemporary work. These shows were in part a response to the 1988 *The Spirit Sings* exhibition, at the Glenbow Museum, Calgary, which had the misfortune to be sponsored by an oil company locked in a land dispute with a local Native group. There were

allegations of cultural and commercial exploitation, not to mention hypocrisy, and the exhibition became the focus of boycotts and vocal protests by the Native community.

4 Hill and Hill, 1994; foreword by W.R. West Jr., p. 12.

5 Cassia, 1992, p. 30.

6 Cousins, 1993, p. 28.

7 David Jones, keeper of Human History at Ipswich Museum, discusses the implications for a museum curator of the sometimes bloody collection history of the objects his/her care: 'Ethnography was used to justify colonialism and oppression, and museums contributed to this by constantly placing contemporary cultures in the past and 'normalizing' their vanishing', (Jones, 1992, p. 24). Robertson (1993) discusses a particularly shaming example of racial violence in a museum context: the stuffed African still on display at the museum in Banyoles, Spain.

8 Meyer, 1974; Cole, 1985; MacClancey 1988.

9 Sewid-Smith (1979); Cole and Chaikin (1990).

10 Cranmer Webster, 1990: see also the film *Potlatch: A Strict Law Bids Us Dance* (1974, Dennis Wheeler), available from the Museum of Mankind, London.

11 Clifford (1991) discusses the museums at Cape Mudge and Alert Bay, as well as the University of British Columbia Museum of Anthropology and the Provincial Museum at Victoria

12 Price (1989, pp.70–9) gives vivid examples, culled from the journals and diaries of numbers of Western artefact collectors, of the practice of theft, extortion, bribery, fraud, sacrilege and venality in which they commonly indulged or with which they corrupted others, and concludes (p. 74): 'These are the encounters that have supplied our museums, from the Musée de l'homme to the Metropolitan Museum of Art, with the great bulk of their non-Western artistic treasures.' Although the literature on the subject includes 'popular' as well as academic works, I think it is probably fair to say that museum-going public is still relatively unaware of this aspect of the histories of the collections they admire. And, without impugning the museum profession, this side of art history is unlikely to receive as full a coverage – in museum displays and literature, for example – as it might, whilst Western art historians retain a vested professional interest in the possession of non-Western material. Whatever your motives, if there are no collections, there are no jobs.

13 The bulk of the Benin treasures remain in England and are reluctantly parted with even for temporary exhibitions. In 1977, the British Museum refused to lend an exceptional Benin ivory mask to the Nigerian government for FESTAC, a second world festival of Black and African art. Refusal was made on the grounds that the ivory was cracked and a change in humidity might damage it irreparably. The issue was widely publicised (and resented) in Nigeria and was still a live issue in Benin and Nigeria in 1990 (Picton, 1990: p.57)

14 '..My work is concerned with the theft, collection and hoarding of African objects by collectors and museums ... The claim that museum collections create a wider understanding between people and their cultures is questionable when a) many treasures of the black creative world are stashed below the ground in the vaults and warehouses of national institutions and b) 200 years or more of the display of appropriated goods, stolen black art objects under glass cases, has done nothing to convince white Europeans that black people have an important part to claim in the history of creativity.' This angry statement is by the artist Lubaina Himid (Himid 1990, p. 34). Similar views, often equally forcefully expressed are given in, for instance, Araeen, 1989; Price, 1989 and Torgovnick, 1990.

15 It is interesting and perhaps not surprising that the overwhelming majority of teaching staff was male; and it was my impression that the students who responded most readily to these metaphors were also male. Female students frequently found the teaching style too aggressive.

16 Jessica Rawson: personal communication, 1994. The origins of this type of workshop mass production may be found in the technique of assembling objects in parts, which dates back to at least as early as the middle of the second millennium BC.

17 This form of workshop specialisation lasted in the modified form of 'studio' works produced by a master and his assistants, right through to the nineteenth century. It was commonplace, for instance, for a master to do the faces and important parts of the figure and for studio assistants to do the less prestigious drapery. Versions of the practice are also found in the twentieth century: none of Henry Moore's late large-scale works, for example, were physically made by Moore himself: more recently, Jeff Koons has thrown the debate about authorship and creativity into question by commissioning other artists to make 'his' works for him.

18 Lewis, 1969; Lincoln, 1988.

19 In the Spring of 1912, Picasso first affixed a piece of alien material to the surface of a picture. This was the invention of collage. The picture was the *Still Life with chair caning*, in which the piece of commercial oilcloth gummed to the canvas begins a whole range and repertoire of pictorial and sculptural innovation (Hilton, 1981, p.42). As Sally Price has pointed out, this particular interpretation of art history completely ignores 'the artistry of countless women throughout history who have devoted aesthetic energy to scrapbooks, applique, photo albums, and patchwork quilts ... well in advance of Picasso's or Braque's interest in that particular approach to artistic expression' (Price, 1989, p.5).

20 The most famous example being *Head of a Bull, Metamorphosis* Musée Picasso, Paris. 1943, made of the saddle and handlebars of a bicycle.

21 Torgovnick, 1990, p.123.

22 This feeling was so strong that William Rubin has become almost a hate figure in parts of the literature, with Rasheed Araeeen (1989), Marianna Torgovnick (1990) and John Yau (1990), for instance, all inveighing against him to varying degrees.

23 Consider this, of Picasso's *Les Demoiselles d'Avignon*: 'no other modern work reveals more of the rock foundation of sexist antihumanism or goes further and deeper to justify and celebrate the domination of woman by man' (Duncan1990 [1973, 1982], p.97). Duncan discusses Matisse, de Kooning and others, as well as Picasso. See also Foster, 1985; Torgovnick 1990 pp.119–29, for more explicit commentary on the connections between the 'female' and the 'primitive'.

24 It may seem that I am being overly solicitous about the sensibilities of those from whose cultures we borrow. In fact, if anything I am understating the case. North American peoples for example, are extremely possessive about particular motifs and cultural properties. Even stories are frequently considered to be private property and their telling to be a right

belonging to one individual or one family. Styles and subjects in the visual arts are often jealously guarded, and their unauthorized use is considered humiliating and insulting. In British Columbia, the production of objects in 'Northwest Coast' style by anyone other than a Native American is regarded as an insult, and the handful of non-Native artists who work commercially in the Northwest Coast style, mainly in the US, are not well regarded at all by many in the Native community. It would not do for a moment to think that Native Americans are in any sense naive about this. Native people are as anxious to use their cultural property as an economic and political tool as we are, and seek to restrict its use in order to enhance its value.

On the question of the offensiveness of unlicensed borrowings of material by artists, I also do not exaggerate. As a comparison, consider the way in which contemporary Western artists continue to offend even in our own society by what many people consider to be inappropriate or unlicensed borrowings of material. There was recently great distress about the use by an artist of material from human foetuses, and on the day I write this essay (21 January 1995), a news report on radio 4 gives an airing to 'controversy' over two artists who have created an installation about suicide (Erika Rothenberg and Tracy Tynan: *Suicide Notes*, at the Centre for Community Arts in Glasgow), which uses (without permission) the suicide notes of the victims – a borrowing which the interviewer considers unjustifiable and voyeuristic. These borrowings are pushing towards the boundaries of what is acceptable in our own society; if they are disliked then it is necessary to challenge not just the particular artists and individual cases, but the ideology which gave rise to the idea of the legitimacy of unchecked artistic 'rapaciousness' and which has already given similar offence to many in cultures other than our own.

25 Laing, 1992, section on 'Magic and Symbolism', n.p.

26 By the latter, I do not mean, of course, a return to the bad old days of drawing still life by rote (an English-visual tradition sadly much tarnished by over-use and bad teaching). Any attempt to use fully the resources within any visual tradition (Bangladeshi, English, Nigerian, North American, Pakistani) would be made, I hope, without losing sight of the genuine pleasures and benefits of imaginative self-expression; and with a fully critical awareness of the negative as well as the positive connotations of treating a visual style as an ethnic or national 'possession'.

BIBLIOGRAPHY

ARAEEN, R. (1989) 'Our Bauhaus Others' Mudhouse'; pp.3–14, in *Third Text, 6*; Spring, 1989: editor Rasheed Araeen. This issue contained English translations of all but one of the articles from the special issue of *Les Cahiers du Musée National d'Art Moderne*, Paris, published to coincide with the exhibition 'Magiciens de la Terre'.

CASSIA, P.S. (1992) 'Ways of Displaying', *Museums Journal*, January 1992, pp.28–31.

CLIFFORD, J. (1991) 'Four Northwest Coast Museums: Travel Reflections'; pp.212–54 in Karp and Lavine, *Exhibiting Cultures; The Poetics and Politics of Museum Display*, Washington and London, Smithsonian Institution Press

COLE, D. (1985) *Heritage; The Scramble for Northwest Coast Artifacts*,Vancouver/Toronto, Douglas & McIntyre.

COLE,D. and CHAIKIN, I. (1990) *Iron hand upon the people: the law against the potlatch on the Northwest coast*

COUSINS, J. (1993) *The Pitt Rivers Museum*, Oxford, Pitt Rivers Museum.

CRANMER WEBSTER, G. (1990) 'Kwakiutl since 1980' in W. Sturtevant (ed.), *Handbook of North American Indians: Volume 7; Northwest Coast.* Volume editor Wayne Suttles, pp.387–90.

DUNCAN, C. (1993 [1973, 1982]) 'Virility and Domination in Early twentieth century Vanguard Painting', chapter 4 (pp. 81–108) of *The aesthetics of power; essays in critical art history*, 1993, Cambridge. [First published in *Artforum*, December 1973, pp.30–9: revised and reprinted in *Feminism and Art History: questioning the litany*, ed. Broude and Garrard, 1982; pp.292–313].

FOSTER, H. (1985) 'The "Primitive" Unconscious of Modern Art'; pp.181–208 in H. Foster, *Recodings*, 1985. Also published in *October*, 34, Fall 1985, pp. 45–70 and [in edited form] in Frascina and Harris, *Art in Modern Culture*, (Phaidon/OU 1992); pp.199–209.

HILL, T. and HILL, R. SR., eds (1994) *Journey: Native American Identity and Belief*, published in conjunction with an exhibition at the National Museum of the American Indian, George Gustav Heye Center, Alexander Hamilton Custom House, New York. New York, Smithsonian Institution.

HILTON, T. (1981) Introduction, pp.31–88 in *Picasso's Picassos*, exh.cat., ed. Michael Raeburn. Hayward Gallery, Arts Council of Great Britain, London.

HIMID, L. (1990) 'Objects are in most of their more obvious manifestations, Subjects'; pp.34–5 in Clementine Deliss *et al: Durch*, 8/9: 'Lotte or the Transformation of the Object' (essays associated with an exhibition at the Grazer Kunstverein). Graz: Grazer Kunstverein / Akademische Druck- u. Verlaganstalt

JONES, D. (1992) 'Dealing with the Past', *Museums Journal*, January 1992, pp.24–7.

LAING, A. (1992) *American Indians: Expressive Arts - 5-14: Art and Design Pack; Notes for Teachers*. Museums Education Service, Strathclyde Regional Council Education Department.

LEWIS, P.H. (1969) *The Social Context of Art in Northern New Ireland*, Field Museum of Natural History, Chicago.

LINCOLN (ed.) (1988) *Of Spirits: Idea and Image in new Ireland*, New York.

MACCLANCY, J. (1988) 'A natural curiosity; The British market in primitive art'; pp.163–76 in *Res*, 15, Spring 1988.

MCMASTER, G. and MARTIN, L.A. eds (1992) *Indigena; Contemporary Native perspectives in Canadian art*, Tortola: Craftsman House.

MEYER, K. E., (1974) *The Plundered Past*, London, Hamish Hamilton.

NEMIROFF, D. *et al* (1992) *Land Spirit Power; First Nations at the National Gallery of Canada*, Ottawa National Gallery of Canada.

PRICE, S. (1989), *Primitive Art in Civilized Places*, Chicago and London, University of Chicago Press.

ROBERTSON, A.F. (1993) 'The desiccated African in Banyoles', in *Anthropology Today*, vol.9, no.I February 1993, pp.2–3.

RUBIN, W. ed. (1984) *'Primitivism' in 20th Century Art*, 2 vols. New York, Museum of Modem Art.

SEWID-SMITH, D. (My-yah-nelth) (1979) *Prosecution or Persecution*, Cape Mudge, British Columbia, Nu-yum-Balees Society.

TORGOVNICK, M. (1990) *Gone Primitive; Savage Intellects, Modern Lives*, Chicago and London, University of Chicago Press.

WRIGHT, R. ed. (1991) *A Time of Gathering; native heritage in Washington State*, Burke Museum, Seattle and London, University of Washington Press.

YAU, J. (1990) 'Please wait by the Coatroom'; pp.132–9 in R. Ferguson *et al., Out There; Marginalization and Contemporary Cultures*, Cambridge (Mass.) and London, MIT Press.

ART FOR EARTH'S SAKE

A CONSIDERATION OF ISSUES RAISED BY THE CONTEMPORARY

ART OF THE FIRST PEOPLES OF NORTH AMERICA

JOHN HOLT

In the quest to fulfil the expectation that we have a 'multi-cultural' dimension to our teaching we may be prompted to fill our classrooms with masks from Africa, textiles from Asia, reproductions of Aboriginal paintings and totems from the West Coast of America. I extend, however a note of caution at this tendency towards the presentation of a 'cultural kaleidoscope', for, in the sustained use of visual images and symbolic language of cultures other than our own, there is, I believe, an inherent danger that if the images we introduce into the artroom are represented out of context, or even worse with a misleading or stereotypical association then we will do an enormous disservice to the cultures we represent.

There is, therefore, a responsibility to extend the visual language of a culture with sensitivity and a deep concern for the ethos and cultural context of the tradition we are making reference to. It is also the case that to project a culture as 'dead', by representing only its ancient or traditional symbology, is to misstate the living, contemporary vision of its people. This compounds the misconception that tribal cultures in particular are of the past and have no contemporaneous life with Western culture. This understandably angers many people from non-Western cultures who see this misrepresentation as a further extension of colonial repression. Museums and ethnographic collections have helped to sustain the 'death' of the other for many years now with their anthropological samples, which have kept tribal people in the past tense.

In this chapter I intend to consider a number of significant issues raised by contemporary visual artists from the First Peoples of North America within a North American context. I make little concession to the Canadian/American divide for many of the corollaries of the arts of aboriginal people have the same root and causation. This is not to deny the differing histories of Native artists, or the differences between the provision within Canada and America, but more as an introduction to the context within which First Nations artists find themselves in more general terms. I have used quotes liberally throughout as I wish the voice of aboriginal peoples to be foremost in the text.

LANGUAGE

The First Peoples of North America are acknowledged victims of a sustained cultural policy which clearly set out to eradicate them (the contemporary and oft used concept for this is 'ethnic cleansing'). The question of how to relate to the language of their colonizers has caused much debate

within aboriginal communities. Leonard Crow Dog, a Sioux medicine man, explains:

> Our modern Sioux language has been white-manized. There's no power in it. I get my knowledge of the old tales of my people out of a drum, or the sound of a flute, out of my visions and out of our sacred herb pejuta, but above all out of the ancient words from way back, the words of the grandfathers, the language that was there at the beginning of time, the language given to We-Ota-Wichasha, Blood Clot Boy. If that language, these words, should ever die, then our legends will die too.[1]

It became very difficult for the early missionaries determined to convert the 'lost souls' of the 'heathen savages'; when confronted with the task of translating the Bible into the language of Tribal People they faced enormous gulfs of cultural compatibility. Concepts such as 'sin' did not exist in aboriginal culture and hence not in their language, indeed in Cree the closest approximation to a word for sin was one which when translated meant to carry out an act which would damage the future of one's children!

Paula Gunn Allen, in her book *The Sacred Hoop. Recovering the Feminine in Native Traditions*, writes, 'American Indians are tribal people who define themselves and are defined by ritual understandings, that is, by spiritual or sacred ceremonial shapings.' Paula Gunn Allen, a Laguna Pueblo/Sioux writer and one of the foremost aboriginal literary critics expands on this definition of 'ritual', she continues; 'their communitarian aspect derives simply from the nature of the tribal community, which is assumed to be intact as long as the ritual or sacred center of the community is intact.' So then in relation to ritual and ceremony where does art exist? To 'ritual based' cultures it seems, the 'Arts' did not exist, indeed, according to anthropologist Christian F. Feest there was no word for art found among pre-modern Amerindians.

None of the native languages of North America seem to contain a word that can be regarded as synonymous with the western concept of art, which is separable from the rest of daily life. It might therefore be possible to argue that no art in the Western sense was produced by the aboriginal inhabitants of North America. Judging from the number of books devoted to, of museums exhibiting, and of dealers offering for sale items of 'North American Indian Art', however, we cannot simply let the matter rest there.[2]

The question of the acclimation of another's language is a huge step to take when one considers the capacity of language to construct a reality, and when the mind set of the culture one is commandeering the language from is essentially incompatible with one's own. Compounding the experience of disorientation felt by many aboriginal peoples is that the cultural language of their colonizers had to be appropriated to survive. It seems that a price had to be paid for just being an Indian. As Jimmie Durham, Cherokee poet and artist, states:

> One of the most terrible aspects of our situation today is that we do not feel we are authentic. We do not think that we are real Indians ... For the most part, we just feel guilty, and try to measure up to the white man's definition of ourselves.[3]

ADAPTATION

How then do the visual linguists of the aboriginal peoples of North America deal with the use of a language descended from a European history? It may be argued that visual language is less culturally specific than an oral or literary language and this may be so, but nevertheless we cannot deny the European aesthetic and its cultural implications which is full of innuendoes which included patriarchal, materialistic and anthropocentric viewpoints. All is not submerged however in the dominance of a Western view. Alfred Young Man, a Plains Cree who is Assistant Professor in Native American Art at the University of Lethbridge, defines the status of contemporary aboriginal art in its own terms:

> Art, in the American Indian world view today, is being used in ways that question the very foundation of Western thinking. Native artists have taken this predominantly linear, left brained mode of thinking to task. They are radically altering the non-Indians' perception of Native Americans and the way they perceive themselves as contemporary people living in the twentieth century, into what the American Indian was before Columbus; not a regression back to a perceived primitivism and stone age mentality, but ahead to what they take to be a superior and more human value system.[4]

One thing that can be clearly detected in this latter part of the twentieth century is a need, evidenced in Western cultural thought, to challenge the prevailing cultural paradigm. Suzi Gablik artist, and cultural critic in her influential book, *The Re-Enchantment of Art*, contests that a de-

mythologized culture becomes addicted to whatever anaesthetizes the pain of meaninglessness and 'archetypal starvation'. She states:

> Our culture has failed to generate a living cosmology that would enable us to hold the sacredness and interconnectedness of life in mind ... Art moved by empathetic attunement, not tied to an art historical logic but orientating us to the cycles of life, helps us to recognize that we are part of an interconnected web that ultimately we cannot dominate. Such art begins to offer a completely different way of looking at the world.[5]

What consolation to the aboriginal peoples that this appeal for an ethos of connectedness be made by their colonizers 500 years after the process of colonization began! What irony for a people devastated by the reductionism and dualism of their oppressors to hear the appeal for an acknowledgement of sacredness and transformation in their own culture. 'But we have been trying to tell you this for hundreds of years. Why did you not listen then? Why now?', one might hear the past and present voices of the people of the First Nations saying to us.

The future of the art of the American Indian lies outside of the artificially constructed boundaries of 'Western Man's' mythological universe. The search for my 'art' pays homage to my People's traditions while working towards stripping away layer after layer of the European mistake, most of which depended upon assuming that I was some sort of bona fide colonialist animal, made over into a second rate image of the white man. The whiteness belongs to them! Let them have it.[6]

An Alternative Aesthetic

So the dilemma of the contemporary aboriginal artist is evident. How to relate to a cultural system which appears to present an opposing world view, a different aesthetic (Plate 2). If a cultural aesthetic, in all its seeming complexity, is the result of a specific history and consequent 'mind set' then where do the 'colonized' fit into both the process and outcome of that version of reality? The First Peoples' contribution to Western history has not been as colonizer or despot, and, like indigenous peoples throughout the world they have had to adapt to survive. However, we should not see them as mere victims of colonization either as that would ignore their achievements and contribution to the present cultural milieu, a contribution that remains unacknowledged in both the fields of literature and the visual arts.

How then is contemporary native work to be contextualized? How is it to be viewed? If the premise of the work of First Peoples is distinctly different from the white, Euro-centric thesis, then how is it to be regarded? It may well be that it has to be 'experienced', as opposed to being reduced and analysed, for it often demands an experiential relationship with the viewer than merely an intellectual one, or more, it demands both! To deconstruct this work in post-modernist fashion is inappropriate, and places it into an alien context. However, we should be wary of isolating it as though there were a 'Nativist' movement divorced from the realities of the Post-Modernist world. Loretta Todd, a Metis film maker, states:

> But what of our own theories of art, our own philosophies of life, our own purposes for representation? By reducing our cultural expression to simply the question of Modernism or Post-Modernism, art or anthropology, or whether we are contemporary or traditional, we are placed on the edges of the dominant culture, while the dominant culture determines whether we are allowed to enter into its realm of art.[7]

When we assert our own meanings and philosophies of representation we render the divisions irrelevant, and maintain our Aboriginal right to name ourselves. However, when we articulate the dichotomy of the traditional versus the contemporary, we are referencing the centre, acknowledging the authority of the ethnographer, the anthropologist, the art historian, the cultural critic, the art collector. We have to play 'catch up' to the academic and other institutions of art, and set up an opposition within our communities that keeps us in our position of 'other'. We are caught in the grasp of neo-colonialism, in the gaze of the connoisseur or consumer, forever trapped in a process that divides and conquers.

This problem of the right of self determination and purpose of representation can be clearly seen in the situation of the Australian Aborigines. Contemporary Aboriginal art from remote Australian communities exists in the world market place today as a deliberate transformation of Ancestral designs originally made for ceremony. At an exhibition of Aboriginal Art at the Hayward Gallery in London, I discussed the problems

encountered by white people in engaging with Aboriginal Images with an Aboriginal Art Historian. He stated that the white viewer 'looking' at aboriginal paintings could never reach into the reality of the work as it will never be in their psychic and cultural understanding to be able to do so. It is true, he said that some of the 'dreamings' of Aborigines will never be seen by white people for the sacred nature of the works make them taboo for anyone except the Aboriginal people themselves.

> ... And, one has to remember that what we see today of Aboriginal art is only that which we have been allowed to see ...

> ...Neither the study of ethnography nor aesthetic appreciation alone can possibly capture the scope of a culture, its objects and images. Its expression and the figures it produces are the transcription of a knowledge and interpretation of the world. To interpret these – after our own fashion –requires a healthy balance of analytical spirit combined with sensitivity.[8]

Professor Nicholas Deleary of Trent University, Ontario, set out to define what we must do in order to engage with native culture in a way that may open us up to a deeper understanding:

> If we choose to try to understand and sensibly appreciate Native Culture, way of life and spirituality we must be willing, first of all to accept that there is involved a very special way of 'seeing the world'. Secondly, and a necessary further step, we must make an attempt to 'participate' in this way of seeing. The implications are very serious. Quite simply, if we are to accomplish this it can mean a significant transformation in our thinking and living in the world. If we are not willing to consider another way of 'seeing' the world, and, possibly eliminate entirely our chances of even really understanding Native peoples and their ways.[9] (Plate 3)

COUNTERING THE STEREOTYPE

The perceived cliché of the Native American artist is one that has plagued aboriginal artists from the beginning of the century when the Institute of American Indian Art was set up to develop Native easel painting. In 1958, Oscar Howe, a Sioux painter, submitted a painting to the Philbrook Art Centre, which had pioneered an annual exhibition of 'Indian Art'. Oscar had his painting rejected because it was said to be not 'a traditional Indian painting'. Oscar Howe responded with a moving letter which addressed, probably for the first time, the strictures of expectation placed upon aboriginal artists.

> Dear Mrs Snodgrass,
> Whoever said that my paintings are not in the traditional Indian style has poor knowledge of Indian art indeed. There is much more to Indian Art than pretty stylized pictures. There was also power and strength and individualism (emotional and intellectual insight) in the old Indian paintings. Every bit in my painting is a true studied fact of Indian paintings. Are we to be held back forever with one phase of Indian painting, with no right for individualism, dictated to as the Indian has always been, put on reservations and treated like a child, and only the White Man knows what is best for him? Now, even in Art, 'You little child do what *we* think is best for you, nothing different'. Well I am not going to stand for it. Indian Art can compete with any Art in the world, but not as a suppressed Art. I see much of the mismanagement and treatment of my people. It makes me cry inside to look at those poor people. My father died there about three years ago in a little shack, my two brothers still living there in shacks, never enough to eat, never enough clothing, treated as second class citizens. This is one of the reasons I have tried to keep the fine ways and culture of my forefathers alive. But one could easily turn to becoming a social protest painter. I only hope the Art World will not be one more contributor to holding us in chains.[10]

One of the most powerful contemporary voices to challenge the reductionist attitudes towards aboriginal people is the Cherokee artist Jimmie Durham. Durham counters the most cherished white liberal image of Indianness – the Noble Savage stereotype. He attacks the museological context into which Native Peoples are placed and confronts us with an assemblage of found objects constructed into parodies of the 'Indian' as misrepresented by the establishment view.

> To be an American Indian artist is quite possibly to be more sophisticated and universal than many white artists can manage, for what should be obvious reasons. But people approach American Indian Art with ulterior motives. I suspect, cynically maybe, that some people enjoy a 'frisson' of the exotic mixed with a safely disguised guilt, plus the comfort expected from a familiar landscape ... It would be impossible, and I think

immoral, to attempt to discuss American Indian art sensibly without making central the realities of our lives. One of these realities is the racism manifested in the stereotypes by which North Americans may deny other political realities such as enforced poverty and alienation and constant land loss. It is because of such stereotypes that people often expect American Indian art to concern itself with only the most comforting subject matter. If one goes to an exhibition of Latin American art, there is the expectation that political realities will be taken up constantly by the artists. But American Indian art is supposed to transcend that in mystical ways, or perhaps sometimes now to present the case in such a way that the American people can be entertained by our sorrows.[11]

Not content with allowing others to perpetrate a reductionist and inappropriate analysis of their work, aboriginal artists seem to be defiant in their stand to define their own work and its very nature. The question must be asked, if we are to view the contemporary arts of Aboriginal Americans, and if this view requires a specific way of seeing, as Professor Deleary contests, then where do we acquire this alternative mode of perception? We must, I feel acknowledge the contribution and achievements of First Nation artists, in the way we present history and cultural theory in our schools, colleges and universities. There must be 'Native Studies' built into the curriculum to recognize the contribution Aboriginal People have made and continue to make to the cultures of North America. Implicit in all this is not merely a white view of Native culture, but that the articulate voice, in all its formal outcomes be heard at first hand. There is debate within Aboriginal Cultural discourse itself, particularly around the issues of authenticity and language, but this is a healthy and necessary debate retaining a strength in the central sacred ethos which, it is felt must be protected against the erosion of Western materialism.

In 1992 Gerald McMaster (Plains Cree) and Lee-Ann Martin (Mohawk) curated an exhibition entitled 'Indigena' which displayed a collection of Native Canadian artworks at the Canadian Museum of Civilization. They wrote in the introduction to the catalogue:

> The artists and especially the writers in 'INDIGENA' reject the ethnocentric language of conquest and dominance, and the denial of Aboriginal identity and sovereignty that it implies.[12]

Indigenous artists in all fields across the Americas are seizing this opportunity to reflect upon the past, depict contemporary realities and present a vision for the future. Many of their works will be overtly militant and accusing; others will try to unravel complex histories and redefine relationships of Aboriginal peoples within a constantly changing environment.

The continuum of the diverse cultures of the First Peoples of North America from their early ancestors with their ritual shapings and cosmic mythology to the contemporary Aboriginal artist, reconstructing images and visual language is still intact. Permeated by both the sacred view and the need to protect and sustain their cultures in the face of the constant pressures of assimilation, First Nation Art is often vociferous and challenging in its formal outcomes. Its presence and influence into mainstream Western cultural structures is evident and ever growing.

The distinguished Kiowa/Cherokee writer N. Scott Mamaday, in his novel *The Ancient Child*, wrote of a young Kiowa boy, who, far from home reflects on the Kiowa myth of the transformation of a boy into a bear:

> Art – drawing, painting – is an intelligence of some kind, the hand and the eye bringing the imagination down upon the picture plane; and this a nearly perfect understanding of the act of understanding. Ha! Someone looking into a glass – transmitted to the fingertips, an understanding not of ice bears and fright but of these and more, a composed unity of fragments which is a whole.[13]

How is this act of transformation to be experienced in our schools and colleges? I once showed a Mohawk friend a series of photographs of work produced by students who had constructed maps of themselves in the landscape of a rural environment. Using the elements, the trees, leaves, water, earth and air, they had assembled mythological structures born of their own life experiences, defining their own identities. They were, he observed, 'Constructing their own ceremonies, not taking ours.' Their work informed as it was by the cultural paradigm of First Peoples through theoretical exposure and personal research, was owned by the individual students who in their way were reconstructing a cultural language, were making partnerships with cultures that they had engaged with.

As Sitting Bull, the great Lakota chief, once said:

> Let us put our minds together and see what we can build for our children. (Plate 4)

NOTES

1 Erdoes, R. and Ortiz, A., ed., *American Indian Myths and Legends*, Pantheon, 1984, p.xiii.

2 Feest, C. F., *Native Arts of North America*, Thames and Hudson, 1980, p.9.

3 Durham, J., and Fisher, J., 'The Ground Has Been Covered', *Artforum*, vol.26, no.10, Summer 1988, pp.99–105.

4 Young Man, A., 'Issues and Trends in Contemporary Native Art', *Parallelogramme*, vol.13, no.3 Feb.–March 1988, pp.24–39.

5 Gablik, S., *The Re-Enchantment of Art*, Thames and Hudson, 1991, p.82, p.88.

6 Op.cit., note 4, p.31.

7 Todd, L., *Indigena. Contemporary Native Perspectives*, Canadian Museum of Civilization, 1992, p.75.

8 Hubert Martin, J., *Aratjara. Art of the First Australians*, exh. cat., Kunstsammulung Nordrhein-Westfalen, Dusseldorf, 1993. p.32.

9 Deleary, N., *Culture and Community*, Course Programme, Trent University, Section 1 *Another Way of Seeing.*

10 King, J.S., 'The Pre-eminence of Oscar Howe', *Oscar Howe: A retrospective exhibition*, Tulsa, Oklahoma, Thomas Gilcrease Museum Association, 1982, p.19.

11 Durham, J., *A Certain Lack of Coherence*, Kala Press, 1993, pp.107–8.

12 McMaster, G. and Martin, L.A. ed., *INDIGENA. Contemporary Native Perspectives.* Canadian Museum of Civilization, Douglas and McIntyre, 1992, p.18.

13 Momaday, N.S., *The Ancient Child*, New York, Harper Perennial, 1989, p.132.

USING CONTEMPORARY ART

LUCY DAWE LANE

As the twentieth century closes, contemporary art offers a plethora of possibilities. In this situation of pluralism, itself a sign of health as much as of fragmentation, this chapter will suggest how to make positive use of any aspect of contemporary practice in schools; how to plunder it for all it is worth, which is a great deal. The purpose of this chapter is threefold:

- to propose reasons why contemporary art is an important and unique resource to support the implementation of the National Curriculum for Art
- to identify key issues with which contemporary artists are concerned and to explore ways in which broad curricular themes can link to these issues; and
- to suggest ways in which teachers of art and design can update their subject knowledge and identify resources available to them.

Why Contemporary Art?

For many people the very notion of contemporary art spells difficulty, and excites anxiety, even anger. Teachers of art and design have every reason to use established collections of historical and modern art, as they present tried and tested examples of quality, seminal works, readable histories. The contemporary, however, has yet to be fixed, judged, categorized. Walk into an exhibition of new work, and the visitor is in uncharted territory. Posterity has yet to sift it all into something altogether more manageable. It is the intention here to argue that the difficulties that contemporary art at first presents and which usually preclude the use of contemporary art in schools are also the reasons why it is a challenge worth taking on. Art needs to be exposed to young people as often as possible, and art is deliberately made the passive side of the equation. It is time to train active audiences to read and enjoy the visual languages that are made available to them. If people only realized, art is at their disposal.

Art requires audiences for survival or at least to become part of common visual currency. At the Whitechapel Art Gallery, London, it is a daily occurrence that pupils from the neighbouring schools, among other visitors, will come in and furnish mute art objects with diverse and often startlingly sophisticated readings of their own making. This is the power that future audiences have. Art objects are purpose-built for receiving meanings from those who use them. Currently artists are making works which actually need audiences to take on an active role in completing them by finding potential meanings in them. Art is made to be treated with critical rigour, rather than swallowed whole. What is more, it does not bite back.

Teachers of art and design have a responsibility to ensure that art made today has a role to play as part of the day-to-day lives of all pupils. It is not yet known which of the objects made today will ultimately be most evocative of the end of this cen-

tury, but an example like *House,* made by Rachel Whiteread in 1993, is already part of a collective memory bank. This is not because it was preserved, or placed in a museum, but because so many people saw it, read about it, watched it on television: because it entered the minds of many people, and therefore, in a way, still exists. The public had as important a role to play in the creation of that sculpture's significance as did the critics, dealers and councillors who fought over the span of its brief existence.

ART AND THE PRESENT

The most compelling reason for including contemporary art in the secondary school curriculum is that it reflects on current cultures. Either self-consciously, or in spite of itself, art is a product of its own times and can be approached as familiar ground which is going to reflect some of the concerns, interest and experiences of pupils, simply because that experience is of the late twentieth century. This truism sets the scene for enabling pupils to feel a sense of ownership over this material in a way which they may not feel for historical objects. Moreover, the many cultures which art objects can be said to reflect and invoke today mean that the study of art can provide an arena for developing an awareness of cultural difference, issues of imperialism between cultures, sexual difference and so on. How pupils situate themselves in contemporary debates on any subject from environmental issues to fashion can be picked up and used to woo them into a direct involvement with visual art.

The clumsy argument for matching cultural groups to relevant art objects by using such criteria as gender and race has, one hopes, long been replaced by the desire for individuals to develop a finely honed sense of their own 'place'. They also need to be given a wide enough sense of various cultural perspectives to be able to choose the avenues along which they wish to travel in the future.

ART AND ART HISTORY

To pursue the issue of teaching art history, the work of a contemporary artist can provide an ideal introduction to an area of study, by revealing in very deep and often very personal ways how art objects and cultures of the past can feed directly into the creative processes of today. Artists are themselves the most exacting and critical of art history scholars, mining the past both visually and ideologically, but also re-evaluating it, even reinventing it. Their gaze does not stop with art objects either, but casts a contemporary consciousness and visual sense over the ideas and objects of social and political histories, and of anthropology, the history of science, and medicine. The list is as long as the number of disciplines history encompasses. It is important that pupils are able to appreciate the variety of research that artists might undertake in order to create their work, and that the discipline of art is far from hermetic.

ART AND THE FUTURE

Having briefly explored the reasons why some artists today provide a route into art history, it is also worth mentioning that many also have a unique role to play in shaping the future. Despite the tiredness of the very concept of an 'avant-garde' in today's permissive climate, it is nevertheless true that artists are defining the future visual environment and the visual languages that will operate. It only has to be mentioned how ubiquitous early twentieth-century fine art images now are in advertising, in the cinema, in fashion and so on. Even though it plays with the notion of exclusiveness by appearing to single out only those who are enough in the know to buy the product, the recent 'Picasseau' campaign by advertisers of Perrier, using a Cubist-style bottle, relied on recognition for the message to work. What at first caused outrage and confusion becomes an accepted and understood language to be used in a relatively casual and undemanding context. There is every reason to think that this process will continue, so that art being made now will become part of the visual vocabulary of many more people in the future than it reaches currently.

LEARNING VISUAL LANGUAGES

What can teachers do in the meantime? Do they wait for the art of today to become assimilated before using it in school, or do they try to bridge the gap, and negotiate the difficulty, the unreadability, of new works of art? If art is a language or a group of languages which use visual rather than verbal signs, then an analogy with language learning may be appropriate for discussing how to proceed with art.

While there is an argument for beginning by learning rules of grammar and declensions of nouns, verbs etc., there is also a case for learning

through immersion in the spoken language, for plunging right in. The idea of listening to language/ looking at art as a constant activity alongside practising the speaking/making for one's self is useful. In this model the idea of keeping pupils away from art objects for fear of their being too complex just does not stand up. Taking part in a conversation can be the best way to get interested enough to want to learn the rules.

Having mentioned rules, it is also worth bearing in mind that artists today are intensely involved in a debate about visual grammar. The early twentieth century saw new rules being forged for the use of visual language. Since then the pace of change has increased such that currently there can be very many different conversations going on, each with a separate agenda. There are some artists working within genres such as landscape painting, whereas for others the redefinition of landscape, and of the place of painting, happened many moons ago. The result is that artists as diverse as Richard Long and Michael Andrews can both be said to be contemporary landscape artists, but their mind-sets and methodologies are almost totally exclusive to one another, perhaps like dialects of the same parent language. There are even returns to earlier forms and ideas, such as neo-Expressionism and neo-Conceptualism, so that the problem which art and design teachers set for themselves is not merely to include in their teaching reference to the many new visual ideas which are currently being forged but also to make sense of how complex the organic whole is to these raw shoots at the extremities.

BROADENING IDEAS ABOUT ART

It is vital to introduce into schools some sense of the changing relationship between skills and ideas in the making of art, and how these are fused together with a different emphasis according to the intentions of the artist . Intentions might vary at different historical moments and in different cultural contexts. Again, it is important to grasp that today there is no one orthodoxy in these matters, so the breadth of available variations within contemporary practice presents an inclusive and somewhat confusing picture to young people. The issue of skill and talent is one which affects everyone, and the current openness with which artists use any method and explore any material at their disposal to put across ideas, rather than rely on innate or cultivated practical skills, is surely a wel-

come environment in which to encourage pupils to negotiate as well as to develop their own manual abilities. There are several areas in which it is possible to succeed in art, and the National Curriculum happily bears this out, with attention being paid to understanding art, to investigate skills and to the quality of ideas, as well as to the finished product. But how will pupils feel about this, when most are engaged in their own struggle to fulfil their expectations, in terms of drawing skills, for example?

One of the most common reactions to a contemporary art object is that the artist has made a deficient object, one which seems to exhibit a lack of ability. This lack might be either in the area of physical skill, or in the ability to make an object which is at once comprehensible to the viewer. The idea that this could be deliberate, as part of a strategy to focus on aspects other than the display of talent, or indeed a decision to make something which does not reveal any recognized patterns of thought, cannot at first be entertained.

It is important to investigate the reasons why a change has taken place in artists' attitudes towards demonstrating skill, and to discuss what skill actually represents in a post-industrial society. Is a preoccupation with, and questioning of, manual skill in fine art a reflection of a similar ambivalence in attitudes towards technologies which have taken over most manual activities? To question an artist's use of industrial techniques to make objects, for example, is a bit like saying that mathematicians should not use calculators. Behind the shift in aims away from the demonstration of skill lies the decline of academy-style art training which was the norm in the last century, and which was eventually replaced by the Bauhaus model. The goals shifted at that time to embrace creativity and invention, rather than the imitation of models found in nature, and the exploration of the formal possibilities of each medium took precedence over traditional subjects.

When looking at a work of art it is important to remember that the artist has deliberated on every aspect of its physical appearance and that, rather than looking for mistakes, the aim is to find clues to the artist's intentions. Gauging the intentions and deliberations of the artist must therefore be seen as one essential step in the process of reading works of art. It does not follow that viewers should agree with the artist's proposed meanings entirely. Rather, they might consider the art object a cross-

ing over, a confluence of ideas, both those of the artist and their own. In this case the artist's input is only one part of the work.

Artists are perhaps only united by the necessity to define and analyse their own practice; by a consciousness of their position, which means that to paint is to decide to paint as a deliberate move in the continuing and lively debate about the status of painting. It is possible to do almost anything, as no area of object-making need stand outside aesthetic consideration. It is not possible, however, for artists to do anything meaningful without considering, even if choosing then to disregard, the context of current visual and theoretical debate. The implications of this statement for the implementation of the National Curriculum for Art are far-reaching.

THE VALUE OF ORIGINALITY

It is useful to recognize a dual standard in society today towards originality. On the one hand, the constant creation of demand for the new in fashion, in technological inventions, in the design of cars and washing machines, etc. is what drives capitalism. On the other hand, there is deep suspicion towards anything which is unrecognizable and defies expectations. Whereas the ideal of individualism is deeply rooted in people's consciousness, and consumerism offers genuine possibilities for self-expression, these possibilities are within strictly defined limits. Underlying the market there has to be some degree of conformity, because it is a mass market.

However, young people are naturally inventive with the materials at their disposal, especially in terms of combining available options in, for example, street fashion to produce their own styles. There is much here that can be harnessed to generate an understanding of how artists work and think. They too are open to experimenting with materials, and have an eclectic visual approach to existing objects. It is essential to give pupils a sense of the relationship between the professional artist's approach to everyday experiences, and their own, so that they can begin to practise various ideas for themselves, and do so with an awareness that, whether or not they will themselves become artists, these skills are all beneficial in their own right.

Most people would think of practical skills in various media if asked what it is that artists do. Lateral thinking, problem-setting and solving,

investigative skills, creative drive, perseverance, the ability to work alone, or to collaborate with other specialists who have complementary skills; this might sound like a list of personal skills for any number of jobs. The transferable skills learnt during an art school training have formed some of the most influential and original people at work today, in fields as diverse as pop music and banking.

WHICH CONTEMPORARY ART?

Having discussed arguments for the use of contemporary art, broad topic headings are used in order to focus upon examples of projects with artists and secondary schools undertaken by the Whitechapel Art Gallery. Reference is also made to a wider selection of artists' work where appropriate to the topic headings. It is intended that these topics will reveal how varied the approaches and products of individual artists can be on a single theme, and that teachers will see how to match or to complement their own pupils' existing interests and experiences through a considered choice of contemporary art for study.

ART AND THE ENVIRONMENT

The depth with which artists consider their visual surroundings, and the diverse ways in which this feeds their work, will, on viewing that work, or working alongside an artist, promote a similar seriousness about investigative and documentary activities in school.

Consider the city. Artists today find aesthetic interest in almost any aspect of the made environment, whether it be the spectacular, such as the new environment of London Docklands, which has already been the site of many projects and commissions, or the commonplace, such as the featureless interiors of public buildings recorded meticulously by the painter Paul Winstanley. The city as a total system, as explored by Julian Opie, or the city as a conglomeration of individually seen and experienced textures and incidents, is an endless mine of visual ideas.

While many artists work in studios in inner-city areas, where rents are cheap, artists have also used the urban environment to create a setting for showing their work, rather than choosing to exhibit in pristine galleries. *The Freeze* exhibition of 1988, organized by then art student Damien Hirst, in a disused warehouse in Wapping, is a now famous example. Artists are drawn to make site-

specific works in urban and suburban settings, often by drawing out existing qualities of a space, and altering them only minimally. They might be attracted either by the everyday ordinariness of the place, or by its almost exotic qualities of decay.

Some work is virtually invisible, such as Cornelia Parker's temporary sculpture in a Limehouse church spire, which was impossible to see from the street. In contrast, other public art works, whether permanent or temporary, can completely alter their surroundings by dominating the space they occupy. It is this aspect of contemporary art that often reaches the press and public beyond art circles, and quite often because the work does not meet with public approval or expectations. Festivals or large-scale projects in the UK, such as the Tyne International, Edge, or Television and South West Arts, include a variety of works in public spaces both urban and rural, and would provide an excellent study for local schools.

The opposites of the city in environmental terms, such as a desert or an Arctic wasteland, preoccupy artists for different reasons. Christo's large-scale artworks such as *Wrapped Coast* exploit the scale and drama of uninhabited spaces, whereas Ian McKeever's journeys to hostile and uninhabited places result in paintings which take account of not only the large-scale formations of landscapes, but also the minutiae of rock formations.

There is now a tradition of work which uses natural materials in rural and wild places, to make works which are temporary, and often result only in verbal or photographic productions. Richard Long, Ian Hamilton Finlay and David Nash represent just some of the very individual ways in which this type of work first developed in Britain. The idea of a walk, or a sculpture built with ice, being a work of art might seem odd at first, but when art is seen as an activity, with certain intentions planned and then carried out by artists, rather than having a lasting product, the range of possibilities is extended.

Pupils appreciate the moral position that much of this art represents in terms of not using materials to produce yet more objects, but merely to move materials around for a while, to create equally stunning visual or conceptual results. Again, the idea that art can exist only temporarily, especially if it is only ever seen by the artist who made it, provides challenging philosophical problems to explore. These ideas can be investigated by making ephemeral works in school, and experimenting with natural materials (the simpler the better: artist Andy Goldsworthy has made rain sculpture by lying down on hard ground the moment the rain starts, and revealing a dry image of his body, which lasts only a few minutes before being covered by more rain).

A project undertaken by artist Kate Allen with special educational needs pupils at Stormont House School in London in 1991 combined two extremes of environment by creating a hybrid: an urban rain forest, made largely from scrap materials. Following the principles of her own working methods, the project created an archaeological record of objects found by pupils, from shoes to safety pins, and set them into cardboard boxes using differently coloured layers of plaster. Into these blocks of plaster were set lengths of wood to form the supports for exotic foliage, and fauna, again made from found materials. The impact of these 'trees', when brought together in a display at the Whitechapel Art Gallery, was stunning.

Another project relied on a formula for collecting materials. Artist Jordan Baseman led a series of three Saturday GCSE workshops at the Whitechapel Art Gallery during an exhibition of contemporary Japanese art, and spent a total of five days continuing the work at Central Foundation Girls' School. The exhibition as a whole concentrated on the high technology available to artists today, such as LEDs and computerized photomontage. Shinro Ohtake's work was in contrast, quite low-tech in techniques and therefore made an excellent choice for practical investigation. Jordan asked participants to collect a diary of rubbish over the winter holiday. This resulted in a huge diversity of material and methods of collection. Furnished with black plastic sacks, pupils returned in January with an extraordinary array of magazine clippings, in Bengali and in English, Christmas decorations, bus tickets, meal wrappings, etc.

Inspired by the diaries documenting worldwide travel made by Ohtake, the pupils made fascinating books. Some had three-dimensional objects incorporated in them: all had a wry and iconoclastic slant to them, and a refined sense of combining and cross-fertilizing materials from the different cultures encountered as a natural part of their holiday. During the workshops it was decided that they would fax Ohtake in Japan, and as a result, he replied and sent participants small collages and then colour photocopied notebooks with their names on the front. This sort of matter-of-fact and yet very real involvement with artists succeeded in

both cases in closing the gap between the artists' true concerns and the everyday experience of pupils, by providing carefully prepared routes into the concepts behind the work, and room for personal contributions within the framework of the project.

ART AND TECHNOLOGY

As with contrasting environmental topics, looking at technologies has high- and low-tech aspects in artistic practice. An important issue for schools is to demarcate visual art practice from the study of technology *per se*. This chapter is concerned only with the creative harnessing of technology by artists, for their own very distinct contribution to present-day society. Bill Viola is an American artist whose approach to video and computer technologies lies not in what the machines can do, but in what he can do with them. His interest goes beyond a love affair with technology for its own sake. This attitude can be found among many other artists who will often ignore the technical finesse or logical extremes of a medium, and use them at a very unsophisticated level because the focus of their interest is elsewhere.

The same could be said of painting as of computer graphics, in that the medium has to be fully grasped technically, before this kind of approach is truly a choice rather than just a necessity. But very welcome it can be to teachers who are daunted by the prospect of starting a video project because the school possesses no equipment – in which case a very effective course could run using any home players and camcorders that might be borrowed. The inspiration of an artist during a short residency can often spur a teacher into extending into a new medium by plunging in and starting with an artistic aim, which the technology has to be made to serve.

Creating a still life on video, for example, which requires a fixed position for the camera, and frees all members of a group to explore ways of introducing different materials and objects into the picture, could be a useful first step to using video visually rather than as a narrative medium. In early 1994, artist Shona Illingworth made a short film on the theme of fire and water with Bengali women and girls living close to the Whitechapel Art Gallery. The theme naturally provided action through time, and allowed the group to introduce other materials which they associated with these elements. In this project, as with most successful work planned and undertaken by the Gallery, the

principle of 'less is more' when setting the content resulted in a corresponding richness and coherence in the finished work.

Contemporary artists use an array of industrial techniques and materials in their work. One of the most memorable pieces of work made in recent years is Richard Wilson's *20:50*, originally shown at Matt's Gallery in 1987, and now the property of Saatchi Galleries. The work is composed of a room which appears to be half-filled with sump oil. The material is as precisely calculated in its effect as oil paint, and refers to painting in the way it literally reflects nature (the ceiling above). In contrast of scale, cotton buds, a mass-produced product rather than a raw material of industry, have been used by artist Caroline Russell. She uses such existing products, together with display techniques and industrially produced finishes, in order to comment directly on the process of display and sale of consumer goods.

What is striking about both these examples is how, once out of context and isolated in a gallery, these materials become extraordinarily beautiful. There is a great challenge and also a great deal of enjoyment to be had in discovering and sharing the aesthetic qualities of everyday objects. Projects which simply modify the context, or even create a special context for looking at certain objects and materials are well within the reach of every art and design department, and such art practice has a distinguished history.

The meanings which found objects, artefacts and materials can generate are diverse. Picasso used existing objects for their anthropomorphic or zoomorphic qualities, most famously the bicycle saddle and handle bars becoming a bull's head. In contrast Ange Leccia, a Parisian artist, uses portable cassette players and television sets, and displays them, often on top of their boxes, and in the same symmetrical formations that are seen in shop windows. They represent themselves, and are placed in art galleries for the viewer to contemplate their meaning. The context requires that they are perceived differently. It may be that, when looking to buy something in a shop, the emphasis is on differentiation: what distinguishes one model from another, both functionally and aesthetically. The artist presents half a dozen of the same kind, and dwells on the generic type, which stands for all ghetto blasters everywhere.

Introducing practical projects using existing objects or materials might be profitable only when those chosen have some resonance with the pupils

concerned. Designer training shoes, for example need not be relegated for ever to be a subject for still-life drawing. They could be used as found objects to trigger further work which examines their significance. For example, everyone understands about aesthetic value and material cost when the object in question is a real part of their own lexicon of values. Making work which explores this would involve tackling one of the most thorny issues of all: art and money.

ART AS COMMODITY

One of the most significant developments of this century has been the decision at various times, by artists. to stop making saleable objects, or even stop making objects at all. Resulting work includes performance art, conceptual work and installations. Some of these works set out to protest against the fetishization of art objects and the market value they represent, when to artists their value lies in the ideas they contain and the aesthetic pleasure they generate. Nevertheless many seminal works which attempt to defy market forces very often end up being tied to them, because contact is through lists and slide collections held by Regional Arts Boards. They will also know which artists are interested and experienced in providing educational activities. Building up a long-term relationship with even one artist can have real impact on a school, and bring to life at least one example of art practice.

It would be ideal to find a contrast between a ceramic artist, or printmaker, and a fine artist practising in a very different way, and to compare the two studio environments. One might resemble a workshop, with systematically laid-out tools and equipment; the other might be a clean white space, with very little in it, or be full of a chaotic array of materials and objects, and have masses of unfinished work around. Once back at school, it may be possible to recreate a studio by removing all tables from a room and creating an empty space to work in, to see how the scale and nature of the work made can change due to the circumstances of its production. If all the art produced at school has a school-art feel to it, maybe that is because all art-rooms have an art-room look to them.

GALLERIES

Starting locally, it is worth getting to know the collections and exhibition spaces in the locality of the school, and any commercial galleries, however small. The main advantage of using local resources, in conjunction with occasional visits to special collections or exhibitions, is that it can make a local resource a regular point of reference. A study of a local collection can reveal much about attitudes to contemporary art if only by its absence, or by the tokenism of one or two tired-looking abstracts. Are they well displayed? What would the pupils do to add to the collection? Would they buy or make work which was interesting because relevant to the locality? Knowledge of how the collection came about would lead to further conclusions about the significance of its contents. Whether it started as a bequest or as a municipal foundation, for example, could have completely different implications for further study.

Public exhibition galleries are a particularly valuable resource, because they provide a cross-section of work being made today, and if the space specializes in showing certain types of work or concentrates on one medium, then it is well worth planning this into the art and design curriculum so that full advantage can be taken of the annual programme. Many museums and galleries offer some kind of support to schools. A full education programme will include teachers' evenings and in-service courses, workshops, tours and talks undertaken by gallery staff and/or artists; some with outreach activities taking place in schools.

If there is little or no activity that answers specific needs, it may be worth trying to cultivate a curator or exhibitions organizer to generate some rapport between school and the venue. While the National Curriculum for Art demands services from galleries and museums, there is not the accompanying commitment from central government or from Local Education Authorities to bear the cost of providing gallery education services. The field has grown enormously over the past ten years, encouraged greatly by funding support and education policy coming from the Arts Council and from Regional Arts Boards. However, many posts and facilities are under threat, due to a lack of funds, and sadly often suffer from a lack of commitment to education from within the institutions themselves.

SECONDARY SOURCES

The provision of adequate books, slides and reproductions in support of the National Curriculum for Art is very difficult for many schools which lack sufficient funding. For contemporary art, although there are some ravishing books, there are also

cheaper resources available from galleries exhibiting new work, such as illustrated leaflets and catalogues, and sometimes slides or postcards.

In addition to these resources, art magazines provide an introduction to issues in contemporary art. There are several on the market, with *Art Monthly*, *Frieze* and *Modern Painters* providing a survey of available critical positions. Specialist magazines such as *Third Text*, which has a perspective on cultures worldwide, and *Feminist Art News* also give a sense of the different dialogues going on in specific areas of visual art. As well as looking at the criticism, reviews and exhibition announcements that these provide, there is a case for making accessible some copies of *Apollo*, *Gazette des Beaux Arts* and the *Burlington Magazine*, and also some Sotheby's and Christie's catalogues, to present a picture of the commercial world of art-dealing.

In London there is a bimonthly sheet of all exhibitions in contemporary spaces, both public and commercial. This free leaflet, which is obtainable at most public galleries, is an excellent way of getting an instant overview and update of the contemporary art scene. If pupils have seen the work of a particular artist in an exhibition, they can trace any subsequent shows that include that artist.

In summary, it is essential that pupils in secondary education are given every opportunity to experience the richness of current artistic practice, and have access to an unbiased selection of resources. They are not only the potential artists of the future, but also they should all be considered the audiences for contemporary art, and they should be able to negotiate the art world with ease and confidence.

YOUNG PEOPLE AND CONTEMPORARY ART

IAN COLE

LOOKING AT ART

A group of eight year olds in a gallery contemplate a picture. Starting from the top left and moving anti-clockwise around the edge, they identify a line of domestic cattle looking out at them. They seem to be outside a fence. Inside there are buildings with men and women engaged in conversation or arranged by the artist in groups of different sizes. These people occupy distinct compartments. Some hold spears and seem to be hunting; others by their authoritative or reassuring gestures seem to be leaders, priests or counsellors. Some spaces are occupied by women engaged in domestic chores. At the centre is a circular enclosure. It is occupied by two dogs, whose expressions hover uneasily between anxiety and irritation as if they have been roused from sleep, and by a store of fruit or onions. There are several entrances to this central circle from various points in the surrounding compartments.

It seems to be a picture about order and sufficiency. Along the top of the image runs a piece of writing explaining that this depicts the kraal of the artist's father. 'He had 8 wives, 9 sons, 8 daughters and bushmen stayed with him. He had 200 head of cattle. He got enough corn.' In his community he was clearly a man of some standing.

The image is starkly black and white. It is dramatic without being theatrical, nostalgic without being maudlin. It is matter-of-fact. Its appearance is that of a stack of boxes which reveal the separate but related goings-on of a community which is quite different from those of the children looking at the picture. It looks like a structured society with special areas for people, animals, food storage and activities.

The picture is a linocut by the Namibian artist, John Muafangejo (1943–87), entitled *Muafangejo's Kraal*, 1980.[1] It describes, in a schematic way, his memory of village life in Southern Africa in the 1950s when he was a boy. In the writing at the top of the picture he goes on to observe that his father died in 1955 'while John was 12 years old'. The picture represents the peace and security Muafangejo lost after the death of his father when family upheaval and political unrest in South West Africa combined to upset the settled existence he had become used to.

This picture and the many others in the exhibition which deal with personal experiences, biblical stories, tribal customs, wildlife, political and social events, provide the children who are in the gallery with glimpses of ways of life and sets of values that are both different from and comparable to their own. The account set out below represents a conflation of their observations and opinions about this picture and the artist who made it. Their remarks were made in response to questions put to them by their teachers working closely with gallery education staff.

The principal objective of this and similar explorations is to see how much children can observe and detect by looking carefully and sympathetically at an image. They check what they find against their own knowledge of how the world works. These children belong to the television age and have seen something of life in different parts of the world. Some are from different parts of the world themselves and they bring additional sensibilities to the consideration of the work. Some see the picture as a documentary and point to the compartmental way the picture is composed with everything separately identified but visually combined. They consider how this form of depiction enabled the artist to sum up what he felt about his recollection of his childhood and his father. They imagine a photograph of the scene and consider what would be lost and gained, in what ways it would be different.

They try to decide who or what this picture is about – the artist, the artist's father, village life, sadness, material possessions. Several think it can be about all these things both separately and at the same time. Some children engage with the picture on physiological or emotional terms. Others are more analytical. There are a few for whom it holds no fascination at all. They acknowledge some of its qualities of sadness or humour but they find it unexciting in comparison to the computer games they play. Mostly they explain these shortcomings with patience and an acute awareness of the pros and cons of their preferred visual stimuli.

CHILDREN AND TEACHERS

On the whole young children seem to be open-minded, aware and tolerant. They know how to get on in the world and if they bring inhibitions to the gallery they tend to be those of their parents rather than their own. The teachers of children in Key Stages 1, 2 and 3 also seem to be, on the whole, adventurous and generous of spirit where contemporary art is concerned. They are mostly not art specialists and have the refreshing approach of people without fixed ideas or reputations to protect. They want to discover new things and to give their children the opportunity to do so too. Practised at teamwork, they know how to combine their own particular skills and knowledge with the ideas and insights gallery staff are able to provide about the work on show.

Twentieth-century art can be problematic. It is often non-representational and frequently not obviously about the world as we know it. Sometimes it is made of materials and by processes which are unusual and unconventional. Often it can seem to be the result of self-indulgent larking about. Worst of all it can appear to serve no obvious use or purpose. To the teachers who bring their children to the Museum of Modern Art, Oxford and to galleries like it, these are not so much problems as opportunities for learning and enjoyment.

There seem to be two principal problems which potentially stand between young people and their active enjoyment and consumption of twentieth-century art. The first is that, to many of them, art, and particularly modern or contemporary art, seems to have little relevance to the living of their daily lives. The second is the still prevalent feeling that the articulation of worthwhile responses to art and the understanding and enjoyment of it are predicated on assimilation of authorized bodies of knowledge.

The practice of art education in schools and colleges developed from a form of Modernist values and ideas adopted in the early years of this century. The world proposed by Modernism was one untroubled by the discourses of other disciplines or views. This now seems anachronistic but much art teaching still measures and defines itself in relation to the particular practices and materials which are thought to be intrinsic to it. Largely dissociated from everyday life, art can seem both mystifying and irrelevant to many young people who see little or no relation between it and the things that are important to them. The task of the galleries is to present as diverse a number of views as possible about artists, their work and the circumstances in which it is made and seen. They do this through a combination of their exhibitions and education programmes.

The exhibition programme at the Museum of Modern Art in Oxford offers opportunities for looking at a wide variety of views of the world through the eyes of artists, designers and, occasionally, makers. The programme includes fine art from the West, the art of non-western cultures, design and the applied arts, ceramics, photography, architecture, film, video, performance and installation. There are at present four exhibition slots per year, each carrying from one to four exhibitions.

Programming and presentation are neither innocent nor neutral. One of the primary tasks of education departments is to make sure that a degree of self-examination, challenge and, at

times, subversion are squarely on the agenda. This does not mean substituting one set of orthodoxies for another. Curatorial, educational or political positions on issues such as ethnicity, gender and sexuality can be examined for what they appear to be in the prevailing circumstances and compared with other ways of thinking about the world and the things in it. The conclusions are left to the visitors.

WORKING IN THE GALLERY

The Education Programme at the Museum of Modern Art starts from the basis that young people bring valuable experience of the world with them when they come to the gallery. They can draw on this experience rather than on somebody else's to articulate their opening responses to works of art. Their experience is not free of values or the received wisdom of their families, but they feel it is theirs. In this way they can establish a personally reasoned connection with the work on display and prepare the ground for the exploration of different social, cultural or art historical material which may relate to the work in question. This is a first step in asking young people to consider how the work of art may sit in relation to their own worlds and the priorities they construct within it.

The second step is to explore a variety of viewpoints from which the work can be seen. Who made the work? Where and under what circumstances was it made? What does the work look like? Who or what is in it? What materials and processes have been used? What is the subject of the work? How does this relate to any or all of the above questions?

Work with young people at the Museum is carried out through structured discussion workshops. These take place in the galleries and vary in form and duration. Some last an hour, others stretch over a morning, afternoon or a whole day. They can consist of question-and-answer sessions, active research and feedback on tasks set by gallery staff and teachers, and the use of artefacts or images which prompt comparison with work on show – or combinations of these.

Following initial question and answer explorations of pieces of work children are given specific tasks to do. These are given either in written or verbal form, but always clearly and within the context of further information about a particular work or the artist. Sometimes they do these tasks in two or threes, sometimes alone. Often they are sub-divided to investigate different aspects of a work or exhibition. Later feedback sessions not only promote debate but enable groups or nominated spokespersons to report on their findings and advance arguments which they have to defend.

Some tasks are simple and basic, aimed at enabling children to find their way around and gain access to simple pieces of information and experience. In the case of an exhibition of work by Donald Judd[2] (Plates 5, 6) some children are sent off to look at the labels. The ubiquitous 'Untitled' tag given to objects, stacks and furniture alike provides the basis for an examination of simple ideas about art and objecthood.

Other tasks require more puzzling out. Several pairs of twelve year-olds are given some information about measurement and proportion in Judd's work. They go off with their teachers to find examples of division and subdivision both in the work and in the way it is set in the spaces of the galleries. They come back with a number of observations which enable gallery staff to lead them into a consideration of how modular pieces like the stacks 'measure' the distances between floor and ceiling. They are sent out into the town to specific locations to find examples of how windows and geometric division of facades can measure out buildings. There are two good examples that they easily find. Later they make another small expedition to take photographs of a Victorian terrace to compare with some of Judd's 'one-after-another' modular pieces.

One group of children is asked 'Why geometry?' They are given a map of the USA with its largely orthogonal divisions and one of Europe where national borders are determined on the whole by mountains and rivers. They have a panoramic photograph of the Arizona desert, aerial photographs of the prairies and Los Angeles with their grid organizations of fields and streets. They also find a photograph of a Ford assembly line, pictures of Judd's rigorously geometric installations at Marfa, Texas, reproductions of Native American geometric rugs and blankets which Judd admired, and a video of the film *Witness* starring Harrison Ford, from which they are asked to examine the sequence where Ford assists the Amish community in building the geometric structure of a barn, the symbol of their social cohesion and their ability to overcome adversity.[3]

The deliberate loading of tasks such as this is never disguised. Children and teachers know

something has been set up for them to tussle over and in most cases they rise to the challenge. The information provided should be tantalizing and substantial enough to leave space for speculation, further research and the formulation of intelligent hypotheses. The relationship between orthogonally organized America and geometric Judd is clearly not something to be presented as fact or as cause and effect. Nevertheless it enables children to explore some plausible possibilities for grounding abstract art in human activity and thought.

One pair of researchers discovers the carefully laid clue that Judd tended to use stock materials made in stock sizes and that, give or take a few inches, these correspond fairly closely to the arm-span of most adults – about 48 inches. They speculate reasonably that such dimensions were what one or two men could have carried in the days before fork-lift trucks. This provides a human framework for the wooden and metal boxes, and prompts them to consider the whole disposition of the gallery space in terms of human proportion. They return to school with the idea of looking further into the relationship between the human form, measurement and art.

The concept of modularity presents few difficulties. From an early age children start to deal with abstract concepts such as time and distance by learning that they can understand them in terms of identical modular, potentially interchangeable, units – seconds, minutes, hours, centimetres, metres, kilometres, and so on. When children are asked to express their journey to the Museum they eventually arrive at descriptions in which time or distance are the measurement.

Further questions about the different ways they can picture their journey – as a series of such units or as an arrangement of images, sounds and events of greater or lesser importance within the whole – bring them to consider notions of ordering and composing as discrete ways of thinking differently about the world. They compare a 'composed' painting – sometimes a Chardin still life, on other occasions a paper collage by Picasso or a Renaissance altarpiece – with a modular 'ordered' Judd piece. They explore and weigh up Minimalist notions of 'democratic' ordering, where each unit has nominally the same value, status and interchangeability, with 'European' hierarchical composition, where parts of varying importance are subservient to the greater whole.

Judd's interest in colour and machine-tooled finish prompts some children to a long and expert-ly informed consideration of the aesthetics of Japanese motor cycle stylings in relation to performance. Subsequently they take no hostages when subjecting the rolled aluminium boxes with their perspex inlays to a searingly critical evaluation based on the expertise they have gained in their school technology classes.

Discussion of Judd's work gives rise to lengthy considerations of different ways of thinking about the world and the extent to which ideas differ from age to age and from culture to culture. Some groups of older Key Stage 3 children compare the different philosophies which lie behind mass production and the handmade unique object and feel that both seem to co-exist in Judd's work: they observe that the chairs and some of the boxes follow the same pattern but are different in detail.

Some children want to know how the pieces on show are made. They can see they have been assembled and are interested to learn, from slides showing the installation of the exhibition, that the precision-made objects are carefully put together by a team of people working by hand and eye. One group happens to be in the gallery when Judd's fabricator passes through and he gives them a few minutes of first-hand information about Judd himself, why he let other people make his work, how much each piece costs to make and how much it is worth. This gives them additional frames of reference for thinking about the work.

An exhibition of Philip Guston's drawings[4] provides opportunities for examining subject matter genres, in particular still life and landscape. Both categories are taken for granted as being part of the art teacher's repertoire of activity. Many of Guston's images use the genre of still life in a particularly idiosyncratic and unusual way. They enable young people to examine alternatives to their established notions of groups of arbitrarily chosen objects tastefully arranged at some central point for observation, rendering and the measuring and improvement of technique.

Guston looked around him and put in his drawings what he saw in his studio or what he remembered from elsewhere. Sometimes he placed them in some outdoor location so that they became surreal figures in a landscape. His objects were the familiar bits and pieces which littered his studio – cigarette ends, kettles, shoes, bottles, irons – but because of the memories and knowledge of Jewish history he called on they are loaded with possibilities for interpretation which go deeper than their immediate appearance. Along with these contextual refer-

ences, the influence of comic book drawing styles (in which inanimate objects frequently come to life or where characters unsurprisingly perform physically impossible feats) and references to US political history in the sixties provide rich resources both for discursive exploration and for practical work.

The exhibition of Guston's drawings is shown in 1989 when schools are still able to release pupils and teachers from their time-table obligations for several days at a time without howls of protest from other subject teachers. The Museum organizes a five-day critical studies programme for fifteen Key Stage 3 children and their teachers.

The first morning is spent collecting information in the gallery, looking at the various phases of Guston's drawings but paying particular attention to the examples of still life. Later that day the group goes to a nearby scrapyard to collect reasonably portable bits and pieces that take their fancy and they supplement their collection by bringing in personal objects the following day.

All these objects are placed more or less at random around the Museum's Education Studio and on subsequent days the group go to work, selecting objects they want to draw and leaving out what does not appeal to them. Through a series of assignments the group considers approaches to still life which range through the significance and meaning they attach to the objects they choose, their anthropomorphic qualities and the meanings which can be constructed using different selections in their drawings. They work on a variety of scales from A2 to enormous wall and floor pieces of about four feet by six feet using charcoal and chalk and always against the clock. One of the subtexts of the project is to demonstrate how large-scale, vigorous work, which also engages the children with ideas, can be accommodated within the normal constraints of the school timetable structure. Every assignment, large or small, is completed within forty-five minutes.

The children in this group consider random juxtapositions of objects, in life and in art, and conscious arrangements. They think about how they arrange objects and possessions in their own rooms, whether they choose and place things deliberately or by chance or instinct. Some of them feel that arrangements happen 'unthinkingly'. They think about surprise and expectation, about why Guston represents so many of the elements in his images as entangled with one another. They are asked to consider how these ideas, and the way they are presently working, might affect the way they think about their own relationships with people and the world around them.

Work in the gallery with the Guston show routinely makes use of other examples of still life and landscape, using reproductions of work from available art history books. Examples range from Van Eyck's *Arnolfini Marriage* with its cameos of symbolic objects to Dutch *trompe l'oeil* painting, through Chardin and Cézanne, Picasso and Braque, Morandi, Richard Hamilton, Guston and Boltanski, though not in the chronological sequence set out here.

Actual objects are presented for examination and children are asked whether things are always just what they seem or whether they can acquire other meanings by association. Irons, toasters, apples, bottles and glasses, newspapers, Daz packets (a favourite of the school art room since the advent of Pop Art), shoes and, in the case of some groups, personal possessions brought from home for the occasion, are all discussed in terms of what associations they might call up beyond what they actually are. It becomes clear to some that still life and other subject matter genres can serve equally as vehicles for commenting on the world at large as they can be discrete subjects within the world of art.

Art after Physics,[5] a retrospective exhibition of the work of John Latham, includes early figurative work, semi-abstract relief paintings, conceptual pieces, abstract spray paintings and documentation of site specific and live works. Many children have a considerably better grasp of some of the scientific concepts than gallery staff and this presents opportunities for them to take greater control of their explorations, leading rather than following or being prompted. The variety of the work on show provides a rich forum for the discussion of what art can be and what assumptions can be made by artist and spectator.

Latham's autonomous declaration of northern slag heaps as works of art and his characterization of them as female receives considerable critical attention.[6] Many think it presumptuous and naïve to assert that people's lives can be improved merely by redesignating as a work of art something commonly held to be an eyesore. They wonder why Latham is so surprised and angry at the negative response of the local people he had not taken into his confidence. Photographs of Didcot Power Station, a local landmark, are shown as a means of comparison. Opinions vary. Many think the towers are ugly and almost all have an ecological opinion to express. Several children point out that,

in certain weather conditions or when large plumes of steam rise to the sky, the power station can take on a different aspect. They talk about it in aesthetic terms.

Many are intrigued with Latham's notion that a work of art is an event which evolves and acquires new meanings with each presentation and each visitor who stands before it. They are fascinated to learn that, far from being upset when a piece of plaster falls off one work during the installation at the Museum, Latham sees it as a development in the life of the picture and insists that it is left where it has fallen. The information that he often turns the pages of the singed books when pieces are exhibited in new locations sends the pupils off to peer at the textual offerings in more detail to see what is currently on offer.

Children are able to discuss and comment knowledgeably on the references Latham makes to process in his work. They appreciate the significance of his use of materials such as electrical transformers and the symbolism of the electrician's or plumber's conduit pipe. They puzzle over the singed books fixed in plaster and are asked what they understand by the expression 'cast in concrete'. They move on to debate how they themselves would give visual form to fixed ideas and give their opinions about Latham's success. Their attention is drawn to the types of book the artist uses and to the particular passages he has chosen to open them at. They notice that many are manuals or course books which give instruction or advice. Some wonder about the significance of what is burned away and can now never be known. They think of everyday examples, of things partially revealed and ponder the artist's decision to singe the pages rather than wholly destroy them by burning. Some realize that the power of symbols lies in their capacity to allude to a number of possibilities without ever quite stating any of them definitively.

They think Latham's word play with NOITs and SKOOBs is fun. They like the idea of subverting established order. They discuss ways in which the meanings of established relationships would be both revealed and changed by a reversal of roles or position.

Children at Key Stages 1 and 2 enjoy the way Latham uses materials. The qualities they ascribe to plaster come from their own experience of it in everyday use. They describe it as a mending material which can fill gaps or which, with simple reinforcement, can become a strong support for bro-

ken limbs but which is also brittle and impermanent. Their observations offer a useful route through which to explore concepts of metaphor, symbolism, and how change of use and context can alter meaning.

The ways in which we imagine and form ideas are approached through the metaphor of the conduit piping and electric cable which seem to move between objects in unexpected ways. The children's experience of formal school structures and the relative informality of other learning situations enables them to talk confidently about the difference between brick-by-brick incremental learning processes and non-linear modes of learning and thinking. They are able to see in the conduit piping (which appears in several works connecting diverse and apparently dissimilar parts) how the acquisition and transmission of ideas and feelings can be given visual form in ways which are at once clear and ambiguous. Several grasp that this area of ambiguity and uncertainty is what gives them, as spectators, the chance to have their own say in what is actually happening between them and the image in question.

Conclusion

Looking at art, whether in the art history book, the lecture hall or in the gallery, is a relational activity. Do we consider art as communication or do we communicate in the presence of art? We have to decide for ourselves the circumstances under which art counts but one thing is certain –just looking is seldom enough. We can be fascinated and enthralled by what we see but the excitement, fear, pleasure and wonder of sensation are retrieved and given meaning by the language we write or speak. Whatever our experience, we give voice to our thoughts and feelings.

There seems to be a widely held expectation in this country that children should love art and that art should be beautiful or concerned with beautiful things. Few reasons are advance for this expectation by its proponents. The genius of Michelangelo or Picasso is established and authenticated, their posthumous dedication to beauty beyond doubt.

To love art, however, is to risk ceasing to think and respond critically to it. To value art, on the other hand, is to locate it in relation to other cultural constructs. If children are encouraged to value art they adopt, in doing so, a critical stance towards it, its practitioners and its institutions. The

examination and contextualizing of art increases, rather than lessens, its mystery and fascination. The reconnection of art to the real worlds of people is to bring it down to earth in the most useful of senses.

These 'real' worlds are hedged about with qualifications. All spectatorship takes place under some form of regime – the exhibition programme, curatorial selection or display, the gallery building, its location and funding, the school classroom or the lecture-hall, the gallery workshop, the prevailing economic conditions, the cultural and political climate of the day, the operation of memory and the articulation of history. The circumstances under which we apprehend the art which is made in the world will always be affected or determined by one or several sets of conditions. We cannot always do much about the various forms of control but to be aware of their existence and of their agendas if they have them is to be able to evaluate their effect on us and what we look at.

We can regard them as prescriptions and limitations or, more constructively, as opportunities for thinking about the world in different ways. The agendas of artists, curators, educators, institutions, dealers, politicians, historians, and all the rest offer potentially intriguing angles from which to view the world we live in. They are the points by which we navigate our way through the world and find our position in relation to others. We may find that it is an ever varying one.

All spectators have the right to decide what to look at from what is available. Young people will only choose to incorporate art and its institutions into their worlds if they can detect intrinsic value which enables them to enjoy and consume art as they do other social products. This is not to suggest, as some do, that art galleries should adopt slick marketing ploys or Mickey Mouse approaches to education and exhibition programming. That really does betray a lack of confidence in the material. It is to reassert the conviction that art is a product of human circumstance and endeavour and will most readily reveal its currency through approaches to it which seek those connections out.

NOTES

1 Muafangejo, J., *I was Loneliness*, Museum of Modern Art, Oxford, 7 July – 29 September 1991.

2 *Donald Judd, Sculpture, Prints, Furniture, Architecture*, Museum of Modern Art Oxford, 15 January – 26 March 1995.

3 Richard Wentworth used this sequence as an example in a talk on Judd entitled *Fixing up America the orthogonal way*, 17 January 1995.

4 *The Drawings of Philip Guston*, Museum of Modern Art Oxford, 28 May – 23 July 1989, organized by the Museum of Modern Art New York.

5 John Latham, *Art after Physics*, Museum of Modern Art Oxford, 13 October 1991 – 5 January 1992.

6 *Niddrie Woman*, 1976.

7 During the installation of the exhibition Latham resprayed one piece lent by the Tate Gallery. He still considered it his work, despite having sold it. The Tate, on the other hand, was alarmed that the provenance of the picture had been changed.

ABORIGINAL ART

MICHELE TALLACK

INTRODUCTION

The richness and diversity of Aboriginal art provides an exciting, stimulating resource for teachers wanting to enable their pupils to understand and appreciate art 'from a variety of periods and cultures, Western and non-Western' or 'a range of traditions from a variety of times and places'.[1] Although in the western world interest in the art of the Aboriginal clans is a relatively recent phenomenon, Aboriginal art can provide pupils with access to one of the oldest, unbroken living traditions of art making in the world, traditions which archaeological evidence suggests are older than those of Europe. As Wally Caruana, Curator of Aboriginal Art at the National Gallery of Australia, Canberra, has pointed out, there is evidence of Aboriginal rock paintings having been produced in Arnhem Land in Northern Australia some fifty thousand years ago which makes them older than the earliest European examples of rock paintings at Altamira and Lascaux.[2] Caruana provides visual evidence to show that these traditions have been handed down over the centuries to the present time in the shape of a rock painting done in the 1960s by the Aboriginal artist Najombolmi. It could be argued, therefore, that on these grounds alone, on the basis of the antiquity and continuity of these art-making traditions, traditions which are not static, but which are still living and developing, Aboriginal art ought to be the focus of informed critical discussions in classrooms, galleries and museums.

If, however, informed critical discussion is to take place in classrooms and galleries or museums, if pupils are to be enabled to appreciate, enjoy and gain authentic knowledge and understanding of Aboriginal works of art, we have to identify the facts and issues that ought to inform such discussion. The question of what kind of facts we, as teachers, need to know in order to enable pupils to understand Aboriginal art is a complex one. An obvious way in for teachers is to familiarize themselves with the myths and legends that form most of the subject matter of the Aboriginal clans. This is relatively easy to research, being well documented by Caruana and other writers, including Howard Morphy in his seminal book on the Yolgnu people of North-east Arnhem Land.[3] What is less easy to identify are the range of issues that ought to be raised in discussions of Aboriginal works of art, issues related to the production and consumption of these works. As teachers, we have to identify questions that will provide a basis for discussions during which pupils not only learn a great deal about Aboriginal art, but will also engage in debate about important questions that relate to the ways in which we see, value and understand the works of art of cultures other than our own.

This essay addresses some selected key issues in order to try to provide a set of questions to be used

in discussions of Aboriginal art which might not only enable pupils to acquire a truthful and accurate picture of some of the facts and purposes which lie behind the creation of this art, but to acquire an understanding of the ways in which they ought to approach and think about it. The issues addressed will not in themselves provide a comprehensive list, or an exclusive list, of what should be considered and discussed in relation to the art of the Aboriginal clans but they are central to any analysis of Aboriginal art and some of them are issues and questions which could prove to be equally useful when seeking to understand the art forms of other non-Western cultures.

MUSEUMS AND GALLERIES: DISPLAYING & LABELLING OF NON-WESTERN OBJECTS 'ART' VERSUS 'ARTEFACTS'

The question of how much we can understand Aboriginal and other non-western works of art is to a certain extent related to what we already understand about art of other cultures. As members of a particular culture we will already have acquired, often subconsciously, ways of thinking about the art forms of other cultures which are derived from our education, our reading and to a large extent from ways in which such works of art are presented to us by museums and galleries.

For most of us, our first contact with non-western artefacts is through visits to ethnology museums or art galleries. The fact that non-western artefacts of the past can be found in these two quite different types of institutions, which have quite different purposes is, of itself, highly significant. It immediately raises the question of whether these objects are 'art' or 'artefacts'.

Most older non-western artefacts are still to be found in ethnology museums, museums designed to give information about cultures of the past. These objects were collected by anthropologists for whom they were significant in that they provided information on the lifestyles, religions, beliefs and practices of non-western peoples. The information provided by anthropologists that accompanies displays of these objects is factual, identifying the geographical locations in which they were found, their age, the materials of which they were made and describing the uses to which they were put.

The fact that non-western works of art are included in displays which are designed to show artefacts of the past, displays which are accompanied and explained by information based on data collected by anthropologists, can lead to problems. Pupils faced with such displays can acquire rather mixed messages as to the quality and value of the non-western works of art on show. When African or other non-western artefacts, which we call works of art, are included in collections designed to explain the lifestyles of peoples of past cultures and are presented alongside objects such as bows and arrows or flint arrowheads, this tends to suggest to pupils that the works of art are relics of peoples who were 'undeveloped' or 'primitive' and are therefore, 'crude' or 'less advanced' than western works of art. To compound this view, it must be remembered that many of the non western artefacts pupils are likely to see in ethnology museums would have been collected and given by nineteenth century anthropologists who would not have considered them to be art at all since they did not conform to the contemporary western standards for judging art. They would have regarded them as functional artefacts and would not have dreamed of offering them to an art gallery or museum.

Art galleries are generally perceived as having quite different functions from those of ethnology museums. They are seen as places where visitors go to enjoy and derive aesthetic experiences from beautiful or otherwise aesthetically satisfying objects. They are repositories of excellence, places where visitors expect to find 'quality' art, past or present. They do educate by telling us the functions that art had in different cultures, but that is not their primary purpose for most visitors.

Art galleries promote a different view of non-western artefacts, but one which is in some ways equally problematic. When major galleries started acquiring and displaying non western artefacts they were often displayed and labelled in ways which categorized them as 'fine art'. These labels reduced the factual information relating to the original functions of the objects, often just briefly locating them in a particular culture and time. By so doing art galleries de-contextualized these objects and redefined them as fine art according to western canons. Not unnaturally, many visitors to art galleries today apply these canons when judging the non-western objects on display; canons which incorporate western notions of what constitutes 'fine art' and ideas about aesthetic 'quality'.

One of the most important reasons why non-western artefacts acquired this change of status, and why, in the twentieth century, wealthy private collectors and directors and curators of major art

galleries and museums began to value these objects as art and to build up collections came about because, in the first decade of the twentieth century, major western artists appropriated them and used them as stimulation for their own work. Picasso and many other western modern artists 'discovered' non-western objects in ethnology museums and used them for their own purposes, and in so doing, they changed westerners' perceptions of them. Non-western artefacts started appearing in art galleries and became perceived and labelled as art, not by the people who made them, but by those who had collected them.

The question of whose perceptions are being conveyed by museums and galleries and what kind of information ought to accompany exhibitions of such objects has, of recent years, been hotly debated and continues to be debated today. A famous example of the artefact versus art controversy was the series of exchanges which took place in *Artforum* in 1984–5 over the prestigious *'Primitivism' in 20th Century Art* exhibition at the Museum of Modern Art in New York (MoMA) in 1984. Thomas McEvilley, Professor at the Institute for the Arts, Rice University, Houston, criticized the way in which non-western artefacts were presented in this important exhibition which had been mounted to show how modern western artists had used such objects as stimulation for their own work. The displays juxtaposed non-western artefacts with works of art created by major twentieth-century western artists and presented the western and non western objects as fine art. McEvilley argued that the non-western objects were not intended by their makers to be seen as 'art' since the intention behind their making was 'shamanic.'[4] McEvilley argued that these objects were originally made for religious and ritual purposes not for aesthetic reasons and maintained that MoMA ought to have provided anthropological information about the original purposes and functions of these objects and about the intentions of the makers. He argued that the objects had been de-contextualized and displayed in ways which reflected the point of view of western modernist art historians who valued them for their own reasons in aesthetic terms, as art objects, but that the artisans who had made them would have quite different perceptions of them maintaining that:

> If you or I were a native tribal artisan or spectator walking through the halls of MoMA we would see an entirely different show from the

one we see as 20th century New Yorkers. We would see primarily not form, but content, and not art, but religion or magic.[5]

Professor William Rubin of MoMA responded by arguing that it would not have been appropriate to give anthropological information alongside the non-western objects since the aim of the exhibition was to de-contextualize these artefacts and to show how they had been re-contextualized within western culture; and that was what the exhibition was all about. The aim of the exhibition was to show how western artists had used such objects as stimulation for their own work. Rubin defended presenting these objects as art on the grounds that the makers were not only making religious objects, they were craftspeople and artists too. He accused McEvilley of denying these cultures 'the fact of their art and their great artists.'[6]

This debate highlights the 'ethnology museum' versus 'art gallery' issue. Had the non-western artefacts been seen in an ethnology museum they would have been seen in a way which was quite different from the way they would have been viewed by visitors to MoMA. For Rubin and the other organizers of the exhibition, the non-western artefacts were meant to be seen as art which was equal in quality to that of the western 'greats' they stood alongside. For McEvilley, divorcing them from their contexts gave visitors to the exhibition an erroneous view of them.

Rubin's argument that the non-western artefacts had been re-contextualized within western culture was valid in that they had been re-contextualized by the western fine artists who, by using them as sources for their own 'fine art' had changed westerners' perceptions of them. Thus, to western eyes, the non western 'artefacts' metamorphosed into 'fine art objects'. It is almost certain that the artisans who had produced them would have had no such concept and what McEvilley was raising was the question of how the creators of these objects would have liked them to be viewed. A question, in view of their antiquity, since most of them were nineteenth-century if not earlier in origin, that could never be answered.

At the heart of this problem is the fact that, until fairly recently, most older non-western artefacts on show in the west were de-contextualized by being removed from their original locations, separated from their original functions and relocated within the context of western institutions whose purpose was to educate. They acquired new

purposes and the language used to label and explain them was related to these new purposes.

Today, a great deal of non-western artefacts are presented as art, are exhibited in galleries and museums as works of art and many contemporary non-western makers and producers are starting to call themselves artists. This has not lessened the 'fine art' debate, however. If anything it has intensified even though we can now ask the makers directly about the functions and purposes of their works. One of the major reasons for the intensification of the debate is that non-western works of art are sold in an international art market organized and run mainly by non-producers to meet the needs and desires of major art galleries and private collectors. The values and perceptions of these exhibitors and their customers are often significantly different from those held by the makers.

With reference to Aboriginal art, Howard Morphy points to the fact that many museums and galleries, in Australia and elsewhere, select works which are then displayed as Aboriginal 'fine art'. He argues that this is a definition arrived at not by the producers but by the consumers in that:

> The paintings and sculptures that fit into the Aboriginal fine art category are defined as fine art not by the producers but by their final purchasers; by the collectors, art gallery curators, trustees dealers and expert consultants associated with the fine art world.[7]

Following the trend established earlier with African and other non-western art forms in western galleries, Aboriginal art, too, has changed its status with its recent move into art galleries. Morphy shows that this placing of Aboriginal art within the realm of fine art is a recent phenomenon in that until recently Aboriginal paintings were:

> primarily classified as ethnography (or very occasionally as 'primitive' art), exhibited in natural history museums, and written about as anthropological data.[8]

In his chapter on 'Art for Sale', Morphy describes how Aboriginal art has grown in status and value since the early 1970s, how major art galleries have increased their collections and how the art market has discovered and is promoting Aboriginal art with works by leading Aboriginal artists selling for prices equal to those commanded by white Australian artists.[9]

This means that the criteria for judging Aboriginal art are established by the gallery/dealer networks. In 1990 in a paper given at a workshop in Canberra organized by the Australian Institute of Aboriginal and Torres Strait Islanders Studies (AIATSIS) and funded by AIATSIS and the Aboriginal and Torres Strait Islanders Commission (ATSIC) entitled 'Marketing Aboriginal Arts in the 1990s', Vivien Anderson, Director of a major fine art gallery in Melbourne, in her paper 'Private Galleries' defended the 'fine art' judgements used by her gallery in their selection of works by 'quality' aboriginal artists. She argued as follows:

> It is in fact every commercial gallery's right to develop their own exhibition policy that best fits the eclectic tastes of the directors and the clientele. At Deutscher Brunswick Street we believe that by exhibiting black and white Australian art, we can validate our view that Aboriginal art is as much part of the pictorial history of this country as white art.[10]

While this seems a legitimate concern, showing respect for the diversity of cultures in Australia, it could be read as legitimizing Aboriginal art, in effect saying it is 'as good as' white Australian art, since the terms 'fine art' and 'quality' are key terms in the range of labels habitually used by art historians, curators and gallery owners to label and describe western or white Australian works of art which are perceived to provide models of excellence. Non-Aboriginal terminology and concepts are being applied to Aboriginal works of art. Furthermore, all the emphasis is on catering for the tastes of the directors and gallery clientele, whose tastes and preferences clearly dictate what should be exhibited.

The issue is not whether Aboriginal art or other non-western art forms ought to be exhibited in public or private galleries. The issues which perhaps ought to be debated with pupils are: who is selecting the works; what kind of criteria are being used and how the works are presented to the public, that is to say, us, and our pupils.

'PRIMITIVISM', 'PRIMITIVE' AND 'EXOTIC'

In the west many terms are commonly used which are indicators of ways in which we perceive and evaluate non-western works of art. Two terms which are frequently used in discussions of non-western works of art are the terms 'primitivism' and 'primitive'. Both terms can lead to problems

particularly when, as is often the case, they are used interchangeably.

In relation to the term 'primitivism' McEvilley in his discussion of the MoMa exhibition pointed out that:

> in the context of Modern art 'primitivism' is a specific technical term; the word, placed in quotation marks in the show's title; designates Modern work that alludes to tribal objects or in some way incorporates or expresses their influence.[11]

McEvilley is applying the term in a way which it is generally applied by art historians and museum curators to certain kinds of works by twentieth-century western artists. There are, however, other ways of applying it. The Concise Oxford Dictionary defines 'primitivism' as 'belief in superiority of what is primitive'. In relation to the term 'primitive' the Dictionary defines 'primitive' in a variety of ways including the somewhat pejorative 'undeveloped, uncultured, at an early stage of civilization.'

So if we, or our pupils, applied both terms to a non-western artwork we might see it, rather confusingly, as superior because it was the product of an undeveloped, uncultured, possibly uncivilized people. This has, in fact, often happened in the past. From the eighteenth century onwards there has been a distinct strand in western taste which valued and admired so called 'primitive' art because it was perceived as being fresh or unsophisticated as the product of peoples who were closer to nature and by implication, untainted by progress. This same trend in taste ascribed value to non-western works of art on the grounds of their 'exotic' qualities, because they looked 'different'. This somewhat patronizing view is still evident today. Morphy has shown that whilst some non-Aboriginals compared Aboriginal art unfavourably to figurative western fine art because of its differences, these differences were perceived as being of value by others who saw them as 'exotic'.[12]

Ought one to judge non-western works of art on this basis? Judgements of this kind are clearly not aesthetic in character, but are based on notions of 'difference' which ascribe value to works of art on the basis of whether or not they fit certain ideas about what art ought to look like. It could be argued that to judge Aboriginal art solely on the grounds of its 'difference' or its 'exotic' qualities in effect devalues it because such a judge-

ment does not take into account important criteria such as whether its form is satisfying, complex, beautiful, or whether it displays a high degree of skill. It does not take into account its meaning, the significance it had to its maker, or the effect the maker intended it to have on the viewer.

These terms are often used loosely in connection with non-western art forms without careful thought as to what they are actually indicating. The term 'primitive' is particularly dangerous if misapplied. Too often it has generated false perceptions and understandings about the quality and value of non-western works of art, whether Aboriginal or otherwise. The issue of the terms we use to label and describe such artworks is a crucial one in that such terms lead to ways of viewing and valuing them which are not only false, but can actually undermine the very aims that underpin the use of non-western works of art in art education.

Part of discussions that take place with Key Stages 2 and 3 pupils about Aboriginal and other non-western art forms ought to focus on how they were seen in the past, why they are presented in galleries and museums they way they are, why the language we use to discuss them has to be carefully chosen and on the issue of culturally-determined ways of seeing, that is to say on the central problem that our perceptions of such artforms might not be shared by the people who make them.

How Aboriginals View Their Art

Howard Morphy has given a thorough and extensive analysis of the ways in which Aboriginal works of art are perceived, understood and valued. He outlines the numerous ways in which the art of the Yolgnu, the people of North-east Arnhem Land, is viewed by non-Aboriginals and the ways in which the Yolgnu themselves view their works of art. He also describes some of the ways in which some perceptions can change over time. Morphy points to a range of what he calls 'frames' or ways of seeing Aboriginal art, defining a 'frame' as: the encompassing set of cultural practices and understandings that defines the meaning of an object in a particular context.'[13]

He shows that Aboriginals and non-Aboriginals (Europeans and white Australians) use a variety of 'frames' which operate at different levels and are connected in complex ways. Some of these 'frames' are quite divergent.

For Aboriginals, their art not only gives them an identity in that it defines which clan they belong to, it defines their relationship to their traditional lands and represents sacred knowledge which is part of their inheritance handed down from generation to generation. It tells them about their clan, their relationship to sacred ancestral and supernatural beings, and defines their roles and duties as members of their clans. As Caruana explains:

> It is by the acquisition of knowledge, not material possessions, that one attains status in Aboriginal culture. Art is an expression of knowledge, and hence a statement of authority. Through the use of ancestrally inherited designs, artists assert their identity, and their rights and responsibilities. They also define the relationships between individuals and groups, and affirm their connections to the land and the Dreaming.[14]

Elsewhere Caruana defined the all-important Dreaming as follows:

> The time of creation is known as the Dreaming. The Dreaming is more than an account of the genesis of the universe; it encompasses the power of the ancestral beings, which is constantly tapped and renewed in ceremony and in art by their descendants. The supernatural beings, the events and places associated with them and the things they created form the great themes of Aboriginal art.[15]

For Aboriginals art is a vehicle through which the power and knowledge of the ancestral beings, the creators, is handed down to the clans. So art is a vital part of a clan's inheritance, without which it cannot survive. As Morphy points out:

> Paintings are part of the ancestral (wangarr) inheritance of clans. They are as much the property of clans as the land itself. They are not so much owned as integral to the very existence of the clan.[16]

The transmission and handing down of this sacred knowledge and power through art, means that art production becomes a sacred trust, surrounded by rituals and rules which safeguard the clan's inheritance. So for the Yolgnu:

> Painting is a ritual act surrounded by rules and restrictions on who can paint which design in what context and who can see which design where.[17]

An Aboriginal artist inherits the right to depict certain subjects in certain ways according to established rules. Therefore, although an artist can be said to have the right to use the stipulated designs, these can only be used by that artist and cannot be used by artists in other clans. An artist cannot use the designs that belong to other clans unless related to them in some way. This is, in effect, a copyright law. George Milpurrurru, an artist from central Arnhem Land, spelled this out clearly in a taped interview with John Mundine, an expert on central Arnhem Land art and artists, in 1987:

> I am Ganalbingu, and if someone wants to use one of our madayin (sacred designs) or pictures they have to ask me or Johnny Bulun Bulun or Bobby Bununggur, all these Ganalbingu people, for licence. But I can paint the Oenpelli python, Nawarran, because the Dreaming belongs to my wife's people. I have to get licence from them.[18]

For many clans, access to sacred knowledge was the prerogative of men so paintings were handed down as part of male initiation processes. In the Yolgnu, boys are given limited rights to certain kinds of designs and learn by watching their fathers paint. As they get older they learn more designs and thus acquire more knowledge. Designs can be altered by individuals subject to certain regulations. There are, as Morphy has outlined, complex systems of giving access to different kinds of sacred knowledge some of which are more important than others. Some designs are severely restricted in that they represent crucially important sacred knowledge to which only full initiates may gain access. Some knowledge is public and available to all.

Morphy points out that in the Yolgnu women and uninitiated men are only allowed access to certain kinds of public knowledge but that a man will gradually be allowed access to the restricted forms 'until eventually he learns all he can of those aspects of sacred law that he has rights in.'[19] However, the taboos surrounding the role of women in relation to art production are being gradually eroded. After being excluded for generations from 'inside' knowledge, in many clans today women can and do act as artists and become known to non-Aboriginals as such. Morphy points out that in the case of some Yolngu clans, women are increasingly becoming involved in paintings associated with ceremonies which hitherto formed

part of 'inside' knowledge which was the property of male members of clans.[20]

The secret knowledge is also protected by the way in which individual components of a work of art, lines, circles, etc. can have several meanings, some of which may be public, others restricted. While public or 'outside' meanings may be divulged to non-initiates, others will be concealed:

> The deeper and more religiously significant 'inside' meanings are privy to only those who have the proper ritual standing. The Aboriginal elders divulge only the superficial 'outside' interpretations of designs to those not initiated to receive the deeper meanings. Thus, ritual knowledge which is so important to Aboriginal culture, is protected and not dissipated – for knowledge, not material objects, is the essential property of Aboriginal culture.[21]

These facts about how the Aboriginals view their art raises some important issues of which pupils need to become aware.

Firstly, since, until recently, much of their art was not created to be hung in galleries and museums but was part of socialization processes and the product of clan history, rituals and beliefs which were handed down through the generations. Should such older works which are clearly related to secret rituals be placed in museums or galleries at all? Does this in effect, through dissemination, weaken the ancestral inheritance of the clans?

Secondly, the fact that, until recently, many Aboriginal clans excluded women from access to the sacred 'inside' knowledge embodied in clan designs, raises important gender related issues. Pupils should be made aware of this and it might be useful for teachers to compare this situation with gender issues connected with the history of art in the West.

Thirdly, strict 'copyright' rules applied by clans about art making, use of designs, content of designs, and those who are allowed to see certain designs, are still in force today. There are complex levels of meaning of which some are highly secret and may not, in any circumstances, be divulged to outsiders. Do we, as westerners, therefore, have the right to try and gain access to these meanings? Should we not accept that we shall always be excluded by Aboriginal law from fully understanding this culture? Should we not, at the very least, give pupils an opportunity to discuss the way in which our desire to obtain factual information conflicts with the desire of Aboriginals to protect their secret knowledge; give pupils an opportunity to debate both points of view, to balance our western desire for information in order to understand and value, against the equally strong desire of Aboriginals to uphold ancient laws in order to safeguard their interests?

Underpinning this key issue is the question of the extent to which our own cultural conditioning will prevent us from obtaining a full understanding of Aboriginal art. The question as to whether we or our pupils can ever hope to understand fully works of art which are the products of peoples whose beliefs, values, history and development differs radically from our own. It is difficult enough for us in the twentieth century to get inside the minds and hearts of art-makers and their audiences of previous centuries even when we are their cultural descendants; difficult for us to see their art in the way they saw it, because the world we inhabit is vastly different from the world they inhabited. How much more difficult it would be, therefore, if not impossible, to try to become Aboriginals, to try and take on board their stored collective memories, experiences, attitudes and beliefs in order to engage fully with their art. Would it not be a kind of arrogance for us, or our pupils, to even try to take over in its entirety the cultural inheritance of these peoples?

DIVERSITY AND NEW DEVELOPMENTS IN ABORIGINAL ART

Another issue derived from the way in which we tend to view the arts of non-western cultures, is that we tend to make generalizations about them. For many non-Aboriginals, Aboriginal art means dots, circles and patterns. This limited view ignores the wide range of art forms and objects produced by the Aboriginal clans. There are important differences between the art forms of different clans which must be taken into account. To say that Aboriginal art is all about dots and circles is like saying that all western art looks like the ceiling of the Sistine Chapel. This reduction of Aboriginal art to a few formal elements ignores the fact that just as there is a wide variety of Aboriginal clans in the vast continent of Australia, so is there a wide variety of art objects and art forms produced by these clans. Luke Taylor has shown that in West Arnhem Land, which he points out is a region of rocks, caves and cliffs, there are numerous examples of rock paintings

showing large animal or human figures. He shows how the artists of the region paint the natural species which inhabit their lands, using 'x-ray' details, showing the interior parts of the bodies, the organs and the skeletons of the animals (Plates 7, 8):

> The artists of West Arnhem Land are unique amongst their contemporaries in employing powerful and animated natural figurative forms. The anatomical contours of the subject are crisply drawn against the red of the background, while the interior of the figure vibrates with dots or contrasting patterns of cross-hatched coloured lines.[22]

Even within a region there are differences as Caruana points out:

> In West Arnhem Land, bark paintings tend to feature naturalistic images against a plain ground, while the use of geometric designs covering the entire painting surface is more prevalent toward the east.'[23]

Caruana also points out that, in the case of the Tiwi people who lived on the isolated Melville and Bathurst Islands, their isolation has led to the development of customs and artforms that differ significantly from those of mainland clans. Caruana points out that not only is matrilineal inheritance part of the Tiwi social structure, but that women are involved in sacred ceremonies and art-making. He also shows how the wooden poles called tutini which feature in Tiwi Pukumani mortuary rites, rites which relate to their own genesis legends, were carved and decorated and used as grave markers and led to the development of their main art form, painted figurative sculpture showing key figures from creation legends (Figures 5 & 6).[24]

One has only to compare these Tiwi sculptures with the most well-known artform of the great central and western deserts, the large ground paintings of lines and circles painted using organic pigments directly onto the soil to see how the geographical location of a clan affects its art production. Anthony Forge has shown that these ground paintings relate specifically to their desert location in that:

> The central deserts of Australia are vast and have been inhabited for millennia by Aborigines who lived at a very low population density moving over the land. The products of the land were their sole resource and its surface, their primary icon.[25]

Forge has shown that these ground paintings relate to rituals associated with creation myths focusing on ancestor-beings who emerged and journeyed over the deserts:

> Stated very simply one of the purposes of ritual is to open up the surface of the land and tap the creative power of the still-existent Dreaming. In the most important male rituals this is done by elaborate and beautiful paintings on the ground at the correct sites where ancestors had emerged or acted. These ground paintings re-create the creation.[26]

For those who see Aboriginal art as fixed and static, ossified by tradition and custom into ordained unchanging forms using traditional techniques, desert painting provides a salutary lesson. One of the great contemporary success stories is the way in which ephemeral desert painting changed its character and became accessible to a wider audience. The events surrounding the development of desert ground paintings in the 1970s are well known and documented by Caruana, Forge and others. It happened at the Papunya desert settlement, when desert artists encouraged by Geoffrey Bardon, an art teacher at the school in Papunya, started using hardboard, canvas and synthetic paints. Their previously ephemeral ground- and body-paintings became transformed into portable permanent images painted on boards and canvases.

Forge has shown how, after going through a 'Europeanized' period when the artists started using non-traditional animalistic and figurative elements, many of the artists returned to the elements of their traditional ground paintings, fusing traditional elements of circles, lines and dots, the dots having become more prominent and numerous than previously, to recreate their lands on board and canvas (Plate 9). Forge goes on to say that by the 1980s the best of these large scale works were by desert artists using non-Aboriginal materials to paint decidedly traditional subjects, using iconography handed down through centuries:

> ...the great dramatic and overwhelming paintings of the 1980s are all those that use European materials but no aspect of European vision–they are formed totally by evolving Aboriginal artistic conventions. They are painted with the canvas laid on the surface of the earth and they are of the surface of the earth. They are both maps and icons...[27]

Because Aboriginal art consists of traditional designs handed down as an inheritance through

the generations, there is a great danger that it could come to be seen by pupils as static, unevolving, outdated and irrelevant today. Nothing could be further from the truth. Not only do many Aboriginal artists use modern western materials, but some artists today use their art to make contemporary political statements; to restate their position within the rapidly changing contexts of Australian life.

For example, Aboriginals use their art to make political statements about their hereditary rights respecting their tribal lands. The Aboriginal artist Galarrwuy Yunupingu puts it this way:

> When we paint...we are painting as we have always done to demonstrate our continuing link with our country and the rights and responsibilities we have to it. Furthermore, we paint to show the rest of the world that we own this country, and that the land owns us. Our painting is a political act.[28]

He goes on to say that non-Aboriginals don't realize this, or choose to ignore this political dimension of clan works of art.

Aboriginal artists are increasingly using their art to make political statements, not just about land ownership, but about the effect European settlement has had on the indigenous peoples of this continent. In 1988 many Australians celebrated the two hundred years that had elapsed since the continent was opened up to Europeans. The Bicentennial celebrations aroused mixed feelings with many Aboriginals and some non-Aboriginals boycotting the celebrations. Forty-three Aboriginal artists responded by producing a major public art-work 'The Aboriginal Memorial', consisting of two hundred log coffins, now on permanent exhibition in the National Gallery of Canberra.

In Arnhem Land log coffins are used to re-bury the bones of the deceased in a ceremony which takes place some time after a person dies. During a complex ceremony the bones are placed in a hollowed log which is painted with the clan designs of the deceased. The log is then placed upright and acts as a memorial to the deceased. John Mundine, who has acted as art adviser and agent for Aboriginal communities in Arnhem Land for many years, points out in a booklet explaining the installation that the 1988 'Aboriginal Memorial' made up of two hundred such hollow logs is in effect a forest which is a war memorial:

> Each hollow log is ceremonially a Bone Coffin, so in essence the forest is really like a large cemetery of dead Aboriginals, a War Cemetery,

a War Memorial to all those Aboriginals who died defending their country. Two hundred poles were commissioned to represent the two hundred years of white contact and black agony.[29]

The nearest western equivalents of this memorial are the tombs to unknown soldiers across the western world commemorating the fallen in the two world wars. 'The Aboriginal Memorial' makes a telling statement about the impact of European colonization on Aboriginals. It also re-affirms the ongoing presence of the Aboriginal clans and the continuing relationship they have with the land. The placing of bones in hollow logs acts as a symbol of rebirth. The dead are returned to the lands from which they emerged and become part of the eternally renewed life cycle of nature itself. Through this artwork, as Mundine points out, the Aboriginal peoples are saying: 'The forest, the environment is us; we are the environment.'[30]

This art-work, therefore, operates on several levels. It acts as a sobering reminder of Aboriginal history, it restates the rights of the Aboriginal clans to ownership of their lands and it acts as an expression of faith in beliefs that go back thousands of years. Through this installation, these clans show that Aboriginal art, whose traditions go back thirty thousand years or more, is still alive, strong and capable of adapting to circumstance, producing statements which are relevant to contemporary life.

Some Aboriginals today use their art for political purposes, others use it to comment on the extent to which traditional Aboriginal ways of living have changed or to reflect the outcomes of intermarriage between Aboriginals and non-Aboriginals. Many Aboriginals now live in Australian cities, having abandoned traditional ways of living on the land and having become absorbed into urban life. Others have married non-Aboriginals and their children have acquired the values and traditions of two cultures. As a result, some contemporary urban Aboriginal artists fuse European and Aboriginal artistic traditions in order to produce exciting, innovative works that make clear statements about their relationship to two cultures.

Such an artist is Trevor Nickolls born in Adelaide in 1949, of an Aboriginal mother and a father of English-Irish descent, who has worked since the late 1960s in the major Australian cities of Melbourne, Darwin, Sydney and Canberra. His works contain references to the works of key western artists, such

as Giotto, which he often fuses with traditional motifs and styles of Aboriginal bark paintings.

Nickolls's work is predominantly landscape-based and is, as Ulli Beier points out, largely auto-biographical. Beier's 1985 monograph on the artist shows how he produces contrasting idyllic rural, and considerably less than idyllic urban scenes. How, in his 'Garden of Eden' 1982, he uses a traditional western subject to portray an Aboriginal ancestor-being, Adam, living in harmony with a European ancestor-being Eve; the figures placed within an idyllic Aboriginal Eden landscape, flat and patterned using the dots, circles and motifs of Aboriginal art; whilst in 'Dollar Dreaming' of 1984, he shows a vision of people 'encapsulated in their urban cubicles'.[31]

It is clear that there are references in 'Dollar Dreaming' to the tensions that Nickolls experiences inhabiting and working within two cultures. As Beier points out, the large dollar sign which is also a Rainbow serpent, dominates the work. What Beier doesn't say is that the Rainbow Serpent is a key ancestor-being in Aboriginal creation myths and as an image has very specific meanings. Luke Taylor, in his essay on West Arnhem Land art and artists referred to above, describes how Yingarna, the Rainbow Serpent, the original creator-being of the West Arnhem Land territory, is mother to all species as well as being, through the metaphor of swallowing and regurgitating, a symbol of transformation and rebirth.[32] In this work Yingarna, fuses with the western ancestor being, the dollar, to become a composite symbol representing two cultures. This dual ancestor-being not only appears to swallow and devour its urban children, but the two ancestor-beings appear to be engaged in a battle for supremacy resulting from the meeting of antipathetic ways of living. It is unclear which ancestor-being will succeed in swallowing the other, or what kind of society will emerge from this regurgitation and transformation process.

Nickolls draws on two cultures, two sets of artistic language, to create images which are clearly twentieth century in content and form. Aboriginal art has always been about the art makers' relationship with the environment. With Nickolls it could be argued, only the environment has changed; the relationship with it is still the important factor, a fact he seemed to acknowledge when he said: 'All artists should relate first to their own environment and that means that all Australian artists must in some way relate to Aboriginal art.'[33]

Nickolls deliberately locates his work within western 'fine art' traditions. He sees himself not as an Aboriginal artist, but as an Australian artist who draws on Aboriginal traditions, and as such was one of two Aboriginal artists who represented Australia at the 1990 Venice Biennale.

It is important for pupils to understand that not only is variety an important aspect of Aboriginal art but that living art forms change and alter over time as the circumstances and lifestyles of their makers change; that an art that is strong develops and alters as its makers come into contact with new influences. It is not a question of whether modern Aboriginal art is less good than more obviously traditional earlier art forms because it is less 'different' from western art forms; it is a question of enabling pupils to understand that Aboriginal art is part of a world history of art, a history within which the art of different cultures has constantly acted as a spur and impetus to the development of new art forms.

CULTURAL PLUNDERING

It has been shown above how cultural plundering has taken place in the past when non-western artefacts have been taken out of context and placed in museums where they have been wrongly labelled, and that it can also take place when we demand access to the secret knowledge embedded in certain Aboriginal works. It is also important for pupils to come to see how non-western art forms can be subject to cultural plundering by larger and more powerful cultures. With the growth of interest in Aboriginal art and tourism, Aboriginal motifs have been applied to all kinds of objects by non-Aboriginals. The Aboriginal artist Djon Scott-Mundine has shown that not only are Aboriginal artists being pressurized to produce to order to 'fulfil the wishes of white buyers' but that the 'whites appropriating Aboriginal styles and designs to fill the demand shortfall' are in effect committing a crime:

> Market growth has often led to what I call 'the second crime'. Having taken away the land, children and lives, the only thing left is identity through art and now this also is being abused.[34]

Non-Aboriginal artists and craftspeople have been using traditional Aboriginal motifs and designs for years. Roland Black showed that thirty and more years ago white artists were enthusiastically turning to Aboriginal art for inspiration. Black cites, amongst a list of non-Aboriginal artists, the exam-

ple of Byram Mansell, the self-styled 'originator of the Australian school of painting', who believed that modern Australian painters should take the traditions of Aboriginal art to produce an authentic Australian school of art.[35]

Pupils could debate the numerous issues raised by this 'taking over' of the art forms of the indigenous peoples of Australia, for this 'taking over' extends to all kinds of art and design objects, many of which are made for the tourist market by non-Aboriginals. Some Aboriginals have responded by creating works of art for the tourist market, works which are carefully authenticated in their labelling and accompanying documentation. However, a significant proportion of mass produced tourist goods are produced not only by non-Aboriginals but in countries other than Australia, an example of cultural plundering in the interest of profit which not only takes traditional motifs and designs away from the clans which own them, but deprives them of much needed income. This is clearly an issue which pupils who may become tourists and, therefore, consumers in the future, should be made aware of since it applies not only to Aboriginal art, but to many non-western art forms across the world that have become popular with tourists.

As outlined in the beginning, this essay seeks to pinpoint some of the issues which ought to be addressed in relation to Aboriginal art and to provide frameworks for discussion of Aboriginal works of art. The issues raised about where pupils will see such works of art, who obtained them, how they are labelled and described and the purposes that lie behind their display and labelling, are issues which are common to art of all non-western cultures, as are the issues of the language we use to talk about them.

The ways in which Aboriginals see their art and the related issue of what they want, or don't want, us to know and see is a crucial one if we are to encourage pupils to show proper respect and understanding of cultural needs. Whilst the Dreamings and their attendant rules relate specifically to Aboriginal art, other non-western cultures have their own rules and taboos which are often ignored by westerners.

The issue of women having been excluded from art-making is also important in that, in the history of art, women have been excluded in most cultures to a lesser or greater degree from art-making activities. This has been as much a fact of western art production as it has of non-western art production. Pupils should not assume that this custom was exclusively an Aboriginal one. The issue of diversity and development is again one which can be applied to the works of art of many non-western cultures. We need to broaden and deepen our understanding of Aboriginal and other non-western cultures, so that we and our pupils avoid damaging generalizations which prevent us from respecting the rich diversity of the arts of these cultures. We need to break away from the notion that all non-western art is to be found in ethnology museums; to understand that in many parts of the world traditional art forms are still being used and developed to create new living contemporary art.

The issue of what happens when non-western cultures meet western cultures is a crucial one. Such meetings can produce rich, exciting re-workings of traditional imagery or lead to cultural plundering which at best trivializes, or at worst destroys, a non-western artform.

Aboriginal art can provide an important means whereby pupils can progressively acquire knowledge about a particular culture, gradually deepening their understanding of it over the years. Key Stage 1 pupils can start by learning the stories and legends and examining the ways in which they are represented. Key Stage 2 pupils can build on this by relating those legends to the lifestyles, customs and beliefs of the Aboriginal clans and can begin to address, in a small way, some of the issues outlined above. In Key Stage 3 the issues need to be opened up so that by Key Stage 4 students will be able to apply a framework for understanding and questioning the production and consumption of Aboriginal art which will give them a comprehensive understanding of it. Once acquired, this framework, or sets of questions and ways of understanding can be adapted and applied to the arts of other non-western cultures. It is only through the acquisition of such frameworks that pupils will be enabled to gain an authentic and truthful understanding of the arts of these cultures.

NOTES

1 *Art in the National Curriculum*, 1994, pp.4–6.

2 Caruana, 'Aboriginal Art', 1993, p.7.

3 Morphy, H., 'Ancestral Connections – Art and an Aboriginal System of Knowledge', 1991.

4 McEvilley, T., 'Doctor Lawyer Indian Chief: 'Primitivism' in 20th Century Art' at the Museum of Modern Art in 1984', in *Artforum*, November 1984, p.55.

5 McEvilley, ibid, p.59.

6 Rubin, W., 'On Doctor Lawyer Indian Chief: 'Primitivism' in 20th Century Art at the Museum of Modern Art in 1984', letter, *Artforum*, February 1985, p.45.

7 Morphy, 1991, p.22.

8 Morphy, 1991, p.28.

9 Morphy, 1991, pp.23–8.

10 Anderson, V., 'Private Galleries' in Altman, J. and Taylor, L. eds, 'Marketing Aboriginal Art in the l990s', 1990, p.45.

11 McEvilley, 1984, p.55.

12 Morphy, 1991, p.28.

13 Morphy, 1991, p.21.

14 Caruana, 1993, pp.14–15.

15 'Windows on the Dreaming – Aboriginal Paintings in the Australian National Gallery', 1989, Caruana, 1989, p.9.

16 Morphy, 1991, p.57.

17 Morphy, 1991, p.21.

18 Transcribed and included as 'Bark Painting – a Personal View' in Caruana, ed., 'Windows on the Dreaming – Aboriginal Paintings in the Australian National Gallery', 1989, p.20.

19 Morphy, 1991, p.75.

20 Morphy, l991, p.198.

21 Caruana, 1989, p.10.

22 Taylor, L., 'West Arnhem Land – Figures of Power' in Caruana, 'Windows on the Dreaming – Aboriginal Paintings in the National Gallery of Australia', 1989, p.22.

23 Caruana, 1993, p.25.

24 Caruana, 1993, pp.85–8.

25 Forge, A., 'The Desert Tradition in the Present', in Caruana, ed., *Windows on the Dreaming – Aboriginal Paintings in the National Gallery of Australia*, 1989, p.153.

26 Forge, op..cit., p.152.

27 Forge, op.cit., pp.151–3.

28 Yunupingu, G., 'The Black/White Conflict', in Caruana, op.cit., p.14.

29 Mundine, J., *Aboriginal Memorial*, 1988, Ramingining Arts.

30 Mundine, op.cit.

31 Beier, U., *Dream Time – Machine Time – The Art of Trevor Nickolls*, 1985, p.60.

32 Taylor, 1989, pp.24 and 30.

33 Beier, op.cit., p.28.

34 Scott-Mundine, D., 'Cultural Sustainability and the Market', in J. Altman and L. Taylor (Eds) *Marketing Aboriginal Art in the 1990s*, pp.51–2.

35 Black, R., *Old and New Australian Aboriginal Art*, 1964, pp.134, 135.

BIBLIOGRAPHY

ANDERSON, V. (1990) 'Private Galleries' in Altman J., and Taylor, L., (Eds) *Marketing Aboriginal Art in the 1990s*, Aboriginal Studies Press, Canberra.

BEIER, U. (1985) *Dream Time – Machine Time – The Art of Trevor Nickolls*, Robert Brown and Associates (Aust) Pty. Ltd., and Aboriginal Artists Agency Ltd.

BLACK, R. (1964) *Old and New Australian Aboriginal Art*, Angus and Robertson Ltd, Sydney.

CARUANA, W. (1993) *Aboriginal Art*, Thames and Hudson.

CARUANA, W., ed. (1989) *Windows on the Dreaming – Aboriginal Paintings in the Australian National Gallery*, Ellsyd Press.

DES (1994) *Art in the national curriculum (England)*, HMSO.

FORGE, A., 'The Desert – Tradition in the Present', in Caruana, W., op.cit.

MCEVILLEY, T. (1984) 'Doctor Lawyer Indian Chief – 'Primitivism' in 20th Century Art at the Museum of Modern Art in 1984', *Artforum*, November 1984.

MILPURRURRU, G., 'Bark Painting – a Personal View', in Caruana, W., op.cit.

MORPHY, H. (1991) *Ancestral Connections – Art and an Aboriginal System of Knowledge*, University of Chicago Press.

MUNDINE, J. (1988) *Aboriginal Memorial*, Ramingining Arts.

RUBIN, W., 'On 'Doctor Lawyer Indian Chief: 'Primitivism' in 20th Century Art at the Museum of Modern Art in 1984', Letters, *Artforum*, February 1985.

SCOTT-MUNDINE, D. (1990) 'Cultural Sustainability and the Market' in Altman, J., and Taylor, L., (Eds) *Marketing Aboriginal Art in the 1990s*, Aboriginal Studies Press, Canberra.

TAYLOR, L., 'West Arnhem Land – Figures of Power' in Caruana, W., op.cit.

YUNUPINGU, G., 'The Black/White Conflict' in Caruana, W., op.cit.

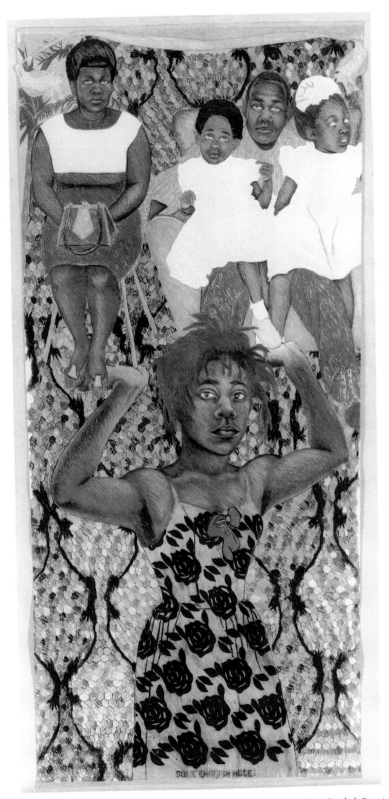

1. Sonia Boyce, *She ain't Holding Them Up, She's Holding On (Some English Rose)*, pastel and crayon on paper, Cleveland County Arts and Museums.

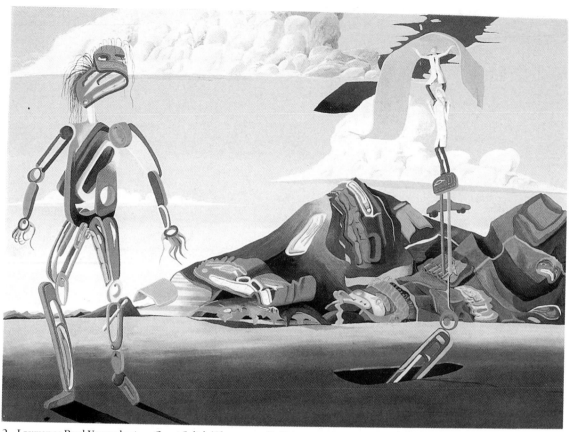

2. Lawrence Paul Yuxwelupton, Coast Salish/Okanagan, *Red Man Watching White Man Trying to Fix Hole in Sky*, © the artist.

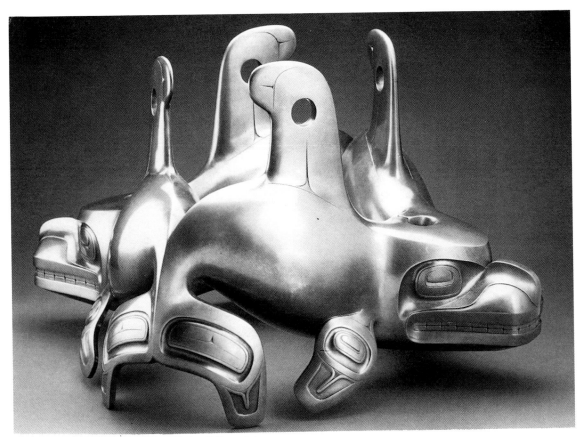

3. Robert Davidson, Haida, *Killer Whales*, © the artist.

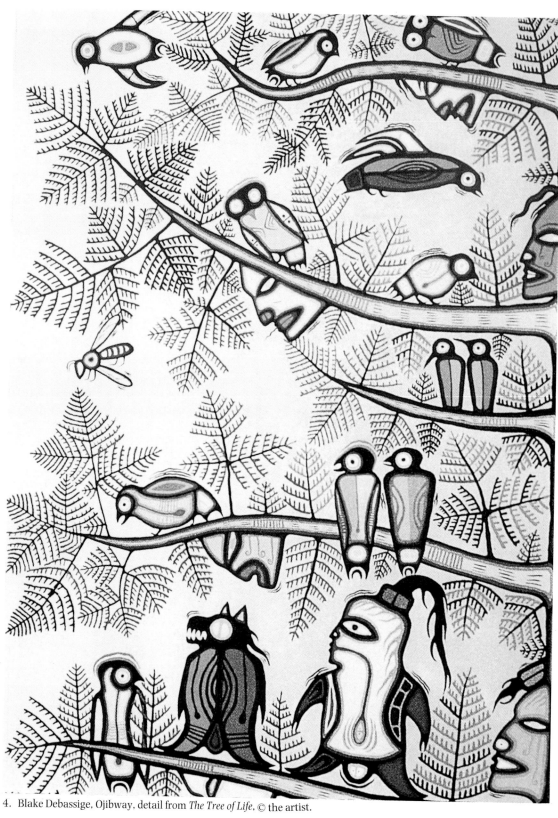

4. Blake Debassige, Ojibway, detail from *The Tree of Life*, © the artist.

5. Donald Judd, *Untitled*, 1989, exhibited at the Museum
of Modern Art, Oxford.

6. Donald Judd, installation view, Museum of Modern Art,
Oxford.

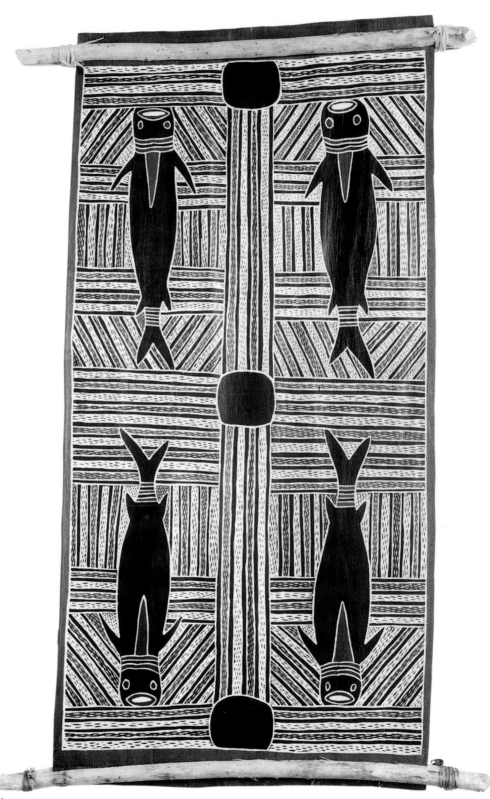

7. Bark painting, ochre on tree bark, Rebecca Hossack Gallery, London.

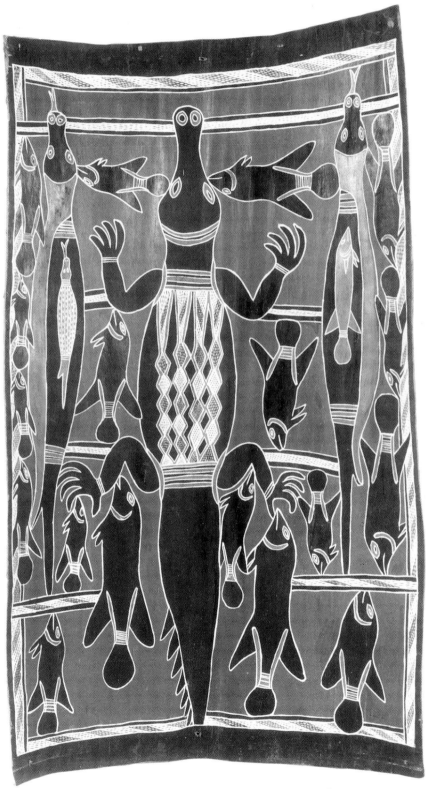

8. Bark painting, ochre on tree bark, Rebecca Hossack Gallery, London.

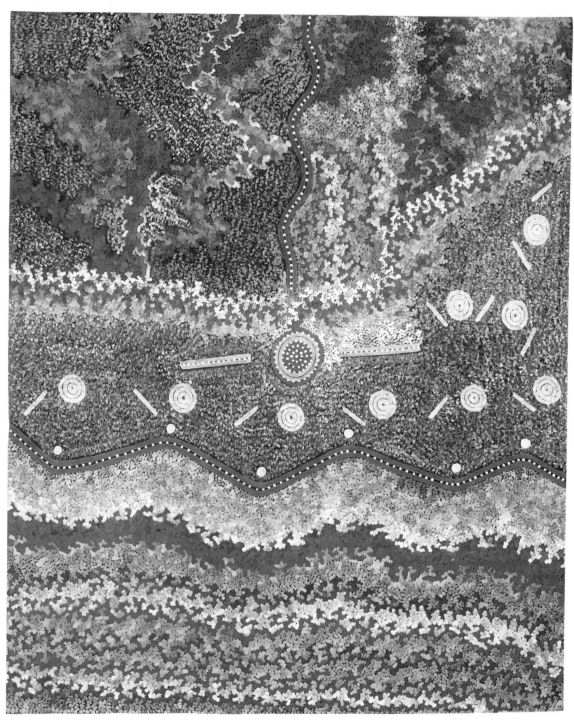

9. Maxie Tjampitjnpa, *Water Dreaming at Watalpunya*, synthetic polymer paint on canvas, National Gallery of Art, Canberra.

THE NON-SOVEREIGN SELF (DIASPORA IDENTITIES)

GORDON BENNETT

The starting point of critical elaboration is the consciousness of what one really is, and is 'knowing thyself' as a product of the historical process to date, which has deposited in you an infinity of traces without leaving an inventory.

Antonio Gramsci[1]

From the start I wish to establish that I am writing as a single individual and not as some may have anticipated a representative of the entire 'Australoid race'. I do not intend to present any evidence of my authenticity nor to build any particular position on the grounds of any ethnic essentialism. Rather, I would ask that I be understood as a person who for many years has been struggling against simplistic binary codes of categorization and identification that tend to polarize identity into black and white opposites.

THE VOYAGE OUT

The issues of my life and art were established before I was born. The processes of colonization in Australia deposited me in a situation beyond my control. The forces of official 'Assimilationist Policy' (adopted 1951), were thrust upon my mother as a young woman living at Cherbourg mission, euphemistically called a settlement, but actually a type of 'holding' camp in which aborigines were placed after being forcibly removed from their land.[2] Grace Bradley grew up as an orphan

from the age of two. She never knew her own mother and father or her mother's country, language or customs as all cultural manifestations of the various Aboriginal groups present at Cherbourg were officially forbidden. Grace is reluctant to talk of her life at the dormitory, a home for young girls and women, but has told me a little of the raids on garbage bins, and on the superintendent's orchard where she and the other children would go to supplement the dormitory diet, and of the practice of shaving girls' heads for punishment. At the dormitory domestic science school, my mother was taught domestic skills and was sent to work for a white middle class family. After proving that she could live successfully with white people for a period of three years, she was able to secure an official permit to leave the mission. She went to live in the nearby town of Monto and managed to secure a job as a domestic at a local hotel. While working at the hotel, she met my father, an Englishman working as a foreman electrical linesman for a large British construction company contracted by the Queensland Government.

The process of assimilation into the dominant colonial culture of Euro-Australia was completed over at least three generations of my mother's family. The experiences of my great-grandmother and grand-mother may never be known, but it is a fact of my life that this process of assimilation was

completed by my mother and inherited by me. My upbringing was overwhelmingly Euro-Australian, with never a word spoken about my Aboriginal heritage. I first learnt about Aborigines at primary school as part of the social studies curriculum. The history I was taught was the history of colonization. A school history primer, written in 1917, reads in its opening passage:

> When people talk about 'the history of Australia' they mean the history of the white people who have lived in Australia. There is a good reason why we should not stretch the term to make it include the history of the dark-skinned wandering tribes who hurled boomerangs and ate snakes in their native land for long ages before the arrival of the first intruders from Europe ... for they have nothing that can be called history. They have dim legends and queer fairy tales, and deep-rooted customs which have come down from long, long ago: but they have no history, as we use the word. When the white man came among them, he found them living just as their fathers and grandfathers and remote ancestors had lived before them ... Change and progress are the stuff of which history is made: these blacks knew no change and made no progress, as far as we can tell. Men of science may peer at them and try to guess where they came from, how they got to Australia, how their strange customs began, and what those customs mean; but the historian is not concerned with them. He is concerned with Australia only as the dwelling-place of white men and women, settlers from overseas It is his business to tell us how these white folk found the land, how they settled it, how they explored it, and how they gradually made it the Australia we know today.[3]

By the 1960s, when I began primary school, very little had changed. It was not until 1967 that Aborigines were even given the right to be counted in the national census as Australian citizens; this was accomplished through a national referendum. At school I learnt that Aborigines had dark brown skin, thin limbs, thick lips, black hair and dark brown eyes. I did drawings of tools and weapons in my project book, just like all the other children, and like them I also wrote in my books that each Aboriginal family had their own hut, that men hunt kangaroos, possums and emus; that women collect seeds, eggs, fruit and yams.

The men also paint their bodies in red, yellow, white and black, or in featherdown stuck with human blood when they dress up, and make music with a didgeridoo. That was to be the extent of my formal education on Aborigines and Aboriginal culture until art college in 1986.

I can't remember exactly when it dawned on me that I had an Aboriginal heritage. I generally say that it was around the age of eleven, but this was my age when my family returned to Queensland after eight years living in the southern state of Victoria, and Aborigines were far more visible in Queensland. I was certainly aware of it by the time I was sixteen years old after having been in the workforce since leaving school at fifteen. It was upon entering the workforce that I really learnt how low the general opinion of Aboriginal people was. As a shy and inarticulate teenager, my response to these derogatory opinions was silence, self-loathing and denial of my heritage. I could find nothing with which to identify with Aborigines or Aboriginal culture. I withdrew into books, mostly science-fiction, thereby indoctrinating myself into the narratives of exploration and colonization as projected into the future of the vast human diaspora; or so the story goes.

The dominant myth of Australia was the history of exploration and colonization; the spirit of the explorer, the pioneer, and the settler was a spirit in which all Australians could share. Such was the unproblematic sense of national identity I was taught to believe in; this may be seen in the light of the first of two ways of thinking about 'cultural identity' that Stuart Hall identifies in 'Cultural Identity and Diaspora', albeit the antithesis to the essentially black experience being described. This Australian identity that so effectively colonized my mind and body was presumed to be a white experience. Informed as it was by the colonial diaspora of an essentially western culture, it was nevertheless, a similar kind of homogeneous, collective 'one true self' that Stuart Hall defines as,

> ... hiding inside the many other, more superficial or artificially imposed 'selves', which people with a shared history and ancestry hold in common. Within the terms of this definition, our cultural identities reflect the common historical experiences and shared cultural codes which provide us, as 'one people', with stable, unchanging and continuous frames of reference and meaning, beneath the shifting divisions and vicissitudes of our actual history.[4]

As I have stated elsewhere,[5] the realization of my Aboriginal heritage created a rift in my sense of identity. I had never thought to question my identity, and I had never thought to question the narratives of colonialism upon which my sense of 'Australianness' had been predicated. Neither had I thought to question the representation of Aborigines as the quintessential primitive Other against which the civilized 'collective self' of my peers was measured. Aborigines are imagined by white Australians within a powerful and seemingly inescapable whirlpool of 'civilization' and 'savagery' which engages European representations of Aborigines in a type of tautology. Being a negative transgressive image of civilization, the grotesque formulation of the 'savage' lacks any positivity – whether paraded in the masks of the noble, comic, or ignoble. All are found in the same exotic places and with the same dark skin-expressions of the same semiotic formula by which the colonized have another's struggle for identity thrust upon them.[6] My personal experience of this phenomenon led to a feeling of complete alienation from my peers. My house in the outer suburbs of Brisbane became a fortress from which I would venture out into a world in which I felt I didn't belong. I would spend some twenty minutes each morning in meditation just to reassure myself that I was confident and intelligent enough to face a day on the 'outside'; I was later diagnosed as suffering from a mild form of agoraphobia. I think what was happening to me is best articulated by Adrian Piper when she writes:

> Blacks like me are unwilling observers of the forms racism takes when racists believe there are no blacks present. Sometimes it hurts so much we want to disappear, disembody, disinherit ourselves from our blackness. Our experiences in this society manifest themselves in neuroses, demoralization, anger, and in art.[7]

By the time I had reached the age of thirty, and after fifteen years in the workforce, I felt that I couldn't take it any more. I bailed out. I applied to art college and was accepted under the 'mature age' student programme. Art had been my best subject at school, all those long years ago. I needed a way out of my life situation and art was to be the key to unlock the door.

THE VOYAGE IN

At art college I somehow felt that I belonged. It was a haven, a world of ideas, theories and concepts ranging from the chemical structure of paint to the socio-psychological and political structure of culture itself. It was the humanities electives that interested me most of all; communication theory and art history, which, I duly noted, positioned the rock art of 'primitive' man as its foundation progressing through the Renaissance to Modernism, were compulsory subjects for the first year. However, it wasn't until my Post-Modernism elective in the second year that I really understood the full implications of what art college could mean for me.

I found the information I was absorbing liberating. I use the word 'absorbing' purposely in order to establish a point on my relationship to theory. My interest in theory is the foundation of my art, but I soon found that I could not verbalize my intuitions and understanding of the theories to which I was being exposed. I could write well enough to impress my teachers, but to talk theory was just beyond me; I was still that inarticulate teenager who had retreated into a crippling silence many years before. In a sense I felt disconnected from the physical world where speech was the primary mode of communication. I felt too deeply inside myself, and yet paradoxically outside myself at the same time, to be able to articulate verbally what any particular theory meant to me. In a way I was like one of Frantz Fanon's race of 'angels', and indeed I came to use the image of an 'angel of colour', wounded by white shafted arrows, as a signifier of a wounded human spirit long before I had heard of Fanon.[8]

I found the language in which I was most articulate to be the visual language of painting. After all, I had come to art college to be an 'artist', and although my preconceptions of an artist were quite romantic at first, I had never intended to be a theorist, or an academic per se. Post-Modernism was but one of my second year electives. I did two other electives in that year, Art Therapy and an unusual elective called, Personal, Interpersonal and Creative Development. The next year I chose as my electives Aboriginal Art and Culture, and Classicism. The Aboriginal Art and Culture elective opened my mind to the complexity and sophistication of the many and varied indigenous Australian cultures, part of which was my own heritage; but which part? I didn't feel comfortable with depicting x-ray fish or kangaroos, which were certainly valid expressions for people closer to their traditions than I was. I wanted to get in touch with my 'Aboriginality', if only to heal

myself, but to paint fish and kangaroos and the like would have been like painting empty signs of this thing called 'Aboriginality'.

Aboriginality, I soon discovered, was an ephemeral thing, something that could not be adequately pinned down to a set of particular characteristics, although many people, both black and white, still try. I see one of its manifestations as a kind of strategy, born out of a necessity, to conceive a collective indigenous Australian identity, that is in its essence not white. This was supposed to give someone like me something seemingly solid to cling onto, a kind of life-raft to keep from going under. I was told by many Aboriginal people that Aboriginality is in the heart. I interpret this as an underlying 'truth' that cannot be verbalized, save to say that it is an essence of shared experience, of pain and of loss and of the struggle to maintain human dignity in the face of a colonial onslaught that, as Fanon observed:

> ... is not satisfied merely with holding a people in its grip and emptying the native's brain of all form and content. By a kind of perverted logic, it turns to the past of oppressed people, and distorts, disfigures and destroys it.[9]

There are sound strategic reasons for investing in essentialist versions of Aboriginality because, in many ways, it's all we have; while white Australia has all the material and institutional support. However, I would contest the concept of Aboriginality as being nothing more or less than a strategic logocentre for whatever purposes such a stratagem may be gainfully applied.[10] While I would concede that a strategic logocentre may be one of the manifestations that Aboriginality can take, I would also point to this kind of essentialist identity as being the objects of what Fanon once called a

> ... passionate research ... directed by the secret hope of discovering beyond the misery of today, beyond self-contempt, resignation and abjuration, some very beautiful and splendid era whose existence rehabilitates us both in regard to ourselves and in regard to others.[11]

While I do not wish to underestimate the importance of such an essentialist identity, I began to realize a certain kind of trap that I was falling into. Everything I knew about Aborigines, everything I was finding out about my heritage in my art college elective on Aboriginal Art and Culture, was filtered through a European perspective, through

the canons of Anthropology and Ethnography: those 'men of science' who peered at Aboriginal people and made judgements based on an assumed cultural superiority predicated on such binary definitions as Civilized and Savage, Self and Other. Euro-Australian power, knowledge and Aborigines, I soon realized, were mutually constitutive – they produce and maintain one another through discursive practices which have become known as Aboriginalism.[12]

Aboriginalism has been characterized by an overarching relationship of power between colonizer and colonized. This renders Aborigines as inert objects who have been spoken for by others. Furthermore, Aboriginalism essentializes its object of study; Aborigines are manufactured in ontological or foundational terms as an essence which exists in binary opposition to non-Aborigines, and which is not subject to historical change.[13] The so-called 'mixed bloods' or 'detribalized remnants' have been considered unworthy of serious anthropological consideration since they lacked the prestige attached to the classic field-work enterprise which typically involved living intimately for one or two years with people who are isolated from the modern world.[14]

The traditionalist studies of Anthropology and Ethnography have thus tended to reinforce popular romantic beliefs of an 'authentic' Aboriginality associated with the 'Dreaming' and images of primitive desert people, thereby supporting the popular judgement that only remote 'full bloods' are real Aborigines.[15] Aborigines are thus still being cast and recast as the living embodiment of the 'childhood of humanity', that which is the evidence of the progress of history and of western culture. Today popular primitivism enforces an expectation for contemporary Aboriginal subjects to display or to demonstrate evidence of their authenticity, either by asserting an essentialist position (I am Aboriginal), or by being knowledgeable (I know everything about the kinship systems of Arnhemland), as if Aboriginal culture were some kind of endowment.[16] Furthermore, such expectations are based on a myth of an Aboriginal culture that is both static and homogeneous, which is none other than the reified binary Other of the hidden 'norm' that is white and western.

Aboriginality is no life-raft for me. It remains too problematical to identify with and leave unquestioned. After all, it was this very same problem of identification that drove me to bail out of my life in the suburbs in the first place, and I

wasn't about to provide a foil for anyone to affirm that colonial identity I myself had rejected. I decided that I was in a very interesting position. My mind and body had been effectively colonized by western culture, and yet my Aboriginality, which had been historically, socially and personally repressed, was still part of me and I was obtaining the tools and language to explore it in my own terms. In a conceptual sense I was liberated from the binary prison of self and other; the wall had collapsed, but where was I? In a real sense I was still living in the suburbs and in a world where there were very real demands to be either one thing or the other. There was still no place for me to simply 'be', (utopia can be very lonely). I decided that I would attempt to create a place by adopting a strategy of intervention and disturbance through my art.

At first my painting was characterized by an overt expressionism informed by theory. My first interest in a theoretical basis for my painting came from theories on the grotesque as well as postmodern theory and strategies of appropriation. I quoted in an essay at the time a passage from *The Critical Idiom: The Grotesque* by Phillip Thompson:

The characteristic impact of the grotesque, the shock which it causes, may be used to bewilder and disorient the spectator, jeopardize or shatter their conventions by opening up onto vertiginous new perspectives characterized by the destruction of logic and regression to the unconscious-madness, hysteria or nightmare. Thus the spectator may be jolted out of accustomed ways of perceiving the world and confronted by radically different and disturbing perspectives.[17]

I did a painting in early 1988 that depicted a decapitated Aboriginal man standing over Vincent van Gogh's bed, with blood streaming skywards to join with the vortex of Vincent's starry night. It was exhibited at the inaugural Adelaide Biennial of Australian Art in 1990. I was subjected to a racist verbal attack in a crowded Adelaide restaurant after the opening by a woman who stated that she 'could not handle' my painting. At first I was devastated and returned to my hotel, but later I decided that this attack was at least evidence that a painting can have an effect. However, by this time I had already moved towards a cooler, more overtly conceptual approach, although one which retained elements of the grotesque as a strategy of 'Turning Around'.[18] I say this in response to a statement by Ian MacLean which reads:

The grotesque was the only aesthetic with which (colonial) Europeans could accommodate the Aboriginal presence; and Aborigines found that they were only able to be heard from within such an aesthetic.[19]

In the Aboriginal Art and Culture elective at art college, I also learnt something of the hidden history of colonial Australia, of the outrageous violence perpetrated in the name of 'civilization'. Through the reading lists I discovered such historians as Henry Reynolds who, far from being the kind of historian described in the 1917 school history primer, was interested in addressing the imbalance of Australian history by describing life on the other side of the frontier.[20] Reynolds also acknowledges the contribution made by Aboriginal people to the exploration and development of Australia, information that was also new to me.[21] The year was 1988, Australia was in the grip of Bicentennial celebrations. Aboriginal groups declared a year of mourning, I started to use illustrations out of old social studies and history textbooks in order to intervene in the seamless flow of images that I believed were reinforcing the popular sense of an Australian colonial identity.

I didn't want to destroy this mythic identity, which would have meant endorsing some kind of replacement; in any case I am not naive enough to think that painting alone could do that. What I had in mind was to create a field of disturbance which would necessitate re-reading the image and the mythology. For example, I focused on perspective because its discursive underpinning of the colonialist field of representation exposed the ideological framing of the observing subject and the observed object within a Eurocentric power structure. By disrupting this field of representation, I hoped to implicate the observing subject in the production of meaning, not in order to affirm the subject but in order to stimulate thought and the possibility of exceeding the historical parameters that frame it. This project has formed the basis for my art practice since graduating from art college at the end of 1988.

Since graduating I have sought to expand my methods of disturbing and disrupting the field of pictorial reproduction, as well as trying to avoid any simplistic critical containment or stylistic categorization as an Aboriginal artist producing 'Aboriginal Art'. I have felt frustrated at times, perhaps because I am impatient to be accepted on terms that may not have come into being as yet.

One of my long-term goals for my work is to have the paintings returned to the pages of the text books from which many of them originated, where they may act as sites for a new kind of knowledge. This is, I believe, starting to happen in a limited way, at least in the art curriculums. If I am pessimistic about ever living in such a new world myself, I hold a deep hope that maybe my daughter or her children might. Until then I take comfort in knowing that I am far from alone in my explorations of the possibilities for change I believe to be inherent in the kind of hybridity that Stuart Hall describes in 'Cultural Identity and Diaspora', and which Homi Bhabha refers to in 'The Third Space'.[22]

I would like to conclude with a quote by Bain Attwood from his introduction to *Power, Knowledge and Aborigines*:

> The domain of Aboriginal Studies has ... started to change in theoretical terms. Two interrelated developments can be pinpointed. First, Aborigines are viewed as socially constructed subjects with identities which are relational and dynamic rather than oppositional (in the binary sense) and given. This challenge to essentialism and the teleological assumptions embedded in Aboriginalist scholarship involves historicizing the processes that have constructed Aborigines, thus revealing how Aboriginal identity has been fluid and shifting, and above all, contingent on colonial power relations. This approach necessarily involves a new object of Knowledge – Ourselves, European Australians, rather than Them, the Aborigines – and this entails a consideration of the nature of our colonizing culture and the nature of our knowledge and power relations to Aborigines.[23]

This means opening up 'the locked cupboard of our history' where the crimes we have 'perpetrated upon Australia's first inhabitants' have lain hidden, and coming 'to terms with the continuing Aboriginal presence'.[24]

NOTES

1 Gramsci, A., *The Prison Notebooks: Selections*, trans. and ed. Q. Hoare and G. Howell Smith, International Publishers, New York, 1971, p.324.

2 Rowse, T., 'Strelow's Strap', *Power, Knowledge and Aborigines*, B. Attwood and J. Arnold eds, La Trobe University Press in association with the National Centre for Australian Studies, Monash University, 1992, p.101. 'Up to 1950 ... [the] process of gradual erosion [of indigenous authority] had been limited by serious deficiencies in the financial resources required to curb and repress Aboriginal culture effectively: ... But with official adoption of the so-called Assimilation Policy by the Commonwealth Government in 1951, the nation's resources were, as it turned out, largely used to engage very considerable staffs of Welfare Officers so that a paternalistic system of control could be instituted over all Aboriginal populations under direct Administration control.' (Strelow, *Geography and the Totemic Landscape*, pp.106–7)

3 Murdoch, W., *The Making of Australia: An Introductory History*, Melbourne, 1917, p.9. This was one of a series of Australian history school books written by Murdoch. The others were entitled *The Struggle for Freedom* and *The Australian Citizen*. The first chapter of *The Making of Australia* is called 'The Unknown Continent', and facing the title page is a drawing of Cook landing at Botany Bay and raising the British flag.

4 Hall, S.,''Cultural Identity and Disaspora', *Identity: Community, Culture and Difference*, J. Rutherford (ed.), Lawrence & Wishart, London, 1990, p.223.

5 Bennett, G., 'Aesthetics and Iconography: An Artist's Approach', *Aratjara: Art of the First Australians*, exh.cat., Kunstammlung Nordrhein-Westfalen, Dusselfdof, 1993, pp.85–91.

6 MacLean, I., 'Colonials Kill Artfully', *Papers on Academic Art: Papers of the Art Association of Australia*, vol. 3, P. Duro (ed.), Canberra, 1991, p.60.

7 Lippard, L., *Mixed Blessings: New Art in a Multicultural America*, Pantheon Books, New York, 1990, p.43. See also Piper, A., 'Flying' in *Adrian Piper*, New York, Alternative Museum, 1987, pp.23–4.

8 Fanon, F., 'On National Culture', in *The Wretched of the Earth*, Penguin Books, London, 1963, p.176, as quoted by Stuart Hall, op.cit., p.226.

9 Fanon, p.170, as quoted by Hall, op. cit., p.224.

10 Mueke, S., 'Lonely Representations', *Power, Knowledge and Aborigines*, op.cit., p.42.

11 Fanon, p.170, as quoted by Hall, op.cit., p.223.

12 Attwood, B., in the introduction to *Power, Knowledge and Aborigines*, op.cit, p.ii.

13 Attwood, ibid, p.xi.

14 Cowlishaw, G., 'Studying Aborigines', *Power, Knowledge and Aborigines*, op.cit, p.24.

15 Cowlishaw, ibid., p.25.

16 Mueke, op.cit., p.40.

17. Thompson, P., *The Critical Idion: The Grotesque*, London, Metheun, 1972, p.13.

18 Lippard, op.cit., pp.199–242, (Irony, humour, and subversion are the most common guises and disguises of those artists leaping out of the melting pot into the fire. They hold up mirrors to the dominant culture, slyly infiltrating mainstream art with alternative experiences – inverse, reverse, perverse. These strategies are forms of tricksterism, or 'i Go Tlunh A Doh Ka' –Cherokee for 'We Are Always Turning Around ... On Purpose' –the title of a 1986 travelling exhibition of American Indian artists organised by Jimmie Durham and Jean Fisher. Those who 're always turning around on purpose'are deliberately moving targets, subverting and 'making light' of the ponderous mechanism set up to 'keep them in their place').

19 MacLean, op.cit., p.64.

20 Reynolds, H., *The Other Side Of The Frontier: Aboriginal Resistance To The European Invasion Of Australia*, Penguin Books, Australia, 1982.

21 Reynolds, H., *With The White People: The Crucial Role of Aborigines in the Exploration and Development of SAustralia*, Penguin Books, Australia, 1990.

22 Hall, S., 'Cultural Identity and Diaspora', and Bhabha, H., 'The Third Space', in *Identity: Community, Culture and Difference*, op cit.

23 Attwood, op cit, p.xv. One should note, however, that much Australian Anthropology remains 'cautious, conservative and ... basically unfashionably empiricist' (J. Morton, 'Crisis, What Crisis?: Australian Aboriginal Anthropology, 1988', *Mankind*, vol.1, 1989, p.7), although some innovative work exists, eg. J. Beckett (ed.) *Past and Present*, Morris, *Domesticating Resistance*, J. Marcus (ed), *Writing Australian Culture: Text, Society and National Identity*, a special issue of *Social Analysis*, No.27, 1990. Furthermore, while the ingredients of a post-Aboriginalist History are evident in the historiography of the last two decades or so, there is little sign of well theorized and well executed work of this nature, but see Bain Attwood's *The Making of the Aborigines* and K. Newmann, 'A Postcolonial Writing of Aboriginal History', *Meanjin*, vol.51, no.2, 1990, pp.277–98. (For helpful discussion of post-Orientalist history, see G. Prakash, 'Writing Post-Orientalist Histories of the Third World: Perspectives from Indian Historiography', *Comparative Studies in Society and History*, vol.32, no.2, 1990, pp.383–408.) And in prehistoric archaeology there has been little change in reconceptualising Aboriginality, but see T. Murray, 'Tasmania and the "Dawn of Humanity"', *Antiquity*, forthcoming, for a consideration of this.

24 Smith, B., *The Spectre of Truganini*, Sydney, 1980, pp.10, 44, as quoted by Attwood.

THE EDUCATION OF YOUNG ARTISTS AND THE ISSUE OF AUDIENCE

CAROL BECKER

Within the dominator system, art has been organized around the primacy of objects rather than relationships, and has been set apart from reciprocal or participative interactions.

(Gablik, 1991, p.62).

As an educator who has weathered the censorship battles of the last five years, I have been forced to rethink the repercussions of the art world's isolation and to consider how we who are involved in training the next generation of artists might begin to incorporate into this process a fundamental concern for the particularities of audience and the placement of art work within a societal context.

Because these deeper questions about the relationship of the artist to society and the conflict between the artist's sense of art and the general public's sense of art have not been adequately addressed by the art world or within the art school environment, a cavernous rift has developed. Work which artists find unproblematic and barely controversial seems blasphemous, pornographic, or mean-spirited to those outside, while art which artists hope will be an interesting and even welcome challenge to society is often met with little or no response. In such ill-fated interchanges, the audience has often believed that artists were being unnecessarily obscure or confrontational at the same time that artists have felt misunderstood and unappreciated. The result has been mutual disappointment and hostility. In part the serious debates artists are now engaged in, in their work, remain hidden to those still caught within the conventional notions of what art will do, what it will be, how far it can go, what subject matter it should address. In our inclusion or exclusion of such discrepancies within the educational process, we directly influence the art-making practices of the next generation of artists and the place they will be able to assume within a democratic society – either encouraging our students' engagement with a larger arena or perpetuating the isolation which has allowed art to become a vulnerable subject of narrow-minded attacks.

To understand why most art which grapples with serious issues generates hostility in non-art-world viewers, it is important to characterize the conventional Western expectation of what function art will serve, and to understand how far this expectation is from the intention of most contemporary art work. At the core of such a discussion must be the concern with conventions of beauty –

that experience of pleasure so many have come to associate with the phenomena of art.

'An uncanny inversion of values'

(Steinberg, 1972, p.13)

The often unconscious expectations of a non-art-world, non-visually-trained audience are that art will be somewhat familiar yet also transcendent, that it will be able to catapult its viewers outside their mundane lives, provide therapeutic resolution to emotional ills and, most significantly, that it will end in wonder. In an article titled 'The repression of beauty', psychologist/philosopher James Hillman (1991) provides a useful understanding of the desire for beauty and of its emotional effect on the organism.

When you see something exquisite, Hillman writes, so much so that it arrests motion,

> You draw in your breath and stop still. This quick intake of breath, this little hshshs as the Japanese draw between their teeth when they see something beautiful in a garden – this *aha-hah* reaction is the aesthetic response just as certain, inevitable, objective and ubiquitous, as wincing in pain and moaning in pleasure. Moreover, this quick intake of breath is also the very root of the word aesthetic, *aisthesis* in Greek, meaning sense-perception. *Aisthesis* goes back to the Homeric *aiou* and *aisthou* which means both 'I perceive' as well as 'I gasp, struggle for breath ... *aisthmoai, aisthanomai*, I breathe in'. (p.63)

Many still bring this traditional expectation to the art object; a hope that something basic will occur to jolt the viewer with an experience of beauty, or the shock of pain. In an escapist sense this represents a desire to find a rarefied place of abandonment which makes few crossovers with the real world, which remains housed in the museum or the pristine whiteness of the gallery, forever hidden from the course of history. In the best sense, this desire for the beautiful pertains to the notion, not unlike that held by members of the Frankfurt School, that beauty is itself subversive, especially in a world suffering from narcolepsy. That, that which arouses desire, stimulates the senses, spurs the imagination – not in a simple, pretty, mindless way, but in a profound and therefore unsettling way – must inevitably challenge the normal course of life which can never satisfy deepest desires or a longing for completeness.

Hillman also contends that 'the work of art allows repressed districts of the world and the soul to leave the ugly and enter into beauty' (p.63); like Goya's Black Paintings, to transform the horrific into something which has shape, line, internal integrity – aesthetics. Many audience members do not realize that what we call art, that which has aesthetics, can manifest itself in a wide range of incarnations and serve many functions. 'Every well constructed object and machine has form,' says John Dewey, 'but there is aesthetic form only when the object having this external form fits into a larger experience' (1934, p.341). But how can we characterize the range of that expanded experience?

If it is successful, the art object resonates within its own history while also entering the ongoing debates in the art-historical world. It speaks to a finely tuned intellect as well as to the collective unconscious. It can operate in images and at times in language or challenge the origin of language with its exploration of images. The work may address national identity as well as that which is subversive to that identity. It may try to articulate the complexity of the past, the remembrance of what is lost, to uncover that which is hidden, layer what is complex, speak the unspeakable, reveal collective fears, unseat personal anxieties, intersect the individual with the universal, challenge the collective dream. It can defy notions of progress and utility – the anchors of the reality principle – suspend linear time, immerse us in pleasure, irrelevance, irreverence, outrageousness. In Kant's sense it creates 'purposiveness without purpose' – concentration for concentration's sake. It might play with, make fun of, denounce the prevailing ideology, mirror back the absurdities of commodification, push and torture the limits of technology, invert what is known until it becomes strange, bombard us with what is strange until it becomes known, return us to a longed-for, if only imagined, childhood, propel us into a visionary future with the child self intact and equip us to function more healthily in the adult world.

Artists re-present the culture from which their identity has been constructed – their race, class, ethnicity, their sexuality, the complex combination of forces which have shaped the way in which they see the world. And they help us to understand, through images and language, the particularity of an individual psyche as it intersects with that of the collective.

These aforementioned are some of the best examples of what art and artists have done, and yet, for a general public, the comprehension and appreciation of art is still often limited to a more simplistic notion that art will bring joy, that it will transform pain. There is something wonderful about art which can create happiness in a direct way, but increasingly artists can only make reference to contentment and the sensuality of an idyllic life in their negation. This type of work is most irritating to those with conventional expectations. They feel deprived of catharsis and the healing effect of beauty, yet, in fact, such work has everything to do with beauty precisely because beauty, as a static value-ridden entity, is so conspicuously absent. In its place is conflict, deconstruction – the taking apart and analysis of what there is and the mourning for a joyousness which no longer seems attainable.

Like Hillman (1991), the contemporary art world also is concerned with lifting repression, but its sense of how you do that contradicts Hillman's proposal. It is seen as reactionary in most art-world circles to make work which does not challenge conventional notions of beauty. In other words, when lushness and exquisiteness do exist it is often within the framework of post-modern appropriation and pastiche. There must be some irony in the presentation – the reminder always that we are not now seduced by what once seduced us and that we are able to stand outside the work with some critical distance and ask: From what ideological position was it formed? For whom was it made? Whose interests does it represent? Whose does it serve? What underlying questions does it ask? What implicit power relations frame it? The unintervened-with object is now rarely accepted on its own terms. A disruptive discourse enters into the experience and the work becomes a locus for serious debate. If this intervention is understood by the viewer, it can help clarify that art lives in the continuum of history, engages with contemporary issues and can be transformed by their demands.

But although art and artists increasingly do try to comment on the historical moment, their discourse is still often hermetic and incomprehensible to those outside. The uncertainty about how clear art needs to be and who is responsible for that clarity, has been the source of much debate and antagonism. According to John Dewey, 'The language of art has to be acquired' (1934, p. 335). It is a learned discourse that may be accessed only through an immersion in art and the art world. But the existence of such a barrier is not acknowledged by those who present art to viewers. The mystification of contemporary art could be lifted in part if the general museum-going audience were cautioned when entering an exhibit, that the work they were about to see might elude, confuse and unnerve them if its language is not decoded, and that in fact the dislocation they may experience is crucial to the work's intent. It is often not understood that a good deal of contemporary work is referenced to art history – the signified is the history of art itself – and is not, as many still believe, the so-called life or emotional experience they expect art to address. Therefore, one can not always 'get' the work intuitively, unless the allusions, spoofs and comments about other contemporary work and intra-art-world debates are made apparent. Also, the environment of the gallery or the museum designed to create a fake neutrality does not always allow the work to establish an adequate context. Why should we expect that an isolated image can reconstruct an entire world around itself? Suzi Gablik quotes Sherry Levine on the 'uneasy death of modernism'. Levine says that the work in which artists are now often engaged 'only has meaning in relation to everyone else's project ...It has no meaning in isolation.' (1991, p.18) Its context, then, is the spectrum of contemporary artistic creation, yet it is often presented in isolation so that it must generate its own meaning, even for those who cannot recreate the absent part of the dialogue.

In practice, what often occurs when a person walks into the sterile museum setting and tries to grapple with a difficult piece of contemporary work is that the viewer is left with the question, 'What does this work mean?' 'Why don't I understand it?' and then, if the work generates a bit of uneasiness or anger, as it often does, the question becomes, 'Is it art?' In Chicago's Museum of Contemporary Art I have heard such queries directed at pieces by such artists as Joseph Beuys, Rebecca Horn, Christian Boltanski. Recently, standing in front of a Rauchenberg painting I heard a man say, 'I could make something like that.' Those expressing such often-heard statements probably feel a great deal of frustration. For them the work is not serving the function they assume it should. Often these audience members question the incorporation of 'found objects', the way the work is constructed; to them somehow the craft is not precise enough, the materials too

mundane, or the representation too minimal. The work appears not to have taken enough labour. These viewers therefore suspect they have been duped and that they too could construct something of equal merit. Because they are able to step outside, to question its authenticity, it is clear that this work does not satisfy their need to be entranced, amazed or swept away. They may or may not be sympathetic to the notion that the work might intentionally wish to transcend preciousness by negating the experience of its own rarification and that it is in fact successful in these terms. Not only might we say that the viewer has found the experience of the work wanting and in this sense has not 'gotten' the artist's intention, but also that the viewer has not understood why this work has been called 'art' at all. The hostility is directed to the artist, but also to the entire art apparatus – gallery owners, museum curators, collectors, critics – those who sanction certain work, position it in the museum or gallery context and, in so doing, raise a certain level of expectation.

When Scott Tyler placed the US flag on the gallery floor at The School of the Art Institute of Chicago, all these issues were raised. The initial reaction of many viewers was fury generated by the placement of the flag in such a compromised position. And this rage was followed by a series of questions: What is this strange thing called 'installation' – a form that is neither painting, sculpture nor photography but in Tyler's case an amalgam of all three? Why was this piece shown within the confines of the Art Institute of Chicago – a well respected and prestigious venue? In reference to this last query, the location of the exhibit was an issue that needed immediate clarification. Tyler's installation 'What is the proper way to display a US Flag?', was not chosen for exhibition by the twentieth-century curator of the museum but rather by a faculty committee selecting work for a student exhibition. Misinformed, thousands of Chicagoans thought it was time to stop contributing their tax dollars to the Art Institute in protest. The School of the Art Institute insisted on making the distinction between the function of a school and that of a museum, in the hope that it would change the perception of the work, but the damage was already done. Within these incidents rest the contradictions artists, educators and young art students are up against. Unfortunately, the pedagogical value of these subtexts often has remained unknown to those not trained to read the questions or to find their complexity exhilarating.

When art causes such a public furore it is often because the work conflates innovation in form with the radicalness in content. A lay person may not easily understand the genre of installation or performance art. These have evolved out of other forms – sculpture, theatre, dance – liberating the artists from the conceptual and physical constraints. But without having knowledge of the restrictions such categories and conventions of form placed on the artist, a more general audience might have little access to, or sympathy for the work. Once the parameters governing artistic activity have been lifted, the artist may be freer to create, but the audience is often lost.

When Karen Finley smears her naked body with chocolate and then covers it with sprouts to represent shit and sperm respectively, there is quite a bit to explain to those who can neither understand the humiliation she experiences as a woman, or the form with which she chooses to express it. She uses monologues, she also uses her body, yet her work is neither theatre nor dance. The simple devices she has found for communicating terribly complicated issues of power and submission are actually extremely effective. When described out of context, however, the work can easily sound banal and crude, an easy target for literalists of the imagination, those hung up on profanity and those unable or unwilling to acknowledge the depth of personal pain that this work attempts to convey. 'Aesthetic experience is a manifestation, a record and celebration of the life of a civilisation, a means of promoting its development, and is also the ultimate judgement upon the quality of a civilisation' (Dewey, 1934: 326). Finley's work embodies a scathing critique of society, yet few outside the art world are interested in exploring the value of such work.

Right-wing U.S. politicians like Jesse Helms and Pat Buchanan, who supposedly focused on issues of pornography, in part have actually been punishing artists for the seriousness of their work's content, the inventiveness of its form and the articulated indictments of society it contains. Had Andres Serrano chosen to present the contradictions of Catholicism in a less unconventional way: had he not submerged a plastic crucifix in a tank filled with urine to photograph it as romantically and mysteriously as he did; or had he chosen to communicate the corruption of the Church and the denigration of the teachings of Christ without the use of imagery, perhaps no one would have paid attention. If Karen Finley had simply talked

about abuses to the female body and had not attempted to create them symbolically, perhaps she would not have been as readily criticized. If performance artist Tim Miller had said the same things about being a gay man in American society during the last twenty years – from the joys of sensual discovery to AIDS –without dramatizing the pain and without taking off his clothes, his National Endowment for the Arts grant might not have been revoked. Or if the late David Wojnarovich, in writing about the Artists Space exhibition inspired by the nightmares of AIDS, had kept his rage in check and hadn't mentioned those government officials whom he held responsible for apathy in the face of this epidemic, Frohnmayer might not have noticed. These artists, and many others, have paid for their radicalness. They have been punished for the political content of their vision and the degree to which they have had to resort to extreme forms to communicate the passion of their positions. But such work has received little support from those outside the art world because its meaning is not understood and its significance as a pedagogical tool and as an analysis of contemporary society, cannot be grasped by those who are only familiar with 'high art' or mainstream mass culture.

However oblivious to its audience such work may seem, there is an important function served by difficult, innovative art which refuses to be assimilated. It does jar the senses, challenges normal perception and destroys the illusion that the world in which we live can be easily understood. 'It can be argued', Terry Eagleton writes, 'that the unreadability of literature is precisely its radicalism ... Literature entices only to refuse, appears complicitous only to cold-shoulder. Literature is always somewhere else' (1975, p.165). Art, in the same vein, can be utterly familiar and yet its opposite. It can baffle where one expects recognition, reject where one longs for acceptance, or be incomprehensible where one desperately seeks understanding. It can also be argued that the difficulty many have trying to grasp the meaning of contemporary art demonstrates the unnecessary exclusivity of the art world – its isolation from most people's lives. But the inability of many to 'read' the visual work that is in front of them is also a mark of how uneven the cultural life of American society actually is. Undoubtedly, the fact that art has been obliterated from the U.S. public-school system is at the source of the problem. Those who are attending or recently have

attended public schools, for the most part, are visually illiterate. And even when art is taught within the school system, those who teach it rarely stretch beyond the traditional humanistic goals of art education, which focuses on genius, masterpiece, divine inspiration and predominantly white Western art that ends with impressionism. Most who teach at the public-school level have not been trained to reflect upon the issues with which contemporary artists actually engage. Like literature, art now often presents itself as 'threat, mystery, challenge, and insult'. 'Literacy admits us to reading,' Eagleton writes, 'so that we can take the full measure of our exclusion'(1975, p.18). Those able to read are actually unable to read. Those able to see are none the less unable to see. But to an audience which has not been taught the pedagogical value of such frustration, this exclusion is a source of great hostility.

Artists and the art world seek to provoke in this way, but are then unwilling to deal with their audience's resultant anger. One could of course argue that the exclusivity of the art world is precisely the point and art should indeed always refuse to blend into mass culture, where images and issues often are flattened to banality. But artists, for the most part, do want their work to be understood and a stated goal for many is accessibility. Some artists talk about their desire to reach a larger audience, one outside the art world, and this has become a more significant issue as art is increasingly more charged with political concerns; some feel an almost moral obligation to reach out and extend to a larger, albeit unnamed, undifferentiated audience beyond that which is familiar.

Yet when one seeks models for a more accessible kind of work, few names come to mind. On everyone's list would be Barbara Kruger and Jenny Holzer, perhaps because their work is language-based and its messages seemingly explicit. What is interesting about their work in relationship to this discussion is the way in which they both position the audience within their discourse and reveal or do not reveal themselves in the process. I watched Jenny Holzer's impressive digital electronic signboards revolving around the curved spaces of the Guggenheim Museum in splendid red, white and amber and wondered, almost out loud, who is this artist and what does she really think about life, art, politics? Is she as paranoid as these aphorisms would have us believe or is this non-specified identity, manifested through these words, a creation, a persona? At

whom is this voice directed? And does her desired audience actually 'get it'?

The aphorisms warn us about private property, sex, love, passion, crimes of the heart, an unnatural Big Brother about whom we should concern ourselves. We wonder what can be made of statements like:

> IT'S BETTER TO BE A GOOD PERSON THAN A FAMOUS PERSON.
>
> IT'S BETTER TO BE NAIVE THAN JADED.
>
> IT'S BETTER TO STUDY THE LIVING FACT THAN TO ANALYZE HISTORY.
>
> IT'S CRUCIAL TO HAVE AN ACTIVE FANTASY LIFE.

OR

> WHAT URGE WILL SAVE US NOW THAT SEX WON'T.
>
> PUT FOOD.OUT IN THE SAME PLACE EVERY DAY AND TALK TO THE PEOPLE WHO COME TO EAT AND ORGANIZE THEM.

These distillations, arguments, bits of conversation, political wisdom, unsolicited advice, fly by us. What is their context? The power of the electronic billboards, the at-once arrogance and diffidence of the voice behind the text leave us breathless. Should we accept the confusion we experience as an essential component of the work? Or can we criticize the non-specificity of the subject and object of such discourse? What might an average viewer deduce? What is the actual effect?

At a Barbara Kruger gallery exhibit in New York I experienced a similar confusion but for different reasons. Obviously Kruger's work has a much more clearly defined point of view – an explicitly political feminist stance. In this particular installation her work was angry and that anger was focused around issues of power, domination and gender-related inequities. The rage was palpable in red, black and white, surrounding the viewer at every turn, even on the floor. But how are we supposed to understand these words? Were these messages for the art world? If so, the art audience has already heard them. Are they for the average gallery-goer? And if so should we assume that the audience shares Kruger's analysis? Or are these questions irrelevant and should we simply be grateful for this forceful surrogate voice enraged for all who feel anger and have no voice of their own?

Both Jenny Holzer and Barbara Kruger speak as the embodiment of reason in an unreasonable world, as truth in an untruthful world, and most assuredly as anger in a world which generates injustice and humiliation but offers few forms of expression for it. Jenny Holzer's aphoristic phrases have appeared on billboards, hat brims, T-shirts, placards. They have allowed the artists, here appearing as disembodied voice, to find a site-specific way to rivet her discourse. She has successfully taken it out of the gallery context and has put it on the streets. Even were this work designed only to feed those in the intellectual vanguard it still would have a purpose. In a sense a great deal of what appears as political work and seems as if it should stretch beyond the normal art-world context may actually have a more useful function as theory. It appeals to those able and willing to grapple with art as an expression of ideas and to understand it philosophically – beyond, in spite of, instead of the fixation with the object. How much or how little of this is grasped by those outside the ranks of the initiated, those exiled from the communication – the ex-communicated – can only be imagined.

The complexity of these issues poses a pedagogical challenge for those engaged in the education of young art students. How might this next generation be taught to grapple with these concerns? Can they be encouraged to serve as a bridge between the cutting edge of art-world ideas and a less art-sophisticated audience. In truth, the issue of audience is rarely raised in the American art-school pedagogical process, and by its omission it is usually assumed that work is being made to take its place within the art-world context. This assumption usually becomes self-fulfilling. Yet among people with political consciousness, work which does not reach beyond the gallery world is often thought to have failed. Somehow it is hoped that there will be another venue, a larger arena, a new audience who will be interested in and affected by such work. But even the most political work is often unable to transcend its category as art. And work which is thought to cross over – move between the art-world and a more mass audience – is often co-opted by art-world recognition. This fashionable assimilation is a contradiction for work whose goal is social criticism and criticism of the exclusivity and élitism of the art world from which it has emerged. But because most artists cannot subsist economically, intellectually or emotionally without the approval of the academic art world for grants, teaching positions, exhibitions, critical reviews and ego survival, they set their sights within the art world and are satisfied making a political statement about the hermeticism or corruption of that small arena. It would be ideal if work could break out of categorical bound-

aries and be simultaneously avant-garde and popular but, in practice, this is difficult to achieve. Given these hurdles, educators must set out clear programmatic goals to help students think about their work within a larger societal context and to imagine who their audience might be.

In practice, these fundamental questions about audience only arise when students make work which has an overt political agenda or has some other deliberate message to communicate, work that is after some specific result. Often the reason politically oriented work is so didactic is that it is attempting to 'prove' to viewers in a moral way that they should accept the artist's point of view, see the world or at least a particular aspect of it as the artist does. In its attempt to convince – its sense of its own correctness and also its own isolation – the work often goes overboard, becomes heavy-handed. And that which is designed to persuade, to demonstrate that art can educate, concern itself with the issues of the world, succeeds instead in pushing its viewers away.

Mature artists like Jenny Holzer, Barbara Kruger and Hans Haacke can bring to this challenge a good deal of humour and irony, but student artists grappling with the seriousness of the issues, perhaps for the first time, often lack this ability to step outside and to comment on the absurdity and even futility while none the less waging a strong battle against that which disturbs, unnerves, infuriates them. When students make issue-oriented work they try to tell others what to think. They often assume that their audience knows very little about the question they are addressing and must therefore be educated, or they assume a conservative audience that should be radicalized, or a puritanical one that needs to be shocked. They rarely see, in an objective way, how confrontational and alienating the form of the work actually might be to those outside. At times this work projects their feelings about the world from which they come – their parents, the values presented to them which students now feel they need to combat. These touchstones become the object of their attack. The result, at its worst, may take the form of a generic rebellion – nudity for nudity's sake, anarchism for anarchism's sake. The ultimate effect of the work is not thought through. Students rarely step outside their own subjectivity long enough to measure the result. Even when they do study theory and develop strong philosophical principles, they are rarely taught strategy. And they are given little historical sense of how artists have functioned at other moments in American society or when they have successfully aligned with social movements committed to change.

In the same vein, because students need to be helped to understand not only the subject of their work but its objective, they must learn to ask themselves who would be their ideal viewer and who, most likely, will be their actual viewer? What might their audience need to know to understand the work? How much information should they offer? At a time when the issue of identity is being discussed in all areas of the art world, it is important to challenge the notion of a universal subject, to ask students about the particularities of audience and how much they actually know about the groups they have targeted. In practice, art deliberately designed for a larger audience becomes hermetic when these questions are not asked. Such inquiries, which seem *pro forma* in other disciplines, are truly confrontational within the art world because they smash the absoluteness of subjectivity which is so treasured and goes unchallenged in the traditional art-school environment.

I am not arguing that artists should simplify their work – I believe strongly in the tension created by that which cannot be easily absorbed and therefore engenders struggle. Rather, I am committed to the notion that the traditional expectations for the place of art in society must be challenged, and that young artists must be taught to ask themselves how far they are willing to go to make certain vital connections apparent to a more diverse audience. Without such assistance even Post-Modern work seems caught in a Modernist paradigm – as it waits for its inherent genius and universal appeal to be discovered and to trickle down to the masses. To assist a more direct and honest comprehension, artists simply have to make some attempt to help the viewer through the work's complexity. This is what students in particular find difficult to actualize. Because they themselves don't as yet know how they arrived at their own images, they are not sure what would be necessary to bring other people along with them. And yet, the amount of information disclosed by the piece itself becomes the measure for how much power one bestows on the audience. As we offer students our knowledge and experience, we extend to them the ability to communicate to as large an audience as they choose. In so far as we show them that their arrogance is unstrategic, however principled its intent, we give them the

ability to assert control over the response their work might elicit. As we encourage or discourage the art-school tendency towards hermeticism, we either free young artists from the confines of the art world's terminally hip subculture or circumscribe them within its discourse forever.

The obscurity and Post-Modern nihilism that characterized a great deal of the eighties art world has already begun to transform in the nineties. There is no doubt that student artists are already pushing against the limits that have been handed down to them. They are increasingly committed to finding ways to represent issues like homelessness, the degradation of the environment, AIDS, child abuse. And they are struggling to find new forms within which to present their work. In the face of the gallery system's monetary crisis and the serious degeneration of the urban infrastructure in America, many have already abandoned the desire for a conventional career as a gallery artist and have instead focused on site-specific installation, performance and work which is more community-based. These young artists who have seen through the illusion of the market-place, are not easily seduced by its prestige.

So much of what is wrong, so much of what accounts for the massive gap between artists, writers, intellectuals, theorists and the general public is historical. There has never been, and there is not now, a significant place for artists and intellectuals within American society. This is perhaps the biggest problem the artistic community faces. No matter how well we prepare our students, no matter how much we all attempt to reach beyond the narrow confines within which we have been trained, we none the less struggle against the fundamentally anti-intellectual nature of American society and the visual illiteracy the educational system perpetuates.

But as the economy collapses around us perhaps artists will reach out to align themselves with other groups who also have been seriously disenfranchised. And one hopes the insights, perceptions and brilliance of artists will be sought out in the nineties to solve, in unique ways, problems that appear to be frighteningly unsolvable. These solicitations could break down the artist's sense of isolation and help heal the censorship wounds of the last five years. They could transform the popular perception of art and the artist and help create compassion for those who attempt to articulate a personal vision even when these efforts are met with misunderstanding and opposition. Out of the urgency we are now experiencing, caused by the greed of those without imagination who have been allowed to rule for too long, will come the search for language and images rich and complex enough to represent the economic and spiritual pain many are experiencing, and visionary enough to help construct a sense of renewed passion and expectation for the future. We can only hope that the satisfaction artists might derive from constructing such images will be matched by the audience's pleasure in experiencing them.

BIBLIOGRAPHY

DEWEY, J. (1934) *Art as Experience*, New York, Putnam.

EAGLETON, T. (1975) *Criticism and Ideology*, New York, Verso.

GABLIK, S. (1991) *The Reenchantment of Art*, London and New York, Thames and Hudson.

HILLMAN, J. (1991) 'The repression of beauty', *Tema Celeste*, May, IV, 31, International Edition, 58–64.

STEINBERG, L. (1972) *Other Criteria: Confrontations with Twentieth-Century Art*, Oxford University Press.

INDEX